coats! Max Mara, 60 Years of Italian Fashion

Max Mara, 60 Years of Italian Fashion Color Col

Edited by Adelheid Rasche

Essays by Marco Belpoliti, Mariuccia Casadio, Federica Fornaciari Colin McDowell, Enrica Morini, Adelheid Rasche, Christine Waidenschlager

Catalogue texts by Enrica Morini, Margherita Rosina

coats!

A travelling exhibition

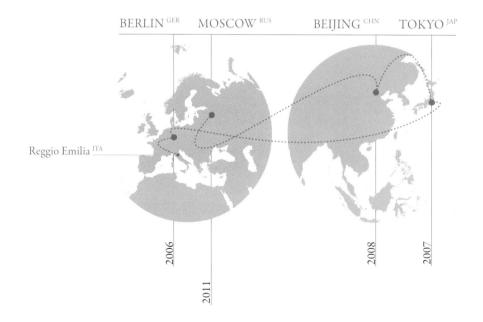

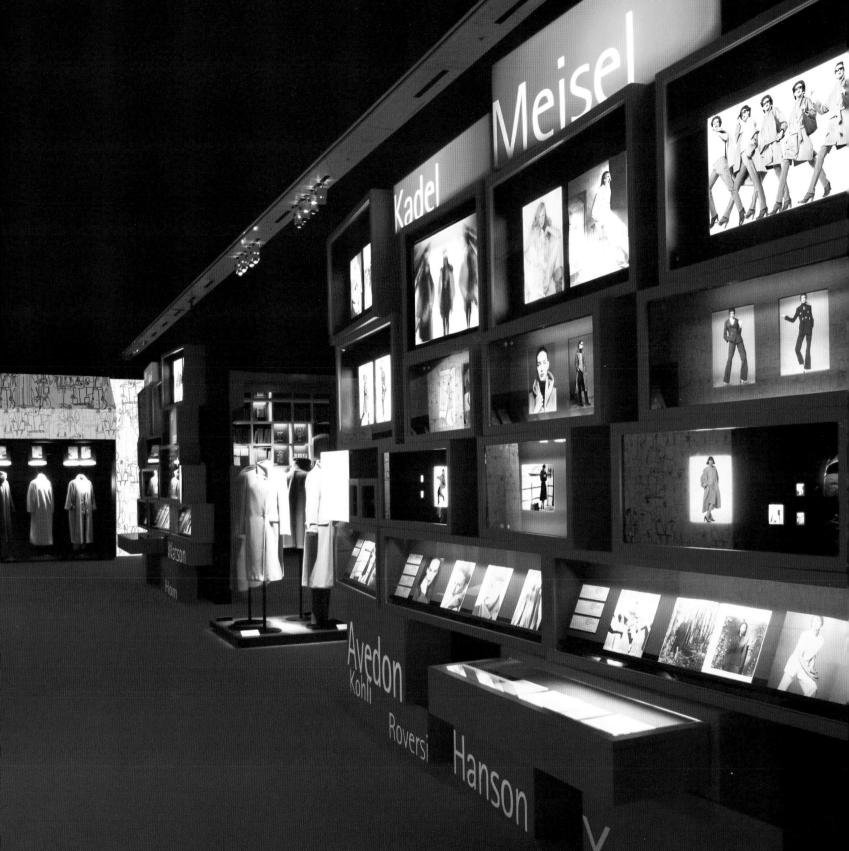

lanson Yave

The publication of this volume concludes an important and meaningful event in the history of Max Mara. Indeed, 2011 marks 60 years of activity for the company.

The travelling exhibition "Coats!" started five years ago at the Staatliche Museen in Berlin and now arrives at a fundamental and significant leg of the tour: the State Historical Museum in Moscow.

With its tradition and culture, I believe that few places like this city are able to evoke the modern development of perhaps the most iconic article of clothing ever created in the history of fashion and costume: the coat.

This catalogue is a testimony of the special and rare experience of travelling backwards through time through our extraordinary Company Archive. This project has been carried out with the help of many people that I would like to thank in equal measure for their rigorous approach, enthusiasm and copious energy put into the research and historical reconstruction through numerous testimonies and thousands of documents.

Among the many considerations that can be made when leafing through the pages full of images and from reading the critical texts, I would like to select one that I think is important in summarising the uniqueness of Max Mara in the panorama of post-war fashion creation.

Our business culture has led us to consider a successful original creation as a real garment chosen by real women in a real market.

The creative skill of the many designers that have worked with us has been a vital stimulus, but has only been able to flourish because there was a wider project involved, in which creativity and innovative skill were expressed at all levels of the process with many different forms of professional expertise, all equally indispensable.

Today this belief still drives our strategies and pushes us to extend the same vision to all those who contribute to the creation of our projects.

Luigi Maramotti, Chairman of the Max Mara Board of Directors

Contents

- 11 Introduction Adelheid Rasche
- 17 Max Mara, Sixty Years of Fashion Enrica Morini
- 81 A Brief History of the Coat Christine Waidenschlager
- 87 The Creation of a Cult Colin McDowell
- 93 The Delicacy Process *Marco Belpoliti*
- 105 An Inspiration that Conquered the Market. Max Mara communication strategies Adelheid Rasche
- 141 Variations on Coat *Mariuccia Casadio*
- 149 A System of Objects.
 The Max Mara Company Archive
 Federica Fornaciari
- 157 Garments from the Max Mara and Sportmax collections Enrica Morini, Margherita Rosina
- 249 Back matters

Introduction

Adelheid Rasche

The future needs a past: Max Mara, 60 years of Italian fashion

San Maurizio, just outside Reggio Emilia (Emilia Romagna region, central Italy), between Parma and Modena. We enter an industrial complex designed on sober, modern lines, covering an area of about 10,000 square metres, and within seconds we find ourselves in the key manufacturing department of the Italian fashion company Max Mara. This is where their world-famous cashmere and camelhair coats are made: it takes less than three hours to complete the seventy-three stages in the production of this now classic garment, first designed in 1981 under style code 101801, and a feature of every winter collection ever since. Two large areas, one for cutting, the other for sewing and pressing, make up this highly professional workroom, where humidity and light levels are automatically controlled. Organised in small groups, the seam-

stresses work on sleeves, collars and inside pockets, the hum of sewing machines filling the air. One of the most delicate operations is the steam ironing of each piece on various special boards, during which the fabric must not be forced in any way. Each model is placed on a mannequin and the final checks are carried out with loving gestures, like the final check a mother gives her children before they leave the house.

Here one clearly understands the true meaning of expressions like "quality research" and "respect for the fabric", and what can be achieved through a combination of technical innovation and artisanal tradition. It is easy for an attentive visitor to turn back the clock to 1951. Usually, when thinking about Italian fashion history, one immediately remembers the *haute couture* shows presented for the first time in Florence in February of that year, when the organiser, Giovanni Battista Giorgini, not only made

North-American clients and experts aware that Italian couture existed, but also permanently focused their attention on it.

1951 was also the year when Achille Maramotti, a lawyer from Reggio Emilia, founded his fashion house that, a few years later, would be given the sounding name Max Mara. Achille Maramotti can unquestionably be considered a pioneer in his field, since he was one of the first entrepreneurs in Italy to successfully apply the concepts of haute couture to industrial production. His family certainly did not play a minor role in this: his great grandmother Marina Rinaldi had been head of a much-respected tailoring atelier in Reggio; his mother, Giulia Fantanesi Maramotti, was the head of a long-established dressmaking school. With the help of one of his mother's female collaborators, Maramotti designed the first fashion coat for women at a moderate price; a boyhood friend, hired as sales representative, secured the first orders. From these modest beginnings the company, which was the first to introduce prêt-à-porter in Italy and enter the market with an extremely innovative product, built up in the space of just a few years a flourishing production focused on what was called "outer wear" at that time, that is to say on elegant coats and suits for women in fine woollen fabrics and robust cottons and linens with a tailored cut, but produced industrially. Until the end of the Sixties, Max Mara sold only to Italian business partners; later on, the company became directly involved in distribution, opening own shops throughout Italy, in order to establish a closer relationship with the end consumer.

This constant evolution through the application of ground-breaking ideas can be considered the special entrepreneurial talent of Achille Maramotti, who was at the helm of the company until the Nineties, when he placed it in the hands of his three children. Thanks to his farsighted business strategy, Max Mara was able to sail ahead also during difficult periods, sometimes even accelerating, whereas the competition was obliged to lower its sails.

This can be seen, for instance, in the different forms of inspiration for the collections, which in the Fifties was drawn from French *haute couture*, while towards the end of the Sixties it came from London, which was then at the forefront of young fashion. Sportmax, the line launched on the market in 1969, was one of the first ever collections of *coordinates*, based on the now firmly established concept of individual garments that can be mixed and matched.

Another significant point is that Max Mara was not founded by a fashion designer, but by a businessman. For sixty years, the company has succeeded egregiously in making a virtue out of necessity and in putting the product first, thus distancing itself from the designer cult that is so widespread in the fashion world. In fact, the inter-

national designers who work with the internal stylists teams on dreaming up the collections, are not even named while they are collaborating with the company: what counts is teamwork, from the planning of the collection and assembly of the prototypes for the sample collection, to the final cutting and making up of the garments. Each production unit holds internal discussions, carries out evaluations and quality controls, makes improvements, and experiments with new technologies. This true workshop spirit has remained intact throughout the many years of the company's development, from its beginnings as a small working group controlled by Achille Maramotti alone, to its present structure that boasts many partnerships, around thirty different collections and about four thousand collaborators worldwide.

What sets Max Mara apart and makes it quite extraordinary is its ability to reconcile four seemingly conflicting contradictions. Firstly, while remaining faithful to its regional origins in the firm conviction that this is where its creative strength lies, Max Mara has become decidedly internationalised since the Sixties, by involving well-known designers and later opening its own boutiques, which are now to be found in more than ninety countries spread over the five continents. Secondly - in an unusual move for this sector - by combining the concepts of fashion and durability: Max Mara offers timeless fashion, which gives it more of an affinity with the luxury goods industry orientated towards lasting values, than the mechanism of short-lived trends typical of the fashion business. In fact, the classic quality of the coat, the basic garment in Max Mara's main collection, has more to do with luxury design than the frenetic pace of fashion. Thirdly, from the very start Achille Maramotti and his collaborators understood how to interpret the market trough strategic analysis but never had a commercial approach to it: by giving due importance to sales figures in the planning of the successive collection, which the company had already used as a marketing tool for a long time, it was always possible to react quickly to customers' growing needs and to further segment supply. Finally, the fourth apparent difference concerns an evaluation that may seem obvious today: for sixty years, Max Mara has been one of those companies that take industrial progress and design creativity equally seriously, along with the development of cutting techniques and models. If, in the early years, industry and design were two completely irreconcilable opposites, today the wide distribution of the product throughout the fashion market opens up an extremely wide range of possibilities.

A fashion company like Max Mara, which has developed considerable know-how in this sector for more than two generations, offers high-quality products that embody

all the benefits of the synergy between creativity and technical progress; it markets them through multifaceted communication strategies, and sends out a clear message: "well-designed, well-made and well-balanced."²

In the beginning there was the coat: the project's origins

In September 2003, when Giorgio Guidotti (President Worldwide PR and Communications of the Max Mara Fashion Group) and the editor of this volume had their first informal meeting in the new Max Mara headquarter, the actual project had still to be precisely defined. Right from the start, the Staatliche Museen in Berlin were strongly motivated to make 'Focus on Fashion', planned at the Kulturforum that year, a resounding success through the collaboration of this "quiet giant" of Italian fashion.

Indeed, Max Mara had been wanting for a long time to stage a large exhibition accompanied by a volume, which was strongly supported by Laura Lusuardi who for many years had been coordinating the design group and had been actively working on preserving the company's historical heritage. At the same time, the company had realised that it possessed a wealth of archival material, which had resulted in the setting up of a special section (Biblioteca Archivio d'Impresa Max Mara), directed by Federica Fornaciari. This was primarily intended for internal use, as a source of inspiration; other possibilities had not, as yet, been fully explored. The first stage consisted in a gathering of the not ordered material that had just begun, and its general organisation; nevertheless, it was not yet possible to draw an overall picture of the various groups of items. While a general outline of the exhibition was being developed, it became clear just how much of the material concerned the company's historical development: of the approximately fifty thousand items held in the internal collection, the majority relates to the garments collections created from 1982; while the designs of the models have been systematically catalogued since the mid-Sixties, the advertising material and relative original photographs, in the majority of cases, only date from the Seventies. The complex evolution of the many individual collections launched by the parent company was difficult to reconstruct, chronological panoramas and systematic indices of consultants, collection themes, photographs and models were still lacking.

It soon became clear that the complex representation of the company's history within the limited sphere of a scientifically constructed retrospective exhibition could only be attempted on the basis of a well-defined theme. And what better theme than the coat, the very core of Max Mara's production for sixty years? The precise key to Achille Maramotti's success was the industrial production of ele-

gant, high-quality coats and suits. A successful story started in 1951 and are still the pillar of every collection: thus, the history of the coat embodies the entire history of Max Mara and its individual strong points.

From the Max Mara and Sportmax collections – the latter founded in 1969 as a line of young coordinates - about five dozen of the most important models were chosen, which perfectly express the message of these two leading company lines, each with their own very different personality. With the exception of certain loans, all the garments in the exhibition are from the Company Archive, which, thanks to numerous donations (such as those from Laura Lusuardi, Giovanna Simonazzi and other employeed), is constantly expanding. Marco Urizzi has made available the grey cape designed by Karl Lagerfeld and purchased in 1971 by his aunt, Fernanda Urizzi, for her trousseau; Rosalia Piaia from Turin has lent a black coat trimmed with fur designed by Colette Demaye in 1968, which she won in the "Referendum della Moda" ("Fashion Referendum") competition and has lovingly conserved.

All the other selected material – designer sketches and technical designs, collection projects, press kits, catalogues, photographs and videos – has been taken from the company's rich heritage, which is being made public for the first time through this exhibition.

Composition of the volume

The versatility of the coat, like a musical theme and its variations, underpins the whole project: it is from the coat as the key product that all the questions spring; it is on its various aspects that the essays in the catalogue focus. For the authors of the essays the challenge lay in establishing diverse, complexly interwoven links: on the one hand, it was a case of presenting the history of the Max Mara company, from simple manufacturer to chief protagonist, in every sense, of the current fashion system; on the other, of establishing points of contact between the history of Italian and international fashion from 1951 on, and then focusing on the history of the woman's coat.

Enrica Morini devotes her richly detailed article to the complex history of the company, marked by Achille Maramotti's precursory innovations, his skilful development of the collections, the creative industrial expansion, the collaboration between internal designer teams and external consultants that still exists today, and the formation of the distribution system operated by the company itself.

The coat is a relatively recent addition to the female wardrobe. In her essay, Christine Waidenschlager presents the first models and the main stages in the coat's evolution through the Twentieth century. A garment strictly linked to street and city wear, which presupposes a female presence in public life, the woman's coat is

The Max Mara's headquarters in Via Fratelli Cervi, Reggio Emilia, photograph from the Sixties

also symbolic of how the image of the sexes has changed in modern times.

Marco Belpoliti's essay centres on industrial production processes and the figures and distinguishing features of mass production, as well as giving an overview of the complex fashion system.

In her article, the editor analyses company communication, which was introduced in the Seventies and developed from then on. To put its message across to customers, fashion needs communication. Max Mara has always recognised the crucial importance of constant, effective PR and press, and to this end uses internationally famous photographers for its catalogues and advertising campaigns, a selection of which is presented here.

Colin McDowell's reflections focus on Max Mara's best-seller, created in 1981 with style code 101801. This classic wool and cashmere coat, inspired by a man's overcoat but with kimono sleeves, continues to feature, virtually unchanged, in every collection, and with sales topping the one hundred thousand mark, it is the company's supreme icon.

From the Nineties onwards, within the ambit of various projects commissioned by Max Mara, this classic garment was given as a subject to various artists to be freely interpreted by them. Mariuccia Casadio's article presents those projects that opened up the world of fashion, bound to the economy, to the pure creative artistic process.

Federica Fornaciari's essay describes the present state of, and future plans for, the company library and archive (Biblioteca Archivio d'Impresa Max Mara), without which the present project could never have been realised.

A sizeable part of the catalogue is devoted to the plates, which present the selected coats photographed by Dhyan Bodha D'Erasmo. They are images seducing the viewer to gaze at them intently, to study the details, the volumes, the textures of the fabrics and the lines. The entries written by Enrica Morini and Margherita Rosina provide exhaustive technical information.

A select bibliography and index of names complete the volume, to encourage further study.

- O. Marquard, quoted in Immanuel Chi, "Used zur Negation von Neuigkeit", in Guido Zurstiege, Siegfried J. Schmidt (edited by), *Werbung, Mode und Design*, Wiesbaden, 2001, pp. 213–222, here p. 214.
- ² Luigi Maramotti in a conversation with Susannah Frankel, cf. "The Max Factor", in *The Sunday Review*, 29 December 1999, pp. 29–30.
- ³ Ulrike Sauer, "Stiller Riese aus Emilia", in *Wirtschaftswoche*, 12 December 2000, pp. 94–96.

Acknowledgments

I owe this volume and exhibition primarily to the Maramotti family, especially Maria Ludovica, Luigi and Ignazio. Without their unconditional support at every stage, and their generosity in realizing the project – begun over eight years ago – its conception and implementation would have been impossible.

My most heartfelt thanks go to Luigi Maramotti, who was always there at the most difficult times and who, with his sharp evaluations, was able to open up new paths when there seemed to be no way out. His clear-sightedness and strength enabled us to effortlessly overcome different mentalities and ways of working.

Naturally, I must also thank the many collaborators at Max Mara, especially Laura Lusuardi, Federica Fornaciari, Giorgio Guidotti, Diego Camparini, Grazia Malagoli and Gabriella Schiatti, all of whom made a crucial contribution to the project with their ideas and support. I would like to say a very personal thank-you to Cesare Di Liborio and Michael Bollé for those "fateful" slices of San Daniele prosciutto!

Curating an exhibition that draws almost exclusively on a rich Company Archive requires great discipline where the actual work is concerned and rigorous organization at every stage. The success depends on various conditions, which I would like to mention. The first is the time factor: rarely, today, does someone designing an exhibition have the possibility of working on the material for three years. For this I must, above all, thank Max

Mara, whose working rhythm is, in any event, dictated by the six months of the "season". I am exceedingly grateful also to the Staatliche Museen in Berlin and to the management of the Kunstbibliothek, both of which authorized and financed many research and service trips to Reggio Emilia. The repeated examination of the selected material resulted in several ideas maturing, and facilitated the elimination of some exhibits already included in the project to achieve greater rigour. The actual selection of the material was made much more productive and enlightening by constantly being able to compare notes with Laura Lusuardi, since, in many cases, her inside knowledge of the collections stimulated new lines of reasoning and approaches.

I was always able to rely on the understanding and unswerving support of the Director of the Max Mara archive, Federica Fornaciari, and his precious collaborators. Jeris Fochi made the film on the industrial processes that is part of the show, and it is thanks to him that the exhibition space reflects the atmosphere of San Maurizio.

Regarding the layout of the exhibition, the architect Ico Migliore of the Milanese firm Migliore+Servetto was involved in the project through Giorgio Guidotti. He and his collaborators, especially Alice Azario, succeeded in designing a layout that perfectly complemented the complex content of the exhibition.

This catalogue is the product of intense teamwork by Max Mara's exhibition department, the authors, the photographers, the architectural firm Migliore + Servetto, the publisher Skira and myself as curator. My heartfelt thanks to everyone, especially to Enrica Morini who was willing to pen the main text on the history of Max Mara; to Dhyan Bodha D'Erasmo and Carlo Vannini for photographing the exhibits; to the Skira's team, who brought the project to completion with great skill and precision.

This volume is dedicated to Achille Maramotti, the founder of Max Mara, to his courageous innovation, his foresight, and his culture of work and of life.

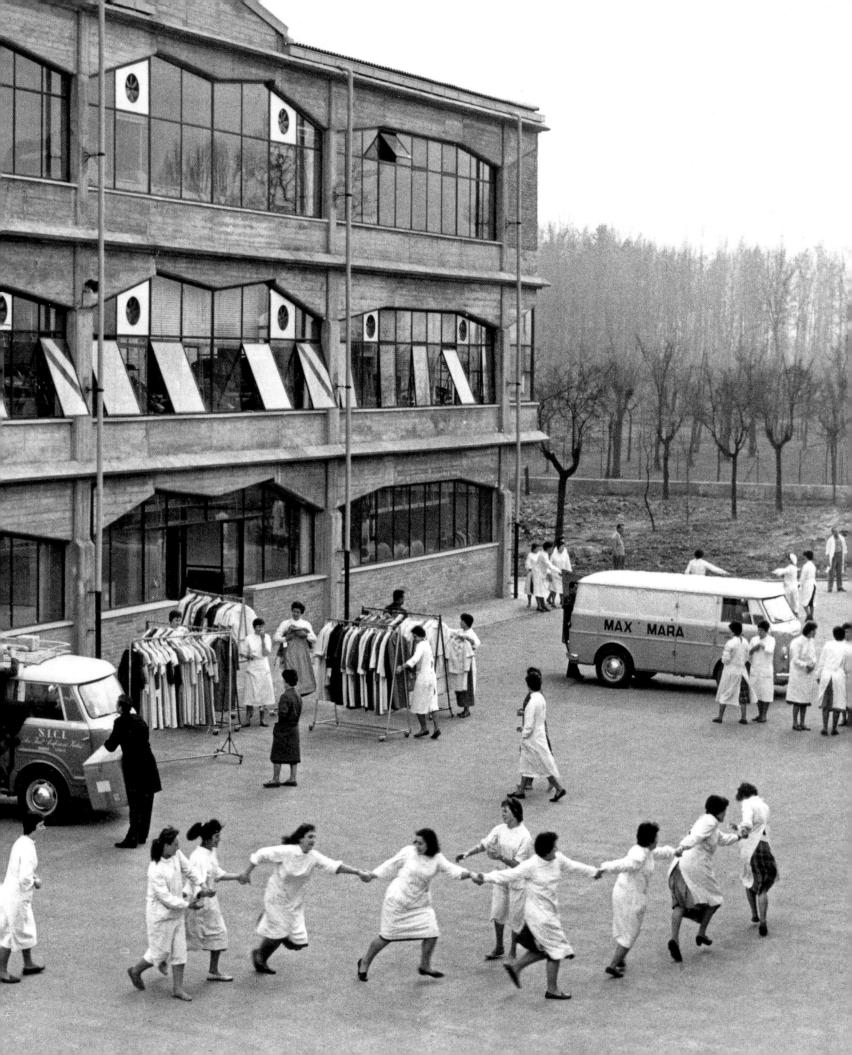

Max Mara, Sixty Years of Fashion

Max Mara: a genuine Italian story, but unquestionably exceptional in terms of the national scenario. It is a story about old-fashioned capitalism, the kind that used to build its fortunes through individuals with great insight and extraordinary business sense. At the same time, in the period following the Second World War, Italy was a country ready to embark on its own industrial revolution. Some of the northern regions had already commenced a shift towards manufacturing in the late Nineteenth century, but postwar reconstruction offered the opportunity to expand and radicalise this process, backed and encouraged by American intervention plans.

When Achille Maramotti graduated with a law degree in 1950, Italy was going through the first phase of its transition from an agricultural economy to a country whose future, though still unshaped, repre-

sented the goal towards which everyone was working.

The young lawyer's career choice immediately diverged from the professional tradition for which he had been trained. However, as he grew up his family must have given him the kind of open-mindedness and motivation needed during that particular moment in history.

His father, who had graduated from the University of Bologna at the turn of the century, moved to Switzerland during the First World War, working at the University of Fribourg and subsequently becoming director of the Institute of Advanced Studies in Chiasso. In 1923 he finally returned to Reggio Emilia, where he began to teach at high school.

His mother, Giulia Fontanesi, must have been an extraordinary example of an emancipated woman. As a girl, in keeping with a family tradition, she attended dressmaking courses in Milan and Turin. She later

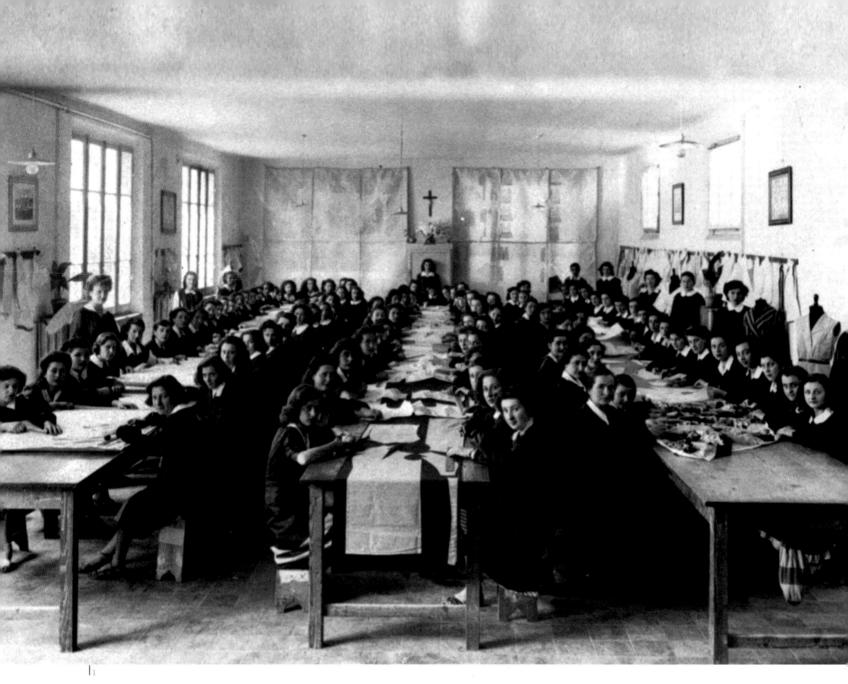

Maramotti dressmaking school, photograph from the Forties

capitalised on this training during the years in Switzerland, teaching in Canton Ticino and using her know-how to form a theory of pattern-making that allowed her to open her own dressmaking school when she returned to Reggio Emilia. Providing girls with specific occupational training so they could become independent was part of the goals of the feminist movement of the early Twentieth century, and Giulia Fontanesi pursued this goal not only at the Maramotti School but also through conferences and various types of educational initiatives.

In 1939 she was widowed with four children to raise, but in 1945 she managed to get Achille into university. This was an exceptional and unquestionably difficult decision at a time in which the disaster wrought by the war was still dramatically evident and living conditions were extremely unstable.

However, the jobs Maramotti undertook to support himself at school seem to have had a far greater influence on him than the Faculty of Law. He handled sales in the Rome area for Cremeria Emiliana of Cavriago (his uncle, Giuseppe Fontanesi, was the company's managing director), and in 1949 he worked at a small raincoat factory in Yverdon, Switzerland, staying there for five months to learn French.

Though the first experience taught him the basics of sales and marketing, the latter – as he himself later observed – was fundamental for his future decisions.¹ At the factory, he discovered that the craft his mother taught could be transformed into an industry, altering the work methods to minimise the production time of the individual garments and reproducing the styles on a large scale.

Maramotti Confezioni

He graduated from university in 1950, and his career as a lawyer promptly came to an end along with his job at Cremeria Emiliana. In 1951, he founded Maramotti Confezioni with the objective of producing quality readymade ladies' wear.

This was a revolutionary move on the Italian scene. First of all, Italy's social structure had never encouraged the establishment of a true garment industry, which was opposed by the extensive network of tailors capable of fulfilling the clothing needs of all social classes, from the elite who demanded the most sophisticated Parisian models to the mending and alterations of used clothing for the less wealthy masses.

The only examples of companies that produced ladies' garments between the two world wars were Merveilleuse, based in Turin, and Fias-Lo Presti Turba in Milan, but their approach was essentially sartorial and catered to a luxury market. The production of men's clothing (mainly shirts) and raincoats was more substantial – though well below the production levels of other countries – and these items were sold through the limited network of department stores established in Italy during this period.

When Maramotti decided to focus his business on ladies' wear, there were no reference models anywhere in the country. As a result, this decision must have been motivated by particular resources and ideas.

The main resource was undoubtedly the experience of his mother, who had specialised in dressmaking, and over the years this had taught him the basic skills he needed for this new business. Yet at the same time, Giulia Fontanesi was truly the child of her own era and she had serious doubts that a bond could be established between mass-produced garments and fashion, which was the prerogative of the noblest haute couture. In essence, her contribution to her son's initiative mainly involved personnel (for example, Marisa Crotti and then the young pattern maker Antonia Montanini) and the workshop rooms needed in order to start out.

The right perspective came from the idea of modernity that the American model offered Europe: the conviction that, in the wake of war, society would not turn to tailors for long but would become accustomed to purchasing industrially produced clothing. The latter was rapidly making inroads in Europe, so much so that, in France, Weill had already translated the term ready-to-wear as prêt-à-porter. The fashion magazines that came from overseas – and that Maramotti began to research and study attentively – showed the high fashion that came from the most prestigious and avant-garde Parisian ateliers. Above all, however, they showcased the enor-

mous number of readymade models that turned to *couture* for inspiration or followed the lines of more "native" sportswear.

Italy was clearly not America, where people had been used to ready-to-wear for centuries, nor was it France, where significant communications and promotional work were however required to expand the habit of ladies' ready-to-wear. Moreover, Maramotti chose to specialise in what was probably the most difficult sector: high-quality outerwear. Coats and suits came under the category of durables. They were "difficult" garments to cut and sew, made of important high-quality wools, and they were generally entrusted to skilled tailors. In short, they were expensive garments made to last for years.

With hindsight, during an interview he granted to Nicola White, the entrepreneur affirmed that the reference market pinpointed from the very beginning was that of the "provincial doctor's wife" - meaning the deeply rooted and traditional Italian middle class. This type of consumer must unquestionably have been frustrated by the provincialism of conventional Italian dressmakers, who – as the industrialist pointed out – were incapable of creating *chic* styles. The objective he set for himself was thus to imagine what women wanted from the garments they wore, and to offer a few "perfect" styles at the same price they would have paid a tailor.

However, this meant competing with an age-old culture encompassing imagination, the choice of fabrics and accessories, fittings, alterations and the secrets that tied each woman to her dressmaker. All this occurred at a time of serious economic straits, and for a type of garment that was considered extremely important.

In all likelihood, this corporate philosophy developed over time. During the early Fifties, it had to rely on practical knowledge of the way Italian women tended to dress and the clothes that made up their basic wardrobe, but it also depended on the possibility of obtaining fabrics suitable for mass production.

The first prototype of 1951, created in the "dining room" with an old Pfaff, was the copy of an original English raincoat made of *storolan*, a synthetic fabric that look like suede. According to Marisa Crotti, Maramotti's first collaborator, it was "a rather long single-breasted jacket with raglan sleeves, raincoat-style flaps, a closed collar, covered buttons, and a very flared back taken up by a two-piece half-belt". For the following spring, they used a "Madras plaid cotton, which was completely warped" and had to be "pulled" before the summer garments could be cut.

Fall/Winter 1952-1953 saw the first plaid coat with fur, inspired by an ad published by Lilli Ann of San Francisco in Harper's Bazaar, and a duffle coat made of Casentino wool in the three classic colours of this fabric: green, orange and black. Despite its small size, this initial core collection provides a glimpse of the concept pursued by Maramotti. In his interview with Nicola White, when discussing the American model Maramotti used the term "copied", thereby suggesting an approach denoted by great historical interest. Small-scale dressmakers reqularly replicated the high-fashion garments published in magazines and, despite a few inevitable differences, the two procedures were quite similar. In this case, a challenge was involved: this small team from Reggio Emilia tested itself against big American industry, trying to produce the same results but without the same instruments and production culture. In short, it was not a copy motivated by the lack of creative ideas, but by the desire to invent a way of making clothing (from design to pattern making, cutting, manufacturing equipment and so on) that was virtually unknown in Italy during that period.

Sales – and this was yet another pioneering chapter in a country without a distribution channel for ready-to-wear – immediately yielded positive results, though the orders were for small quantities. Sales were initially handled by Amos Ciarlini, who rapidly managed to create a network of fabric and dressmaking shops able to sell

such a unique product, but it soon became necessary to hire two other agents (Alberto Rossi and Ubaldo Poli). From Bice Nocetti in Modena to Schiavio in Bologna, to the elegant Duca d'Aosta in Venice⁵ and to departments stores such as CIM in Rome, the company began to attract customers.

Max Mara

During the first phase, work was carried out in the rooms of the Maramotti School, but in 1953 the company, which already had about fifty employees, moved to a former garage of 150 square metres in Piazza San Lorenzo. The business moved again in 1955, this time to a factory of 3,000 square metres in Via IV Novembre, rented to Maramotti by his father-in-law Adelmo Lombardini. By the end of the year, the firm had 220 employees.

Along with the change of venue, the name was also changed from the nineteenth-century-style "Maramotti Confezioni" to "Max Mara Industria Italiana Confezioni".

The period of 1954-1955 marked a turning point. The availability of new space that permitted more extensive industrial production allowed Maramotti to develop the business along new lines. This period also marked the first photographs of different models, some of which taken at Albinea Castle⁶ by Gino Cantoni, a professional photographer from Milan, and others – unsigned – in the company courtyard. Using a very amateurish language that was nevertheless guite common at the time, each of these images presented a garment worn by a model posing so as to accent the item's particular features. Maramotti thus began to enter into the mindset of fashion: in the early Fifties it was normal for fashion houses and "boutique" producers to have their styles photographed by the few professionals who devoted their time to this sector, in order to provide pictures to newspapers and magazines. Similarly, in the case of Max Mara, the goal was advertising, though shopkeepers customers were the sole targets at the time.

In 1956, however, the company's entry into the world of ready-to-wear was confirmed by far more significant events, as Max Mara was one of the exhibitors at SAMIA and also made its appearance in trade magazines.

By this time, the number of companies producing ready-to-wear had started to mushroom and an array of initiatives had arisen around them. The Associazione Italiana Industriali dell'Abbigliamento (AIIA), a trade association with organisational tasks, had already been founded in 1945. From the very beginning, it chiefly handled contractual matters, though it also worked extensively towards developing the sector. In fact, at Lyon in 1947 it took part in the establishment of the European Association of Clothing Industries (Association Européenne

- 3 A model wearing a Max Mara coat photographed at Albinea Castle, 1954-1955
- Max Mara, F/W 1956-57 collection, Grazia, 26 August 1956 (courtesy Grazia/Mondadori)

des Industries de l'Habillement, AEIH). At first, however, the ready-to-wear sector it oversaw was composed of a galaxy of specialisations, most of which pertaining to the past rather than to the future.⁷

Instead, in the mid-Fifties the Italian <code>prêt-à-porter</code> industry – mainly working in men's clothing, though with a growing focus on ladies' wear – started to become an important area that needed new organisational and sales tools in order to develop. With the Florence fashion shows invented by Giovanni Battista Giorgini, high fashion and luxury tailoring had found the way to reach the American market. Something similar had been attempted for the clothing industry and textile production.

The first Salone Mercato Internazionale dell'Abbigliamento (SAMIA) was inaugurated on 24 November 1955 for the purpose of promoting ready-to-wear on

both the domestic and foreign markets. Organised by the Ente Italiano Moda, it was based in Turin, almost as if to revive an experience that had been interrupted by war. The rendezvous was held twice a year, in November for the spring/summer season and in April for fall/winter, and it offered manufacterers the chance to see what their competitors were doing, obtain the opinions and advice of highly experienced fashion journalists (though their experience was based on another type of fashion), and come into contact with the needs of markets that differed from the craft ones followed until then with basic methods. What clearly emerged from all this was the need to qualify women's prêt-à-porter with a more marked and creative fashion content, and the seasonal choice of new or exclusive fabrics could also contribute to this. However, the latter option was not an easy one,

5 6

above all for the labels that were not established within textile companies. The Mercato Internazionale dei Tessili per l'Abbigliamento e l'Arredamento a Milano (MITAM), was held in Milan in 1957 for the first time, and responded to this need.

All these initiatives required a decisive turning point in communications and implied that the general public had to be aware of what the clothing industry had to offer. According to Elena Strada, "The establishment of SAMIA helped enhance the image of mass-produced garments, spurned until then, and improved their visibility. Tellingly, starting in the Fifties, Italian fashion magazines began to publish articles about ready-to-wear on a more regular basis, as well as photographs to introduce clothing manufacturers."

Max Mara was also significantly affected by this climate. It is unclear if it was one of the exhibiting

firms at the first Salone. However, there is no doubt about the fact that it participated in April 1956, as demonstrated by the inclusion of a Max Mara suit in the reportage that, in the autumn, *Linea* devoted to SAMIA and to the large number of pictures published in *Grazia* magazine. Max Mara must have presented numerous new items and, indeed, Marisa Crotti confirms that as of the mid- Fifties the company started to make collections with fifteen-twenty articles, which also included suits.⁹

At this point, everything was in place for a qualitative leap. Maramotti tried to understand how Italian menswear companies worked, and he studied new machinery manufactured in the Netherlands, France and Germany. Most importantly, however, he took his first trip to the United States. America, which had supported the Italian industrialisation process since the

- 5 Max Mara, S/S 1956 collection
- 6 Max Mara, F/W 1956-1957 collection "Black wool suit with a slender, refined slightly-fitted jacket." Linea, Fall 1956
- 7-8 Max Mara, F/W 1957-1958 collection

end of the war, not only offered tangible help¹º but also represented an example to follow. With growing interest and intensity, trade delegations from different European countries interested in learning about the production technologies and methods of American companies travelled there constantly during this period. In France and Italy, the textile and garment industries were the ones that were most involved. In Italy, however, only the former sector could rely on a solid tradition that merely needed renewal, whereas the latter was a completely new idea.

Until then, Maramotti investigated American production by studying it in magazines and contacting industrialists who worked in the field. At this point, however, he clearly realised that it was essential to gain first-hand knowledge of manufacturing methods. It was probably in 1957 that, in New York, he visited Evan-Picone,

a company specialising in ladies' fashion and established at approximately the same time as Max Mara. It was founded in 1949 by Charles Evan and Joseph Picone. Picone was a Sicilian tailor who had emigrated to the United States in 1936, where he began a business that manufactured men's trousers; after the war, its clientele included Brooks Brothers. The idea of manufacturing women's skirts and trousers led to the establishment of the new company, which quickly achieved enviable success.¹¹

Italy's fledgling companies unquestionably had plenty to learn from the American garment industry, such as product research, the technique of cutting in different phases, the production line and, above all, an efficient industrial organisation model.

When he returned to Italy, Maramotti changed Max Mara's production systems. At the new headquarters in

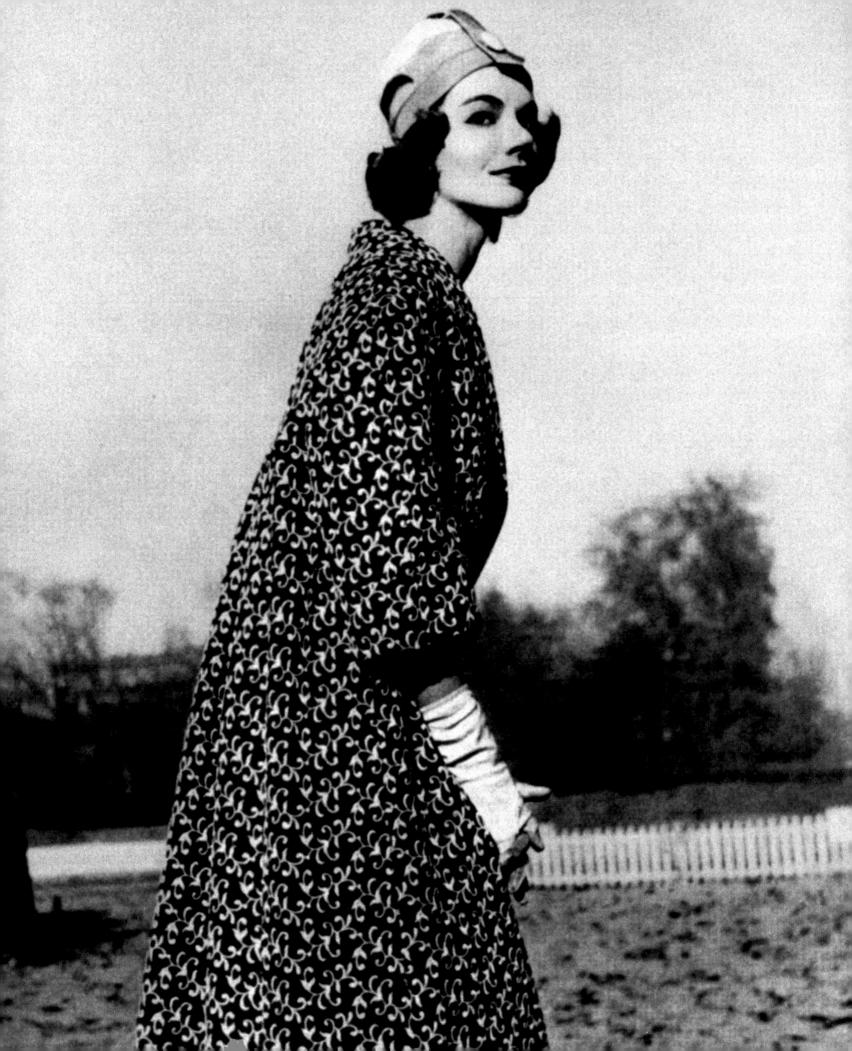

Via Fratelli Cervi, where the company had moved in 1957, he installed a "system of electrically operated intermittent conveyor belts that respected the breakdown of timing and the different operations involved in making coats and jackets: cutting, front, back, lining, sleeves and collar. This system, which led to full-fledged industrialisation of the production process, made it possible to minimise labour costs and reduce the amount of time needed to make a finished item. In the space of a decade, the company went from the eighteen hours initially needed to complete a coat or jacket to the two hours of the early Sixties". Another "study" trip in 1963 led to the idea of adopting the "mattress" system, which made it possible to optimise fabric-cutting time.

Likewise, the type of contract, based on a piecework system that was introduced at the company and later created enormous union problems for Maramotti, 13 was modelled according to the American system.

Industrial transformation went hand in hand with product redevelopment and enhancement.

The range of the early years had concentrated on coats and jackets with a distinctively male cut: roomy, often double-breasted and with a half-belt, and sometimes with a fur collar for a softer look. Rather than taking up the refined trends that could be seen seasonally in fashion magazines, their style approached the wearability and practicality of medium-level American ready-to-wear. We have already noted that, as Maramotti stated in an interview, his first coat was inspired by a Lilli Ann ad.

The transition from the creation of several items per season to the proposal of small collections, which also included elegant suits (with short fitted jackets) as well as "sportier" or everyday ones (with three-quarter- or seven-eighths-length jackets in place of capes), required remarkable pattern-making skills for developing sizes, as well as a new design concept.

Greater knowledge of the market, the experience at SAMIA and, possibly, an awareness of the changing living conditions in Italy, which had essentially gotten over the postwar situation, convinced Maramotti to choose a style that would appeal to the tastes and dreams of the middleclass ladies. The elegant proposal of French haute couture was the ideal benchmark for women who did not like eccentric elements, led a life tied to traditional values and customs, and would be tempted to purchase a garment only if it had the same features as those they could commission from a quality tailor.

When he was interviewed by Nicola White, 14 Achille Maramotti stated that he began to attend French haute couture fashion shows on a seasonal basis in 1956. He reported that, following the method adopted by the great Italian fashion houses and American clothing manufacturers, he had acquired a number of lengths of fabric or clothing to reproduce, converting the taste and style to meet the needs of his own customers and the industry's workmanship methods.

Guided by personal taste, current trends and the versatility of the garments, he focused on certain couturiers (for example, Dior, Givenchy and Balenciaga) rather than others, also bearing in mind that his production encompassed only daywear and specifically specialised in suits and outerwear. Nevertheless, his information about fashion was not limited to this alone: the entrepreneur purchased and pored over the most important Italian and international magazines (for example, Vogue Paris, Jardin des Modes and Harper's Bazaar), annotating the most interesting issues or the novelties that could stimulate ideas.15

The first signs of all this can be gleaned from the collection for Spring 1958, in which the styles acquired a more sophisticated line; some of the overcoats showed a more feminine cut similar to that of couture proposals. Starting in autumn of that year, changes involved suit jackets in particular, which gradually lost the close fit typical of the "New Look" to take on a straighter shape that tapered at the hem, along the lines of the new fashion that couturiers such as Givenchy and Balenciaga had launched years before. In the following season, the sack-dress line was further softened by round collars, little pockets, half-belts and decorative fringes that seemed to blend the Spanish couturier's old concepts with the style the young Yves Saint Laurent was bringing to Dior.

However, the true transformation came about with the F/W 1959-1960 collection. The garments published in magazine articles presented completely new fashion components and exquisite cuts. Above all, however, they plied great design know-how approaching the proposals of Balenciaga and Givenchy. For suits, short jackets were fitted based on an updated proportional concept - with broad shoulders and narrow hemlines - whereas skirts were looser around the hips. Coats required more careful research: masculine lines were abandoned, and the collection offered "doctors' wives" an array of elegant, feminine and "stylish" capes with gathers, big collars and the wide three-quarter-length sleeves that were so fashionable at the time.

However, the most interesting model from the collection was a "full model tapered at the hem" that Bellezza published in the August 1959 issue, highlighting its proportions and class. It reflected nothing short of a foray into Parisian haute couture. Two years earlier, Balenciaga and Givenchy brought to the catwalk long Max Mara, S/S 1958 collection "On this page, Max Mara chooses dark blue cloth embroidered with white in a regular pattern for this elegant coat with a rounded yoke gathered in the centre, which makes it particularly full at the back. It is worn with a white low-necked, sleeveless dress.' Bellezza, February 1958

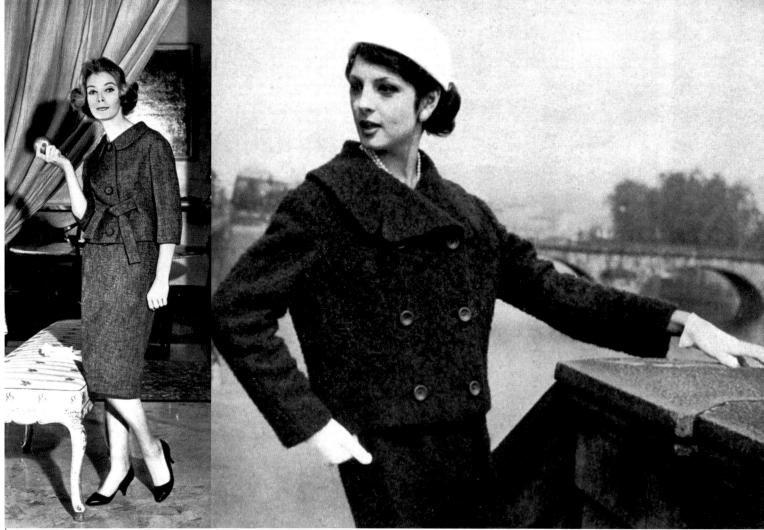

10 11

jackets with batwing sleeves, deftly constructed through avant-garde fitting. The concept was a success, and in later years both designers revived and modified it. In 1960 Jacqueline Kennedy wore a white Givenchy overcoat with these lines during the campaign parade through the streets of Manhattan, three weeks before her husband was elected President of the United States.

The construction of the coat proposed by Max Mara presents such skilfully devised elements that it evokes an expert designer capable of grasping the basic aspects of the original garments and transferring them cogently to the language of ready-to-wear. During the interview, Maramotti declared his preference for Balenciaga, due to the fact that the clean lines and perfect proportions of his fashions made them highly adaptable. However, the Spanish designer achieved these results through construction that was so complex and studied in detail that simple copying was exceedingly difficult.

This was probably the crux of the problem faced by the clothing industry, and it helps clarify the essential difference between Maramotti and his Italian competitors. Indeed, the challenge did not involve copying couture, but creating a bridge between high fashion and ready-to-wear, safeguarding the specific aspects of the two production systems. The former had two great advantages.

First of all, it made clothes to measure, with the timing and techniques distinctive of manual workmanship, and it was the guardian of a sartorial philosophy that had been established, perfected and incorporated over the centuries.

Secondly, it catered to an elite clientele whose lifestyle was open to even the most eccentric and spectacular apparel.

Instead, the latter had to design garments that could be mass-produced, be transferred to the proportions required by different sizes (so that each outfit would look the same on women of different builds) and, at the same time, be manufactured based on industrial equipment and timing. Its purpose was to reach the broadest possible public of women who wanted a garment that was not too expensive, and was suitable for a "normal" and dynamic lifestyle that envisaged daily activities such as work. However, this goal came to the fore in a difficult setting: though ready-to-wear had a longstanding tradition in the United States, it was completely new in Italy and thus did not have the cultur-

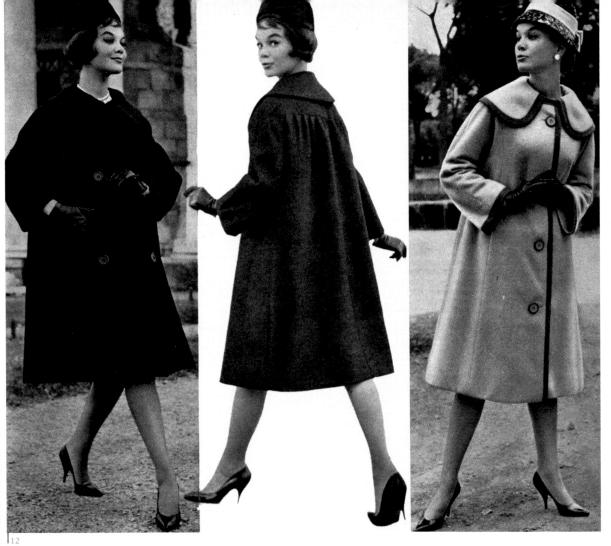

- 10 Max Mara, S/S 1959 collection "The novelty of this Max Mara two-piece in bouclé is the half-belt tied casually beneath the bust." Bellezza, February 1959
- 11 Max Mara, F/W 1959-1960 collection "Following in the footsteps of Haute Couture, ready-to-wear has completely abandoned the typically masculine suit and is adopting the latest styles. This Max Mara winter two-piece has a short doublebreasted jacket with a high button fastening and shaped, rounded shawl collar. The straight skirt is softened by the loose tucks." Bellezza, August 1959
- 12 Max Mara, F/W 1959-1960 collection Left: "A charming flared coat in soft yet robust brown wool: it has a flat collar, half kimono sleeves, and a rather low four-button closure. Ideal for afternoon wear. On the right, the same model seen from the back. The fullness is created by the gathering below the cape." Right: "This champagne shaggy wool coat edged with iron grey is fairly close-fitting in front, while the back has a softer line." Grazia, August 1959 (courtesy Grazia/Mondadori)

al background to support it. For example, during this pioneering stage the still-uncompleted process of defining standard sizes also influenced the type and variety of garments that could be produced. Moreover, mechanical production meant making garments "lighter" by eliminating all the sartorial touches – often concealed – that guaranteed the formal perfection of haute couture, while seeking the same effect through design, assembly and sewing. And these problems were being addressed for the first time.

All this had the potential to limit the industrial range to the basic standards of "necessary" clothing or to lead to low-quality copying of the exterior aspects of recent trends, and this occurred in many cases.

Maramotti had another idea: he wanted to create a garment that, though inspired by the style of elite fashion, would have completely original characteristics. He took up the challenge of inventing a work method that would not be restricted to the commonplace transfer of classic tailoring standards by shifting from manual to machine work, but that could transform industrial production into a new type of language. The readymade garment had to be conceived differently from a tailormade one.

To simplify this concept, we could say that it meant giving fashion contents to ready-to-wear, but it did not simply involve proposing a few novelties. The stakes were much higher, and they had to do with the very identity of this brand-new sector that seemingly fell between small fashion houses and haute couture. Maramotti's pioneering insight was that he considered it another sector that was probably closer to design than crafts.

The work methods involved in both industrial clothing manufacture and furniture production implied completely different rules and potentials comprared to traditional ones, but this did not make them any less rich, flexible or creative. If anything, the problem involved fully understanding these potentials and designing a product that could emphasise them, as done in the past by the Bauhaus and, in the current era, by Italian architects.

To become another form of fashion, ready-to-wear had to invent not only its own creative model, but above all a different conception of all the steps that transform a sketch into a garment, from the search for materials to pattern making, the development of sizes, the search for increasingly improved and flexible manufacturing

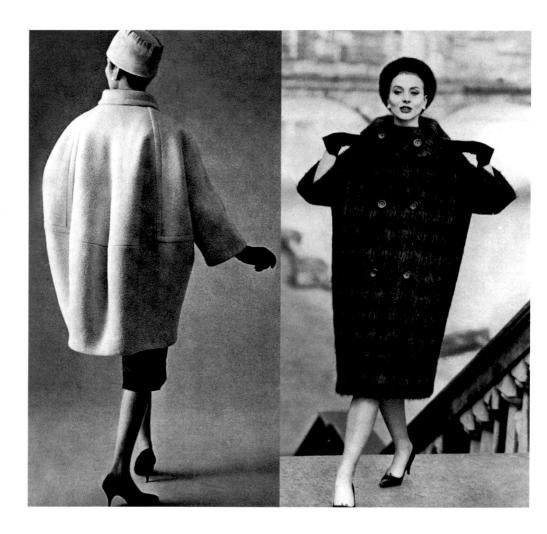

13 14 15

systems, and so on. For each of these sectors, Maramotti - with the ability that only the most capable entrepreneurs know they possess - chose young assistants who, in their individual fields, rapidly demonstrated the creative skills needed to transform design into reality. In each field, he encouraged research and experimentation. The studies performed to develop size charts are enlightening.

This work was conducted through continuous comparisons between empirical tests and theoretical revisions, in order to find constants that would make it possible to market a product that would have the same appeal for women of different builds.

The problem of the "fashion content" of industrially produced apparel was also examined by the AIIA (Italian Association of Clothing Industries) in 1959. Maramotti was one of the founding members of the Fashion Committee, established "to promote coordination action between creation, production and distribution", but above all to offer a creative contribution through the study of trends, the publication of a magazine and the circulation of news. Alongside "Max Mara di Reggio Emilia", we find Abital of Rho, Ballarini of Caselle Torinese, Caesar, Juvenilia and Gruppo Finanziario Tessile of Turin, Lubiam of Mantua, Manifattura Lane Marzotto of Valdagno, Pirelli Confezioni of Arona, Rosier, Sealup, Tescosa and Valstar of Milan, and – as "supporting members" that subsequently took part in the project - Forest of Pisa, Hettemarks of Bari, Buosi of Treviso and Unimac (Ruggeri) of Vimodrone. 17

The group of Italian clothing manufacturers thus began to expand substantially. At the same time, it was probably dealing with a problem that had gradually become widespread on an international level: the growth of prêt-à-porter was seriously undermining high fashion. and this was due not only to the fact that the latter was becoming increasingly expensive, whereas its clientele was diminishing.

The industry's substantial creative dependence on couture, combined with the ability for rapid copying of ideas that were shown on the catwalk and that a communications system - far more developed than before immediately circulated around the world, forced the great fashion houses to step up the pace, introducing new ideas that were rapidly rendered commonplace by the

- 13 Balenciaga, jacket sketch, S/S 1957
- 14 Givenchy, long jacket, 1957
- 15 Max Mara, F/W 1959-1960 collection "The proportions of this full coat that tapers at the hem have been carefully studied. The sleeves are barely accentuated by the fluted cut. The collar is inserted in the doublebreasted fastening. The long-hair mohair wool fabric with woven tartan design in soft tones from burnt brown to pale tobacco makes this model, accentuating its class. Bellezza, August 1959
- 16 Max Mara, F/W 1960-1961 collection
- 'The two coats are by Max Mara...: the first in bouclé wool and flamme with large white, grey and black checks, has a classic line and is young and easy-to-wear. The second, in camel-coloured wool with the casual cut of a raincoat, has raglan sleeves. The pockets are concealed in the two trims that extend from yoke to hem, focusing the attention on the doublebreasted front. Bellezza, August 1960

replicas brought out on the more conventional ready-towear market.

In many cases, the Fashion Committee's appeal to its members in terms of quality, the coordination of trends and the choice of a recognisable style with which to characterise the different companies led to the decision to hire creative designers and experts with the ability to create consistent collections or, at least, to make the most of the need to propose articles inspired by the new ideas from Paris or Rome, which were in such great demand.

The Italian fashion press also participated in the project to launch ready-to-wear. Starting in the mid-Fifties, the styles were published in women's magazines such as Grazia, as well as trade publications such as Linea and Bellezza. At the same time, however, it was during this period that a bond of collaboration was forged between the garment industry and the new types of magazines that were changing communications in this sector. The monthly Arianna and the weekly Amica began to devote entire reportages - which could be easily defined as monographs - to various companies, publishing extensive selections from their collections. Given the lack of direct advertising, these advertorials provided readers with complete information on what the clothing market had to offer, even listing the prices of the garments and the addresses of shops where they could be purchased. In particular, Max Mara invented an unusual approach for attracting women's attention: a prize contest for an entire wardrobe as well as individual garments, by drawing the names of readers who submitted comments about the published garments.

Sixties-style Elegance

In terms of fashion content, the growing similarity with French taste represented Max Mara's choice of a style identity. In 1960 the label had already distinguished itself for garments "designed with the most fashionable lines, yet also characterised by a simple and casual style, the most appropriate style for the modern woman". 18

Though the inspiration of the designs of great *couturiers*, from Balenciaga to Chanel, was evident in Max Mara models, in 1962 the entry of Gianni lotti (a very young designer from Reggio Emilia who, after this initial experience, collaborated for years with Silvano Malta) helped give the range a more recognisable look.

It had become increasingly difficult to identify the female clientele of the boom years simply as the "provincial doctor's wife" Maramotti mentioned in the 1996 interview. Though women were still provincial in outlook.

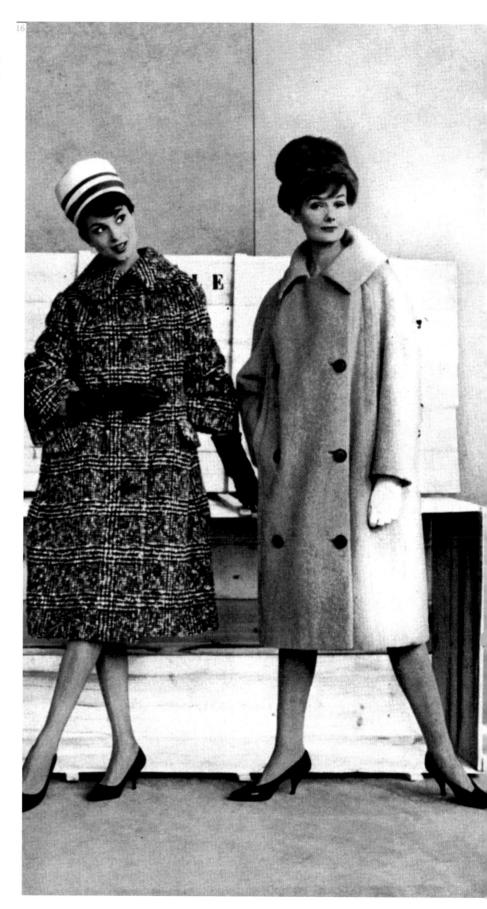

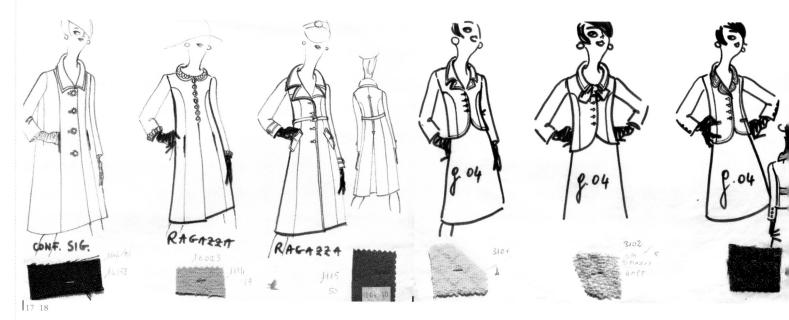

they were paying closer attention to the rest of the world, with more up-to-date lifestyles and extremely modern cultural and social objectives.

The fashionable women of the early Sixties also had their new myths: Audrey Hepburn dressed by Givenchy in Breakfast at Tiffany's, Chanel and her extraordinary tweed suits, and Jacqueline Kennedy, the young and extraordinarily elegant wife of the American president. Women around the world began to observe the slim suits, complete with little hats, that the First Lady wore on official occasions, just as they were enchanted by the perfection of Mademoiselle Coco's models. In both cases, the objective was to reproduce them in order to take part in this chic and sophisticated modernity.

By observing the way the members of Milan's smart set dressed, Achille Maramotti grasped this trend and made it his own. Over the years, there were several tributes to Chanel, clearly evident in some cases, and implied through necklines, bow blouses and braided trim in others.

Nevertheless, it was the "Jackie style" that effectively became the hallmark of the collections put out during this period. They essentially targeted contemporary and active young women who were nevertheless attentive to the rules of somewhat formal elegance that combined French tradition with the innovative approach of American culture. The First Lady had a very lay approach to fashion. She did not pursue the latest novelties but cogently sought her own style, mixing French and American creations, originals and copies, models from the current season with clothes she'd had for years, in order to create the image of a way of dressing that was unfettered by the whims of fashion. Apart from evening gowns, her wardrobe was mainly composed of suits with a short, loose-fitting jacket and a slightly flared knee-length skirt, and highly elegant slim coats.

These were the garments Max Mara proposed to customers: collarless suits or suits with small collars, a few oversized buttons and slightly cropped sleeves to show off gloves, and exquisitely cut capes suitable for formal occasions.

Some of the garments are so faithful to the styles that inspired them that they seem to be overt references: for example, the light blue Shetland wool coat from the F/W 1962-1963 collection, which replicates the Oleg Cassini overcoat Jackie wore during the official visit to Lahore in the spring of that year (the photographs of this trip must have been published in the papers at the time the company was working on the F/W collection). Naturally, it is impossible to say if the resemblance between the two garments is accidental or intentional, but the fact is that this example helps clarify the difference between readyto-wear and haute couture.

Oleg Cassini's overcoat, 20 made of crisp and lustrous wool/silk Alaskine, was slightly fitted, though the doublebreasted button closing gives it a high-waisted look, and it had small shoulders and set-in sleeves.

The Max Mara coat (the fact that it was named Alaska may not be coincidental), made of plain Shetland wool, has kimono shoulders, a looser line and two diagonal pockets. The closing is also lower, in order to accentuate the detail of the off-centre stand-up collar.

The analogy between the two garments underscores the different approaches in creating them. In the first case, the objective was a ceremonial cape, made to fit the customer and her needs using an important new fabric, and it featured an array of details appropriate for the occasion on which it would be worn. In the latter, the

- 17 Gianni lotti, coat sketches Max Mara S/S 1962 collection
- 18 Gianni lotti, suit sketches, Max Mara S/S 1962 collection
- 19 Max Mara, collection S/S 1962 Two suits inspired by the latest Chanel style. The first in ecru wool cloth has a straight skirt and jacket with two pockets trimmed in blue and red. The second is in bright red matted wool with blue edging All the buttons are gilt. Fabric by Lanifau. Lanificio Faudella S.p.a Novità lanerie. Biella-Favignano." Linea, Summer 1962

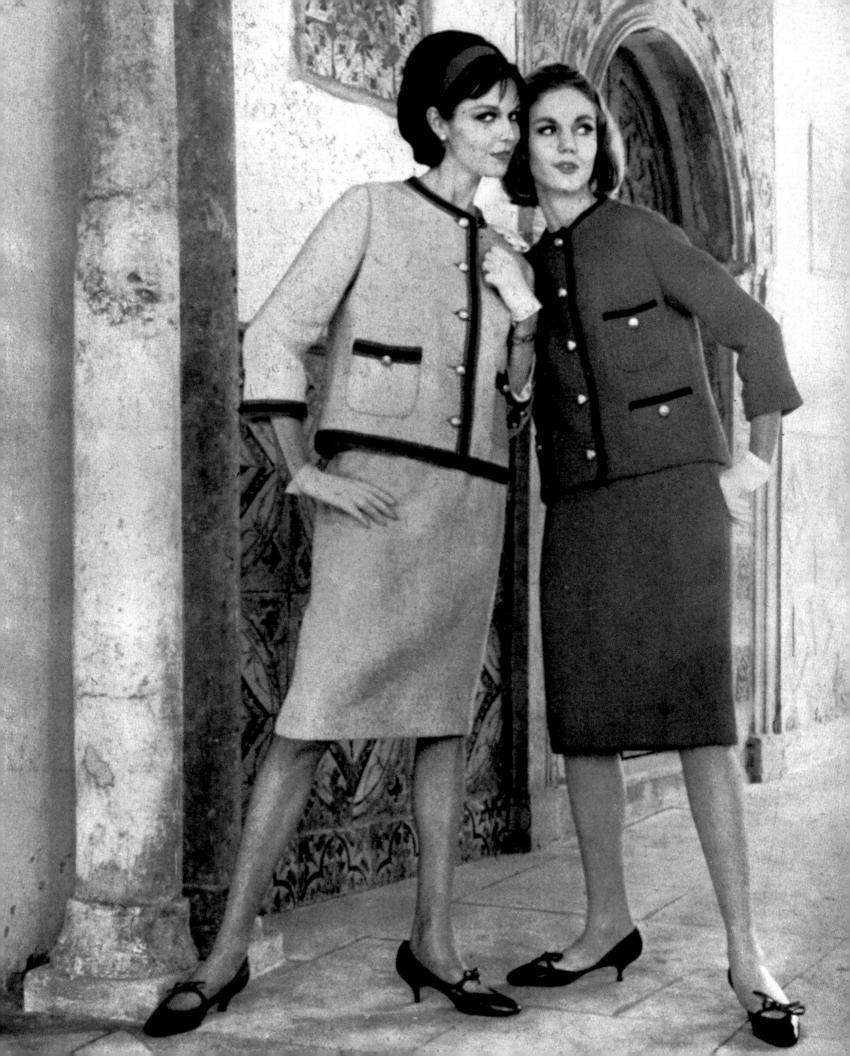

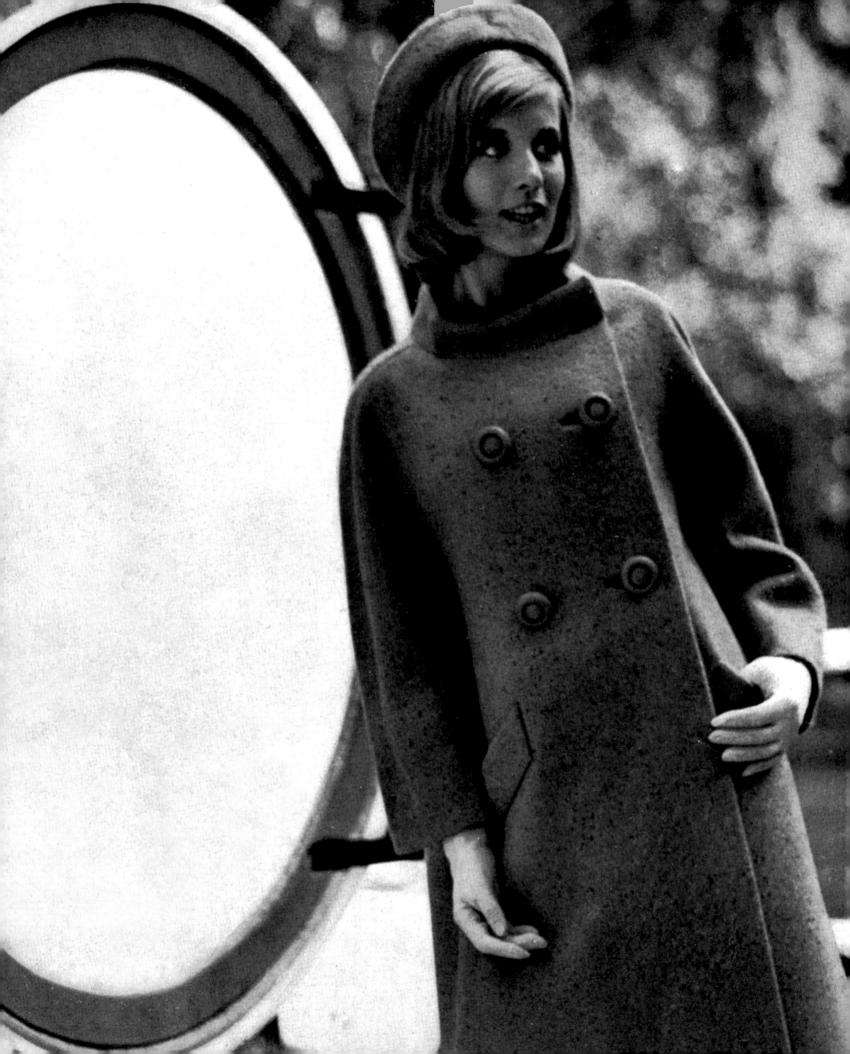

concept served as a starting point for a new product that catered to the standards of ready-to-wear, which required a somewhat inexpensive fabric flexible enough for industrial production, a style designed for optimum wearability, buttons to ensure perfect fastening, and pockets that - without affecting from the elegance of this model - made it more practical. Thus, the former was created as a one-off item for an official occasion so important that it required clothing capable of representing the American presidency, whereas the features of the latter made it a product suitable for all women who identified with this style and could wear it in hundreds of different settings.

The "Jackie style" continued to be fashionable and remained part of Max Mara's collections even after the tragic end of Kennedy's presidency. Unusual little suits with sleeveless jackets and sophisticated matelassée wool capes were proposed again in 1965, but something new was afoot in society and Western fashion.

Young Fashion and the Pop Style

The ranks of young ladies with pillbox hats were stepping aside for the teenagers of the Sixties, and innovations in clothing no longer came from haute-couture catwalks - which quickly adapted to the phenomenon but from prêt-à-porter created by young designers and sold by cutting-edge boutiques. London, Paris and New York were at the heart of this new movement.

Maramotti also realised that the teen market was one worth pursuing. Far more willing to purchase readymade clothing than their mothers had been, they represented the future of this production sector. They unquestionably had different tastes compared to those Max Mara had followed until then, and they were after a younger and more natural way of dressing. Eccentric elements with a hint of scandal arrived from London, but the Italian panorama was mainly composed of young ladies seeking their own style, without necessarily embracing all the excesses of the Pop culture. The earliest experiments were proposed in the S/S 1965 collection: tube dresses with a Claudine collar and halter neck tops, with a prim look decidedly inspired by English fashion. In the following season, an entire collection was devoted to teens.

Such a decisive change of style, with forays into a culture that was emerging during this period, could easily have posed a problem for the Max Mara staff, and Achille Maramotti decided to test a method that had yielded excellent results in France. During the Fifties, fashion journalists had played a key role in updating consumer trends, not only through the role of department-store fashion directors²¹ (a position adopted by

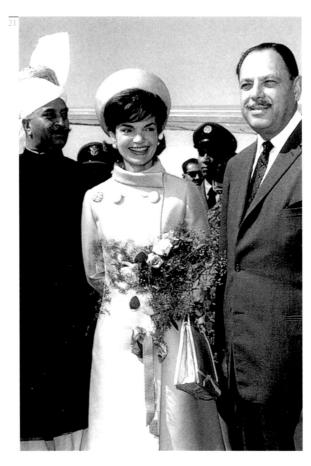

- 20 Max Mara F/W 1962-1963 collection "The Max Mara 'Alaska' model is an elegant double-breasted coat in blue Shetland with a very wide collar and small black buttons. Fabric by anifau. Lanificio Faudella S.p.a Novità lanerie. Biella-Favignano.' Linea, Fall 1962
- Jacqueline Kennedy wearing a coat by Oleg Cassini, Lahore, (Bettmann/Corbis)

American stores), but also as trendsetters and the creators of new styles through the pages of magazines. This may be why Maramotti felt that Lison Bonfils was the right design consultant for junior fashion. Like other professionals of her generation, Bonfils had grown up in the world of Paris fashion, working first as a catwalk model and then joining the staff at Elle where, on assignment by the magazine's legendary head Hélène Gordon-Lazareff, she created new fashions to propose to younger readers through the pages of the magazine.

Her role at Max Mara became so important that, for the very first time, the presentation of the F/W 1965-1966 Pop collection²² announced that it had been "created by Lison Bonfils".

However, the form of communication that was used, which may have been suggested by the French journalist - more accustomed to these instruments and aware of the importance of suitable information - also represented an innovation. The four paperboards in the Archives effectively represent a press kit reflecting the philosophy of the initiative, illustrating the contents and motivations in a clear and immediate language.

First of all, they explained that the Pop line had arisen through the observation that "the classic traditional Max Mara collection, which was still a benchmark for

women with a refined taste, did not meet the needs of the large young customer base formed over the past five years". With regard to this new target, it was noted that "modern life stimulated girls to leave home, creating in them new needs that must be satisfied" and that "cinema, magazines and television created in young people the desire to wear the fashions of their idols (cover girls, actors, singers, etc.)". Moving on to identify fashion consumption among young people, it was said that "the concept of the high-quality garment that is expensive but lasts five years, comes in a classic colour and is easy to wear has become outdated" since "girls love to vary their clothes and look for new and lively things that have good lines, have high-impact detailing and are inexpensive". All this opened up new horizons for prêt-à-porter, also because "readymade clothing means no wasted time and permits an immediate choice".

The "junior client" was pinpointed as a girl between the age of fifteen/sixteen and twenty-two/twenty-three (extended to thirty years of age only for "certain tall, slender, original and elegant women") who came from all social classes, an aspect underscored somewhat insistently through repeated reference to the reasonable cost of the garments.

Likewise, every press release emphasised the themes of the collection, highlighting the creative thrust that had inspired the various designs. First of all, cinema: cowboys were the starting point for short jackets, whereas Thirtiesstyle vamps inspired shawl collars and the use of black. Then the English style came with its classic fabrics and colours, Burberry raincoats and military styles, as well as the 1900s style "of our grandmothers" with redingotes, narrow sleeves, side fastenings and strass buttons. However, the most avant-garde theme alluded to the modern technique, with "Air Force blue" that was intended to evoke planes, and above all, there was a tribute to Courrèges, defined as "one of the greatest innovators of fashion", and his "new line recalling to cosmonauts, science fiction and Pop Art".

The great innovation represented by Max Mara lay in pinpointing the younger generation,23 "often disoriented by the traditionalism of ready-to-wear",24 as the future market for clothing manufacturers, and in embracing probably more than the "press kit" could ever relay - the new way of dressing that the Pop culture was proposing, after which the line was named. In the advertising brochure for the Max Mara collection, the photographs devoted to the Pop line²⁵ stand out not only because of their colours and styles, but above all for the choice and look of the fashion models. First of all, they are very young and wear knee socks; they are not characterised by any of the signs that, in the language of fashion

22 Max Mara Pop, F/W 1965-1966

"This coat in dark blue linen was one of the 72 models by Max Mara, Rosier, Cori and Marzotto presented at the Sanremo Festival. The event was promoted by Amica and ATA (Sanremo Casino), which organizes the festival.

Amica, 24 January 1965 (ph. Amica/RCS Periodici)

23 Cilla Black, Petula Clark, Sandy Shaw, 1965 (Hulton Archive)

communications, represented the ideal of more adult elegance (artificial posing, elaborate make-up and hairstyles, hats, gloves and so on).

The Designers

The year 1965 marked a new phase: Maramotti began to rely on the very young *clerici vagantes* of fashion who, a short time later, would be called "designers" in Italy, and who offered their creativity to companies (often more than one at a time).

Despite what a number of people said, this was not actually a novelty. This system dated back to at least the thirties in the United States, and in France it had been making inroads for some time. In Italy it came in the wake of the practice of engaging professional and freelance draughtsmen (or dress designers), who were used extensively by couturiers and had already been introduced by several clothing manufacturers. The designers of the new generation began to enter the ready-to-wear industry during this period. After working for Apem (the clothing manufacturer for the Rinascente department-store chain), Jean-Baptiste Caumont moved to Rosier in 1963, and Walter Albini began his career with Cadette in 1964. Nonetheless, the method Maramotti adopted in working with creatives was entirely unique. In his case, it did not involve buying fashion plates from which to draw ideas and details for individual garments, nor did it mean limiting the role of the company to the simple production of what they designed. What he implemented was a system for circulating and discussing ideas that drew in the entire company in order to achieve the goal of producing something with its own identity, free of the rules of fashion houses.

What he offered the designers who came onto the scene at the time was the invention of a new way of dressing that profoundly questioned the classic standards of traditional clothing and represented a challenge for the industry. Teenagers were not looking to clothing as a status symbol, and they were completely insensitive to the "precious" detailing of tailored garments. Likewise, they were indifferent towards the garment's uniqueness. The true children of mass society, they were fascinated by group fashion and the idea of owning the same clothes worn by their current idols or their peers.

This represented enormous potential for the industry and for mass production. What young people wanted were styles that would attract their attention because of colour, "modern" details, variety and novelty, but also because they offered new wearability with respect to couturier garments. It was not longer important that they guarantee the somewhat restrictive formal perfection achieved through doubling, padding, lining, and concealed hooks and buttons.

Girls preferred practical and comfortable outfits that would not impede movement and that had simple fastenings: clothes that could be worn anywhere and anytime. On the other hand, the teenage lifestyle did not contemplate the occasions that had punctuated the formation of the adult wardrobe. The new points of reference were school, informal get-togethers with friends and dancing, which required strenuous physical activity to which clothing had to adapt.

Fabrics also took on a different importance. The refined know-how of mothers gave way to serene *nonchalance*. The precious fabrics that, until then, had been a hallmark of classic clothing were handily replaced by less important materials that were colourful, modern and less expensive.

In the second half of the Sixties, a cultural and social framework arose that formed the perfect setting for industrial products.

This is the aspect that Maramotti grasped, and it was along these lines that he used the contributions of designers who, possibly because of the very fact that they were young, shared this lifestyle and the attitudes of their peers. As we have already noted, however, this was not

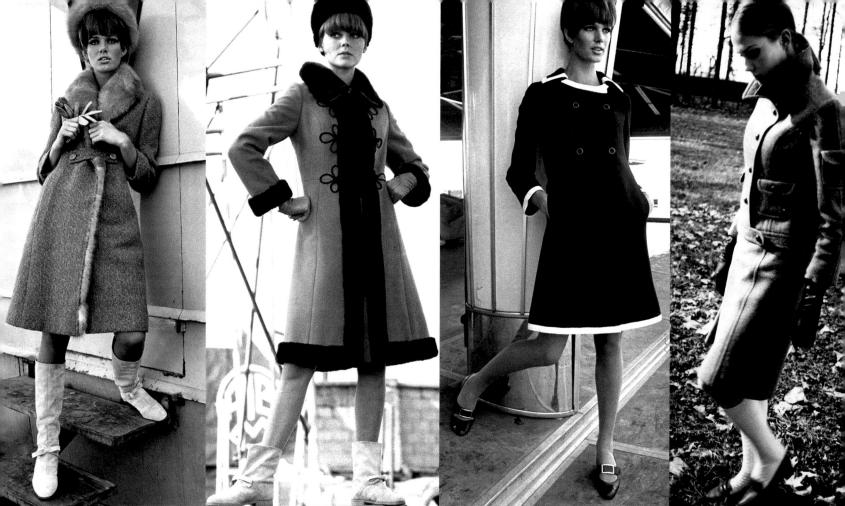

24 25 26 27

simply a matter of putting certain designs into production, but on the contrary of revolutionising the very concept of fashion.

The creative figure proposes ideas that, accentuating change, are initially disjointed from reality but also represent a challenge for production. In this case, however, the problem involved creating a design ethos that would link these ideas with the company. As a result, the company adopted a work system based on comparison, discussion and the creative fusion between the designer, the company staff and the entrepreneur, who always served as a stimulus and catalyst for the entire project. Indeed, the idea had to be transformed into a product and then be examined in relation to objective aspects such as materials, designs, production, costs and the market – modifying them if necessary, but through realistic transitions and adjustments that would become second nature.

The insight Maramotti showed in choosing consultants and staff unquestionably stemmed from the fact that he always had the goal of his work and the pursuit of excellence clearly in mind.

This was not merely a commercial decision. His ultimate goal was the growth of a new corporate culture capable of expressing a revolutionary concept of the way people dressed, akin to the way that the furniture indus-

try was using design to construct the way they lived. However, this analogy between the two sectors, which has often been pointed out by scholars and journalists, concealed a radical diversity: durability. Whereas a lamp or a piece of furniture – though created in a specific period as part of mass production – can have an extremely long life and be manufactured and purchased for decades, a dress lasts a single season. Each new design piece must coexist with what was proposed before. As a rule, it takes years before an object goes out of production and, even in this case, there is nothing to prevent it from being revived in later eras.

None of this happens in fashion, with the exception of certain accessories that, for reasons that are often unpredictable, enjoy a different fate (such as Hermès' Kelly bag, Chanel's two-tone sandals and so on). Clothing generally lasts for a season, and each collection presents the public with a set of clothing designed for the occasion.

This fact also influenced the relationship that the two sectors forged with creative research.

While it is entirely understandable that, from the very beginning, furniture manufacturers chose to turn to different designers and architects for new projects on a case-by-case basis, in the clothing industry it soon became customary to forge a stable relationship with a

single designer, who could thus mould a style and make it recognisable.

Maramotti chose an original path, adopting the former model and independently building the image of the company and its collections, which multiplied over time. All the new consultants (each was assigned to design only a few collections) introduced stimuli for renewal, which were examined in relation to the type of taste with which Max Mara had chosen to present itself to its public. Above all, however, they were examined against the philosophy of the company, which they helped develop and modified along the lines of the transformations that society itself was undergoing at the same time.

Perhaps it was precisely to remain faithful to the style he had imparted to his product and, above all, as an aesthetic choice of which he was profoundly convinced, that during this radical transformation phase Maramotti again turned to French fashion: not haute couture (which was also in the throes of a revolution, with new names and avant-garde styles), but the designers who were creating a new form of young and natural prêt-à-porter that was completely independent of high fashion and for which boutiques represented the perfect form of distribution, communications and connection with target consumers. In this scenario, new labels were created, often through the initiative of the designers themselves, and other labels were transformed through the creative input of professionals working on this type of garments.

On 12 October 1966, the American fashion newspaper Women's Wear Daily published a list of those it considered the best French designers of the period. They were Christiane Bailly, Emmanuelle Khanh, Graziella Fontana, Michèle Rosier, Jacques Delahaye, Karl Lagerfeld, Daniel Hechter and Jean Cacharel. We cannot help but acknowledge Maramotti's insight:²⁶ the previous year he had signed a consultancy contract with Graziella Fontana to design both of the 1966 collections. The result was an even more specific reference to the style of young French prêt-à-porter, the kind found in the most famous and fashionable boutiques in Paris – Dorothée, Vogue and Laura, for example – but also in Rome and Milan.

In the spring of 1967 it was Emmanuelle Khanh's turn, with styles proposing the lines and colours of Pop avant-garde. There was also a series of new production ideas, such as snap closings and the application of modern materials such as plastic. Starting with F/W 1967, Colette Demaye designed the young line for three seasons.

In this climate of general cultural change, the Max

Mara line also had to be characterised by a more youthful and innovative style, while bearing in mind that the clothes proposed for thirty-year-olds could not be too similar to those designed for teenagers. Jacques Delahaye was contacted to handle this task. Despite the fact that he had appeared in the *Woman's Wear Daily* list, he was known for a more classic style than his colleagues. Tellingly, in 1968 he was offered a contract by the *couturier* Jacques Heim. Delahaye's move to *haute couture* was probably the reason Max Mara replaced him with Karl Lagerfeld for a season.

The styles of the French designers actually brought Max Mara away from high-quality $pr\hat{e}t-\dot{a}-porter$ and into the world of fashion. For traditional lines, the competition was composed of large-scale industries, but in this sector it was essentially represented by small companies with a very lean structure, often characterised by a single type of processing (knitwear is a prime example) or a single product category, which could adapt quickly to changing trends, or by boutiques that directly commissioned the garments they would then sell.

Moreover, in 1967 the events organised in Florence acknowledged the change underway and devoted a section to designer ready-to-wear, which was open to the *prêt-à-porter* of large fashion houses and, above all, of the new labels (such as Missoni, Krizia and Billy Ballo) that had chosen to qualify their offer with what was a clear "fashion content".

Maramotti adopted a complex industrial strategy that did not end with the product but also experimented with more modern forms of distribution. In 1964, Max Mara had already launched a chain of single-brand shops in the most important Italian cities,²⁷ but between 1967 and 1968 the company inaugurated a new shop in Milan.

Located in Corso Vittorio Emanuele, one of the traditional shopping cult areas in Milan, the store was established as a partnership with Bruno Magli, a Bologna based footwear manufacturer who was working in the field of accessories and had the same spirit as Maramotti. The store was called 2M.

Planned by set designer Giulio Coltellacci in a style that proposed all the design innovations of the era, it resembled a large emporium in which one could find all the proposals of the two labels, thus offering customers the chance to create on-the-spot combinations of clothing and accessories.

However, all of fashion was changing in the late Sixties. May 1968 also stirred things up to a certain extent. The ways of dressing multiplied spontaneously and not all of them could be translated immediately into the language of professional fashion. Teenagers had grown up, and they began to orient their clothing choices based

- 24 Max Mara Pop, F/W 1965-1966 collection; model: Ines Kummernuss (ph. Giovanni Lunardi) "For slander women, a Max Mara coat in beige and blue melange wool, with red guanaco collar and lapel facing. The two-button strap fastening is completely new. As accessories ... sand-coloured antelope boots (Magli Boutique)." Amica, 31 October 1965 (ph. Amica/RCS Periodici)
- 25 Max Mara Pop, F/W 1965-1966 collection; model: Ines Kummernuss (ph. Giovanni Lunardi) "This Max Mara camel wool coat with hook fastening adds that extra something to a tall and slender woman's winter wardrobe. Lapel facings, collar and cuffs in Pannofix ... short sand-coloured reindeer boots (Magli)." Amica, 31 October 1965
- 26 Max Mara Pop, F/W 1965-1966 collection; model: Ines Kummernuss (ph. Giovanni Lunardi) "Courrèges-style evening wear. Max Mara suit for the young and slim who like to keep up with fashion: black covercoat edged with white and silver lamé, like the matching dress, with a high cape and neckline at the back framed by epaulettes. Black calf shoes with silver buckle (Magli)."

 Amica, 31 October 1965 (ph. Amica/RCS Periodici)
- 27 Max Mara Pop, "Francis" suit, F/W 1965-1966 collection

- 28 Graziella Fontana, technical sketches with fabric samples, album of the Pop F/W 1966-1967 collection
- 29 Max Mara Pop, F/W 1966-1967 collection
 "For the young and those who prefer a sporty look, a Harris tweed suit with panelled skirt and blouson jacket with belt incorporated, wide military-style collar and slit pockets."

 Amica, 30 October 1966 (ph. Amica/RCS Periodici)

on the groups to which they belonged, on lifestyles that had little or nothing in common with the rules of the past, and even on choices that stemmed from new cultural or political models.

Clothing had to reckon with a radical change in customs, which were matched by new consumer habits. Prim young ladies in pastel suits were gone, but so were the young girls in miniskirts and short fluorescent jackets. The clothing industry was forced to identify its target within a potentially large but virtually unstudied market, and it had to deal with the concept of streetwear and creativity.

With his usual acumen, in an interview he gave in 1971 Maramotti stated that "fashion comes... from the street, in the broadest and most sociological meaning of the term, but it is also true that it needs to find an individual and industrial awareness that can grasp it and transform it into styles: in short, that can transfer 'costume' to 'custom'. The result is that women's tastes and demands can be oriented by the same standards in which they must be interpreted. In fashion, one can even 'impose', but only the things that, albeit unconsciously, are already wanted."²⁸

Sportmax

As a way to respond to what women wanted, Max Mara underwent radical renewal that went far beyond the simple adaptation of fashions or styles.

Between 1968 and 1969, the company was completely reorganised: the corporate structure was changed, new sales outlets were sought, production was diversified and a new label was launched. The Max Mara and Pop lines, which had been part of a single collection until then, were separated. The former continued along the same lines, proposing essentially classic and formal clothing composed of important outerwear, suits and dresses, whereas the latter – named Sportmax – acquired a more specific and broader character.

The project for the new brand was not limited to a youthful characterisation of the product, but accompanied a different type of product range. Once again, the United States – and Evan-Picone in particular – suggested the path to follow. Maramotti's idea was to propose co-ordinated items that could be purchased individually and assembled according to the customer's tastes and needs. This concept had long distinguished American sportswear, which even inspired the name of the new

label. This way of designing sample collections had been perfected following the stock-market crash of 1929 to create purchase opportunities during a period marked by a sharp drop-off in consumption. Initially, it revolved around traditional outfits, separating jackets from skirts or trousers so that customers could purchase just one of the garments.

This innovation ultimately broke a now-traditional dress code and led to the concept of separates. It soon became clear that the supply of sample collections composed of garments that were linked by tailored details, decorative features or style could help customers invent a customised wardrobe. Naturally, this also meant that the industry had to be in a position to propose a complete range of clothing, encompassing extremely different types and merchandise sectors that ranged from coats and jackets to blouses and shirts, from trousers to knitwear.

The company did not turn to a French designer to create Sportmax's first F/W 1969–1970 collection. The idea arose within the company, and direct management was the only way to ensure that its philosophy would be maintained while also monitoring any problems that could arise from diversification. Laura Lusuardi, a young designer who had started an apprenticeship with the Max Mara Pattern Department just a few years earlier, was chosen to design the articles that, based on Maramotti's strategic project, would comprise the new collection; Laura Lusuardi subsequently became fashion coordinator.²⁹

To quote the advertising brochure, Lusuardi proposed "young styles suitable for any occasion", designed to form "a coordinated wardrobe in which each garment has been created to match the others".

The label no longer focused on a junior clientele and, instead, the accent was on the fact that a young style had become suitable for all women: it was a way of dressing that had replaced the dream of class and elegance popular only a few years earlier. Above all, however, the label produced precisely what would soon be called "casual" in Italy as well. In other words, "fixed" outfits were abandoned, to be replaced by a mix of individual garments that were linked by a common element. The wardrobe that Laura Lusuardi designed for the modern woman was composed of a series of basics that could be mixed and matched according to the imagination, taste and lifestyle of the person wearing them, and they ranged from coats and jackets to skirts, trousers, waistcoats, blouses and sweaters.

In essence, it was essentially an embryonic form of the "co-ordinated" total look, whose creation required reorganizing the company, revising and extending

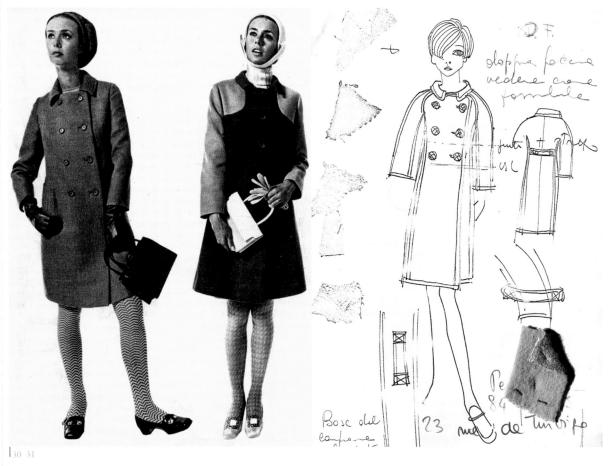

collection
Left: "The subtle line of this coat
in double-face blue and ice wool
muslin makes it ideal for every
figure. The back has a fitted look
created by long olive-shaped cuts
and on each side, accentuated with
rows of double stitching, there are
pockets with flaps. The small,

30 Max Mara Pop. F/W 1966-1967

rounded collar and square neckline are the latest." Right: "The fitted look of the upper part of this coat is created by the pinafore effect of the contrasting beige and brown facings. The

beige and brown facings. The slightly bell-shaped skirt, the height of fashion nowadays, makes it a coat that will take you anywhere. With a simple change of accessories, it is perfect for day wear and not-too-formal evening occasions."

Amica, 30 October 1966 (ph. Amica/RCS Periodici)

31 Graziella Fontana, technical sketch with fabric samples, Max Mara Pop F/W 1966-1967 collection, album of the collection

production, tackling new types of workmanship and establishing relations with outside collaborators. The concept of coordinates became the hallmark of the new label, and it was taken up in subsequent collections, accompanied by a growing focus on the fashion content: jersey was combined with heavy wools or peasant prints, and maxi lengths distinguished armystyle coats.

Sportmax was not presented at SAMIA but at the first Modaselezione, a new event devoted to industrial high-quality ready-to-wear, which was inaugurated in Turin on 18 April 1969.³¹ The initiative was supported by the Fashion Committee, which participated with a large delegation that included Sportmax as well as Cori-Biki, Sidi, Duca di Bard, Iliagirl, Cinzia Ruggeri, Piero Chiesa (the owner of Sealup, who also presented a small collection under his own name), Mafbo, Max Vita, Luigi Baldo, Carlo Lavatelli, Sergio Bonanni, Thea Boutique and Miss Rosier.³²

1969 was also marked by the first ventures into international sales, which did not commence with Germany – the most important market for Italian ready-to-wear³³ – but Belgium and France,³⁴ followed by Great Britain, the Netherlands and Switzerland.

At this point, the consumer target crossed national borders and the style of the product had to pay greater attention to European tastes.

Fashions and Voques of the Seventies

For the Reggio Emilia company, the early Seventies were characterised by experimentation. Interviewed in an article published about the company in Arianna in October 1971, Maramotti stated, "The first step towards serious planning without any surprises lies in what we could call a language difference, the difference that - in my opinion – exists between two words: Fashion and Voque. Let me explain. By Fashion I mean the garment - or rather, garments - that can give a woman the confidence that she will always feel at ease anywhere, and that can offer an affirmative answer to a specific question: do I look good in these clothes? By Vogue, however, I mean the clothes a woman wears because they're worn by anyone who wants to be trendy. The so-called group outfit. Using these words as a starting point, they can easily be translated into products and thus labels: Fashion = Max Mara; Voque = Sportmax."35

In the autumn of 1971, the collections of the two labels were designed by Karl Lagerfeld and Nanni Strada.

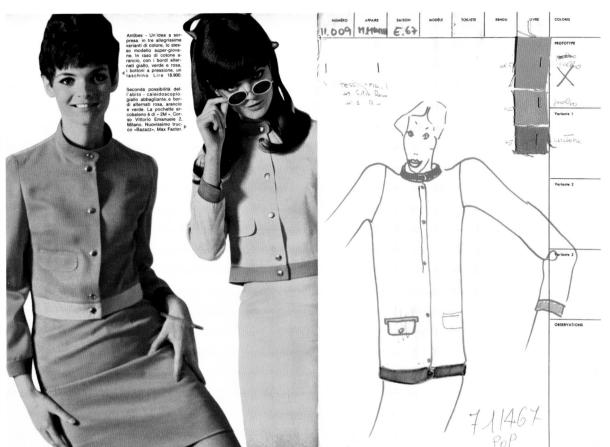

- 32 Max Mara Pop, "Antibes" suit in two different colours, *Arianna*, April
- 33 Emmanuelle Khanh, sketch for the Max Mara Pop S/S 1967 collection

The "fashion" proposed by the former was characterised by a casual style composed of coats and jackets with a hood and/or cape that were extremely unusual in both cut and colours - an uncommon palette for a winter wardrobe. The "vogue" conceived by the latter offered other ideas.36 As Maramotti observed, "For our garments, we turned to Afghanistan and Tibet for inspiration. Because cold plus sunshine stands for colour. And if you look closely at our clothes, you'll find that though they are composed of thousands of cuts and details, above all they are made up of bright colours".37 In reality, this went beyond colour alone. Nanni Strada had studied ancient and traditional Oriental apparel and transformed it into clothes cut according to strictly geometric forms that revealed their purity in the unworn garment stretched out on a flat surface.

However, the real innovation on which the company and designers had been working was the possibility of producing unlined outerwear, a radical concept for the Italian ready-to-wear industry. The absence of lining posed a number of problems. First of all, the seams had to look "finished" on the *reverse* as well. Secondly, it was necessary to create a style that would not need any reinforcement or padding.

For Lagerfeld's designs, the company perfected a type of seam resembling that of shirts (flat-fell seam), but it was executed using machines that worked with double-face fabric. Trimming one of the edges to be joined yielded seams that were not overly thick.

In turn, exploiting his experience in knitwear, Nanni Strada suggested a stitching system used in that sector. To do this, the company set up a special production line with machinery manufactured by Rimoldi, which created special feet to adapt the overlock stitch invented for jersey and knits. The result was a line of clothing with showy decorative stitching, created with thread in graduated colours contrasting with the ground fabric.

The latter experiment gained enormous space in women's magazines, but above all it galvanised the attention of those who had closely been observing the innovations of Italian fashion and "the progress being made by industries". Flavio Lucchini, art director of *Vogue Italia*, devoted four pages to the "revolutionary little collection prepared by Nanni Strada for Sportmax", publishing photographs of the clothes worn by models but also laid flat.³⁸

Moreover, Domus, a magazine specialising in archi-

32 33

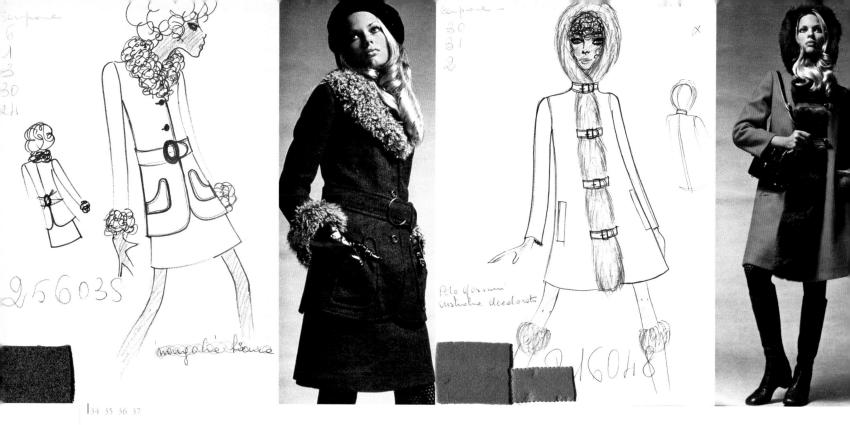

tecture and design, dedicated an entire reportage to this topic, complete with an article by Tommaso Trini.39

All this could have represented a watershed for the Max Mara image: an uncommon bond between fashion and design, and a move towards a more elite and sophisticated target than the one pursued until then. However, this was not the path chosen by Maramotti, who continued to focus on the goal of appealing to a broad group of female consumers. Indeed, the deep bond between design and fashion did not lie in individual avant-garde proposals, but in the guest to create a brand-new product whose construction standards could be found in the production process itself, yet was fully in step with a new lifestyle. It was not a matter of creating a new elite, but of working cogently within a mass market.

The Max Mara collection for the following season, designed by Lagerfeld, was emblematic of this approach, flaunting brightly coloured suits, striped or navy blue overcoats, and safari jackets à la Saint Laurent. Giornale Tessile described it as "a practical and elegant wardrobe for all occasions, without the discomfiture of clothing spawned by strained intellectualism", intended for "a woman who fits in perfectly with the dynamics of her era. Thus, there are no references to folk themes or the 'revival' aestheticisms inspired by literature".40 For the company, this meant moving away from a certain type of fashion, which during this period was focusing more and more on reviving the stylistic elements of the past, and on overly sophisticated forms of exoticism.

In autumn, the "young classic" concept also spread to Sportmax and was interpreted with "comfortable capes,

super-warm short jackets, trousers, skirts, and colourful loose-fitting heavy jackets", designed for a life of "work, school or food shopping".41

The rejection of "futile extravagance" became Maramotti's distinguishing trait. The styles were increasingly characterised by simple lines, excellent cuts, perfect workmanship and high-quality fabrics. Double-face fabric, tried several years earlier by haute couture, became one of the qualifying elements of many coats with a look of casual elegance, a term that meant a perfect garment for any occasion.

The reason for this choice probably also lay in the particular situation the Italian ready-to-wear industry was facing during this period. It had grown at a dizzying pace throughout the previous decade, thanks to the low cost of materials and labour, and at this point it was going through a profound structural crisis. Within a very short period of time, all the conditions that had promoted its development had changed: the relationship between workers and entrepreneurs had been reversed and the price of raw materials began to spiral as a result of the oil crisis. The scenario was also changing in terms of consumption.

The shift among consumers from custom-tailored clothing to industrial products was virtually complete and thus there was no room for market expansion. At the same time, new lifestyles had oriented demand among the younger generations towards casual wear and simple, inexpensive and highly diversified clothing. According to lacopo Pergreffi, during this period "dressing became a system of symbolic identification that needed increasingly frequent renewal. As a result, distribution also altered

- 34 Colette Demaye, suit sketch di tailleur for the Pop F/W 1968-1969
- 35 Max Mara Pop. F/W 1968-1969 "An alternative to the coat? A heavyweight suit in grey Shetland with cuffs and shawl collar in matching Mongolia fur. The long jacket has a stitched belt. The pockets and rounded edges are also accentuated with stitching Amica, 29 October 1968 (ph. Amica/RCS Periodici)
- 6 Colette Demaye, coat sketch for the Pop F/W 1968-1969 collection
- 37 Max Mara Pop, F/W 1968-1969 collection "A model inspired by the duffle coat in shepherd's wool and a stunning shade of rust. The typical toggle and loop fastening is given a new look here by the Tasmanian opossum border extending from hood to hem. Amica, 29 October 1968 (ph. Amica/RCS Periodici)
- 8 Max Mara, S/S 1968 collection "Contrasting colours for a Shantung silk suit with a long jacket and skirt with loose pleats to create movement. The jacket has two waistcoat pockets, a straight, rising collar and a belt with metal plaque like the buttons Amica, 21 May 1968 (ph. Amica/RCS Periodici)

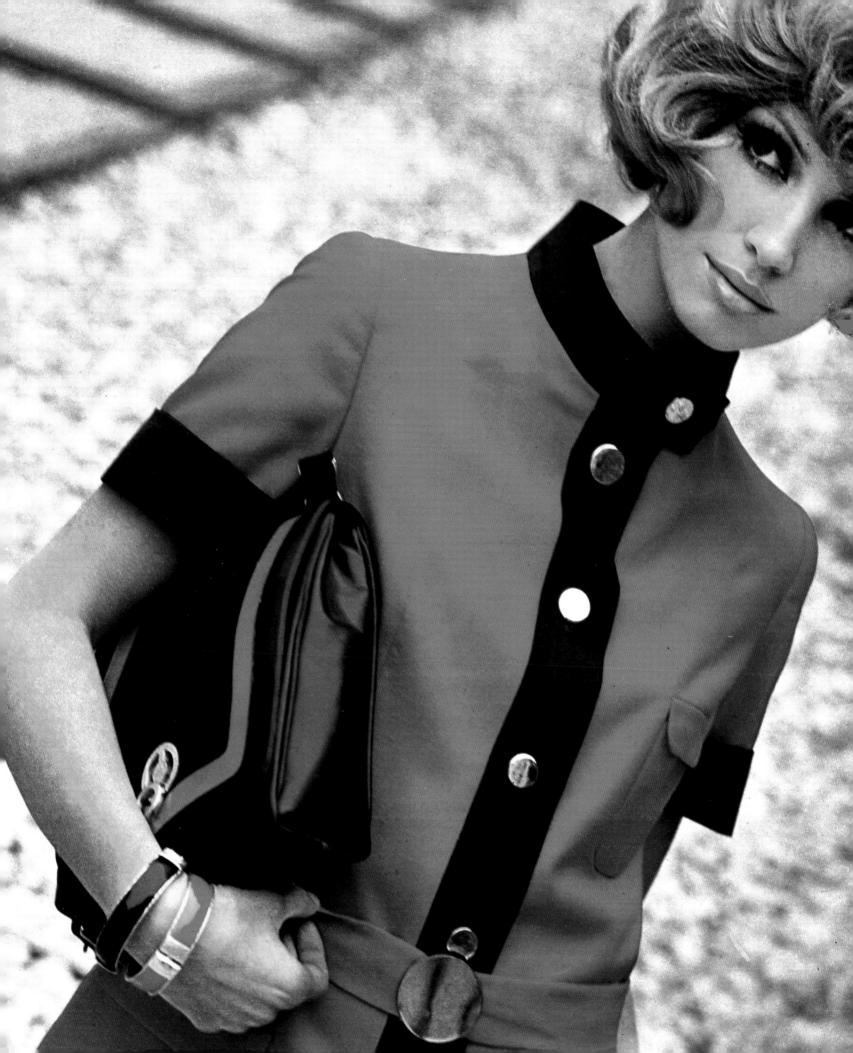

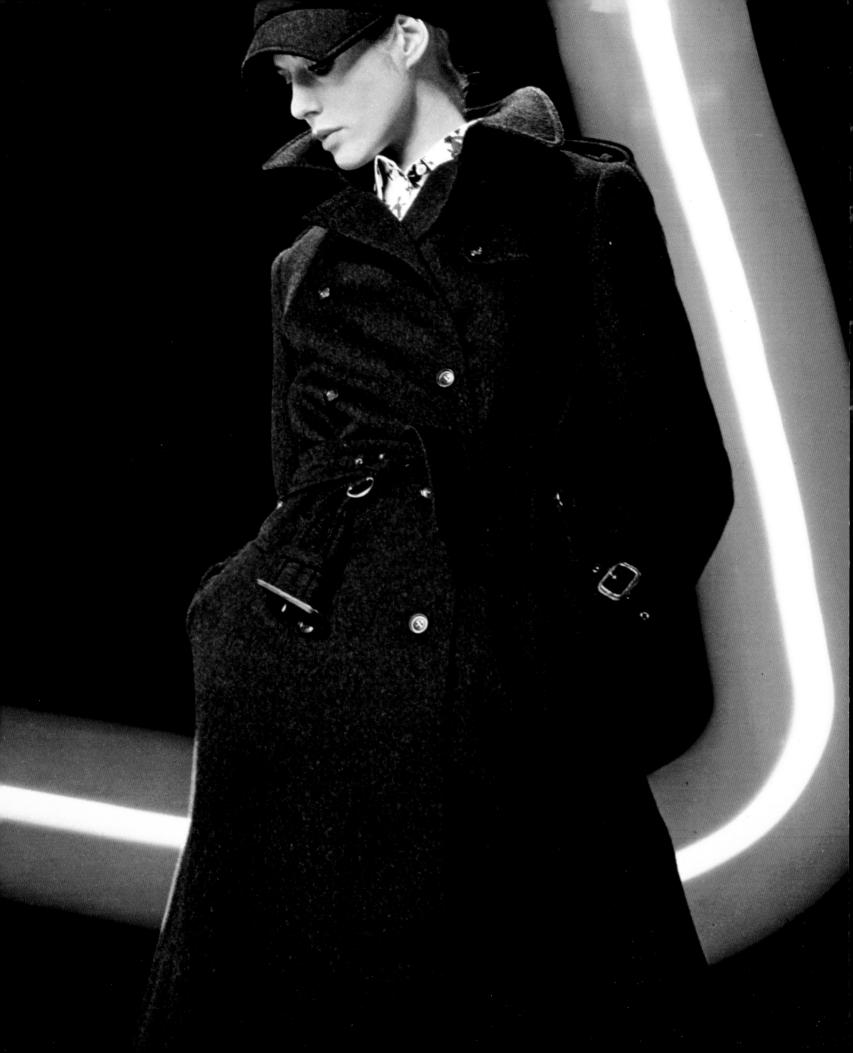

buying behaviour: instead of work orders concentrated on a few articles, the retail trade expressed the demand wider range of products in terms of styles and materials, further increasing the complexity of clothing." ⁴²

All this created enormous problems for companies specialising in traditional apparel. The creative "subjection" to high fashion, which had characterised the production of most of the major clothing manufacturers, showed unexpected limitations. Haute couture was gradually losing its role as a beacon of taste and a laboratory of trends, replaced by younger and more pioneering prêt-à-porter that, with its more democratic approach to the general public, responded better to a widespread desire for new ideas devoid of the elitist and luxurious notes (accessible only to the chosen few who led an "exceptional" kind of life) that had made the fortune of upscale fashion houses. The economic crisis of the beginning of the decade also triggered a drop in Italian consumption, a fact that diminished the competitiveness of domestic products in favour of imports from developing countries.

These factors had various repercussions on the fashion sector, starting with the bankruptcy (between 1975

and 1978) of large industries such as Unimac (Ruggeri), Rosier and Hettemarks, which were unable to deal with the changing scenario. They also led to the overhaul of the production models of other companies such as Gruppo Finanziario Tessile, culminating with decentralised production and the creation of a "constellation" of small companies linked as a commodity chain, making it possible to solve numerous aspects related to union claims and to face the requests of the fashion market with the necessary flexibility.

In this difficult period, the Max Mara Group adopted its own strategy, fine-tuning a system that had already been adopted previously due to its production specificity and the target markets of the different labels, 43 studied through the now-extensive chain of single-brand stores. Style and research continued to be characterised by the contribution of a considerable number of designers, whose creative input was used for individual collections or brief periods. This approach involved not only the consultancy of a single professional, but also of several designers working as a team and, as a rule, with Laura Lusuardi, who took on an increasingly evident role as a product manager. Several

- 59 Sportmax, F/W 1969-1970 collection "Green loden coat with matching Shetland skirt, sleeveless pullover and flower-print flannel blouse." Amica, 29 October 1969 (ph. Amica/RCS Periodici)
- 40 Brochure for the first Sportmax F/W 1969-1970 collection

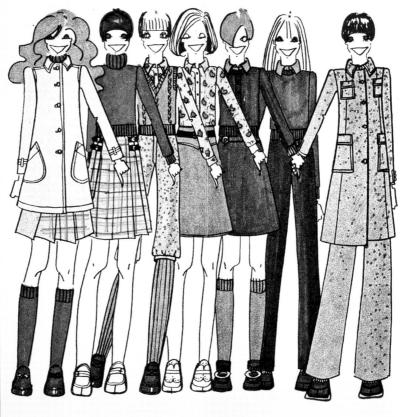

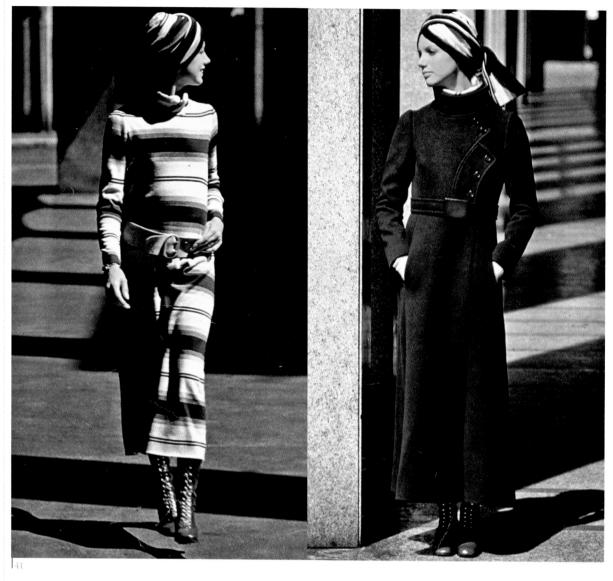

- 41 Sportmax, F/W 1970-1971 collection "Maxi coat with matching ... pullover dress in jersey with irregular stripes, topped by a scarf that can also be worn turban-style. It is calf-length with a flowing line and has a ring collar and fitted sleeves." "This maxi coat in cloth focuses on this season's colour and a subtle line, and has a deep vent in the back. The side closure, inspired by military dress, extends to the funnel collar; a belt with matching plaque buckle highlights the military style." Amica, 15 September 1970 (ph. Amica/RCS Periodici)
- 42 Sportmax, F/W 1971-1972, Grazia, 7 November 1971 (courtesy Grazia/Mondadori)
- 43 Sketches by Laura Lusuardi for Sportmax, F/W 1970-1971 collection, with fabric samples

of the designers previously involved were already famous, such as Karl Lagerfeld,⁴⁴ who worked regularly with Chloé by this time, and Guy Paulin,⁴⁵ who had linked his name with fashion phenomena such as Dorothée Bis in Paris and Paraphernalia in New York. Nanni Strada⁴⁶ had also become an established name in this sector, collaborating with names of the calibre of Avoncelli, Cadette and Fiorucci. Instead, Luciano Soprani⁴⁷ had moved up through the ranks of Max Mara. Hired in 1965 as a dress designer, he helped design the collections between 1973 and 1976, when he started a freelance career in Milan, where the Italian ready-to-wear industry was developing.

Over the years, the relationship the Group established with these professionals became increasing specific and unique. Unlike what would happen a short time later in other cases, the company was never tied to just one name and, above all, it never stepped back into the shad-

ows with respect to its designers. The purpose of this type of consultancy was to bring in ideas and new inspiration, often with intriguing leitmotifs linking them to design teams capable of transforming them – through extremely professional examination and verification work – into a "real" ready-to-wear item.

As Titti Matteoni wrote in 1986, "contacts with designers" were always "managed with skill and balance by the in-house creative office employees, so that the product would be supported by outside work but would always be tied to the company image and not to the hand of a single designer". Committed to perfecting his project, during the first half of the decade Maramotti encouraged a brand identity characterised by a fashion that, though not particularly innovative, was of excellent quality. This was a stormy period on both a social level and for the Italian clothing industry, and he chose to market ready-to-wear that was increasingly

researched in terms of design and manufacturing but that also had a design content that reconciled various fleeting trends, drawing from them the elements needed to construct a way of dressing rather than a fashion. In short, this meant just enough of a vintage touch to look timeless, men's styles and fabrics that were transformed into comfortable and practical women's wear, classic clothing and feminine prints that were renewed and updated to meet new tastes – but without forgetting the occasions that enticed the more traditional middle class to buy clothes ("a perfect outfit for a springtime wedding" 49). Paris continued to be the prime focus.

In April 1974, the opening lines of a spread on the Max Mara collection, published in *Amica*, stated: "The dress-and-jacket concept was relaunched a few years ago by a famous *couturier*, Yves Saint Laurent, after years of oblivion. And it was immediately taken up by ready-to-wear, because it fully responds to what women expect from fashion today".⁵⁰

For younger consumers, Sportmax offered a more casual way of dressing, composed of heavy jackets, blousons, casual trousers, plaid skirts and tweed suits, some with a distinctive "college look" such as the style proposed by Guy Paulin in autumn 1973.

"Prêt-à-porter" Fashion

Despite the continuing recession, in a certain way 1975 was a symbolic year for Italian fashion: Giorgio Armani presented his first collection and the Federazione Nazionale delle Industrie Tessili e dell'Abbigliamento (the Italian Textile Foundation) was established. The organisation, better known as Federtessile, was the initial outcome of the commitment undertaken by trade associations, and it united entrepreneurs from the entire industry to deal jointly with the sector's severe crisis via a programme policy that was destined to outshine expectations in a very short time. These results were possible above all because of the fact that, during this period, industrialists began to invest in creating a new production model, organising labour and upgrading equipment, but they also poured money into creative research.

The *prêt-à-porter* catwalks, concentrated in Milan by this time, had long offered the image of a hotbed of fashion. Constantly churning out new ideas, young designers and small companies proposed the type of casual and fun product that was so popular among young consumers. In October 1975, however, *Amica* had the following to say about a garment as traditional as a coat. "In fashion today, fortunately changes are not so far-reaching that a garment will be old in a matter of months. Added to

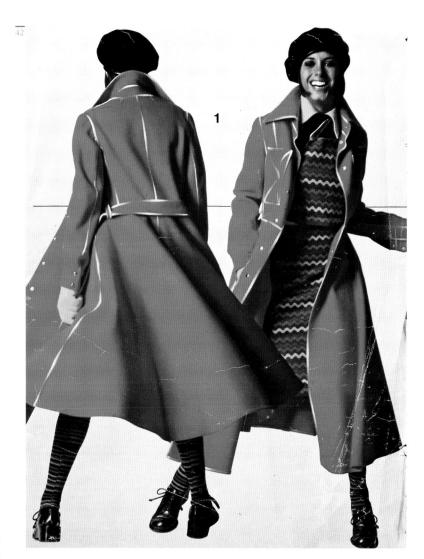

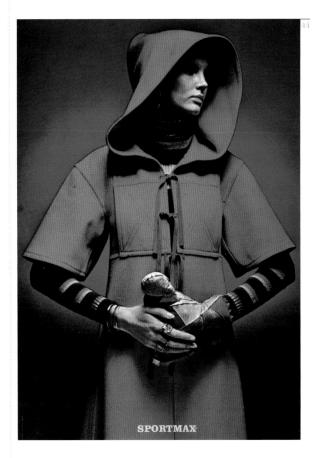

- this is women's desire not to be forced into pre-established moulds and in clothing that 'feels constrictive'. Thus, the choice of clothing has become extremely simplified yet broadened at the same time, because the concept of being 'fashionable' is far weaker and more elastic than it once was."⁵¹ However, the article closed with a piece of advice: "If you want to add a decidedly '76 touch to last year's coat, simply toss a shawl over your shoulders, or add a chunky knit waistcoat".
- Indeed, there was a new "vogue" to borrow Maramotti's term that was making inroads not only in upscale knitwear, but also in the proposals of the trendiest labels: the folk, rustic and country look that suggested coarse wool, rough fabrics and dull colours, altering the proportions of clothes and suggesting old-fashioned accessories such as knit shawls. This was a fashion that did not shun the ideas and styles of dress of the feminist movements.

The loose-fitting and hooded styles that were presented by both Max Mara and Sportmax, and that also appeared in the ads for the season, testify to the fact that the company had fully grasped what was happening in terms of customs and tastes of its customers, and it offered its own version of the latest trend.

The arrival of Jean Charles de Castelbajac⁵² as a consultant for the Sportmax collections of the next few seasons marked a turning point. The very young French designer did not confine himself to classic sportswear that respected tradition, but came up with quasi-technical clothes that alluded to sports such as hunting, fishing and motorbiking, and to spacesuits and special army clothes. The materials also changed with respect to what had been used for city wear until then, ranging from coarse cotton canvas – including padded and quilted types – to corduroy, waterproof materials, hemp, coarse wool and even spinnaker fabric, often in unusual combinations.

In a 1986 interview, Castelbajac pointed out, "I work with my materials. I cut the basic styles from them using my scissors like a hatchet. I need this incredible mass of materials, so I can dig into them to see which ones go together. They almost never go together. This incompatibility of colours and materials represents the essence of my clothes (for others, it comes from form). Until I find [the right thing], I have other weaves remade, I have other nylon fabrics dyed, until things finally go together".⁵³

These were neither the true technical clothes such as the type that came into vogue during the following decade, nor their fashion reinterpretation, a trend bolstered by the discovery of synthetic materials and fabrics with special characteristics. Nonetheless, with

- 44 Advertising poster for the Sportmax F/W 1971-1972 collection
- 15 Nanni Strada, sketch for "Etno" coat, Sportmax F/W 1971-1972 collection

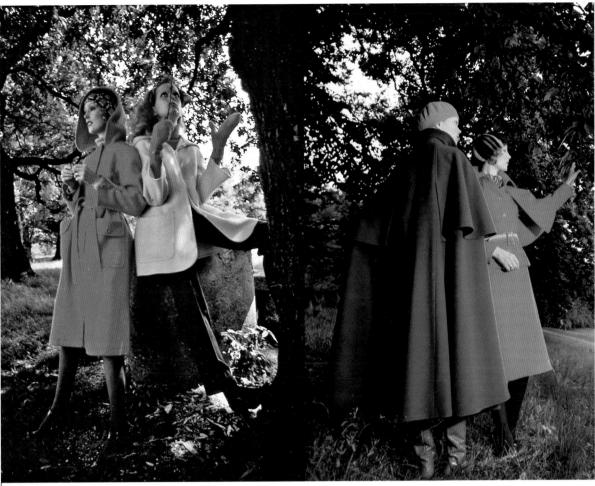

- 46 Max Mara, F/W 1971-1972 collection "Ultra sporty look and bright colours for...Max Mara models. Red coat with hood and large pockets. Model: Tiffany, 42,900 lira. Yellow jacket with hood and zip. Model: York, 29,400 lira." Arianna, October 1971
- 47 Max Mara, F/W 1971-1972 collection "Brightly-coloured soft cloth for...Max Mara models. Cornflower blue cape with wing effect. Model: Tunisi, 32,900 lira. Orange suit with cape. Model: Onice, 36,400 lira." Arianna. October 1971

46 47

his fashion shows inspired by the style and functional details of heavy jackets, rainproof cloaks and jumpsuits whose wit and infectious creative verve reinvented colours and materials, Castelbajac marked the beginning of that process.

By 1976, in Italy – and elsewhere – prêt-à-porter had definitively taken over the role that had once pertained to high fashion. In September of that year, this is how Amica justified an "epochal" decision. "For the very first time, the season will not be inaugurated by high fashion but by Italian prêt-à-porter. Why? Ours is a decision we feel we must explain. For several years now, high fashion - both Italian and French - has gradually lost its absolute guiding role. High fashion once merged research, experimentation and ideas that gave this extraordinarily sophisticated product a meaning that justified the extremely high cost that is usually attributed to a unique and unrepeatable product. For some time now, however, instead of serving as the goldmine of ideas from which the artisans and industrialists of this sector should be able to draw, the fashion shows in Rome and Paris have essentially reproposed the themes already introduced by *prêt-à-porter*. Indeed, the newest ranks of designers have preferred to tackle ready-to-wear collections, turn their attention to broader public and create styles intended for countless women". The article also noted, "There are fewer and fewer people who can (or even want to) afford custom-tailored clothes. And what is the point of creating collections for customers who no longer exist?".⁵⁴

At this point, Maramotti evidently decided that the time had also come to give the company image a more powerful fashion content, and on 18 March 1976 Sportmax held its fashion show at the Hotel Principe di Savoia in Milan for the first time. At the same time, it also launched a communication policy that, in addition to the usual channel of women's magazines with a large circulation, also turned to the magazines periodicals in which it purchased advertising space. As a result, in the September 1977 issue of *Vogue Italia*, in addition to two double-page ads dedicated to Sportmax and Vanity, photographs of these clothes were also published in magazine articles for the first time. In 1971, there had been pages dedicated to Nanni Strada, but this was a

completely isolated case that arose essentially because of the designer's relation with Flavio Lucchini, and not through a move on Maramotti's part.

In this case, an item by Castelbajac and one by Laura Lusuardi appeared in the reportage that was shot at the archaeological site of Petra, 55 whereas Sportmax trousers were shown in the sportswear section. 56

"Prêt-à-porter" in the Eighties

The late Seventies represented an extraordinary period for Italian fashion. Despite the fact that the country was going through a extremely difficult period from a political and social standpoint, between 1979 and 1980 there was a powerful renewal in terms of production, accompanied by a sort of trade euphoria determined by the recovery of the domestic market and, above all, the results achieved on foreign markets.⁵⁷ The reorganisation of the sector and the centrality of the creative factor (represented almost on a symbolic level by a generation of new designers that had stepped into the limelight by creating their own collections) began to show their effects.

Between 1977 and 1978 the redevelopment project promoted by Federtessile achieved its first visible results with the creation of Modit,58 a trade exhibition dedicated to clothing manufacture, to be held in Milan. This confirmed not only the definitive christening of Milan as the benchmark for the sector, but its goal was also to unite under one roof - and systematically organise - all the initiatives that, over the previous decade, had been held in the city on an essentially independent basis. The first Modit, held in March 1978, only hosted companies and was not a big success. As a result, the decision was made to open it to designers, offering a catwalk to those who did not have a suitable venue to present their collections. Five designers participated in the October rendezvous, and the following year all the names in Italian ready-to-wear took turns on the catwalks of the "Centro Sfilate", or fashion-show centre.

Both events were held in Pavilion 14 of the Milan trade-exhibition complex, and they immediately galvanised attention on an international scale. Every year, Modit hosted about two hundred companies that exhibited their new items to an audience of buyers and specialists, half of whom were foreigners. In turn, the Centro Sfilate (later called "Milano Collezioni") had five rooms for fashion shows, as well as all the services required for the press, public relations and so on.

During this watershed period, Max Mara also made another change in the design team. In 1977 Anne-Marie Beretta started her collaboration with the company as design consultant for the main line, and the

- 48 Sportmax, F/W 1972-1973 collection
 "Soft Mouflon for this minicoat in a gorgeous shade, perfect for the young who dare to wear a pale colour in winter. It has a cape in front with stitching that accentuates the seams, large appliqué pockets and a wide collar. The back has a flowing line beneath the V. A kilt and polo-neck sweater are the perfect companions for this coat."

 Amica, 24 October 1972

 (ph. Amica/RCS Periodici)
- 49 Sportmax, F/W 1972-1973 collection Sportmax redingote in houndstooth, a pattern often used for winter coats. It has a collar and wide lapels, vertical seams that make it slim fitting, flap pockets and, at the back, a short buttoned half-belt with a deep inverted pleat below. The pin-tucks in the cape at the back accentuate the soft. figure-enhancing line. It is the classic all-purpose coat that can be worn on many different occasions, perfect with other clothes and suits in a wardrobe and enhanced by the knee-length, which also works with trousers. Amica, 24 October 1972 (ph. Amica/RCS Periodici)

following year Odile Lançon started her collaboration for Sportmax.

Though the latter collaboration maintained the temporary nature typical of the company (albeit for eight seasons, until 1981), the former yielded such extraordinary results that the French designer collaborated for the company for more than thirty years.

In any event, in this period of the Seventies both choices were the result of a specific strategy. On the one hand, despite the growing importance of Italian style and designers, Maramotti continued to prefer French taste, convinced that Paris represented a more solid and professional paradigm of female elegance. At the same time, however, the two designers fully responded to the needs of the Max Mara Group. Beretta, who designed with a geometric eye bordering on architectural precision, attentive to the functional quality of the garment and its essential form, was the perfect person to create that "classic" style that Maramotti pursued with Max Mara.

On the other hand, Odile Lançon – who had worked at Promostyl for four years, sketching out trend notebooks – was the best person to handle a more "voguish" product (to use Maramotti's distinction) such as Sportmax, intended for a young target. It is not a coincidence that this label, which had had fashion shows in Milan for several years, was the one to participate in Milano Collezioni in October 1980.

A look at the F/W 1981-1982 collections clearly reveals the difference. Though the press kit stated that "Sportmax is an outfit, not a costume", the collection from the young line was full of "allusions to places near and far, to different eras" – though interpreted "in a modern and wearable style".

The list of themes uniting the proposed models could easily be the usual list of suggestions that are essentially imperceptible to the inexpert eye. Instead, in this case the references are extremely obvious and direct. For the folk theme, it is clearly evident that "the full skirts with paisley prints evoke the folklore of the East", and that for the theme of the Orient the "images that come from various Asian countries, from India to China, merge with the new way of constructing the heavy cotton fur-lined jacket with kimono sleeves".

This new way of understanding clothing – mixing, contaminating and giving a new and even ironic interpretation to ways of dressing and styles from eras and places distant in space and time – was becoming one of the characteristics of the "Italian Look" that the most famous designers were bringing to the catwalk. The postmodern era would then offer a scholarly theory for this form of cheerful and omnivorous eelecticism that

- 50 Max Mara, F/W 1973-1974 collection "Green and camel, a '74 combination that these two Max Mara coats focus on. On the left, the double-face version (L. 62,100); on the right, the one in Scottish wool (L. 65.900). They are both double-breasted with striking collars and appliqué pockets, and are finished with bold stitching." Amica, 9 October 1973 (ph. Amica/RCS Periodici)
- 51 Max Mara, F/W 1972-1973 collection "One of this year's trendiest colours for this Moufon jacket with a soft casual look. A must for those who lead a busy life and travel a lot. It has a shirt collar, a cape with gathering below, patch pockets and a belt with loops."

 Amica, 31 October 1972 (ph. Amica/RCS Periodici)
- 52 Max Mara, S/S 1974 collection "Another two models from Max Mara based on the combination of dark blue and white, enlivened by other tones. Left, the perfect suit for a spring wedding, composed of a silk twill sleeveless dress with a shallow V-neck, and a lovely cady jacket. Right, the classic jacket whose proportions make it easy to match, even with trousers; here it is worn with a slightly-flared crêpe-de-chine skirt."

 Amica, 7 April 1974
 (ph. Amica/RCS Periodici)

affected not only fashion but also design and architecture. Whereas the Seventies had "destructured" the culture of appearances and the codes adopted for decades by the upper-middle classes of the West, and had taught people the pleasure of casual wear as well as the allure of ethnic clothing as pure fashion items (given that people did not know their significance), the designers of the early Eighties interpreted the desires of a consumer who loved to have a thousand identities and also used dress as a form of disguise that even had a theatrical air about it.

After all, prêt-à-porter had fully stepped into the role once held by haute couture, and had also inherited its opportunity to dare to be eccentric. Indeed, wasn't it Saint Laurent who, only a few years earlier, had brought Diaghilev's tsarinas and the concubines of the Celestial Empire to the catwalk? In the winter 1981 season, nearly all the leading figures of the Italian fashion scene let themselves get carried away with spectacular proposals inspired by the East – Near and Far: Giorgio Armani influenced by the Japanese traditional prints, Krizia by the Beijing circus and the Terracotta Army, and Ferrè by the beauty of the obi.

Behind all this was the confirmation of a cultural interest in exoticism and ethnic elements that certainly could not have escaped a professional such as Odile Lançon. In her new role as special consultant to the Costume Institute of the Metropolitan Museum in New York, international fashion guru Diana Vreeland had promoted two exhibitions, one devoted to the costumes of the Ch'ing Dynasty⁵⁹ and the other to nineteenth-century Vienna under the Hapsburgs.⁶⁰

Thus, Sportmax – with its Chinese jackets and Austro-Hungarian folklore – fully grasped the new trend, but in a unique way. Theatricality was reserved for stunning advertising photos or magazine editorials, whereas the garments belonging to the collection, though new and original, were far more practical than what they appeared in the pictures. The specifications in the press kit, probably intended to reassure buyers, stated unmistakably that the company planned to maintain its approach vis-à-vis avant-garde ideas: it did not propose "costumes" but a "modern and wearable" way of dressing, with exquisitely cut coats and jackets and colourful skirts, all of which were perfectly wearable every day.

None of these explanations were necessary for the parallel Max Mara collection, which offered its followers the quintessence of style and elegance, transferred to the new proportions demanded by fashion: narrow hips, extremely broad shoulders and full sleeves. From the time she arrived in 1977, Anne-Marie Beretta began

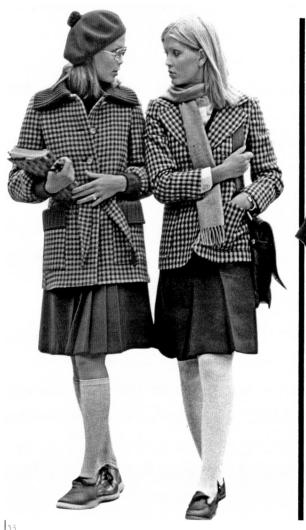

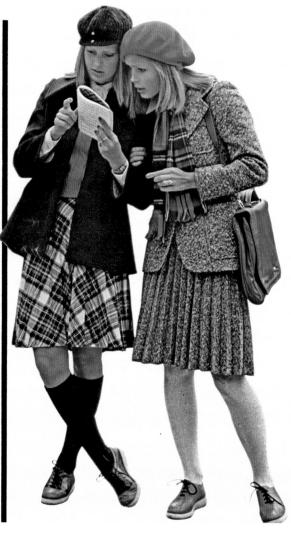

53 Sportmax, F/W 1973-1974 collection "Left: below, a Bordeaux suit roll-neck sweater and Shetland skirt. Above, checked jacket in knit and fabric with soft tie belt. Very like the previous model, this suit which can be divided - has a slender, masculine-style jacket that looks fantastic also with straightcut trousers in a matching colour. Right: the autumn look: dark blue loden jacket with two cufflink buttons; flannel blouse and red knit waistcoat; soft, comfortable, swirly knee-length skirt in a classic tartan. Another bestseller in fashion this year is tweed. Here it is, again, in a suit with a pleated skirt and ultra-classic slim jacket with lapels, rounded hems and appliqué pockets." Amica, 16 October 1973 (ph. Amica/RCS Periodici)

to propose more feminine coats than the trench coat or the double-breasted model with lapels, a deep pleat and a half-belt in the back – clearly masculine and military in origin. Pleats, gathers, stand-up or kerchief collars, and thin knotted leather laces opened up new horizons even for this type of garment, long considered one of the basics of any wardrobe. What had not changed was the philosophy of the garments. The pale pea caban represented the French designer's vision of the elegant casual style that had become the very signature of the label.

The solution she proposed for it reflected her way of designing, using simple and clean forms accented by thin leather trim in a contrasting colour and limiting accessories to a one-button closing. Even the orange coat splashed across the pages of the July/August 1983 issue of *Donna* – which, with its perfect oval line, brought to clothing manufacturing that "impeccable construction of garments" that had been typical of high fashion – came across to customers as an easy-

to-wear item precisely because of its pure construction. Naturally, there was also the camel jacket that, reinterpreted and updated, reproposed the line of the daywear with a male cut that had become the working woman's uniform.

A comparison provides food for thought. Despite the fact that the designers' names were never advertised at a time when this seemed to be the trump card for Italian ready-to-wear, the company never imposed limits on their creative freedom. Just the opposite: it was their imagination and the ways through which their inspiration took form that had the potential to generate innovation. Odile Lançon's folk inspiration diverged completely from the very self-assured but sophisticated and feminine woman created in Anne-Marie Beretta's drawings. However, both were perfectly obtained in the Max Mara collections through the methods that were part of the metier and culture the company had coherently constructed over the years.

The Suits and Coats of the Eighties

The early Eighties marked the end of the crisis that had created such enormous difficulty in the previous decade, and coats and jackets triumphantly returned to the catwalk. The information in the spring 1984 press kit explicitly and proudly declared that "with each season, Max Mara affirms its position as a leader, a specialist in the summer suit and the winter coat". The camel cape – "the classic of classics" – virtually became the icon of the label, and it was the focus of research into "quality" that involved materials, styles and finishes.

According to the November 1985 issue of *Donna* magazine, this item was "so closely tied to traditional and timeless elegance that Max Mara decided to intensify its features. Softness, for example: camel hair has been replaced by cashmere, even softer and more precious. Fullness: in nearly all the coats it is enveloping, taken to extremes. Luminosity: enhanced by big collars that frame the face".⁶¹

Likewise, a new story had commenced for the twopiece suit, and the text accompanying the S/S 1984 collection affirmed that "the traditional suit will always exist, adapting to the requirements of fashion in skirt length or the size of the shoulders".

The feminists of the Seventies, with their clogs and flowered skirts, had stepped aside to make way for a new generation of emancipated women who sought fulfilment in work. The uniform of the career woman specifically resembled that of her male colleagues: shirt, jacket and skirt or trousers, but with certain symbolic characterisations.

The shirt was enriched with feminine touches; the skirt became increasingly shorter and more aggressive, often emphasised by high-heel shoes; trousers could imaginatively vary in style (from traditional men's pleated trousers with cuffs to puffy knee-length styles and the most varied revivals of ethnic trousers). Nevertheless, the true symbol of this new trend was the jacket, which became increasingly fuller – thanks to padded shoulders, pleats and gathers that gave the female chest an unusual size, the legacy of ancient cuirasses or men's doublets.

Here as well, Max Mara decided not to follow extreme trends, but to remain faithful to the range of fashion intended for a broad target that wanted something new but did not appreciate showy and eccentric fads. Nonetheless, this was not a form of conservatism but an original way of using creative stimulus.

The most daring and experimental ideas of the design staff served the purpose of orienting constant renewal of the product, which nevertheless had to respond to the company image and the solid taste that represented its philosophy. By the same token, close attention to the market was the most important commitment for a group that, by the middle of the decade, numbered four manufacturing companies and a distribution firm, had 1,450 employees and produced fourteen ready-to-wear collections. The results were evident in the nearly 3,2 million garments invoiced in 1984, of which 80 percent in Italy and the balance abroad (though this figure rose to 30 percent for certain lines such as Max Mara, Marella and Weekend).

Moreover, it was during this period that Luigi Maramotti was finalising a new commercial and marketing strategy. The idea was to make the most of the shops' knowledge of customers and use this as a "true market indicator", while also expanding the single-brand sales network through franchising, an approach that was revolutionary for the era.⁶³

The shops, co-ordinated from an architectural and graphic standpoint, were to accommodate two product types: one type played a "multi-label" role and showcased the Max Mara, Sportmax, Pianoforte, Weekend, I Blues and other collections, whereas the others were reserved for the plus sizes of the Marina Rinaldi line. The Max & Co. chain was added in 1986.⁶⁴

The decision to study the targets of the various labels clearly strived to cater fully to the product ranges offered to customers. In this scenario, the role of the Max Mara line was to continue the image of evermodern elegance, composed of prized materials and finishes, whereas Sportmax maintained its role as a trendsetter that was more open to fashion stimuli. The fact that the creative team for this line, headed by Grazia Malagoli since 1982, relied on the collaboration of numerous outside designers (for example, Guy Paulin, Sophie George, Tokuko Maeda and Eric Bremner, who were combined in different ways for the various collections throughout the years, probably represented an important contribution.

For example, the proposals from the first half of the decade bear the mark of Paulin and his deft revival of French taste. In his concept of the dress, the full proportions that were *à la page* were achieved with completely original criteria.

The shoulders were almost never artificially padded but rendered important through particular cuts and constructions, the circle or trapeze models were accessorised with wide Fifties-style belts, and the shapes of straight coats evoked the lines of the Twenties. In general, Paulin's model was not so much a go-getting career woman but a refined (and romantic) flirtatious young woman who toyed with fashion.

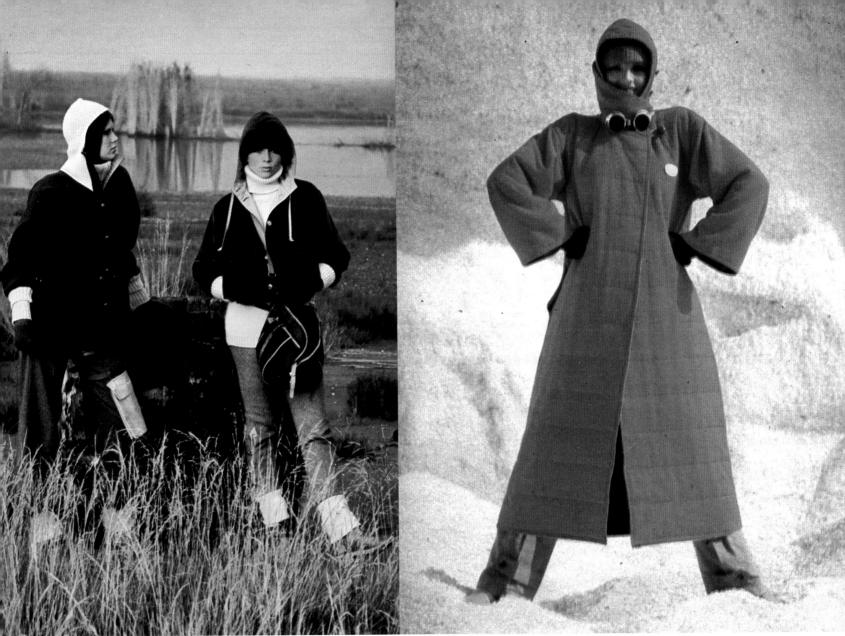

An intenational style

By 1985 Italy had become one of the leading exporters of ladies' wear to the United States, Germany and France, not to mention Japan and Australia, an outcome largely due to the success of its designers and luxury lines. This growth seemed unstoppable, but at the beginning of the following year the declining dollar meant a 25-30 percent increase in the price of Italian fashion, triggering a drop in North American sales. An AllA report apprehensively noted that "the decline of the dollar and low oil prices have currently stimulated the national economy significantly but do not favour and, indeed, can impede the growth prospects of the Italian clothing sector in 1986". Moreover, this was a sector that "on an international and domestic level [began to experience] not only the competition of zero-inflation countries such as Germany but, once again, that of developing countries, whose goods were quoted in dollars".69

In summer 1986, Maramotti plied his legendary lucidity to analyse the reasons behind the surprising results of Italian fashion and, in an article published in Civiltà del lavoro, came up with a proposal to deal with the crisis.70 His viewpoint moved away from the school of thought that considered designers the sole reason for the boom.

On the contrary, he affirmed that "the great success of Italian designers was undoubtedly encouraged by the particular situation of the Italian textile industry, but we think that the textile industry has also expressed the values of creativity and adaptation to the times, because it was - and still is - guided by particularly skilful people who have understood the evolution of customs and the need to update tastes. And therein lies the heart of the problem: over the past fifteen years, all the creative and productive forces in men's and ladies' wear have expressed a freshness of ideas and an ability to adapt the product

- 54 Sportmax, collection F/W 1976-1977 'Woodland hues: rustic, rough fabrics; hand-knitted thick wool écru sweaters: these Max Mara Sportmax models create the feeling that winter is already here. Trousers that have either a tapered or soft line, raw wool sweaters and blouson jackets in corduroy or swamp-green fabric. Amica, 2 September 1976
- (ph. Amica/RCS Periodici)
- 55 Sportmax, F/W 1976–1977 collection "A 'Martian' woman from Max Mara Sportmax, who this winter [...] will be wearing big guilted cotton coats with a balaclava-style hood. Amica, 2 September 1976 (ph. Amica/RCS Periodici)
- 66 Sportmax, F/W 1977-1978 collection 'The colour of a 'Crusader's tabard' for this basic tweed overcoat designed for Sportmax by Laura Lusuardi. It is unlined and has an ample hood trimmed with fox, with two tails at either side that can be used to fasten it or as a scarf. Vogue Italia, September 1977

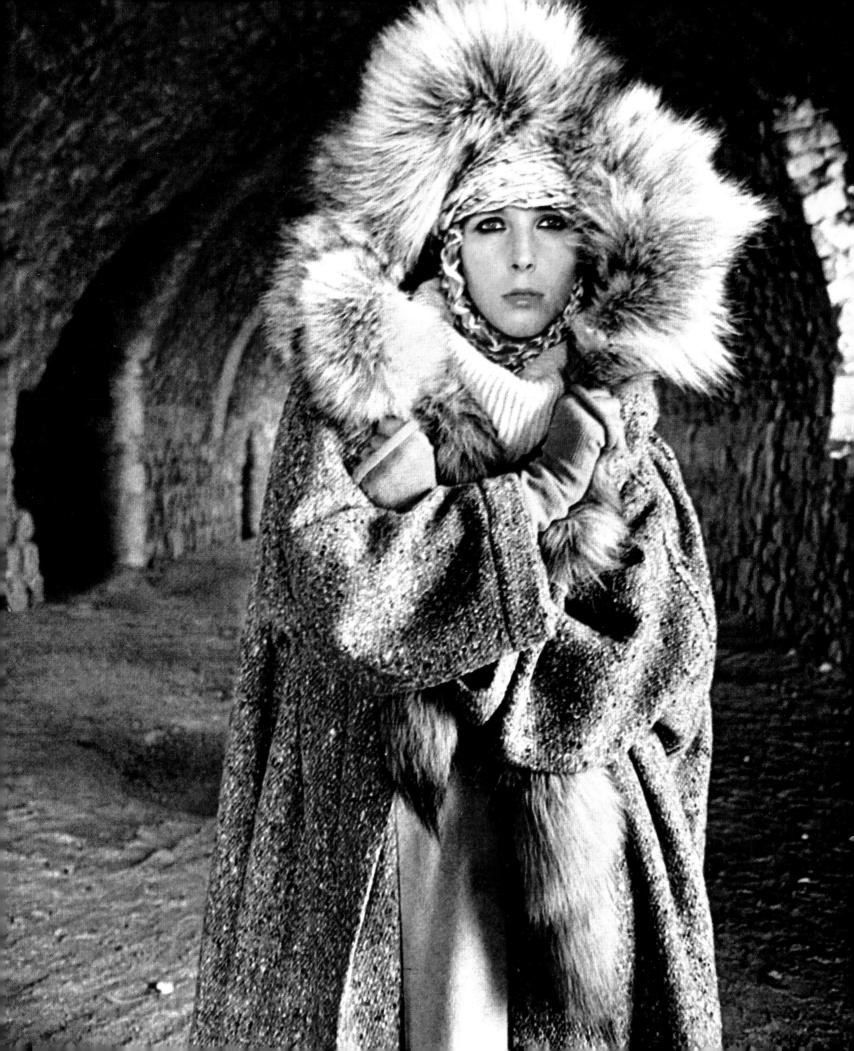

to renewed lifestyle needs with an imagination unseen in other countries, which have had great traditions in this sector in the past. With regard to both raw material (spinning and weaving) and actual clothing manufacture, our production facilities have been set up in a modern way, and though they do not reach at the costs of the Far East – Hong Kong, Taiwan and South Korea, for example – they have managed to organise top-level production in terms of both taste and quality. We can say that our leadership is unquestioned in Europe and America alike".

Therefore, he turned to the production sector to propose a strategy for the future that focused on overhauling the "sales network, which is certainly the weakest part of our organisation". The situation at the time clearly revealed the fact that "European markets have appreciated our product but we have not yet established distribution platforms that will give us sufficient peace of mind to develop foreign sales".

Maramotti's insistence on the topic of marketing arose from several observations related to both the production and effective consumption.

On the one hand, he observed that "the Italian prêt-

 \dot{a} -porter industry absolutely cannot afford to limit itself to the domestic market; large volumes are needed to achieve good economic results, and the penetration of large areas is necessary to reach at large volumes".

At the same time, he noted that "clothing consumption in industrialised countries is increasing slowly but constantly, and Italian *prêt-à-porter* is in a position to exploit the highest range of this market: genius, creativity and the ability to adapt to the substantial demands of fashion are the characteristics typical of our entrepreneurs and designers. Therefore, we are fully convinced that if we are able to reinforce our commercial structures, particularly abroad, as some of our colleagues that produce knitwear have done, Italian *prêt-à-porter* will enjoy a long and fortunate season".

Maramotti's proposal originated from a strategy that his company had studied and implemented several years earlier and that underwent new developments during this period. In a phase in which Italian fashion was beginning to face its first difficulties on the American market, Max Mara was facing the issue of sales in the United States for the very first time. In this case as well, the

- 57 Advertising poster for the Sportmax F/W 1977–1978 collection
- 58 Jean Charles de Castelbajac, sketch of the "Verona" coat, Sportmax F/W 1977-1978 collection

approach was an original one that reflected the company philosophy, starting with the choice of timing, which was not random. Luigi Maramotti, who oversaw the entire operation, stated, "Until then, we did not want to – nor could we – contend with the 'designer collections' of the major designers". This did not mean trying to compete with the popularity of designer wear, but inventing the company's own space, suited to its own product. The plan was to expand the company's presence abroad by "building and gaining important experience on the main markets, proposing an 'international' product – in other words, one that is valid in absolute terms, above and beyond the fact that it is made in Italy", "2 but also one that was reasonably priced.

The new direction of Max Mara's commercial strategy coincided with an event that profoundly influenced Western culture and thus also fashion. The Wall Street crash of 1987 marked a lull in the season of the ephemeral, gaudy ostentation, and cheerful and easygoing contaminations. Go-getting career women began to seek a fragile look and "minimalism" soon became the watchword. Even the sumptuous beauty of the top models that Versace brought to the catwalk was slowly forced to give way to the elegant anorexic look of New York WASPs. This was a process that would eventually take on the guise of a widespread fashion in the Nineties, but that was launched by the catwalks of Japanese designers in Paris, Zoran's styles, and the new trend of American designers such as Donna Karan and Calvin Klein.

Riding the wave of the success of previous years, which was barely affected by the most recent signs, Italian fashion began to wane, as it continued to propose sophisticated and showy fashions that, in certain ways, were even more elitist. Instead, the change in lifestyle bolstered the international success of the industrial group from Reggio Emilia, which came to represent the other side of Italian fashion, composed of classic styles with excellent cuts and high-quality fabrics. These styles reflected the demand for a new and less showy way of dressing that was simple, cultured and refined. Above all, however, it was a type of look that moved away from overly specific references to a specific culture or provenance and proposed an international taste that appealed to women from different countries and continents. In 1994, the company that Women's Wear Daily defined as an "Italian sportswear giant"73 opened a two-floor store on Madison Avenue in New York.

The Max Mara line continued to offer coats that were impeccably made of increasingly prized fabrics, as well as refined suits that, while maintaining the proportions of previous years, began to turn to more delicate colours and softer lines.

combined the photographs of several models with short texts that, like visual poetry, conveyed the company's longstanding approach to fashion. "The/woman/in/a Max Mara/suit/is beautiful/sophisticated/timeless" was the commentary to a houndstooth jacket with a brown collar and a fabric boutonnière. 74 Likewise, "The/ confidence /of/cashmere/the classic cashmere of Max Mara/is soft, warm, precious/is naturally elegant/is forever" were the words explaining a coat with a masculine cut,75 with a headline that knowingly compared it to a diamond. Both texts alluded to something timeless that was thus outside the ephemeral concept of fashion. It was something that

did not have to reckon with sudden changes in trends,

but that instead reflected a way of dressing so profound-

ly rooted in daily culture that it had acquired the traits

ad for the F/W 1988-1989 collection that cleverly

of an immutable tradition - yet also of something so precious and unique that it would be eternally desirable. In short, what is defined in the world of fashion as "a classic".

In the meantime, the role of Sportmax was to grasp the multifaceted changes in the tastes of women in the late Eighties, testing emerging trends – from the most overt maximalism to the understated look of the most discreet and aristocratic female image that was becoming fashionable. The objective chosen for the F/W 1987-1988 collection was "to forge a thin bond between youthful nonconformism and rediscovered femininity", 76 abandoning large proportions and proposing a less contrived silhouette. For the following winter, the catwalk featured styles ironically inspired by haute couture, but also an explosion of colours and fanciful prints. In both cases, the market response was positive.

59-60 Renato Grignaschi for Sportmax, F/W 1981-1982

Creativity as a method

Together with the development of an international network, new production methods and a constantly evolving industrial culture, even the design system strengthened the structure and process to the point of achieving an optimal methodology.

The creative part was entrusted to the fashion director, Laura Lusuardi, with the task of maintaining "the good positioning of every line, its identity and respect for its personality", as well as managing the relationship with the designers who later continued as consultants even if some became more permanent. As for the Max Mara brand, the consultating cooperation of Anne-Marie Beretta continued and in 1987 a contract with lan Griffiths was signed. The design team of the Sportmax Collection, however, was entrusted to Eric Bremner since 1985. All were assisted by young designers who took turns within the design teams of the various lines for a few seasons.

Already in the 80s new talents were being scouted in schools and direct partnerships were quickly established with them. Interviewed by "Fashion" in 1986, Luigi Maramotti explained that in the past "the recruitment of staff for the fashion business was conducted through quite informal channels, whilst over the last few years collaborations with [...] British schools have been increasingly formalised, also thanks to short periods of work experience offered by the company to certain students during the summer holidays, even before completing their studies", 78 as well as other collaborations between training institutes and the company. This attention to young blood and to their preparation led Max Mara to turn their sights to other sources; initially by means of the Italian school system and its longstanding collaboration with Modena's Scuola di Progettista dello Stile di Moda, and later through international initiatives such as the European Social Fund project or directly abroad via awards destined to students from the Anglo-Saxon schools. The result of this was that many young people, including lan Griffiths79 and Eric Bremner of London's Royal College of Art, and Lazaro Hernandez and Jack McCollough (Proenza Schouler) who had studied at New York's Parson School of Design, embarked on their first true work experience in Reggio Emilia.

With time, however, it was noticed that the different school systems provided "pure creative talents who often found it difficult to communicate with the company and relate to its philosophy". It was for this reason that Max Mara decided to intervene, creating a new type of professional figure, who was less artistic but just as essential. In 2003 Reggio Emilia's CIS Scuola superiore per la gestione d'impresa and the Giulia Maramotti Foundation, organised the first course for clothes and

fashion designers, whose aim was to create a "hybrid figure, midway between creativity and creation, between style and company". In other words, "a coordinator who could act as an intermediary between company and free-lance designer".80

As Achille Maramotti explained in 1991, freelance designers "can bring us ideas, an atmosphere, their perception of a type of woman", but to be able to create a successful collection "the whole team, our knowledge of the market and the marketing insights must be put together".⁸¹

Despite this philosophy (or perhaps thanks to it), Max Mara's history narrates a constant link with creativity and in fact demonstrates that the difficult transition from tailoring industry to fashion brand also happened thanks to a wise and cautious use of the innovative contributions of its designers. Despite not having positioned itself at the cutting edge of research, the Reggio Emilia company has always created "fashion" assuming a role of fundamental stature within the context of Made in Italy. Indeed it was chosen as one of the brands which, during the opening ceremony of the 2006 Winter Olympics in Turin, best represented the essence of our country's culture.

The complex relationship between creativity and company culture was confronted in 2000 by Luigi Maramotti in an essay⁸² which explained the philosophy of the Group in a very detailed and considered manner.

After having defined creativity as a "behaviour which comprises activities such as invention, organisation, composition and planning", essential to "understand or improve our social and physical surroundings", he examined the "infinite game of fashion" whose transformations, although determined by "macro-changes in cultures or society", required "human intervention, the work of creative people, of industry and the complicity of the consumers".

"Fashion after all doesn't happen by chance".

As a true industrialist, he proposed the product ("the nucleus of a manufacturing company's culture") as pivotal to the system; "all the interrelated development, production, marketing and promotional activities are coordinated around this", generating "a curious plot within the product itself". According to this logic, the designer's task was to envisage an idealistic future life and create dresses which "satisfy and awaken undeveloped or unidentified desires". Two objectives which are closely connected, from the moment when every fashion proposal is successful, to the moment when the consumers can associate it with a lifestyle to which they want to relate.

Maramotti's reasoning, however, identified another protagonist in this "game" – the company, acting through its identity as a framework for its products and as a point

of reference for the design work. The brand identity, created "from a vision of ideal existence", is, like fashion, in continual evolution; long-lasting success depends on its ability to maintain tradition and innovation in constant balance. The results of a company are largely derived from its ability to notice the smallest sign of change and adapt with immediate flexibility ("strategies for success are more and more difficult to foresee, since the elements to be considered from a creative and marketing point of view have multiplied and everything is subject to change"), but without losing the distinctive character of its identity. According to the businessman from Reggio Emilia, in such a framework, creativity cannot be a skill possessed only by the designer, instead it must form the psychological make-up of the entire organisation. ("To be successful, every single element of the product's development and marketing process must be innovative and each must have a creative attitude.")

It was not by chance that the essay was entitled *Connecting Creativity*.

A new century

Luigi Maramotti's arguments, however, did not depict a shared general view on fashion. The end of the 20th century and the beginning of the new millennium represented a schizophrenic moment for Made in Italy. On the one hand there were brands profiting from huge international success; some such as Gucci or Prada because of their ability to take in the changes in culture and in taste of their young and rich clientele, others such as Armani and Max Mara because of the strength of their image and the continuing style their fashion proposed. On the other hand there were examples of obvious difficulty both for higher- and medium-end manufacturers who struggled to confront a globalised market and competition.

By contrast Paris was regaining its worth, bringing spectacular and anti-conformist fashion to the catwalks but in particular by inventing luxury for the masses. Carefully considered marketing on a female consumer fascinated by the symbols of status of designer labels, in

- 61 Max Mara, F/W 1981-1982 collection
 "A lean line and soft, furry inside:
 the extraordinary fabric is the big
 feature of this caban coat with an
 extremely innovative cut, and
 leather trim."
 Donna, November 1981
- 62 Max Mara, F/W 1981-1982 collection "A sharp look for this roomy camel jacket with corduroy trousers. Sportmax pullover." Donna, November 1981
- 63 Max Mara, F/W 1983–1984 collection "Max Mara: the egg. Mohair coat with ample rounded lapels." Donna, July-August 1983

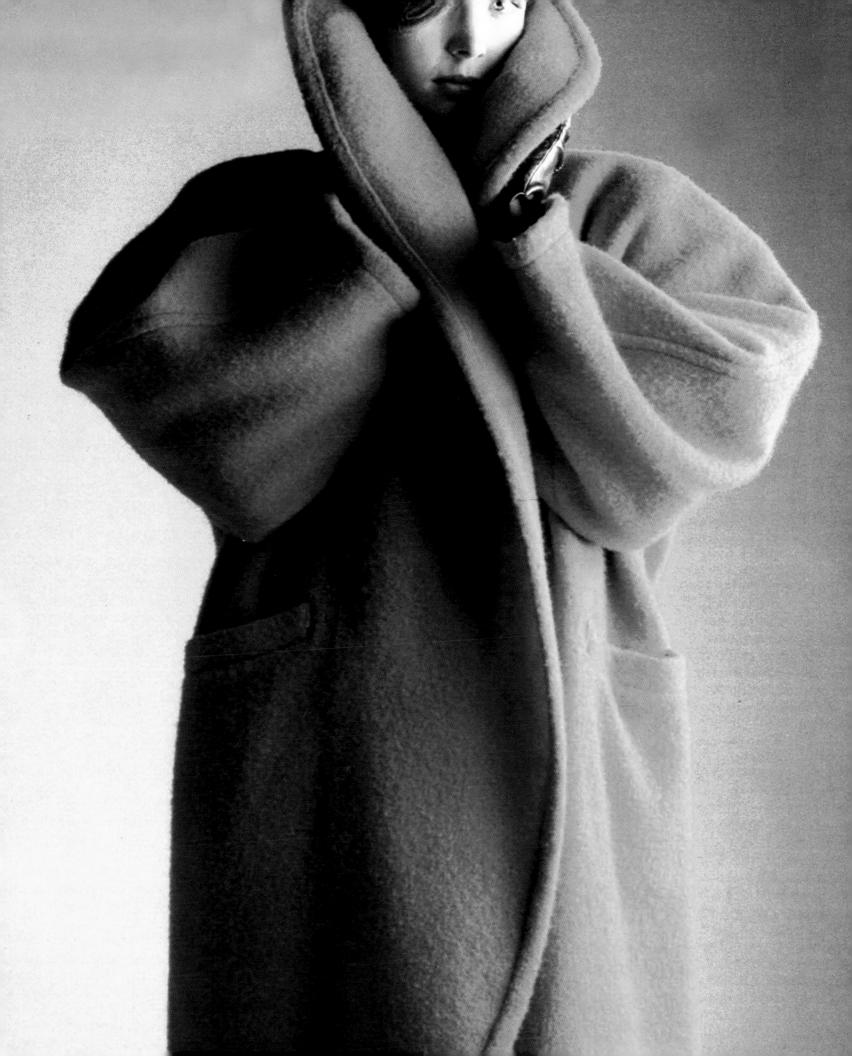

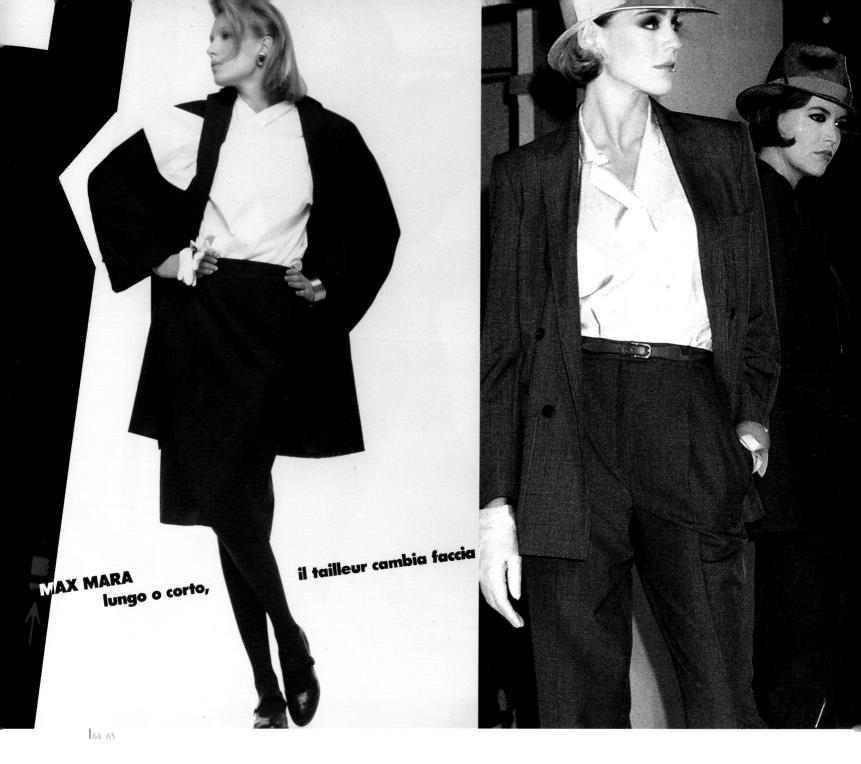

exclusive single-brand stores, offering the latest fashion lines and in particular accessories and perfumes. The focus was moving towards the final consumer, creating an even more central role for the point of sale.

Strong thanks to its strategy based on quality products and a rational diffusion in new markets, between 2000 and 2001 Max Mara reached enviable objectives. Giorgio Guidotti, Communications Director, declared: "Exports are increasingly important; in 1999 they created a profit of 43% on the entire turnover. The aim is to move into foreign markets. We are currently present in 90 countries. The most important remain Europe, Japan ad the USA but

we are also succeeding in Russia".83 And then there was China where Max Mara had been a presence since 1987 but which was going to become of fundamental importance.

The relationship with the consumer continued to be built via a directly managed distribution. The network of stores, either owned or franchised, was increasing in Europe and America spreading to other countries and cities such as Tokyo, Moscow and St. Petersburg.

New boutiques were opening everywhere in fashionable streets and areas; Ginza in the Japanese capital, the Nevskij Prospect in St. Petersburg and New York's Soho

- 64 Max Mara, S/S 1984 collection "Suit... gabardine skirt and full, straight three-quarter jacket with kimono sleeves. Metal bracelets and earrings by Max Mara (Pellini Bijoux). Shoes by Sebastian for Max Mara. A corner of the blouse threads through a large side eyelet in the jacket." Vogue Italia, January 1984
- 65 Max Mara, S/S 1984 collection, Cosmopolitan, March 1984
- 66 Sportmax, press folder, S/S 1982 collection, sketch by Guy Paulin

("Today Soho is one of the world's most important shopping areas; by opening here we can reach a younger and trendier public than the one which loves to shop in Madison Avenue", "4" where the store windows of the historic Max Mara boutique, opened in 1994, emerge).

The regulation of its diffusion, however, was not only a reflection of an unstoppable commercial expansion but also of a well-defined strategy. In 2004 Luigi Maramotti declared: "Thanks to the widespread presence which our boutiques guarantee throughout the world, we are able to perfectly understand our clientele".85

Four years before, whilst describing the development of the Max Mara product from its design to its sale, the businessman himself identified market research as the first point of call, initially involving the expertise available within the company ("We discovered that the most efficient strategy is to conduct this type of research among operational members of the group; in other words those dealing with design, sales and marketing. We base our work on a very simple method: observation. Those involved in developing and marketing the product are fairly knowledgeable and sufficiently informed on the history of the company to know where to find the most interesting insights and how to interpret the information"86).

If the insights on trends and new tendencies emerged from various sources, those relating to the Max Mara clientele definitely came from the single-brand stores. Since the 80s the company has in fact boasted an internal data collection system which allows "the daily and precise monitoring of market reactions to our products in relation to style, size and colour", 87 interviews of the store directors provide more detailed and in-depth analysis relating to the reasons for the success or failure of certain lines. It is a timely detection system, perhaps too much so to be used to stylistic ends, which, as Luigi Maramotti wrote, if used to "collectively understand how our clients' tastes develop and what influences their choices, apart from being extremely interesting, is a precious instrument which can forecast the changes in success of products of future collections and give shape to new strategies." On the other hand "creating to sell is different from creating for the sake of creating. At Max Mara the product is rigorously defined in relation to retail sale".88

The company's philosophy and its choice of strategy were derived from this mass of information, from the belief in the close link between the product's brand identity, quality and style, from the visual identity of the boutiques, the type of advertising, but also from the perfect understanding of the needs of its clientele. From the beginning of the new millennium, the Max Mara female consumer was no longer the wife of the local doctor, as was the case in the 50s, but neither was she

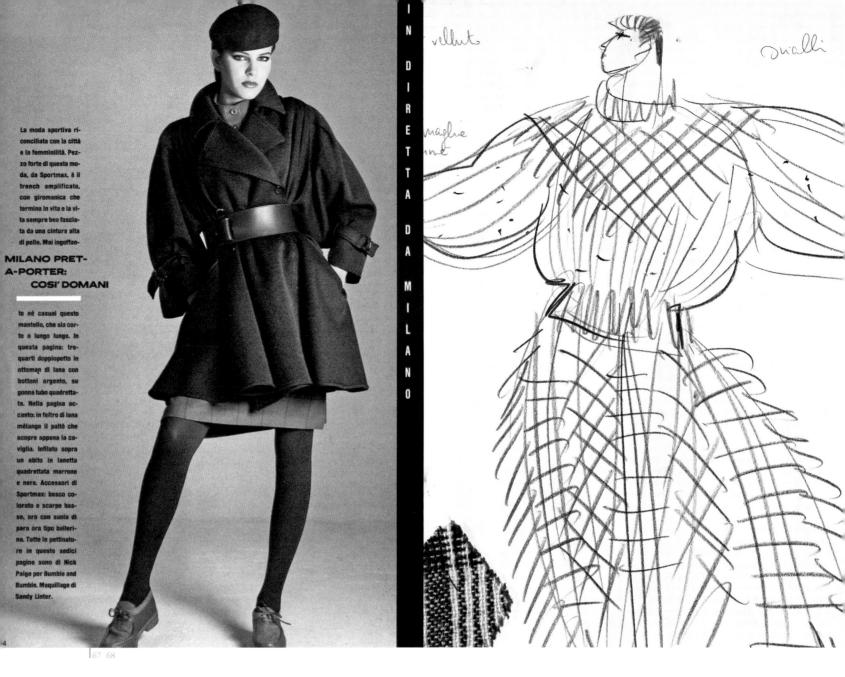

the fashion victim who pursued the distinctive symbols of ostentatious designer labels or the aggressive proposals of trendy stylists. As Giorgio Guidotti explained, "She is a woman who does not want the clothes she buys to compromise the essence of her personality", because "she has a strong and elegant character but which is never excessive".89

Indeed she was a type of woman who loved to be served in modern and elegant stores, informed by refined and considered advertising, but who would not have liked the intrusive and strident bargains which in those years were embraced by a younger or more influenced target. The Max Mara client continued to not be an eccentric woman and therefore did not look for "hippy style things one year and Egyptian princess looks the next", instead "a fashion destined to last".

As Guidotti said, "our models for women, such as

the cashmere jumper, the classic camel coat and flannel trousers, are destined to last more than a season". Not by chance fashion tabloids recognised that the Max Mara 2000-2001 Autumn/Winter collection was among the most sellable of the season"90 and the following year awarded Max Mara the title of "Company of the Year".91 To crown this moment of fortune, in 2003 the company moved to the new site in Mancasale. The hypermodern campus, designed by a team of architects madeup of John McAslan and Peter Walker, winners of the international tender launched by Max Mara in 1995, included three groups of buildings (management, style and prototype, showroom, warehouses and canteen) located in the middle of a 30 hectare green space surrounded by avenues of poplars and canal systems in complete harmony with the traditional Emilian landscape.

- 67 Sportmax, F/W 1983-1984 collection, *Vogue Italia*, July-August 1983
- 68 Guy Paulin, catwalk sketch for the Sportmax F/W 1982-1983 collection

LA È BELLA

DONNA

È SOFISTICATA

IN

È ELEGANTE

TAILLEUR

È SENZA TEMPO

MaxMara

LA

IL CLASSICO CASHMERE DI MAX MARA

SICUREZZA

È MORBIDO, CALDO, PREZIOSO

DEL

È NATURALMENTE ELECANTE

CASHMERE

È PER SEMPRE

MaxMara

68

70-71 Max Mara, advertising for F/W 1988-1989 collection, Sette, weekly issue of Corriere della Sera, 10 September 1988 72-73 Max Mara, advertising for F/W 1988-1989 collection, Sette, weekly issue of Corriere della Sera, 8 October 1988

MAX MARA

Times of Change

The first ten years of the new millennium, conversely, shook the world with traumatic events that would deeply change cultural models, international relationships and ways of living.

The first was the terrorist attack on the United States of 11 September 2001, followed shortly after by the war in Afghanistan and a year and a half later by the one against Irag.

The second was the financial crisis which hit in America in 2007 and rapidly spread across the world involving the entire capitalist system.

If the image of two small planes crashing into the Twin Towers made the world's most powerful nation aware of its weaknesses, whilst also generating a common feeling of mourning and unrest, the spread of the crisis brought with it substantial changes to the ways of life of entire social groups and communities. In addition to all of this, when China and India began to undermine American supremacy, this caused a sort of overturning of the land-scape for the nations which led the world's economic development.

All of this, as was expected, had immediate effects on the fashion industry, imposing a rethinking of its image and its communication (as Giusi Ferré wrote, "luxury and image, words which were very much liked, today fashion reluctantly speaks, with the awkwardness of one who needs to redefine its terms. Boasting luxury, even for the 74 Robert Erdmann for Sportmax, F/W 1991-1992

masses, seems inopportune and inventing a visual identity which is evocative but which does not disturb sensitivity and shake modesty, is a difficult task which cannot be resolved with the standard photos of tigers on a leash or buildings waited on by servants to represent wild beauty and richness"⁹²), but principally reducing their use or rather redirecting them.

A new commercial model represented by chains such as Zara, Gap and H&M which offer clothing at low prices, revamped at a rate which no longer respects the traditional seasonal deadlines, have enjoyed incredible success worldwide. The consumption of fashion became less arduous and more closely linked to the point of sale: the dress on display could be bought fairly easily because of its affordable price, as well as immediately because in a few weeks it would have disappeared to be replaced by another. Visiting stores became a sort of compulsory engagement in order to discover the novelties and play with one's wardrobe, to create a personal style but also for the simple pleasure of changing.

At the same time the luxury designer labels were

concentrating more and more on accessories, launching fresh ideas every season but in particular offering more classic lines; those which gave the public the impression of a lasting purchase and the certainty of owning a universally recognised status symbol. This type of consumption had no need for advertising messages focused on the product but instead a very strong brand identity and stores.

To all of this was added the importance that new markets such as Russia and China assumed for western fashion. If Russian women were the protagonists of the first years of the new century, they were quickly overtaken by the Chinese who were not looking for eccentric or alternative fashion but who were instead fascinated by the perfect elegance of Parisian haute couture of the 50s or by the grace of the most classic *mises*. "The profile of a new consumer class is being defined; the new generation of only-children, brought-up during the economic boom with a greater level of culture and availability of income, with a marked sense of style and always on the look-out for sophisticated, quality products".93

The same phenomenon of taste also concerns those from the West. According to Laura Lusuardi the return of new chic, primarily concerns the youngsters: "They opened their mother's wardrobe and began to wear their classic garments in their own way".94

Yet again the Max Mara strategy proved fitting.

Their advertising had never promised to shock the public; on the contrary, as Maramotti declared, it had always represented "our know-how, balancing the sense of novelty with a strong link to its original values". On the other hand the network of single-brands continued to give positive signals, "for example, the fact that consumption did not considerably decline, means that in this complicated moment our way of producing and communicating is liked".95

Confronting the "contemplative phase" of "all the consumer markets for fashion products" (except China), does not mean having to change strategic models but instead, redefining and reinforcing those adopted until now. At the beginning of 2002 Luigi Maramotti had declared: "There will be relapses from the shock of

September 11th in the sector, but not in our case. In short-term situations such as this, the solution is to double the efforts to increase investments". 97

The objective to accomplish was to create a more direct relationship with the varied world of female consumers. First and foremost we concentrated on the stores which, in the new framework of the international fashion system, were assuming a fundamental role, both as instruments of image and as methods for communication with the public. In 2001 the Max Mara Group could count on approximately 1,250 points of sale spread across the world, rationally divided across the various brands. The first objective was to increase their number (in 2004 there were already 1,827 and in 2010 they would become 2,360, spread over 90 countries) but also to convert some of those strategically placed into flagship stores.

The new philosophy was "to consider the store not only as a point of sale, but also as an ideal location to meet the clientele: layout, furnishings and also staff training, services, mailing and catalogues, everything is tailored to maintain this connection".98 The point of sale should have

- 75 Steven Meisel for Max Mara, F/W 2002-2003
- 76 Max Mara, F/W 2005-2006 collection, coat in white Shetland wool; this model has been worn by Sophia Loren, Isabel Allende, Nawal el-Moutawakel, Susan Sarandon, Wangari Maathai, Manuela Di Centa, Maria Mutola and Somaly Mam, when they carried the Olympic flag at the opening ceremony of the 2006 Winter Olympics in Turin.
- 77 Max Maxa, F/W 2005-2006 collection
 - "Couture. Atelier cut and details for this enveloping bulky coat in houndstooth double wool and alpaca, with striking scarf collar that reveals the luxurious camel colour inside. Coordinated with skirt in the same fabric. Plain black wool and cashmere polo-neck, low boots with platforms, black kid gloves complete the outfit." MM magazine, Fall-Winter 2005–2006

become a "functional epicentre for the display of products and collections through innovative and technological exhibition concepts, which carry away the public through experiences of product use and understanding".

In New York a new Max Mara store (which in 2006 became Sportmax) opened at 450 West Broadway "in the space left available by a car park", with interiors and facades designed so that it could become an "original yet consistent" part of the area. On 1000 In 2004 the new Max Mara store in Florence's via Tornabuoni was inaugurated; the clothes were piled between the shelves of an old bookcase and the 16th-century frescos by Agostino Ciampelli. In 2008 an innovative Sportmax boutique landed in Moscow's Red Square, inside the GUM warehouse and the same year Bologna experimented with the Weekend Store concept.

The new Max Mara image was fully achieved in the restructuring of Milan's "historic" store, which had been inaugurated in Corso Vittorio Emanuele in 1967 and which was reopened to the public in 2009 after a radical refurbishment entrusted to Duccio Maria Grassi, the architect from Reggio Emilia who had created the Group's most important points of sale. The 1,400 square metres on four floors were designed "as a box which communicates with the outside world". Spaces and areas, dressed with aged Ipè wood and furnished with natural materials, were organised to welcome guests and guide them through different thematic routes, so that shopping could become a "multi-sensorial experience, set in a surprising and recreational space". ¹⁰¹

The same year the Max Mara store in Shanghai was opened and in 2010 everyone was invited to celebrate the reopening of the boutique in Paris's Avenue Montaigne, enlarged and refurbished according to the new concept.

On occasion of the inauguration of the flagship store in Athens in 2010, Laura Lusuardi explained: "identity is a crucial aspect which we keep in high consideration. It is very important that the consumer can shop in a store with an atmosphere and which can transmit the founding values of the brand. Athens' new flagship store follows exactly the same concept as those of Paris and Milan. They have been designed to put you at ease, with a large emphasis on the theme of nature which is the essence of the project; organic materials of pure and soft lines create a visibly organised space, offering a great richness of dynamic contrasts".

The second part of the project concerns the product. Even in this case, no creative or stylistic revolutions was necessary. "I believe – observed Maramotti – that in the souls of the consumers there exists a counterbalance to the desire for constant change, typical of fashion, which is strongly tied to the founding values of the product.

The product we offer to the market has values which stand the test of time". 102

The fashion proposed by the Max Mara brand varied form collection to collection, however it still maintained its distinctive character ("tailored, quality and consistent rigour"). In Spring/Summer 2005 there was a revival of the 70s, in Autumn 2006 a more masculine style was proposed and in Winter 2008 there were the shoulders of the 40s ("square, structured and rounded, gathered with drawstrings, highlighted with small puffs"103) and the military style of 2010; even tracksuits made it to the catwalk, reinvented and rethought, neoprene, seguin embroidered on heavy woollen cloths or evening dresses with cloaks for those "true queen of noir" 104 looks. Constant propositions were the "perfect suits and pure, camel or cashmere coats", 105 at times tightened at the waist or embellished with collars, hems and fur trims, consistent with the metropolitan style, casual but elegant, which had always represented the identity of the world's most famous readyto-wear brands". 106

Certain variations of the philosophy were instead endorsed by other lines to draw them nearer to consumer tastes. Sportmax, for example, though maintaining its more fashionable character which had always distinguished it, lost the characteristics which had aimed it at a principally junior public. Consequently Sportmax Code, born in 1999, was characterised by a youthful-casual style composed of lots of essential and comfortable pieces to mix and match.

The new functionality of the stores, nonetheless, also imposed other choices.

The first being speeding up the timings. The six months which for decades had represented fashion seasons were too long; a system of pre-collections was therefore adopted offering closer dates to the public.

Above all it required the reconsideration of the galaxy of clients trying to pinpoint more specific targets, particular needs and new consumer styles to reach out to with untraditional products and methods. "The universe of female consumers is very complex and the possibility to follow it step-by-step is a fundamental and essential advantage"."

The novelties had to rise in true consistence with the rest; "starting from a concrete principle based on brand values – as Maramotti said – we do this without haste, devising long-lasting plans". 108

We began with the most traditional fashion brand extension: perfume, which was launched in 2004, 109 but also a rethinking of the accessories division, which in those years was at the centre of fashion's attention. Announced by Luigi Maramotti the same year, the work carried out alongside a "network of specialised compa-

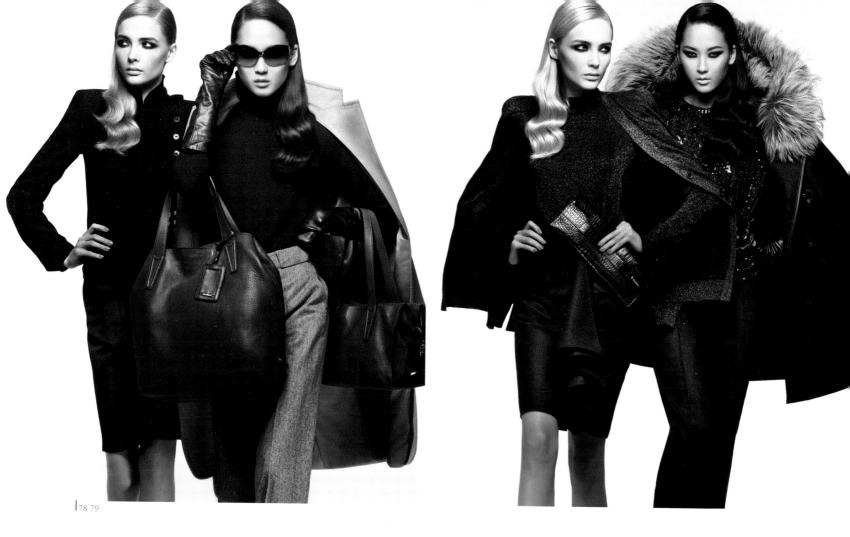

78-79 Craig McDean for Max Mara, F/W 2008-2009

nies-small firms which already collaborate with us" led to the creation of "iconic bags", that is particular models identified by a name such as the Dominique bag of Autumn 2008, Margaux of Autumn 2010, Olimpia of Spring 2011 and to which a large role was dedicated in the advertising campaigns of the outgoing seasons.

The other enlargement project also included other propositions which, although newer, had a more direct relationship with the clothing industry vocation of the Max Mara Group. It was in this way that collections of products began to be experimented with, not presented on the normal fashion catwalks but directly to the clients in select and strategic boutiques.

In January 2007 "Vogue Sposa" announced that a "small, ready-to-wear bridal collection" would be available from March "in all privately owned Max Mara stores throughout Italy" and in "the most important franchises in Italy and abroad (France, England, Germany and Greece)".

In a long interview, "Chiara Cassano, director for the Bridal Product, explained the reasons which had led them to move into this sector and the choices which had been made.

Firstly there had been the discovery that many clients would ask for the light-colour version of the evening

dresses to go to the altar. It was a clear signal to be interpreted in two ways: on the one hand, in a sector which seemed to found its success on the durability of its tailoring methods and timings as well as on the hand-crafting methods, there was space for ready-to-wear dresses; on the other hand the trust in the brand was such that clients, ever since they were young girls, were happy to hand it such a special and symbolic task. Even in this sector consumption habits were changing; "girls today no longer start looking for their dress the year before. Buying the dress ahead of the date could leave them time to change their minds. The physique, the mood and tastes in style can quickly change". Max Mara captured this desire to speed up the preparations proposing a small collection of ready-to-wear models, complete with all the necessary accessories (shoes, hair accessories, flowers, gloves, jewellery, etc.) continually mixed and matched, even on request, and with absolutely competitive value for money ("Before, to spend a lot was a sign of status. Today, spending little is a sign of status"). The project, which began as an experiment, was launched in the spring of 2007 with a collection of 22 models (which increased in number in the following seasons) available to young brides in 50 points of sale equipped with spaces and staff suitable for this type of service. The Milan store also repre-

81-82 Dusan Reljin for Sportmax, F/W 2008-2009

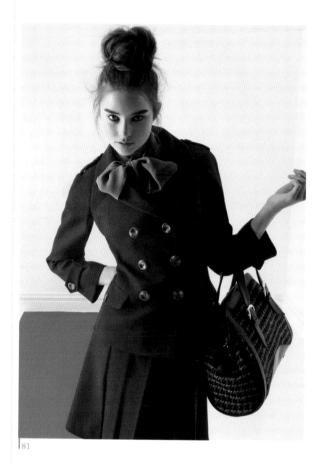

sented a turning point in this sector: a luminous area, facing a garden terrace, in some way isolated from the other visitors was dedicated to the bride; perhaps the most beautiful spot of the entire store.

In 2008 it was the turn of a new project: an item of clothing which complemented the range already offered by the Group, but with particular characteristics: the down jacket. For a long time winter wardrobes had seen the entry of this item of stuffed synthetic fabric which had lost its sporty characteristic becoming an item of city-wear, at times even elegant. In certain countries its success had even surpassed that of the traditional fabric jacket or winter coat.

The collection 'S Max Mara *Design for easy living* as though it were an object of design, studied from a technological and stylistic point of view. The guiding principle was to propose an iconic item, on a par with the camel coat, which was not subjected to the accelerated rhythms of the most fleeting trends and which was characterised more by its performance (adaptability, practicality, lightness, warmness, reversibility, transformability¹¹²) than by its fashionable aspect.

In fact every collection included few models, packaged in an innovative and patented synthetic fabric, exclusively produced and stuffed with Siberian goose

feathers ("considered the cashmere of goose feathers"), but also with waistcoats and accessories such as hoods and cloaks or fur and/or embroidered collars and cuffs, designed so that they could be added to the base item at will.

The desire to highlight the design content of this project was brought to life in the packaging of the puffa jacket, sold to the public in a small bag made of the same material, perfectly cubed in shape and from which the name of the line was derived.

Although conceived within the 'S Max Mara brand, born in 1999 with the intent of creating sophisticated but informal collections using new techniques and materials, the Cube project was announced with specific advertising campaigns entrusted to Max Farago who, using architectural backgrounds to create unedited geometric perspectives, was able to emphasise the essentiality and minimalism of the models.

In 2009 through the "Atelier" project, Max Mara experimented with a completely different type of consumer and sector, which was presented to the press and the public on occasion of the inauguration of the Milan boutique. This time the object of desire was the coat, proposed in an unedited, tailored and precious interpretation and above all in limited edition. There were fifteen

models manufactured in luxurious materials such as double cashmere, pure camel hair, alpaca, bouclé tweed, duchess silk and wool satin, characterised by refined details and finishes such as embroidery, the use of rare linings but above all by a sophisticated line which recalled the golden era of Parisian haute couture. It was a niche and very exclusive product available in only 50 stores worldwide, "devised – as Laura Lusuardi declared – to attract a different clientele into our boutiques", "4 more expert and privileged, searching for trendy yet unusual and costumised products.

The twelve "fancy coats" of the second collection, presented to the public at Paris's Avenue Montaigne boutique in March 2010, had a different mood. The fabrics were still luxurious, enriched with wild furs trims, but the models, with the most fluid lines, showed greater variety, "for the different souls which make up the same woman or women of different generations able to share the same style".

The 2010-11 Autumn/Winter edition will be dedicated to the innovation of the coat, proposing items such as the "little black coat" or the "suit coat".

In 2010 the project, seeking an ever more personalised relationship with the store's clientele, addressed yet another component of the public, the younger type more attentive to fashion. For girls who frequented the Max & Co boutique the company proposed a revival or rather the origins of their "spiritual heritage" in the youthful fashion.

Following the example of other designer labels, Max Mara searched its most distant past for those iconic models which had been the root of its success, but also of the growth of its identity. Any doubt that Reggio Emiliabased company could enter into fashion history was destroyed by Achille Maramotti's decision to create a line dedicated to young women and to entrust its design to the designers. Two-piece sets with short skirts, small coloured coats, 60s jackets from the Pop line were the true cultural origins of the present.

After more than 40 years, ten models of those collections were re-proposed in expressly selected Max&Co boutiques with the label PopCouture. Responsible for this idea is perhaps the extraordinary archive which the company has been organising for years, with a precision enviable to even the most austere professionals of the field; Laura Lusuardi confessed in an interview: "Our young stylists consulted the Pop Max Mara archive from 1965 to 1968 and straightaway came to me saying that the pieces were still current."

The presentation of the models was organised in the stores themselves with special events announced via press releases published on the company website, inviting all young female clients.

83 Mario Sorrenti for Max Mara, F/W 2011-2012

Perhaps it was the age of the target or the fact that the internet is now "the" communication instrument of our time, but the method chosen to divulge the initiative was extremely successful as testify the tens of photos of girls who packed the various stores trying on the items displayed which can be viewed on the web along with a series of commentary blogs.

The alternative fashion of girls of the 60s, who saw themselves as international because they listened to the Beatles, was about to dress those of the new millennium, who chatted among themselves from opposite sides of the world. The web however was not only a method of communication: it was becoming a commercial tool worthy of attention. It was a challenge Max Mara confronted with originality using e-commerce not only to

sell its collections but also to develop the special project Max Mara 101801 Icon Coat.

In 2010 a unique coat was put on sale on-line; the legendary 101801 which had once again gained the company the title of "Best Fashion House", 115 but this time in limited and personalised edition with a label which could be embroidered on request with the name of the client.

In this way the most traditional Max Mara product once again crossed the umpteenth threshold of modernity. But if the coats and jackets constituted the red thread of the long history of the Reggio Emilia-based company, for a long time, in the minds of its clientele, this brand guaranteed quality throughout the whole range of clothing which makes up a woman's wardrobe. From the coloured pop outfits of the 60s, to the innovative casual of the 70s, to the richness of the range of the 80s, including the formal suit but also the evening dress and everything which constituted ideal recreational attire; not to mention the cashmere coats, the refined knitwear, the designer wear and the accessories representing contemporary chic, alongside more youthful and less demanding products, the range of proposals has grown with time.

Little by little the project envisaged by Achille Maramotti in the immediate post-war period has become a reality, dressing both Italian women and those from around the world.

First of all, I would like to thank Luigi Maramotti, Laura Lusuardi and Antonia Montanini for the valuable information and the time they have dedicated to me, Federica Fornaciari with the staff of the company library and archive (Biblioteca Archivio d'Impresa Max Mara), and Diego Camparini for all the help they have given to me.

I am especially grateful to Adelheid Rasche for her trust and collaboration, and to Elena Strada, who has given me access to her university thesis and her rich array of illustrations.

As always, I am grateful to Margherita Rosina and Marialuisa Rizzini.

- ¹ N. White, "Max Mara and the origins of Italian ready-to-wear" in *Modern Italy. Journal of the Association for the Study of Modern Italy*, vol. I, n. 2, 1996, p. 66.
- ² *Ibid.*, p. 70.
- ³ M. Crotti, "La signora Crotti racconta...", in L. Lusuardi (edited by), *Max Mara*, unpublished typescript, 7 June 2002, p. 3. The typescript, transcribed by Francesca Veroni, collects various oral testimonies of the first collaborators of the Max Mara.
- 4 Ibid., p. 4.
- ⁵ A. Ciarlini, "Ciarlini racconta...", in L. Lusuardi (edited by), *Max Mara*, unpublished typescript, 2002.
- ⁶ The castle at Albinea thus played a significant role in the Max Mara image from the very beginning. Achille Maramotti purchased it in 1962 not only as his private residence, but also to house his art collection.
- ⁷ Cf. I. Paris, Associazione Italiana Industriali dell'Abbigliamento. L'autonomia del settore industriale da quello artigianale e i primi tentativi per un controllo istituzionale della moda, DSS PAPERS STO 01-05, University of Brescia, Department of Social Studies, Brescia 2005.

- ⁸ E. Strada, *Max Mara: la storia e lo stile negli anni '50 e '60*, degree thesis, IULM University, Milan, academic year 2004–2005, p. 61.
- 9 M. Crotti, op. cit., p. 5.
- On this subject, see V. Zamagni, "Betting on the Future. The Reconstruction of Italian Industry, 1946-1952" in J. Becker and F. Knipping, *Power in Europe? Great Britain, France, Italy and Germany in a Postwar World, 1945-1950*, Walter de Gruyter, Berlin-New York 1986, pp. 283-300; V. Zamagni, "American Influence on the Italian Economy (1948-58)" in C. Duggan and C. Wagstaff, *Italy in the Cold War. Politics, Culture and Society 1948-58*, Berg, Oxford-Washington D.C. 1995, pp. 77-87; *Studi Storici*, n. 1, January-March 1996 ("Italia, Europa, America. L'integrazione internazionale dell'economia italiana [1945-1963]); N. White, *Reconstructing Italian Fashion. America and the Development of the Italian Fashion Industry*, Berg, Oxford 2000.
- "The relationship between Maramotti and Evan-Picone also generated important results in the decades that followed. In 1977 Luigi, one of Maramotti's sons, tested American selling techniques by working as a salesman for Evan-Picone. (A. Grassi, "Progetto Franchising", *Gap Italia*, December 1984). In 1987 Joseph Picone, who had retired from his company in 1983, became "chairman of Max Mara USA, Inc. the new U.S. subsidiary of the Max Mara Group". ("Joseph Picone leaves retirement to unveil Max Mara to US retailers", *Women's Wear Daily*, 20 January 1987).
- ¹² E. Strada, *op. cit.*, p. 26. On this subject, see also G.L. Basini and G. Lugli (edited by), *L'affermazione dell'industria. Reggio Emilia, 1940–1973*, Laterza, Roma–Bari 1999.
- ¹³ For example, see M. Clerici, "Cavaliere della moda", *Amica*, 11 September 1984; E. Magri, "Faccio il cattivo per essere alla moda", *L'Europeo*, 15 September 1984; M. Oriani, "La guerra del cavalier Achille", *IF*. October 1984.
- 14 N. White, op. cit., p. 69.
- 15 The collections of the volumes of these magazines, which Achille Maramotti had bound, are now part of the book collection at the Max Mara Library.
- 16 N. White, op. cit., p. 69.
- ¹⁷ I. Paris, op. cit., p. 30.
- ¹⁸ "I grandi nomi della confezione italiana: Max Mara", *L'Abbigliamento Italiano*, July 1960.
- 19 N. White, op. cit., p. 69.
- The outfit, composed of an overcoat and hat, is part of the collection at the John F. Kennedy Library and Museum, and was displayed at the exhibition "Jacqueline Kennedy: The White House Years" held at the Metropolitan Museum of Art in New York and at the Musée de la Mode et du Textile in Paris. Cf. H. Bowle (edited by), Jacqueline Kennedy: The White House Years. Selections from the John F. Kennedy Library and Museum, Bulfinch Press, Boston 2001; H. Bowle (edited by), Jacqueline Kennedy: les années Maison-Blanche. Selections de la John F. Kennedy Library and Museum, Flammarion, Paris 2002, p. 150.
- ²¹ Cf. D. Grumbach, *Histoires de la mode*, Seuil, Paris 1993, p. 147 ff.
- ²² Max Mara presenta la sua collezione POP inverno 65/66 creata da Lison Bonfils, 1965, Biblioteca Archivio d'Impresa Max Mara.
- ²³ This decision meant that the company had to conduct new research into sizes. Here as well, Max Mara was at the cutting edge, particularly if we consider the fact that an anthropometric study of very young women was not conducted by GFT until 1971. Cf. Ivan Paris, *Oggetti cuciti. L'abbigliamento pronto in Italia dal primo dopoguerra agli anni Settanta*, Franco Angeli, Milano 2006, p. 386.
- ²⁴ "Il nostro inverno", report by A. Piaggi and A. Riva, *Arianna*, October
- ²⁵ The black-and-white pictures from the entire photo spread on Pop line are part of the Archivio d'Impresa Max Mara.
- ²⁸ It is significant to note that four of the designers included in this list (Emmanuelle Khanh, Graziella Fontana, Jacques Delahaye and Karl Lagerfeld) worked for Max Mara within the span of just a few years.

- ²⁷ Management of the stores was centralised in Maxima, a company that was part of the group.
- ²⁸ "Moda e produzione/risponde Achille Maramotti. Informarsi per saper scegliere", *Giornale Tessile*, 13–19 May 1971.
- ²⁹ C. Verdelli, "Laura Lusuardi. Una caparbia ragazza nel grande mondo della moda" in *Donna Più*, December 1984, pp. 122–26.
- 30 Collezione Sportmax per l'autunno 1969, advertising brochure, 1969, Biblioteca Archivio d'Impresa Max Mara.
- 31 I. Paris, op. cit. (2006), pp. 475-480.
- 32 I. Paris, op. cit. (2005), p. 45.
- ³³ The German market posed a problem for Max Mara. In 1990 Achille Maramotti observed, "The German market is the one that has given us the least satisfaction so far. I acknowledge the fact that it is Europe's most important market and I have asked myself why despite 18 years of continuous approaches we have not managed to establish a significant relation. One of the reasons may lie in the fact that, since my Group is distinguished by a product with a substantial fashion content and this fashion is specifically Latin in origin, the taste of my collections does not coincide with that of German distributors." "Le interviste parallele/Achille Maramotti. Una evoluzione totale", *Fashion*, 8 January 1990. Since 2000, this trend has increased positively, and the German market has achieved extraordinary results for Max Mara distribution.
- ³⁴ Exports to France gradually grew increasingly successful, culminating with the extraordinary results of the Eighties. In some way, it must have symbolised the coronation of Achille Maramotti's plans and of the dialogue on equal footing that he established with French fashion.

The opening of the shop in Avenue Montaigne, a legendary location for the history of *haute couture*, was essentially emblematic of the results that had been achieved.

- ³⁵ M. dell'Aquila, "Tu compri un vestito, però non sai...", *Arianna*, October 1971.
- ³⁶ N. Strada, *Moda design*, Editoriale Modo, Milano 1998, pp. 20-23.
- ³⁷ M. dell'Aquila, op. cit., November 1971.
- ³⁸ "Il design nella moda. Da nuove tecniche industriali nasce un diverso modo di vestire", *Vogue Italia*, November 1971.
- 39 T. Trini, "Abitare l'abito", Domus, May 1972.
- ⁴⁰ "Primavera-Estate 1972/ Max Mara. Una svelta eleganza", *Giornale tessile*, 2-8 September 1971.
- ⁴¹ "Una giornata in città", Amica, 24 October 1972.
- ⁴² I. Pergreffi, "Il tessile abbigliamento" in Gian Luigi Basini, Gianpiero Lugli and Luciano Segreto (edited by), *Produrre per il mondo. L'industria reggiana dalla crisi petrolifera alla globalizzazione*, Laterza, Bari 2005, p. 60.
- ⁴³ The Marella, Albinea, Vanity and I Blues labels were created in the early Seventies; the production of Penny Black began at the end of the decade.
- ** Karl Lagerfeld worked as design consultant for Max Mara F/W 1971-1972 and S/S 1972 collections.
- $^{\mbox{\tiny 45}}$ Guy Paulin worked as design consultant for Sportmax F/W 1970–1971, F/W 1973–1974 and S/S 1974 collections.
- ⁴⁶ Nanni Strada worked as design consultant for Sportmax F/W 1970-1971, F/W 1971-1972, and S/S 1972 collections.
- ⁴⁷ Luciano Soprani worked as design consultant for Max Mara S/S 1973, S/S 1974, F/W 1974-1975 and S/S 1977 collections.
- ⁴⁸ T. Matteoni, "Il gruppo Max Mara. I tanti gioielli di una grande famiglia", *Fashion*, 17 April 1986.
- 49 Amica, 7 April 1974.
- "Una proposta attuale della moda pronta. L'abito con la giacca", Amica, 7 April 1974.
- ⁵¹ "Moda. I cappotti di quest'inverno", Amica, 23 October 1975.
- ⁵² Jean Charles de Castelbajac worked as design consultant for the Sportmax S/S 1976, F/W 1976–1977, S/S 1977 and F/W 1977–1978 collections.
- 53 La mode en directe, Centre Pompidou, Paris 1986, p. 48.
- 54 Amica, 2 September 1976.

- 55 "In Giordania col prêt à porter d'autunno", Vogue Italia, September 1977
- 56 "Classici 24 ore per le sportive a oltranza", Vogue Italia, September 1977.
- $^{\rm 57}$ In 1979 turnover increased by 33.8%, production by 14.6% and exports by 37.2%.
- ⁵⁸ The event was promoted by the Associazione Italiana Industriali dell'Abbigliamento and the Associazione Magliecalze.
- ⁵⁹ Jean Mailey, *The Manchu Dragon. Costumes of the Ch'ing Dynasty* 1644–1912, exhibition catalogue, The Metropolitan Museum of Art, New York 1980.
- ⁶⁰ The Imperial Style: Fashions of the Habsburg Era, exhibition catalogue, The Metropolitan Museum of Art, New York 1979.
- ⁶¹ "La vetrina di Max Mara. Cashmere cammello, caldissimo confort," *Donna*, November 1985.
- 62 Cf. "Industria. Ritratti di sei big", Donna, October 1986.
- ⁶³ Cf. "Max Mara e la distribuzione. Franchising un filo diretto", *Fashion*, 7 November 1984; A. Grassi, *op. cit.*
- ⁶⁴ In 1989 the franchise shops were broken down as follows: Max Mara, 103 in Italy and 32 abroad; Marina Rinaldi, 49 in Italy and 5 abroad; Max & Co, 63 in Italy and 2 in Hong Kong. Cf. H.R. (Hélène Raccah), "I negozi del Gruppo", *Gap Italia*, June 1989.
- ⁶⁵ Guy Paulin worked as design consultant for Sportmax S/S 1982, F/W 1982–1983, S/S 1983, F/W 1983–1984, F/W 1984–1985, S/S 1985 and F/W 1985–1986 collections.
- ⁶⁶ Sophie George worked as design consultant for Sportmax S/S 1984, S/S 1985, S/S 1986 and S/S 1987 collections.
- ⁶⁷ Tokuko Maeda worked on all Sportmax collections from F/W 1984-1985 to F/W 1989-1990.
- ⁶⁸ Eric Bremner collaborated as design consultant for Sportmax collection from the F/W 1985-1986.
- ⁶⁹ M. Maggi, "Vestire bene e al giusto prezzo" Gap Italia, July 1986.
- A. Maramotti, "Prêt à porter: sfondare all'estero", Civiltà del lavoro, August-September 1986.
- 71 M. V. Carloni, "In viaggio per il babbo", $\it Panorama, \, 16$ November 1986.
- 72 T. Matteoni, op. cit., 17 April 1986.
- ⁷³ D. M. Pogoda, "Max Mara Takes Madison", Women's Wear Daily, 7 September 1994.
- ⁷⁴ Sette, weekly issue of Corriere della Sera, 10 September 1988.
- ⁷⁵ Sette, weekly issue of Corriere della Sera, 8 October 1988.
- ⁷⁶ Press folder for the F/W 1987-1988 collection.
- ⁷⁷ Joëlle Piganeau, "Max Mara ne cesse de faire des gammes", *Journal du textile*, September 1991.
- 78 "Gruppo Max Mara. Quando l'azienda entra nella scuola", Fashion, 23 April 1986
- ⁷⁹ Cf. lan Griffiths, *The Invisible Man* in Nicola White, lan Griffiths (edited by), *The Fashion Business*, Berg, Oxford New York 2000, pp. 69-90.
- ⁸⁰ Giampietro Baudo, "Mancano progettisti Max Mara se li forma", *Milano Finanza Fashion*, 7 September 2004.
- 81 Joëlle Piganeau, op. cit., September 1991.
- ⁸² Luigi Maramotti, *Connecting Creativity* in Nicola White, Ian Griffiths (edited by), *The Fashion Business*, Berg, Oxford New York 2000, pp. 91-103.
- ⁸³ "Max Mara, l'export cresce", *La Gazzetta di Reggio*, 29 November 2000.
- ⁸⁴ "Max Mara in west Broadway", *Milano Finanza Fashion*, 3 November 1999.
- ⁸⁵ Cristina Mello-Grand, "Max Mara. Conosciamo il nostro mestiere", *Modaonline.it*, 25 October 2004.
- 86 Luigi Maramotti, op. cit., pp. 91-103.
- ⁸⁷ Luigi Maramotti, *Connecting Creativity* in Nicola White, lan Griffiths (edited by), *The Fashion Business*, Berg, Oxford New York 2000, pp. 69-90
- 88 Luigi Maramotti, Connecting Creativity in Nicola White, Ian Griffiths

(edited by), The Fashion Business, Berg, Oxford New York 2000, p. 101.

- 89 Derek Allen, "Max Mara min risk", Yes Please, March 2000.
- 90 "Il nostro referendum", Fashion, 24 March 2000.
- ⁹¹ Milano Finanza Fashion, 6 March 2001.
- ⁹² Giusi Ferré, "L'immagine, che imbarazzo", *Corriere della Sera*, 10 December 2001.
- ⁹³ Maria Silvia Sacchi, "Moda Sorpresa, la Cina salva il made in Italy", *Corriere della Sera*, 19 July 2010.
- ⁹⁴ Maria Teresa Veneziani, "Cambiare stile in dieci mosse", *Corriere della Sera*. 9 October 2010.
- ⁹⁵ Giusi Ferré, "Maramotti (Max Mara): 'Ritorna la famiglia'", *Corriere della Sera*, 10 December 2011.
- ⁹⁶ Paola Bottelli, "Max Mara + 4% i ricavi 2002", *Il Sole 24 ore*, 2 March 2003.
- ⁹⁷ Paola Bottelli, "Max Mara, il 2002 è partito con slancio", Il Sole 24 ore, 3 March 2002.
- ⁹⁸ Chiara Modini, Elisabetta Campana, "Franchising: a ciascuno il suo", *Fashion*, 16 November 2001, p. 19.
- 99 http://www.maxmara.com/it/Store-Concept
- 100 Interview with Duccio Grassi, DDN, May 2003.
- ¹⁰¹ "Max Mara la carta della ricerca", La Repubblica, 23 February 2009.
- ¹⁰² Giusi Ferré, "Maramotti (Max Mara): 'Ritorna la famiglia'", *Corriere della Sera*, 10 December 2001.
- ¹⁰³ Francesca Lucat, "Max Mara riscopre le spalle", *Imore*, 26 February 2008.
- ¹⁰⁴ Laura Asnaghi, "Dolce&Gabbana, Versace: chiffon e seta", *La Repubblica*, 22 February 2008.
- Paola Bulbarelli, "D&G, Ovvero quando il futuro è un revival", Il Giornale, 26 February 2004.

- ¹⁰⁶ Paola Bulbarelli, "D&G, Ovvero quando il futuro è un revival", *Il Giornale*, 26 February 2004.
- ¹⁰⁷ Cristina Mello-Grand, "Max Mara. Conosciamo il nostro mestiere", *Modaonline.it*, 25 October 2004.
- 108 Ibid.
- "We have been developing the project, crafted from the joint venture between Max Mara and Wella, for two years explains Luigi Maramotti", Paola Bulbarelli, "D&G, Ovvero quando il futuro è un revival", *Il Giornale*, Confronting the 26 February 2004.
- ¹¹⁰ Laura Santambrogio, "Spose à porter", Vogue Sposa, January 2007.
- iii Giulia Landini, "La sposa di Max Mara", *Cherie Sposa*, July-August 2007, pp. 116–121.
- ¹¹² On Max Mara website Here is The Cube project was presented as follows: "Experience The Cube, Enjoy The Evolution. A new icon. Beauty and functionality. Soft and light materials. Refined design. Reversible. Adaptable. Everlasting. Sporty. Elegant. A multi-functional puffa jacket, personalised with various accessories. Constant transformations. Invent it. Remodel it. Rethink it. Make it yours."
- 113 "Max Mara la carta della ricerca", La Repubblica, 23 February 2009.
- ¹¹⁴ "Face to Face. Laura Lusuardi Max Mara", Showdetails, Spring 2010.
- ¹¹⁵ The acknowledgement, delivered by Marie Claire Prix De La Mode at Amsterdam's Concertgebouw on 11 November 2010, was motivated by the following: "This is the winter of the camel-coloured coat and as such the winter of Max Mara, symbol of elegance, famous for its everlasting camel-coloured coats, such as for example the 101801, icon and object of the desires of many women since the 80s. With its suits, elegant tops, cocktail dresses and tweed coats, Max Mara provides the basics for every woman's wardrobe".

A Brief History of the Coat

Christine Waidenschlager

"Then Martin drew out his sword and carved his mantle therewith in two pieces in the middle, and gave that one half to the poor man, for he had nothing else to give to him, and he clad himself with that other half." Jacobus de Voragine, The Golden Legend

The German word *Mantel*, which means coat, comes from the Latin *mantellum*, signifying "veil" or "mantle", indicating this garment's essential function. The coat, in fact, is an outer garment that envelops the body and protects it from the wind, rain and cold. For many centuries, woollen fabrics were ideally used in its manufacture. Only in more recent times, with the invention of new fibres – micro fibres and chemical fibres – have more modern, technological, multifunctional materials been employed. Prior to the Eighteenth century, an ample cape that covered the whole body was worn, while

the shape of today's coats resembles that of a long jacket: a sleeved garment that follows the line of the body and can be completely buttoned in the front. The coat first became fashionable during the Renaissance, with the *zimarra* (simar) in Italy, a draped coat-dress that was still ankle-length in the Fourteenth century and became shorter and fuller during the fifteenth. Lined, and often trimmed, with fur, it made the cloaks that had been worn till then redundant. The more distinguished Italian ladies wore a *zimarra* with a train. In fifteenth-century Spain an outer garment similar to a cloak, known as a *zamarro*, was worn, which was fastened in the front and lined with a thin layer of fur.

In Germany, at the end of the Fifteenth century, the open outer garment became fashionable, later becoming the characteristic attire of the Reformation period. It took the form of a voluminous knee-length coat, open

in the front, with puff sleeves that revealed those of the garment beneath. This coat often had wide lapels that covered the shoulders, and one of its distinctive features was the yoke onto which the fabric was stitched in wide pleats. In winter, the inside, cuffs and hem were lined with fur. The female version was ankle-length, with a collar and short sleeves or sleeveless. To attend Mass, however, the women still had to wear, as they had previously, a cloak known as *Hoike*.

The modern coat came into being in the Eighteenth century, with the redingote. Inspired by the riding coat worn by English gentry, from which its name derives, it first appeared in France in 1728. This was a completely new type of coat in that it was slightly shaped, smooth-fitting and calf-length. It had double collar and was double-breasted, usually with two rows of buttons down the front. It was manufactured from woollen fabrics and worn over another garment or justaucorps (jerkin). A fitted coat for women, designed according to this model and known by the same name, redingote, was introduced by the fashion world in 1785. Like the male version, it had two rows of buttons, but also wide set-in sleeves and an ample neckline edged with a collar that was often double. Unlike its male equivalent, the woman's redingote was not worn over other apparel, but combined with a skirt.

In eighteenth-century female fashion, the coat consisted of the so-called pelisse (fur), a medium-length cape with a hood and slits for the arms. After 1800 the redingote and the pelisse were combined in a new outer garment, which was completely buttoned and also known as a pelisse. Its slender line was inspired by the Empire style, but when Biedermeier became all the rage. with its over-large puff sleeves, the pelisse was necessarily cast aside. It was replaced by shawls and scarves, which were first square and then triangular, and later by various types of manteaux, such as the pèlerine (cloak), capes and fichus. A further stage in the evolution of the coat was represented by the rotonde (fur cape). This full cape fell from the shoulders in ample folds. Like the pèlerine, it was open at the side to accommodate the puff sleeves then in fashion. This garment was one of the first to be mass-produced, and it was the key to the success of Berlin ready-to-wear; when it was launched - which was not until after 1850 - the word "ready-towear" referred only to coat production.

The crinoline fashion, with its hooped skirts and charming combinations, featured many types of coat, generally known as the *sortie*. And since they were created on the lines of the cloak, this produced mantelets and short cloaks that were very close fitting. Thus the women who wore them could hardly move their upper

- Lined leather coat worn by a seamstresses from Slesia; coloured woodcut, Hans Weigel, Trachtenbuch, Nuremberg 1577
- 2 Schamlot coat worn by a noblewoman from Augusta; coloured woodcut, Hans Weigel Trachtenbuch, Nuremberg 1577
- 3 Antonio del Pollaiuolo, David with the Head of Goliath, c. 1470, Gëmaldegalerie, Staatliche Museen zu Berlin, Berlin

arms. Greater freedom of movement came with the burnous, a long cloak that could be worn at any time of day, and fast became the most popular outerwear of the period. Cut to a semicircular pattern, like the Arab model it was based on, it was open at the front and sleeveless. The attached hood was edged with tassels and trimmed. It went out of fashion around 1865, when the so-called "square capes" came in. The cut of the sleeves intersected with that of the back, allowing the wearer very little room to move.

It was only towards the end of the Seventies of XIX century, when garments again became more streamlined, that female fashion adopted the *paletot* (coat) which since 1830 had been the male coat par excellence. Thus, this mid-length outer garment, without a seamed waist and with wide collar and lapels, became an article of clothing for both sexes, until today. The *paletot* strongly influenced the evolution of the female coat, since it resolved the problem of freedom of movement while symbolising the gradual emancipation of women that had resulted in their acquiring a new social position.

Very soon all the other outer garments such as jackets, fur capes and furs disappeared. Consequently, fabrics changed. Cashmere and grosgrain, a hardwearing woollen cloth, took the place of satin and velvet. Nonetheless, the upper part of the coat continued to be embellished with trimming, lace and gathering, this being the only concession to women. After 1890, and the return of the puff sleeve, the fitted *redingote* replaced the square coat.

At the beginning of the Twentieth century, the design of women's coats began to vary increasingly according to needs and functions: this gave us the walking, travelling and motoring coat, which was either a canvas paletot or a dust coat. The short day coats – worn over skirts that were still long – became more impersonal, which could also be seen in the textiles: robust modern woollen materials such as Cheviot, worsted, twill and knotted fabrics were now considered. Evening coats, on the other hand, continued to be floor length, usually had a train and were made with luxury fabrics and often elaborately styled.

In the Twenties, coats were the same length as the garments worn beneath. The coat became more fitted, the design simple and functional, usually double-breasted and with accentuated lapels or shawl collar. The Thirties saw longer coats and shaped models coming back into fashion. While during the Second World War the female coat was made of raw wool, often of two different kinds. It was fairly full, with shoulder pads that added breadth to the top and gave it a masculine look. An open pleat at the back facilitated movement.

In the Fifties, the woman's coat was no longer shaped and went back to being straight cut. It had wide sleeves with low armholes, was initially knee-length and then a little shorter. With his New Look, Christian Dior (1905-1957) introduced a fitted coat with a full undulating skirt, which was also called *redingote*. In 1952, he deferred to the *ligne sinueuse* by introducing a half-belt at the waist. In 1957, coats became particularly voluminous, as dictated by the *ligne libre*. Until the early Sixties, these two lines were combined in the creations of Cristóbal Balenciaga (1895–1972): straight-cut coats with raglan sleeves. His brilliant solutions deriving from an impeccable cut gave women complete freedom of movement.

The duffle coat and reversible gabardine coat fulfilled sporting needs, while the miniskirt fashion brought with it the knee-length *redingote* with wide cuffs and lapels – pointed or rounded – as well as the double-breasted coat with an unbroken line similar to that of the *princess*, and fairly thick hems.

In 1966, the film *Doctor Zhivago* was such a hit that it inspired the widespread romantic fashion of the calflength coat, followed by that of the voluminous cloak. From 1976, the penchant for a layered look and the rediscovery of folklore brought back capes, plaid shawls and ponchos. Around 1980 cloaks became fairly large, full and open, with raglan or batwing sleeves inserted

Pattum pl. del.

Femme de qualité relevée de couche depuis peu le promenant à theure de midi pour prendre l'air : le premier fruit l'un heure ux hymen sait toute son occupation, et en augure un bonheur durable : elle est en grande pelssée d'un loubée et garnire de mattre à deux rangs, sa tête est enveloppée d'une Therese de tastetas uni.

A thrès cheu l'ssauss et Rapilly sus est la aques du tille de Contances. Avec Prix. du liui.

ILLUSTRIRTE FRAUEN-ZEITUNG.

Anzug mit langem Mantel. Zu dem modefarbenen Tuch des im Rücken anschliessenden, vorn in

ganzer Länge geöffneten Mantels bildet die schwarze Tressen-Garnitur einen wirkungsvollen Contrast. Weisse Bezogupeile: S. Rosenthal, W. Jägenstrasse 38.

eölineten Mantels bildet die schwarze einen wirkungsvollen Contrast. Weisse Sammetfutter und Federschunuck. Rother Regenschirm. Satin *pelisse*, lined with sable, 1785, *Gallerie des Modes et Costumes Français*, Paris 1778–1787

5 Berlin winter model with braided hem, coloured woodcut, *Illustrierte Frauen-Zeitung*, Berlin 1887

Parisian evening coat, coloured lithograph, *Le Moniteur de la Mode*, Paris 1901

Parisian evening coats by Chéruit and Jenny, *Le Style Parisien*, Paris 1916

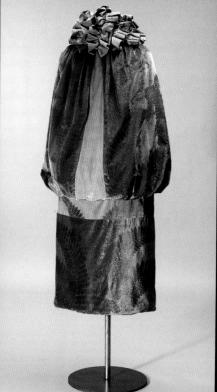

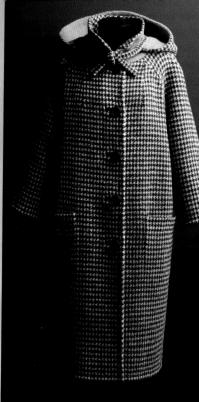

8 9 10 11

almost at waist height, or various types of leg-of-mutton sleeves.

In the winter of 1981 Max Mara launched the coat with the style code 101801 on the international market. At the time, no one imagined it would become a female fashion classic in the space of a few years. Yet that coat with its subtle cut, fashioned from wool and cachemere and as soft to the touch as velvet, hit the nerve centre of fashion in the early Eighties. Its elegant, comfortable lines and oversized kimono sleeves that pleasingly enhance the female form, continue to offer the modern woman a protective mantle as she boldly enters the executive office floor.

This coat has been presented, almost unchanged, in every Max Mara collection ever since. It is the quintes-

sence of the modern female coat whose history began around 1880, when fashion discarded voluminous skirts once and for all, and women began to play an active role in society.

¹ J. de Voragine, *The Golden Legend*, from 'The Life of St. Martin [of Tours]', Volume Six of the English version edited by F. S. Ellis, Temple Classics, 1900

Reference texts

A. Bönsch, Formengeschichte europäischer Kleidung, Böhlau, Wien 2001

F. Hottenroth, *Handbuch der deutschen Tracht*, Weise, Stuttgart, 1896. L. Lion (ed.), *Die Textilbranchen*, Heinrich Killinger, Nordhausen 1922. I. Loschek, *Reclams Mode- und Kostümlexicon*, Reclam, Stuttgart 1994. N. Tarrant, *The Development of Costume*, Routledge, London 1994.

- 8 Pelisse, c. 1822, England, Kunstgewerbemuseum, Staatliche Museen zu Berlin, Berlin
- 9 Christian Dior, New York, black wool overcoat with large round buttons, c. 1950-1951, Max Mara Vintage Coats Collection
- 10 Maria Monaci Gallenga, evening coat, c. 1925, Kunstgewerbemuseum , Staatliche Museen zu Berlin, Berlin
- 11 Cristóbal Balenciaga, reversible coat made from double-face fabric, with detachable hood, early Sixties, Haute Couture, Max Mara Vintage Coats Collection

The Creation of a Cult

Colin McDowell

Clothes do not spring, fully formed, from the air around us. They are born only after a long gestation. They are not invented. Instead, they are the culmination of an evolutionary period which is often complex and never simple. It took much more time, trial and error to create *vitello tonnato* than *spaghetti alle vongole*. A Rolls Royce Silver Cloud was the product of years of engineering, problemsolving and design trial and error. A model T Ford was not.

And that is the difference. A classic looks back as much as it looks forward, as befits an object which has reached perfection only as a result of rejection and acceptance over many years – even centuries. And it is those years which give it the credibility and probity to become not only a classic but also an icon.

Like the word *muse* and, indeed, *classic* itself, the term *icon* is misused and abused in that strange semi-literate patois known as fashion speak, so it is salutary to remind

ourselves of just what an icon is. In its true meaning it simply refers to an image of a figure. But for most of us it is a representation of a sacred personage, to be honoured and worshipped. We are all familiar with the icons which form part of the ritual of the Greek and Russian Orthodox religions. So, to talk of an iconic handbag is, like reference to a totemic pair of shoes, a form of sacrilege, which is, perhaps, something we should remember as a way of tempering our over-enthusiasm.

With that caveat, let's accept that there are iconic objects in fashion, nevertheless. The Chanel suit, the Kelly bag and the Gucci loafer slip neatly into this category as being emotionally and socially above and beyond their utilitarian purpose. They have an aura which is very much more than the sum of their parts, and all reflect a period of the original thought – and a touch of the genius – which brought them to fruition. They

1 Paul Poiret, evening coats, c. 1910

stand outside the ebb and flow of transitory fashion change because, being so perfectly conceived, they cannot change, for to do so would be to diminish them. And, like religious icons, they are worshipped by the fashion followers who, just as their religious counterparts, do occasionally slip over the line which separates faith from idolatry and become fanatics.

Max Mara item 101801 does not suffer that fate. The classic double-breasted overcoat in camel-coloured wool and cashmere was brought to life in 1981 by the French designer Anne Marie Beretta. I say "brought to life" because it was the result of evolution, not revolution, as design classics always are, be it the Marcel Breuer's *Cesca chair* or Alfonso Bialetti's *Moka Express* coffee maker: it is an evolution based on problem-solving and elimination until the purity of form is so absolute that it is complete. There is, literally, no way to improve coat 101801.

So, what is a coat and where does it come from as a concept? To begin to find the answer we must go back a long way, to the days where warfare was conducted in armour, its two purposes being to protect and to frighten. Covering the vulnerability of the body, it was not merely utilitarian. It was also a visual statement of power and magnificence, with its superbly chased, engraved or embossed decoration meant to impress. From these roots – protection and projection – the modern concept of an outer garment grew, to become the over-coat, of which model 101801 is surely the supreme example.

But, before it reached its modern perfection, there were many twists and turns. The intractability of iron and steel were replaced by the malleability of leather, followed by wool. The English milord's eighteenth-century riding coat was a classic of pragmatic design created to function correctly when the wearer was astride a horse, and to look dignified and impressive when he was not. This outdoor coat was adopted and adapted by the French in the years spanning both eighteenth and nineteenth centuries, a time of mania for all things English but especially for items of gentleman's clothing. Re-christened the Redingote, it became the template not just for the male overcoat but eventually also the female.

This could not happen until female dress changed by increasingly evolving along the lines dictated by masculine clothing. Model 101801 could never be worn over the bustles and crinolines of the Nineteenth century. It was only in the early years of the last century that the simplification of silhouette which separates modern dress from historic costume took place. It was a move spearheaded by Paul Poiret, who removed extraneous decoration and put in its place line and shape as the twin bedrocks of modernity. Women stopped walking around looking like animated sofas or complexly curtained windows, and

instead enjoyed some of the freedom in dress which had been taken for granted by men for over a century.

Paul Poiret's coats were often monumental in scale, built to impress as much as protect. In modern terms, the woman's coat was still to evolve. Again, its roots were masculine. The shape of the classic Max Mara coat was first seen in the trenches of First World War, on the back of British army officers. Whereas their French and German counterparts favoured formal overcoats, often belted, the British were inclined to wear theirs more straight-cut to the body, falling from epauletted shoulders. Made of heavy Melton cloth, the material created the shape. It became the standard uniform greatcoat for generations of British army officers, known universally as the *British Warm*.

From there, it was a short jump to the final shape of 101801. Untouched by the hand of *couturiers*, it came directly from motoring, the new craze of the early years of the Twentieth century. The motoring coat was one of the very earliest unisex garments, its shape almost identical for both men and women, frequently with the only differentiation being the side on which it was fastened. Modified and varied throughout the thirties, it was always a formal, non-tailored garment which frequently proclaimed its military heritage. During the Second World War, it became standard outerwear for officers in all branches of the armed services, both women and men. It also became the manteau of high fashion during the war years, tailored by Lucien Lelong and Jacques Griffe in Paris.

After a long and debilitating war, Christian Dior's 1947 New Look brought back glamour and formality to fash-

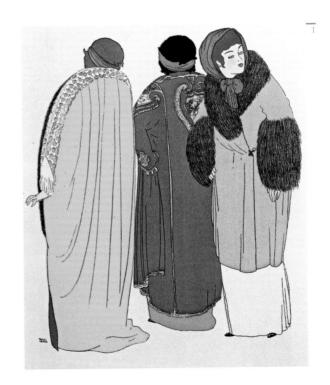

- The original sketch of the coat model 101801
- 3 The coat model 101801

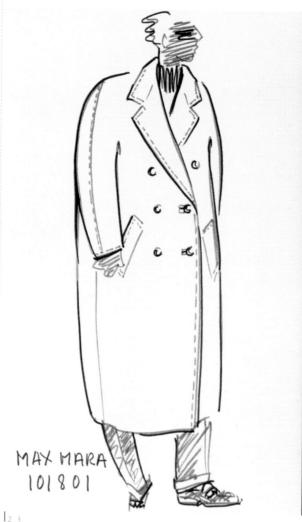

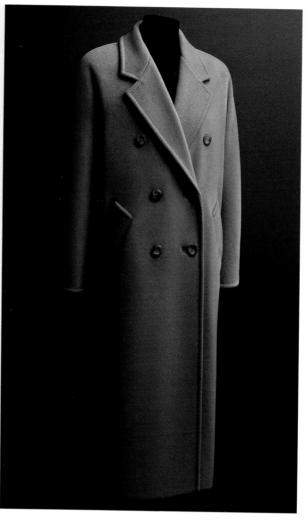

ion, with a strong emphasis on tailoring - a move taken up by Balenciaga, the Spanish designer still considered today to be the father of fashion modernity in the second half of the Twentieth century, as Chanel had been its mother in the first. But it was American designers such as Claire McCardell who were the real modernisers, the ones who actually produced the thinking which made 101801 possible. They were the ones who first realised that overstructured, formal coats heavy with horsehair interlining and padding - no matter how superbly they appeared on the runways of Paris and the pages of international fashion magazines - were not what the busy modern woman required.

A different concept of dress was born. The new thinking did something not previously attempted in the salons of the great couturiers. It created the elegant, sophisticated but casual look which was the true signpost pointing to the future of fashion. Duster coats, swingbacks, duffle coats, patchpockets, top stitching: the path was clear. The loose, straight and unbelted overcoat which had grown from the trenchcoat had moved into fashion

where it remains to this day, brought to its perfection as the ultimate modern yet classic icon of formal-informality by Anne Marie Beretta for Max Mara - model 101801.

We have already said that design classics are the result not of just one designer's brilliant hand - important as that undoubtedly is - but the summation of often many years of adaptation and modification until a design is honed to its irreducible essentials. The Max Mara coat is a perfect example of this. It has been produced in virtually unchanged form since its inception. Relying for its continued appeal on its quality, not only of cut but also of fabric, lining, buttons and stitching, it gives any woman who wears it a feeling of comfort and protection, as coats always have, but also a special feeling of glamour and understated elegance, which only the very best designed coats do. I look at it and my imagination goes back to the great Hollywood stars of the past. In my mind's eye, I see Katharine Hepburn, model 101801 casually slung across her shoulders, over a perfect cream silk shirt and impeccably cut flannel trousers. Or Marlene Dietrich, Carole Lombard, Lauren Bacall. All the actress-

4 Alba Clemente wearing the model 101801

es who, on and off the screen, had the relaxed confidence of women who knew precisely who they were, and thus felt entirely at ease with themselves.

And the tradition continues, with all the women you would expect to understand this coat's superbly assured understatement: Isabella Rossellini, Glenn Close, the Queen of Spain – and every fashion editor in the world, for whom it has become a talisman of their career achievements and proof of their taste and style. It is no surprise that Max Mara has sold over 142,000 101801 coats in the thirty years since it was designed. Like all classics, there seems little reason for it not to be still selling in another thirty years. I hope it will because, like a Magistretti chair, the 101801 is a delight to behold, as well as being a perfectly functioning article.

I would make one final point. Although design classics belong to no particular country or time, their perfection making them universal, they do, of course, reflect the culture of their creator. I have no doubt that the Max Mara 101801 coat, although designed by a Frenchwoman, reflects the timeless qualities that have made Italy, its history and culture, synonymous with artistic excellence. We do not have

to think of the greatness of Michelangelo or Raffaello; Vivaldi or Verdi; Boccaccio or Dante Alighieri. Italian creativity, and along with it, objects like the Max Mara 101801 coat, spring from more humble and visceral roots. I believe the secret of the endless creativity of this favoured nation begins with and is continued though its cuisine. The Italian kitchen is a sacred place, and the concepts and standards learned there at a mother's knee inform and guide this inventive race for the rest of their lives. If you doubt that there is a refinement and elegance in Italian cooking just as there is in Italian fashion, please remember this: when other European cultures were living off food crudely thrown into a pot to stew for hours or even days, the Italians were perfecting the idea of cooking al dente, a sophisticated and precise approach, demanding the discipline and dedication which springs from the belief that even the humblest task must be performed to the very best of the individual's abilities. It is therefore no surprise to me that coat 101801, a rare example of a fashion classic, has come from the same nation. Luckily, like Italian music, art and architecture - not to mention food and wine - it is not merely an Italian pleasure but can be enjoyed across the world.

The Delicacy Process

Marco Belpoliti

At the end of the Fifties fashion left one of its incubators par excellence – Paris – and conquered the world. During the same period, Roland Barthes began an investigation into the fashion system that culminated in a book published in France in 1967, a much-quoted but little read work, due to its inherent difficulties. Yet the French semiologist and writer's rationale in this book is not difficult to understand, on the contrary. *The Fashion System*¹ helps one to distinguish between the garment and the fashion shows, the store windows and the catalogues, the newspaper comments and literary displays of fashion. It also explains the difference between costume, garment and fashion.

Barthes' idea was to analyse the captions accompanying the photographs of apparel in various magazines of the period. His conclusions were significant: fashion is a mechanism linked to mass society, which spreads desires and aspirations while at the same time

confounding economic motives and sexual drives, commercial goals and models of eroticism. It does all this – and here lies the semiologist's discovery – through verbal language. Ours is certainly not a society of the image, as the majority holds, but a society of the word where written language is still dominant.

Barthes differentiates – here lies the complexity – between *signifiers* – in this case the parts, of a physical nature, that constitute the garment, such as a clip, gilt buttons, a suit, a pleat and so forth, and – *signifieds* – the definitions given to the various items of clothing: romantic, casual, weekend, girl, woman and others. His conclusion is unequivocal: "the signifier and signified do not belong to the same language". Fashion thrives on discourses, on signifieds "isolated from the signifier and elevated to high Heaven" ("Blue is in Fashion this Year", 1960).

The pressing room at Max Mara in Via Fratelli Cervi, Reggio Emilia, photograph from the early Sixties

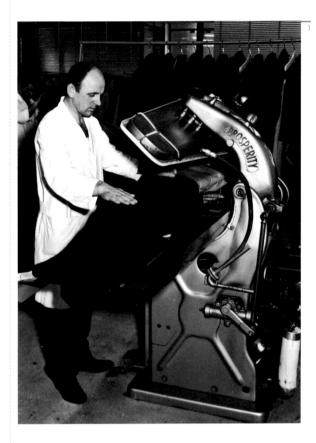

In this text, the French semiologist establishes some of the signifiers on which he will base his later analysis. He defines these as "classes of vestemes": Material, Colour, Motif. But also: garments, defined through the part of the body on which they rest; Head, Neck, Shoulders, Hips, Shoulders-Hips (one-piece garment), Hands, Feet, and so forth. And then Details, which represent Barthes' true insight, something that already existed but no one had listed coherently: Collars, Sleeves, Pockets, Size, Vents, Joins, Pleating, Borders, Stitching, Ornaments

In fashion – and not only – detail is everything: it performs the distinctive function that costume did before fashion existed and everything was simpler to define. The detail, of which the dandy was a past master, lies in the material of a shirt fabric, in buttons, in a buckle; it permits a wealth of combinations and therefore a mode of dress that holds its own against the constant need to stand out from the crowd. Dandysim – Roland Barthes writes – could have only existed in a period when dress was uniform in type but different in details. Today details dominate fashion; they have taken the place of the uniform, or better still, they are the true contemporary uniform.

Another point the semiologist examines, often ironically, is the myth of fashion as caprice. The magazines and the fashion journalists, he writes, focus on this,

creating the myth of the tailor with creative flair. There is a return to the romantic myth of spontaneous creative profusion. "Don't they say tailors make something from nothing?" His aim is to describe the rules, to establish the functional modes of a system – fashion – that is apparently so odd, so random.

The underside of the fabric

It is a pity that Roland Barthes was not familiar with the other face of fashion, which does not so much, or at least not only, concern the shows, the press and the clothes, but above all the ways and places in which clothing is manufactured. Had he been, perhaps he would have added another chapter to his book or maybe written another volume to describe this shadowy face which is equally important and connected with the signifiers, making it the one that actually generates what Barthes defines as classes of vestemes.

The text I am now holding is titled: Il linguaggio dei tessuti (The Language of Fabrics)². It is not a semiotic text, although it is in some measure a work devoted to signs. It is a book filled with figures and images, more than words. It is an in-house manual on fabrics, compiled from data taken from other texts, but also from accumulated know-how. The first chapter is on woven fibres. It functions as - and is - a textbook; its purpose is to teach. Teach what? What fabrics are and how they are manufactured. It is a knowledgeable book, a distillation of know-how, techniques and knowledge gleaned from various sources and times. It was written, or rather compiled, by Marco Peretta; in its own way, it is a collective book that gives form to various kinds of disseminated yet highly-specialised knowledge. It shows and explains how textile fibres are spun, dyed, printed and fixed.

The most riveting thing about the book is the chapter on weaving. The classification of the looms, I am sure, would have fascinated Barthes, with its details worthy of entries in the *Encyclopédie* by Diderot and D'Alembert: shuttle, double-needle, rapier, fly-shuttle, water-jet, air-jet. The manual includes detailed photographs focusing on the distinguishing features of these looms. It explains what they do and how. Precision industrial manufacturing that never neglects the product: the fabric.

There is even a chapter devoted to patching, a craftsman hand finishing. On one page there is a photo of a piece of fabric spread over a sloping board, and hanging over the edge in a series of dense folds; on the far side, we glimpse a seated woman busy embroidering. The caption is short and to the point: "This is essential for some fabrics. This operation is painstakingly carried out by hand by skilled staff."

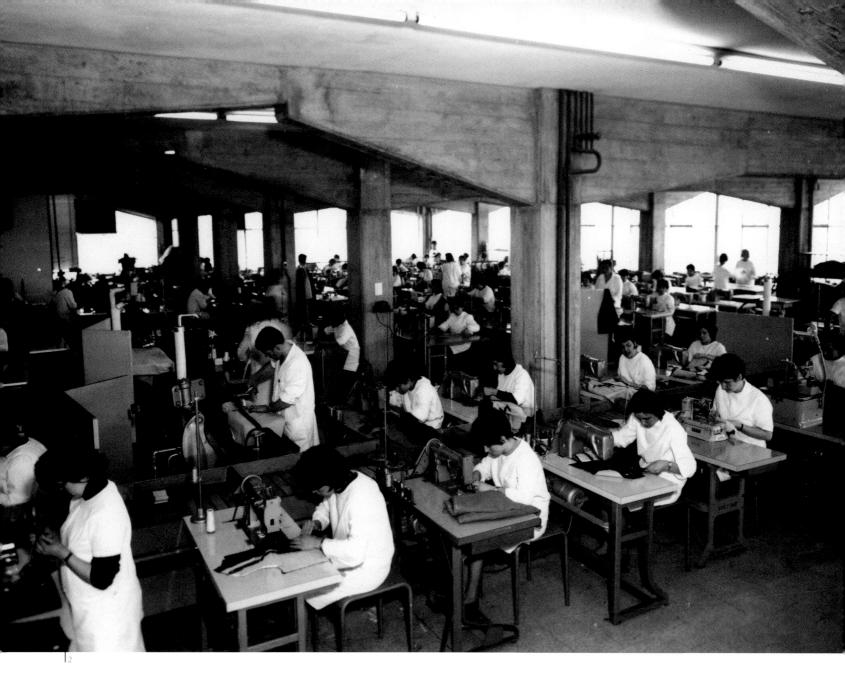

Fabric must never be stressed – a key aspect of Max Mara's philosophy. The term suggests something psychological, an identity, though anonymous, of the material that is manufactured and then made up. Is it still fashion? Yes. But here we are on the opposite side: subtle, *sub-tela*.

The section on "basic weaves" resembles a book of crossword puzzles in which the threads form wefts and warps by passing over and under, filling in, or leaving blank, the spaces on the pattern. The weave – armatura in Italian, deriving from heraldic language – can be light or heavy: heavy when the warp prevails; light when the weft prevails. Weft and warp. We are still in the sphere of linguistics: the way in which language is constructed according to Roman Jakobson, through the syntagmatic and paradigmatic axes.

In weaving things become complicated. Looking at the underside of the fabric and turning it over and over again, we discover how the pattern is formed: two warps and a weft. The language becomes topological: knots and chains. The pages dealing with double wefts and double chains are most interesting. We have not yet reached at the "vestemes" established by Barthes (Head, Neck, Hips and so forth) but the language of forms and colours has already been created.

The manual tells us that one works according to thickness, and the effects are both optical and tactile – haptic. Fabric belongs to the category of touch in which something is felt with the hand rather than just caressed, which is more usual. The tables at the end indicate this tendency towards the haptic, which is however delayed – if not actually impeded, at least where the reader is concerned – by the textile samples glued to the page that are a delight to the eye. The light blue of the Oxford and the yellow of the Panama, the se-

2 The sewing room at Max Mara in Via Fratelli Cervi, Reggio Emilia, photograph from the early Sixties

ductiveness of the quilting and the nuances in the raw crêpe yarn, the elaborateness of the embroidered cotton batiste or the worked piqué. These pages with their rectangular samples sum up the history of fabrics; not all of them, but those that are used in the *Max Mara* factories.

This is the catalogue of lexemes, of the basic units of the language of fabrics with which the company works. Material, in all its forms, structures, connotations and constructions, provides the basic grammar for the infinite composition of the garment. Here the fabric is referred to in its basic form which is already complex: production is the foundation of everything.

Signs and figures

The pages are lined and ordered to fill in; they are covered with clear and precise legible handwriting. At the top the section is indicated, lower down, the operation: stitching. The number and type of operation is also given: 706. The description of the elements is soberly summed up: the series of operations to be carried out to complete the piece, a column for the details, one for the time, one for the cycle, and then a small sketch, a basic yet accurate drawing of the piece indicating where it is to be sewn. These are all operations that were once done by hand in the tailoring department and which now, thanks to the use of machines, are done mechanically but controlled by a man or woman. Common sense is something feminine, as is the delicacy of each operation: take the front, fold the hem, sew the corner, turn the corner, and so on until the cutting of the six threads. Now the piece is turned over and another series of operations, similar to the previous ones but at the same time different, are carried out.

I am describing, albeit approximately, some of the technical cards concerning the making up of the garments. Here, perhaps, we are at square one of the garment, when Barthes' vestemes have not yet appeared but can be just glimpsed in the shapes of the pieces of which the garment is composed. First the fabric, then the pieces that make up the garment. This was, of course, preceded by the drawing, the design of the garment, which is always a sketch: a visualised idea or, perhaps, signs of a mind that thinks through drawing.

The details are worked on first. Fashion is born from these, but also from the factory; refined construction is the aim: bringing together pure elements of construction, functionality and quality in the hand-execution and the machines. Attention is given, for instance, to the methods of trimming pockets, making buttonholes, creating stitching with thick thread. It is the combination of these two working modes with the "design" that creates garments.

On a squared sheet – another technical card – the various information about pockets is indicated: sizes, height, total number of pieces, time required. There is not just one type of pocket – another topological form – but many, all different. Reading the dense columns of these cards is not easy, but behind the rows of figures – the terse language of numbers – there is a whole world: fashion written with numbers, or the gesture translated into a mathematical form, into formulae: *small forms*. We can in fact look on fashion as a combination of forms, each containing, in its turn, other smaller forms. An atom that splits into even more elementary parts. In going to the underside of the fabric, and being precise, the dry language of figures builds up the world in which the form itself is composed,

Finished items ready for delivery, Max Mara factory at San Maurizio, 2001

in this case the pocket: pouch sewn inside the appropriate opening in the garment, destined to contain a hand-kerchief, wallet, keys and other items, or merely decorative. Pockets have many lives and many figures, many forms and many sizes.

The delicacy process

What is the secret of this way of producing a garment industrially? The consistent results. The difference between the machines and fabrics described in Perretta's text and hand-tailoring, in an atelier to be precise, lies in the standardisation of quality. During the mechanisation stage, before the computer was introduced, the machine incorporated the skill of the individual in a rigid, slower way that could be perfected. Compiled at the beginning of the Eighties – as a summa, summary, legacy and document – as the memory of both an industrial process and artisanal know-how, *Il linguaggio dei tessuti* described an era in which the action of the machines did not wholly memorise human action. It replaced it, but still in an approximate way.

Now, the computer has been introduced into the two-part system: man/woman and machine. The machine is a "worker", while the computer gradually incorporates the individual know-how: it repeats the best performance. A triangle. The philosophy is the same: garment assembly as the locking of the fabric. The fabric is the starting and finishing point of the garment. Max Mara: seeing the garment from the point of view of the fabric. The machines baste, memorise actions and are flexible, while in the factory – in the workshop-plant of the industrial group in Reggio Emilia – women's hands move with lightness and skill.

The criterion, still Barthesian, is that of verifying wearability, namely of melding the "vestimentary chain", a fragment of continuity, with the garment itself. The syntagm, as the semiologist defines it, is no longer only the detail, constructed through assembling, but assembling itself as detail. Overturning the way in which the garment is conceived: seeing the garment from the bottom up, that is to say starting from the grammar of its production: warp and weft.

The secret of *prêt-à-porter* is not only economic, but also concerns a constructive formula. From this standpoint, the designer is no longer the demiurge of apparel – the creative as they say – but becomes an element in the garment production system, the constructor of "vestemes", the one who articulates the series and composes the details, starting from a body of given elements. He is flanked by the equally important pattern maker who interprets the two-dimensional design. It is as if the end result were conjured up, although the technical notes that mark the transition from prototype to production haven't yet been provided: the design needs to be "industrialised". This is where the entries come in: from figures to delicacy.

In the Max Mara system the place of production has not only a material but also constructive priority: it supplies the elements of the fashion designers' composition; it does not impoverish them but further develops them through the machines; and the machines, in their turn, are continually modified by those who manufacture them, or by the company technicians, to permit new and different "constructions": everything can be improved. Thus, creativity does not lie with "someone" but is inscribed in the process.

4 Manufacturing phases, Max Mara factory at San Maurzio, 2001

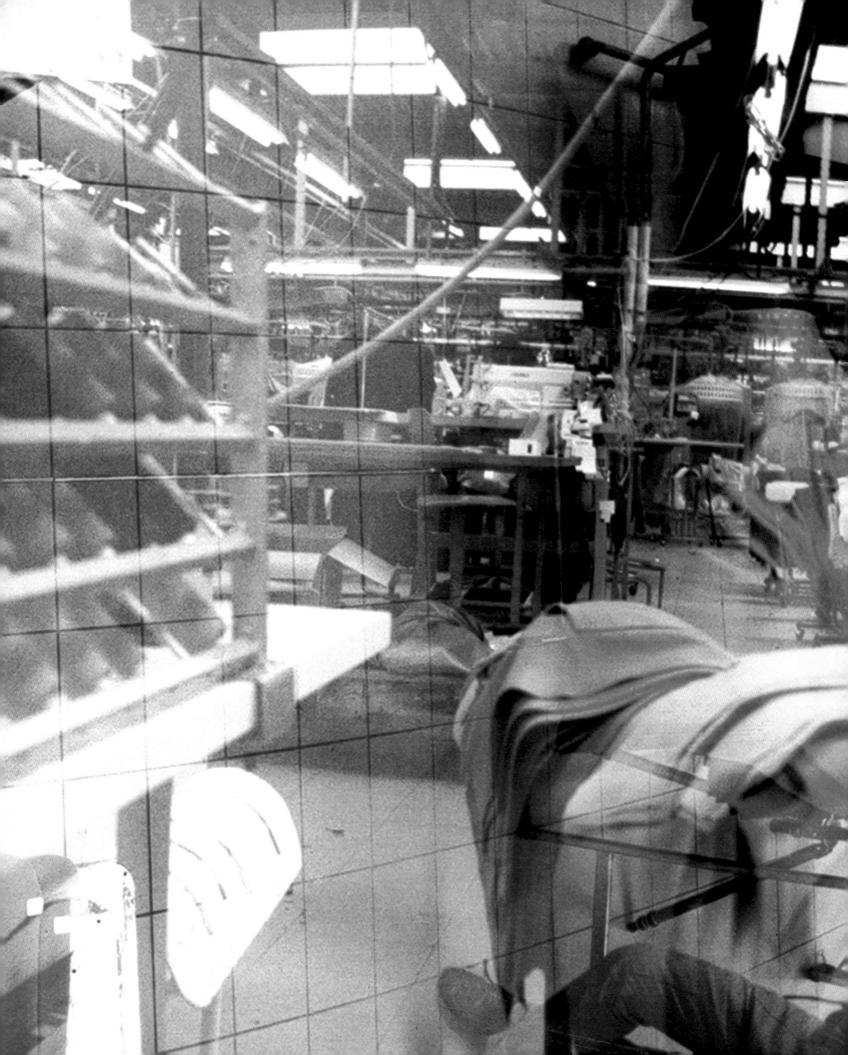

Prior to the language of which Barthes writes there is in fact a project that is not just invention. The machine does not simply follow the sketch, it does not merely execute: the feedback between the various departments engaged on the project constantly plays its part. In this way the lexemes, the parts that compose the discourse that is fashion, pertain to the industrial aspect of garment confection (the etymology of this word embraces the whole process: confection, "to prepare, to execute, to consume").

Let me explain: at the automatic cutting stations, linked to an IT system, the markings to be applied to the stacks or mattresses of fabric laid out for cutting are drawn. The software enables the female operator to study on the monitor the best way to fit together the pieces that make up the garment. It is like doing a jigsaw puzzle: using the minimum fabric, working on the screen to a scale of 1:10. Then the head, fitted with a blade, begins to follow the lines which indicate, as well as the shape of the pieces, also the various operations that will follow. The delicacy begins here.

Thus, also the label system – a dominant element in the present commercial organisation of fashion – becomes a further element in this process of retroac-

tions, occurring at the end of the process, as an addition to and not definition of the garment.

It is no coincidence, therefore, that in its long history Max Mara has produced a "classic" that makes it timeless: the coat. It also has a number of its own: 101801 – like the numbers in the tables listing timing and methods, and operations that female hands carry out on the garments: numbering as form and symbol.

Of all the departments in the factory-workshop in Reggio Emilia, the ironing room is certainly the most fascinating. When the garment arrives here it no longer needs anything else; it will be neither cut nor stitched, it will have nothing added or removed. Yet here "something" happens that evinces the principal quality of this production system: delicacy. In actual fact, the garment still lacks something: a finishing touch with a soft touch. Cutting, sewing, making-up and adjusting require skill; ironing needs that and something more. Here, among the hot irons, large and small, the garment is "put on", an operation that takes place, as if by magic, without bodies: clothes as bodies without a body, laid flat, relaxed by the heat and by the skilful female pressers.

In an interview given almost twenty years after his book on fashion came out, and symbolically titled *Encore*

- 5 Cut parts of of the coat ready for assembly, Max Mara factory at San Maurizio, 2001
- 6 Production phases, Max Mara factory at San Maurizio, 2001

Sezione	ind.ital.co	nf. MAX	MARA	u.t.m
DAVANTI	IMPUH	TURARE	706	
OP: Impunturare d	avanti-conte	ainando ca	กกอก เเลือ-	Staderati
DESCRIZIONE ELEME	tempi elementi	schizzo		
Prendere deventi	9.67	FORMULA	1º DAVANTI	
Pricare orlo e posizionere			RISOLUTIVA	
Cutire angolo		41.17	-	1 1
Voltere engole	TO THE RESIDENCE AND ADDRESS OF THE PARTY OF	16.91	Temuh legger	1 11
Pregare connoncino		14.21	AND NN .	1 13
Posicionare Impunturare K1	14.19 Yedi tebella	278.77+	1 14	
Posizionere intermedi con	matualla altera	1040 x 2	K1+K2+K3	1 13
Pregare orlo e posiciona	ye	14.21		1 13
Imbunturare bicpando	- Vidi tobella			
Impunturare piegendo Posizionere intermedica	10,48×2			
Tagliare & fili Deporre davanti	18.00		50	
Deporte deventi	730			
OP: - 2° dan	-			
DESCRIZIONE ELEM	tempi elementi	tempi	schizzo	
Prendere downti	9.67		2º DAVANTI	
Piegore orlo e posicion	are	14.21		
Ruotare		-11.17		1
Cucire angolo		6.11		I II S
Voltare Angolo		-16.91		
Voltare angolo Posizionare		10.48	1	1 11
			1 1 1	
Imbunturare	K3	Vedi Tabella		1 14 1
Impunturare Posizion, intermedi con a	ntrollo altezza			1 14 1
Impunturare Posizion. intermedi con a	KS antrollo altezza	40.48×2 9.00		
Imbunturare	K3 ontrollo altezza	40.48×2		
Impunturare Posizion. intermedi con a	K3 ontrollo altezza	40.48×2 9.00		4
Impunturare Posizion. intermedi con a	K 3 ontrollo eltezza	40.48×2 9.00		#
Imbunturore Pasiziba Intermedi con a Tagliare 3 fili Isperre documti	ontrollo eltezza	40.48×2 9.00	tempi cicio	schizzo
Impunturare Posizion intermedi con a Tagliare 3 fili Idporre dovanti OP:	ontrollo eltezza	70.48 x 2 9.00 7.30	templ ciclo	
Impunturare Posizion intermedi con a Tagliare 3 fili Idporre dovanti OP:	ontrollo eltezza	70.48 x 2 9.00 7.30	templ ciclo	
Impunturere Posicion intermedi con a Tiogliere 3 fili Inpurre doventi OP:	ontrollo eltezza	70.48 x 2 9.00 7.30	tempi ciclo	
Impunturere Posicion intermedi con a Tiogliere 3 fili Inpurre doventi OP:	ontrollo eltezza	70.48 x 2 9.00 7.30	tempi ciclo	
Impunturere Posizion intermedi con a Tiogliere 3 fili Inpurre doventi OP:	ontrollo eltezza	70.48 x 2 9.00 7.30	tempi	

Sezione					OPERAZIO	MARA		OPERAZIONE
ACCESSORI			STIRARE ADESIVO SU ACCESSORI 201					
TASCHE	APP	LI. NO	ORMALI	TA!	SCHE	APPL.	con c	ANNON
ngombro Lunghezza		Nº lotale Pezzi	Tempo x	Lingo	mbro ghezza	Altezza Nº File	Nº Totale	Tempox pezzo cinin.
7 · 8 cm.	2	180	20.1	7.	8 cm.	2	64	20.6
9 · 10 cm.	2	1.56	20.2	9.	10cm.	2	50	21.8
11.12 cm.	1	68	20.5	11.	12 cm.	1	21	22.1
13 • 14 cm.	1	5/	20.7	13	· 14 cm.	1	18	22.5
15 · 16 cm.	1	50	20.8	15	16 cm.	1	15	23,0
17 · 18 cm.	1	44	2 0,92	17.	18cm.	1	14	23.2
19 · 20cm.	1	40	21.0	19	20cm.	1	12	23.8
21 • 22 cm.	1	36	21.0	21 -	22 cm.	1	11	24.1
23 · 2 4 cm.	1	33	21.3	23	·24 cm.	1	10	24.5
25 • 26 cm.	1	31	21.4	25	26 am	1	9	25,1
27 · 28 cm.	1	2.8	24.5	27	· 28 cm	1	9	25, 1
13						Ш	Ш	

Production phases, Max Mara factory at San Maurizio, 2001

8-11 Pages from the company typescript *II linguaggio dei* tessuti by Marco Perretta,1984

12 Technical sheet from the Seventies displaying timings and methods of working

13 Technical sheet from the Seventies describing the production of pockets

112

14-18 Production phases, Max Mara factory at San Maurizio, 2001

le corps, Barthes draws the interviewer's attention to an aspect that was given little consideration then: delicacy. We must try, he says, to be a little more subtle, a little more delicate, "to sense, through the image of the body, how fragile and, to some extent, vulnerable

While watching the ironed garments pass by, suspended on the hangers of the chain that terminates the workshop-factory-process, the above words came to mind, that need for delicacy that the empty-full garments suggest at the end of a process marked by intelligence and sensibility at every stage. Well before fashion's discourse starts circulating in the world, enveloping bodies, recommending garments and clothes, we truly need, as the French semiologist suggests, a little more delicacy.

¹ R. Barthes, Quest'anno è di moda il blu (1960) in "Revue française de sociologie", pp. 147-162, translated in Il senso della moda, edited by G. Marrone, Einaudi, Torino 2006, pp. 43-62.

² The company typescript *Il linguaggio dei tessuti*, 1984, by Marco Perretta, has been edited by Max Mara.

All quotations by Roland Barthes are translated from the Italian editions of Sistema della moda (1967), Einaudi, Torino, 1970, Il senso della moda, Einaudi, Torino 2006, an anthology edited by G. Marrone, collecting texts from 1957 to 1982.

An Inspiration that Conquered the Market

Max Mara communication strategies

Adelheid Rasche

In the clothing industry today, there is a wide range of marketing strategies between fashion as the product of an industrial and creative process, and clients or consumers. "Marketing in the current meaning of the term is not simply a body of techniques but rather a 'management philosophy' or an approach designed to create and maintain a profit-making company. Marketing is a managerial process responsible for identifying, forecasting and satisfying the client's needs in a profitable way."

Here only communication as a specific sector of marketing is taken into consideration. Without communication, fashion cannot reach its market: it requires images and texts to communicate at an international level, and a system of signs give it recognition and social references. It needs spaces and media in order to reach its targets.²

When Achille Maramotti founded the company in

1951, his main interest lay in the creation and production of industrially produced, quality collections; at the same time, a clientele had to be created throughout Italy. Consequently, defining a market was a key requirement in the early years, which Achille Maramotti did by taking important strategic decisions. These included the choice of a company name that was easy to remember and of the relevant trademark. The first part of this essay, which presents the various trademarks and logos adopted by Max Mara and Sportmax, is devoted to this issue.

From the Seventies on, the company stepped up its investments with two communication strategies: with the collaboration of photographers like Manfredi Bellati, Sarah Moon and Hans Feurer the first successful posters for advertising campaigns were created, and in 1976 the first F/W Sportmax fashion show was held in Milan, followed by the first Max Mara show there in 1983. The

second part of this essay focuses on the catwalk shows and press campaigns.

Starting from 1982 (Max Mara) and 1985 (Sportmax), catalogues of the collections were presented every year. These were created with internationally, renowned photographers, some of the most important being Mike Yavel, Arthur Elgort, Paolo Roversi, Max Vadukul, Richard Avedon, Steven Meisel and Craig McDean (for Max Mara); and Peter Lindbergh, Martin Brading, Robert Erdmann, Albert Watson, Marc Hom, Dusan Reljin, Inez van Lamsweerde and Vinoodh Matadin (for Sportmax).³

The most incisive of these advertising and catalogue images are presented in the last part of this essay, and their significance in the context of international fashion photography is also explained there. They were deliberately selected from a limited number of campaigns to mirror the fast-paced evolution of the company's visual communication.

Other communication media, such as *MM Magazine*, the periodical for clients published from 1990 onwards, the still photographs and videos shot behind the scenes at the fashion shows, the lookbooks of the collections, are not considered here.

"That little label is money, aspiration, sex appeal and status."⁴

Brands and logos have existed since the 19th century, when they were used mainly to identify products and companies. Since they serve as recognisable signs to the customer, and as such set the product apart on the market, brands and logos must remain consistent and should be modified with caution, almost imperceptibly. This continuity is particularly important in the fashion industry, since the product is new every season. Thus, the ever-changing product – fashion – and its unchanging visual identity are two complementary elements that must blend perfectly. ⁵

Achille Maramotti founded his company in 1951 under the name of "Maramotti Confezioni". A few years later, he changed this to "Max Mara", with the qualifier "Industria Italiana Confezioni", and patented the first logo. We do not know the precise reasons for the change in name, but the differences between the two names can be very clearly defined where marketing strategy is concerned. "Maramotti Confezioni" has a precise sound and meaning. First, an Italian surname – which at the time many people probably associated with the eponymous dressmaking school owned by Achille's mother, Giulia Fontanesi Maramotti. The second word, "Confezioni", also associates the company with a highly specific sector of the clothing industry – which in the Fifties was neither well-known nor particularly respected.

- Max Mara label, first half
- 2 Max Mara label, second half of the Fifties
- Max Mara label, Seventies
- 4 Max Mara label, Sixties
- 5 Max Mara label, Nineties
- 6 Max Mara Pop label, Sixties
- 7 Sportmax label, Seventies
- 8 Sportmax label designed by Jean Charles de Castelbajac for the catwalk-show garments, second half of the Seventies
- 9 Sportmax label, Nineties

When he altered the name to "Max Mara", Achille Maramotti made some crucial changes. This name with an international sound cannot be associated with a specific geographical identity any more. Apropos of this, it is useful to remember that during the early post-war decade there was no clothing industry worthy of note in Italy, and only some *haute-couture* designers had achieved international fame. The product description that accompanied the new logo became secondary, making the brand name stand out even more. Lastly, the verbal and visual alliteration combined with the name being reduced to a single element, greatly strengthened its linguistic effectiveness as much as its immediate graphic impact.⁶

On the earliest fabric label that has come down to us from the mid Fifties, the name of the company appears in white capitals, followed by the qualifier in English "drawn and manufactured by" in italics and by the letter "M" between two laurel branches woven in gold thread. These elements can be interpreted in various ways: on the one hand, by incorporating the English description Achille Maramotti associated his young company with the international market that was just opening up for the Italian clothing industry - then strongly orientated towards New York ready-to-wear.7 On the other hand, the words "drawn and manufactured" strongly evoked the prestigious artisanal production of French fashion - thus giving industrially-produced garments a little more elegant enhancement. This clever inspired combination of tradition and internationality was significantly enhanced by the third visual element of the label: the laurel branches with the gold monogram evoke a high-ranking social status and the insignia of noble families. "What characterises the brand is the signature, the emblem; the seal, the crest, so to speak. The logo is inspired by heraldry, and has the same function: the accent is on uniqueness and belonging. For this reason identity is in the sense of indivisibility, unit: a term that so often recurs in the world of enterprise."8

From 1958 onwards, the Max Mara label – usually a strip of fabric sewn into the model or a plastic tag with the name written in letters in relief that stood out – was fashioned with ornamental characters in gold (laurel branches and the M monogram) and black (Max Mara, all in capitals); the English qualifier was omitted. The next major change most probably occurred in 1963, when the design of the label was radically modernised and virtually remained unchanged until 1978. By then, the company had gained an important market position and the label had only the name "Max Mara" in black capitals on a light background, partially integrated by the registered trademark

- 10 Poster, Max Mara Confezioni Femminili, 1953
- 11 Poster Max Mara, by Erberto Carboni, 1958

12 Manfredi Bellati for Sportmax, F/W 1972-1973

symbol (®). The logo was always edged with a double line, giving stability to the form that, initially, was almost inevitably a large oval and, in the following years, became a slim rectangle with rounded corners.

It was not until 1979-1980 after many years of continuity that further essential changes were made to the Max Mara logo and, except for a few minor variations, the label remains the same today.

The new characters were far more streamlined and refined; the name and surname were no longer separate, and only the two "M"s remained in capitals. Thus, the double M was even more accentuated, creating a uniformity, and strengthening the feeling of "uniqueness"; and the border disappeared. A new colour scheme was also introduced, with various combinations, all of them classic and refined: grey letters on a white background, black on cream, mid-brown on light brown, and, lastly, gold letters on a gold ground. From the beginning of the Eighties, the words "Made in Italy" often appeared, either printed or woven, in smaller print below. This can be interpreted as an open reference to the strong position that Italian prêt-à-porter had won in the market by then.

The Sportmax collection, introduced in 1969, initially had a logo that was very similar to that of Max Mara: the name, in capitals, was set in the same typeface and framed by a rectangle with rounded corners, delineated by a simple, bold line. Although Sportmax departed considerably from Max Mara as far as design was concerned, and it cultivated a young fashion image, this individuality was not expressed in the logo. A symmetry between the brand image and logo did not emerge until the spring of 1976, when Jean Charles de Castelbajac - who acted as a consultant for Sportmax over the next four seasons - created an essentially new logo, perfectly in keeping with his lively designs for the collections. A large oval contained the words "Sportmax Sportswear Sportmax"; there was a stylised bear, seen from the front, in the centre, and clouds, stars, birds and a rainbow appeared in the background. The lines were a uniform red on a light-brown ground. This logo's message alluded as much to global relations as it did to the playfulness of youth, and both these characteristics were embodied in the models designed by Castelbajac.

After this phase, the Max Mara label was being given the finishing touches in 1979-1980, the Sportmax logo as we know it today was created: it was completely typographical, printed in newly-conceived modern characters with the name in close-spaced capitals, and partially integrated by a plain border or the legend "Made in Italy". The angled name, with bold horizontal lines behind the word "Max", was balanced by the un-

dulating shape of the first four letters. The dominant colours were white, black and silver grey.

If we look at the current Max Mara and Sportmax labels, which have remained virtually unchanged for thirty years, we see that their strength lies in their essential design that does not follow any particular fashion. Quite unmistakable, they conjure up luxury and quality (Max Mara), freshness and charm (Sportmax); their overall look represents the respective brands as a whole.

The fashion industry has always used brands and logos in various forms on labels, tags, hangers and advertising material. Since the Eighties, however, graphic design has assumed a role without precedent in the fashion field. Presentation and packaging have become increasingly important, almost on the same level as the product.9 This is why the logo plays a central role as a principal means of direct communication between the company and the consumer. We find it in the form of a printed fabric label on every model in the collection, unmistakably "branding" it. Logos decorate tags and price lists; they appear in advertisements and on posters. Max Mara has utilised its own trademark as a means of distribution and of identifying its boutiques present in over ninety countries throughout the world, which, as well as the Max Mara collections, also carry Sportmax. One of the most important vehicles for the logo is the packaging, especially the carrier bags with ribbons bearing the brand name, which every customer totes around town with them. The instantly recognisable Max Mara name, with its eloquent understatement, is a guarantee of the brand's style and that of the consumer.

Fashion shows and press material

Today the runway show organised each season for the press, buyers and clients is one of the most important communication elements in the fashion world, and it is on this that the collection's success with the media, and often its international recognition, hinges.

The evolution of the fashion show from the Thirties on, from the *haute couture défilés* marked by an austere, formal atmosphere, to today's media feasts, reveals its huge importance. Today, the preparations for a successful runway show are multifaceted: choice and design of venue, lighting and music, styling and catwalk pace, selection and seating of the guests. Enrico Borello describes the special affinity between fashion and theatre: "The collection is a text that expresses its possible codifications (choice of colours, shapes) with paradigmatic examples (models) presented in a particular communicative situation, the runway show organised at regular intervals."

13 Paolo Roversi for Max Mara, F/W 1987-1988; model: Steevie van der Veen

The Sportmax F/W collection was presented for the first time at a runway show in Milan in 1976, followed by Max Mara in 1983; today these two collections are still presented to professionals during the two Milan fashion weeks, in spring and in autumn. The company archive holds a wealth of documentation on these shows: programmes, special designs for the models presented, catwalk pictures and videos, and also photos by Roxanne Lowit that perfectly capture the behind-theseenes atmosphere, some of which were published in MM Magazine.

In the ambit of external communication, invitations are sent out and press-kits prepared and placed on the seats. Money is no object where graphics are concerned, despite their ephemeral nature, since they must immediately attract the invitees' attention, awaken their interest, and live up to the show itself.

From the very beginning, invitations and information for journalists have been designed according to different graphic concepts: for Max Mara the focus is on classic continuity, while for Sportmax variety and inventiveness are the keynotes.

The Max Mara press-kits have taken virtually the same form for over twenty years: a light-coloured folder with the logo repeated on it, containing a printed sheet with the description of the collection and its salient features, and unsigned sketches of the main models featured. The invitations are equally classic and minimalist.

The first invitations for the Sportmax shows accompanied the collections for which Jean Charles de Castelbajac was working as a consultant. Printed on stiff card, with airy decorative motifs and a telegraphic invitation text, they mirrored the creative verve of the young collection, which, in keeping with the times, dealt with themes like environment, primitive cultures and extraterrestrial issues.

The first press-kits were also very lively; for instance, those for the S/S 1979 collection featured four of the colours from the collection, and the designs, accompanied by a brief text, were printed in colour on the sheets inside. Other kits from the Eighties, organised in a similar way but with different graphics every time, are conserved in the archive.

Starting in the Nineties, the Sportmax press material took a completely different form: at each collection notebooks were distributed which varied in size and graphic design, and which contained just a single page of text describing the main ideas behind the collection. Thus, the models were studied directly on the catwalk, and the journalists could use the notebook to jot down observations or draw personal sketches.

Catalogues and advertising campaigns

"Fashion photography is a cross between photographic style, commercial obligations and creative vision. Its function is to show style, to produce style and, lastly, to sell style." 12

In the Seventies, when Achille Maramotti commissioned for the first time not only the pictures of the collections but also the fashion photographs, ¹³ this genre was still going through a radical creative metamorphosis, which is fully documented by the Max Mara photos preserved in the archives.

Since fashion photography had been well-established in all press media since the Thirties, a generation of young photographers with new social ideas expressed through a personal visual language began now to make its presence felt, in parallel with the production of commercial images. The great majority of the fashion shots so far published in magazines had remained faithful to the traditional themes of visual reportage: thus, for example, Alfa Castaldi's photos in the magazine Arianna, which from 1960 to 1969 presented twice a year over forty Max Mara models in the series of articles entitled "Referendum della Moda" ("Fashion Referendum"), depicted static models either posed against urban landscapes or travelling - this latter being one of the settings for fashion photography that had been used extensively since the Fifties.

In the Seventies, fashion photography considerably broadened its horizons from three standpoints. The first factor to be mentioned is the growing internationalisation both of the markets and of the media, which brought the photographers new clients and offered new stimuli. In the second place, the photographers now had the chance to form new creative relationships by starting to work directly for the fashion houses, while previously collaboration with fashion editors on newspapers and magazines had a central role. From the foregoing derives the most crucial element regarding topics and expression: now, in fact, fashion photography could also reveal feelings and emotions; personal and physical individuality became a welcome criterion and, at the same time, the precise illumination of the details of a garment was abandoned in favour of creating atmosphere and transmitting a social message.

This individuality can be seen particularly in the advertising photos Achille Maramotti commissioned from the French photographer Sarah Moon in the mid-Sixties. For each season or collection, a single photograph in the form of a poster and display stand was used in Max Mara window displays; therefore, the model had to represent a synthesis of the whole collection and the ideas that underpinned it. With her subtle atmospheres composed

of colours and lights, Sarah Moon succeeded in representing this new and powerful image of fashion to great effect. In the photo for the Sportmax F/W 1975-1976 collection, three veiled figures appear before us as if shrouded in mist: in their coats with an ethnic look they exude a feeling of self-confidence that comes from a close relation with nature. They are modern but not "fashionable" women; they are ageless and do not inhabit the real world.

Sarah Moon's two photographs for the next Sportmax and Max Mara winter collections were conceived in a completely different way. Here, too, she represents the graphic silhouette of the coat in a focused way, and the colour is picked up by the chromatic scheme of the background. The message is direct, affirmative and highly optimistic.

Sarah Moon collaborated with Sportmax and Max Mara for several years, creating for the respective collection photographs that are not easily forgotten. Moreover, the kind of woman she depicted was someone with whom the Max Mara customer could identify remarkably well. Years later, Luigi Maramotti emphasised the importance of those photos: "The most meaningful experience in the area of communication was working with Sarah Moon from the beginning of the Seventies. Her photographic images, while presenting the product, were imaginative. They were photos that in essence communicated the product but al-

so the psychology behind it, while projecting the image of the woman who chose that garment." 14

In 1982, when Max Mara presented its first customer catalogue in collaboration with Vogue Italia, a new generation of photographers had begun to inject new life into fashion photography. Diana Edkins, in charge of photography with the New York publisher Condé Nast, remembers Arthur Elgort, Peter Lindbergh, Robert Mapplethorpe, Steven Meisel, Sheila Metzner and Bruce Weber as the key photographers of that generation; while Jean Baptiste Mondino, David Seidner, Paolo Roversi, Ellen von Unwerth, Max Vadukul and Javier Vallhonrat represented the next one.15 Five of these eminent photographers, commissioned by Achille Maramotti and Giorgio Guidotti, head of the advertising and public relations department, worked in the following years several times for Max Mara and Sportmax. This handpicking of internationally renowned professionals revealed a thorough knowledge of the market and a distinct flair for choosing the right collaborators; at the same time, it is evident that the company's top management attributed an important role to communication and, consequently, made available the considerable funds required.

Between 1987 and 1990, Paolo Roversi, Peter Lindbergh and Arthur Elgort worked on the Max Mara advertising campaigns and catalogues using the model Steevie van der Veen, who, as a powerful figure with whom women could identify, was able to develop a

- 14 Peter Lindbergh for Sportmax, S/S 1986; model: Jasmine Le Bon
- 15 Peter Lindbergh for Sportmax, F/W 1986-1987; model: Cecilia Chancellor
- 16-17 Peter Lindbergh for Sportmax, S/S 1987

strong personality over a period that was particularly long for the fashion world. All three photographers portrayed Steevie as a naturally elegant woman with an intense gaze, who was mistress of her own world; a woman who, apparently, acted individually in an urban or natural setting, independently of time and the social environment. Thus, slogans that were particularly important for Max Mara during this period were expressed through the images; words such as timeless, personality, quality and understatement.

Peter Lindbergh had worked for the company since 1984, when he created the first catalogues and advertising campaigns for Sportmax. In his superb black and white photos the young models, seen through his detached gaze, are depicted in close-up as they enter our

visual field as if in search of something. Their poses accentuate the primordial function of coatwear, that of protecting the wearer from the weather and the injustice of the world. The sharp contrast, without any grey tones, makes the immediate impact of the images even

Some of the most outstanding work Lindbergh did for Sportmax was the series of colour photographs he took in 1987 on the beach at Deauville in Normandy: the cold northern light brings out the refined nuances of the collection colours, and the wind adds movement to the shapes of the light garments.

From the Nineties onwards, the difference between the Max Mara and Sportmax messages became increasingly pronounced: the photographic campaigns

8-19 Arthur Elgort for Max Mara, F/W 1989-1990; model: Steevie van der Veen

and catalogues, runway shows and press kits followed their own roads, and are examined separately below.

The advertising campaign for the Max Mara 1993-1994 winter season was photographed by Max Vadukul. The first series of shots featuring Carla Bruni, taken in an historical factory and characterised by layered narrative structures, is still one of the iconic photographic features of the androgynous fashion of that period. By radically changing the perspective, Vadukul created images that considerably enriched classic fashion photography. They focus on the personality of the model, portrayed as she confidently makes her entrance. The viewer can pass from the atmospheric to the intimate image, like a zoom lens, and even "feel" the texture of the fabric.

In these photographs male figures appear in sil-

houette - a remarkable occurrence for Max Mara, since everything usually centres on the fashion garment and the female wearer strutting her stuff. The man's role remains secondary in Vadukul's images, however, and he is only a silent observer in the background.

For the 1995 campaign, Vadukul used Christy Turlington to create a set of superbly balanced images in the wilds of nature, which possess the harmonious atmosphere of the "new naturalness". Nothing detracts from the understated sensuality of the fine garment, which seems to suggest a return to the luxury of simplicity. The rigorous style is mitigated only by the different delicately nuanced tonal values of these black and white photographs.

Thanks to the collaboration with Steven Meisel, which started in 1997 and as from 1999 continued for another

20-21 Arthur Elgort for Max Mara, F/W 1990-1991; model: Steevie van der Veen

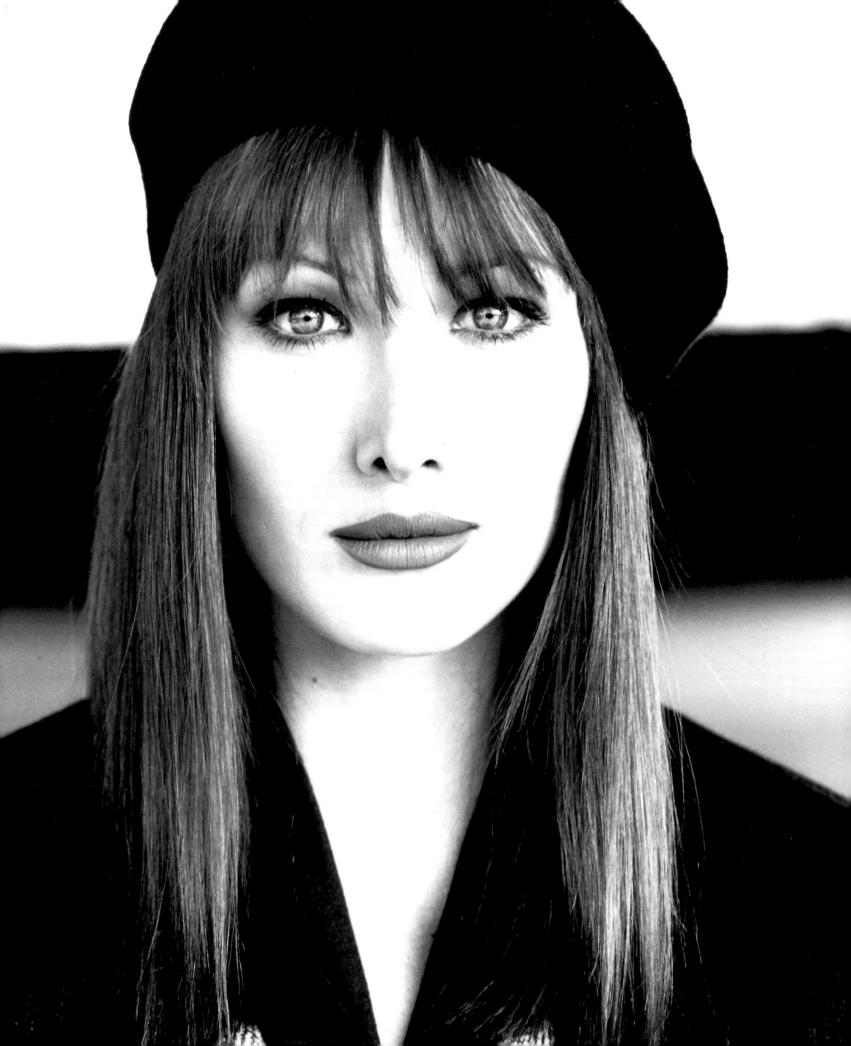

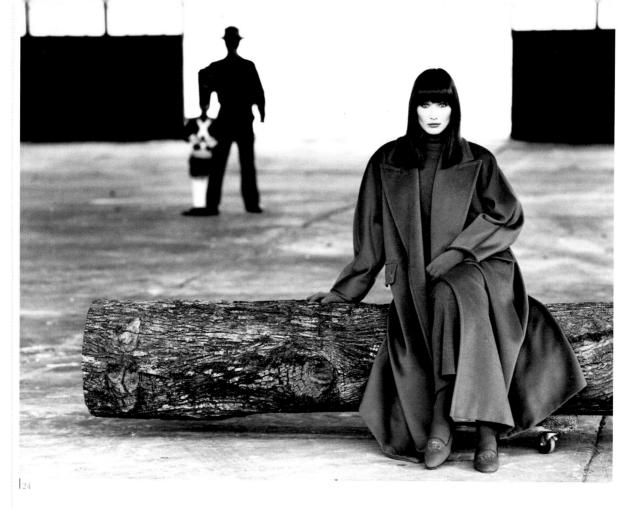

- 24 Max Vadukul for Max Mara F/W 1993-1994; model: Carla Brur
- Max Vadukul for Max Mara F/W 1995-1996; model: Christy Turlington

ten seasons, Max Mara could count on a consummate studio photographer; in fact, it is Meisel they have to thank for those campaigns with extraordinary atmospheres and seductive models. His series with Linda Evangelista, Carolyn Murphy, Liisa Winkler and Stella Tennant features confident women with strong personalities who feel at ease in a low-key glamorous ambience. Their step is almost that of a dancer, and when they appear as forms in motion they fill the still space of the image. In his studio, Meisel often combines graphic backdrops with sophisticated lighting set-ups, creating an artificial enclosed space in sharp contrast with the models in soft cashmere and wool coats who are the focus of the image.

This focus on the product is also encountered in the work of Craig McDean, who was responsible for photographing the 2004 to 2008 Max Mara campaigns. His studio shots show a classic image, reinterpreted with a contemporary atmosphere that maintains a distance. In the last campaign, for the 2008-09 winter collection. he captures the atmosphere of the catwalk; the models approach the viewer and present the items of the collection in a decidedly lively manner, yet still keep their distance. Striking bags and sunglasses now appear on the scene for the first time.

Mario Sorrenti has photographed the campaigns since the 2009 winter season. His Max Mara women are attractive and, at the same time, modern and elegant in the

true sense of the word. At the heart of his photography campaigns are two different concepts. In some seasons, Sorrenti filters in a great deal of femininity, supporting the photographic effect with soft lighting that gives settings a warmth and atmosphere and, through illusion, brings a tactile feel to the fabrics in the images. In other years, Sorrenti works with a certain harshness, for example in the black and white campaign of the 2010-11 winter season. In this instance, he reduces the ambiance element to a minimum, highlighting only the direct visual contact with the model and the silhouettes of the looks.

Richard Avedon's 1998-99 winter season campaign for Max Mara with model Maggie Rizer certainly holds a prominent position. In a studio with artificial environment - a bright white space and a staircase in the background - Avedon dedicates his total concentration to the model and to fashion. The face is made up to look like a doll with a neat haircut - a homage to the Maid of Orléans. The image makes us think of surreal, dreamy worlds. The model's poses and the finest details cause a distraction and playfully interrupt a perfectly formed image: the hem of the skirt is slightly lifted, an unexpected smile, shoes are oversized and a shadow is formed in the background. In this way, the viewer's attention is aroused and captured for a long time. The direct, penetrating gaze of the model also creates a strong connection with the viewer.

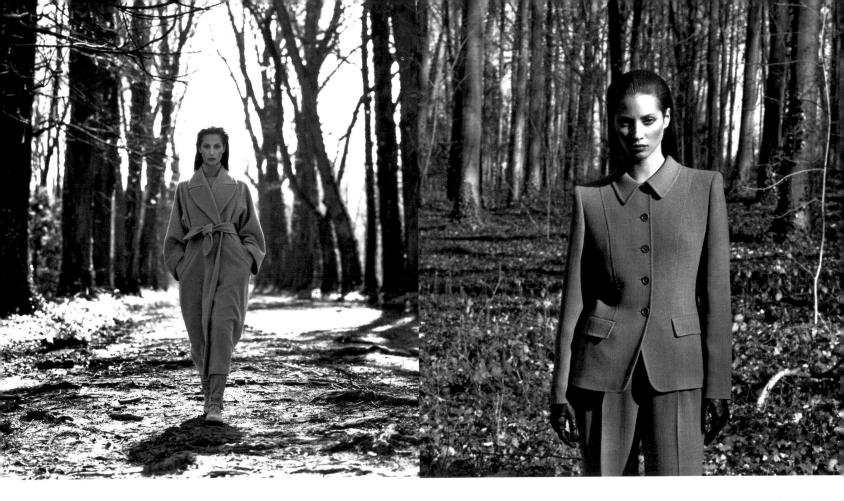

The Nineties saw a radical change in the visual language used for Sportmax. In keeping with the brand's accentuated young image, the models in some photographic series were depicted as friends - it is common knowledge that close relationships are established between girls of the same age during youth, a period when models are adapted to and imitated.

In the series Martin Brading did for Sportmax in 1989, set in a park, new movement is introduced into the image. The model, Emma Sjoberg, moves in front of the camera like a dancer making a leap, her body emits an intense energy that harmonises with her soft, bright blue wool coat. Although no visual contact is established, energy and a zest for living are immediately conveyed to the viewer - the message could not be more positive!

Albert Watson, who from 1993 on created a total of eight campaigns for Sportmax, is an extremely versatile

photographer. He had a knack of interpreting the radical social changes of the period, which were also reflected in the Sportmax collections. In one of the early series he presented the new grunge city-based woman, but the following year his heroines were romantic child-women. In spring 1996, Albert Watson came up with a modern interpretation of the visual language of the Sixties, which in this particular season was well-evident also in fashion: close-ups, cold studio atmospheres, curvy, slender bodies and bright colours create images with a clear message.

On the other hand, Marc Hom, who directed six campaigns from 1997 on, plunges us into a surreal world in which strange creatures move with great selfassurance. These are campaigns that initially provoke the viewer, making him or her look twice; distance is deliberately accentuated and illusory.

In 2001, the photographers Mert & Marcus intro-

28-30 Richard Avedon for Max Mara F/W 1998-1999; model: Maggie Rizer

- 31 Steven Meisel for Max Mara, F/W 1997-1998; model: Linda Evangelista
- 32-33 Steven Meisel for Max Mara, F/W 1999-2000; model: Carolyn Murphy
 - 34 Steven Meisel for Max Mara, S/S 1997; model: Linda Evangelista
 - 35 Steven Meisel for Max Mara, F/W 2000-2001; model: Liisa Winkler

36 Craig McDean for Max Mara, F/W 2004-2005; model: Natasha Poly

37 Craig McDean for Max Mara, F/W 2005–2006; model: Hana Soukupova

38-39-40 Craig McDean for Max Mara, F/W 2006-2007; model: Raquel Zimmerman

duced the theme of sexual attraction - regarding both the fashion and the models - directly into the images for the first time in the history of Sportmax. With her provocative sceptical gaze, the model makes eye contact with the viewer, and the fetishist and androgynous aspects of the creations are accentuated.

In winter 2004, Mikael Jansson offered an exciting new interpretation with his series of large format exterior shots which seem to be strongly influenced by the images in the first catalogue for the Pop collection (1965). Shot from a low angle, the Twiggy-like girls focus the viewer's gaze on the innovative collection, and the brightly-coloured models stand out superbly among the bare trees of a wood in autumn.

Dusan Reljin also relates to the power of fashion in his series of shots for the 2006-07 autumn/winter collection. His model is an "Alice in Wonderland" and lives in a fairytale world that invites the viewer in. These theatrically arranged photographs form an ideal frame of illusion where fashion and life appear to be a unique entity and make you want to discover this dream-like world. This setting of the studio with silhouettes of punched, irregular shapes on strips of light paper, resembling leaves, also forms a pendant with pieces of the collection characterised by pierced or laced needlework.

For the next winter collection (2007-08) Dusan Reljin puts two city cowgirls on the scene in relaxed poses. If the world of illusions first set the action, in this case

- 41-42 Mario Sorrrenti for Max Mara, F/W 2010-2011; model Freja Beha
 - 43 Mario Sorrrenti for Max Mara, F/W 2009-2010; model Eniko Mihalik

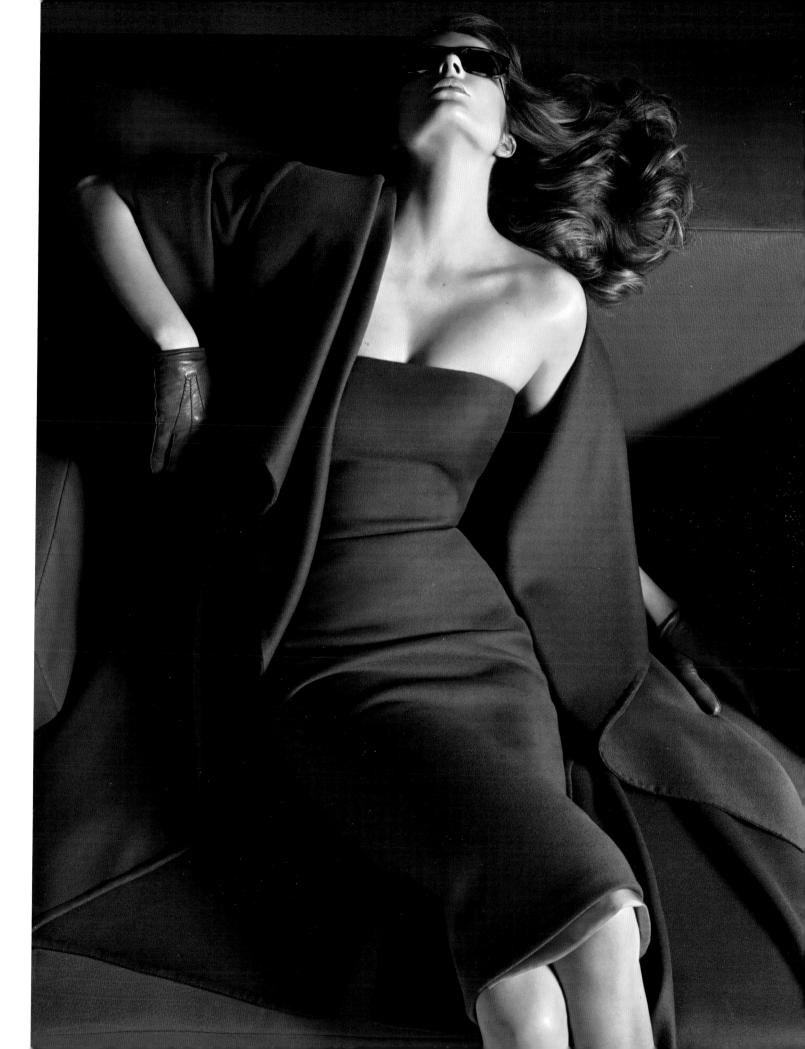

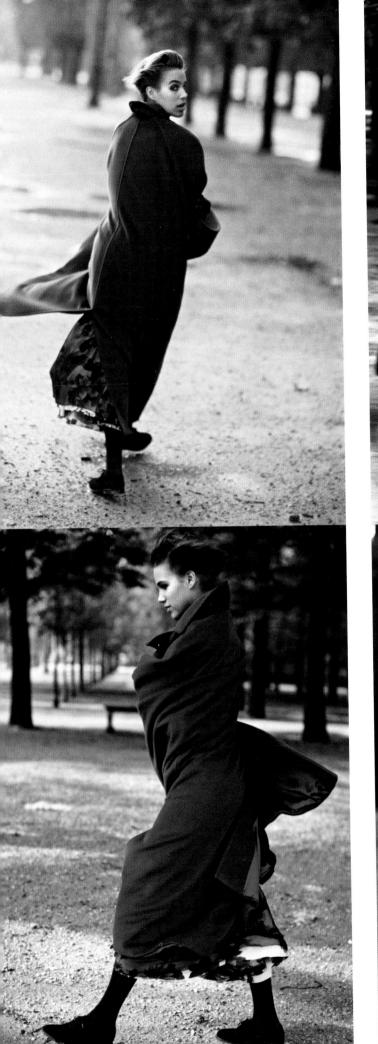

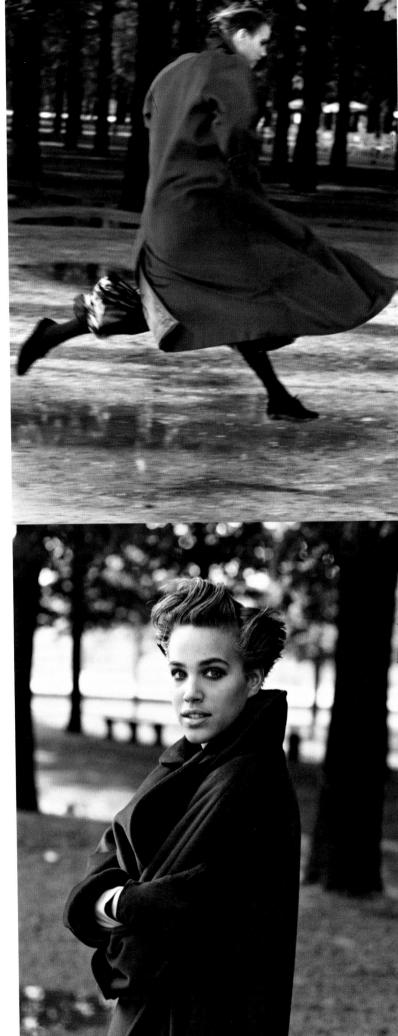

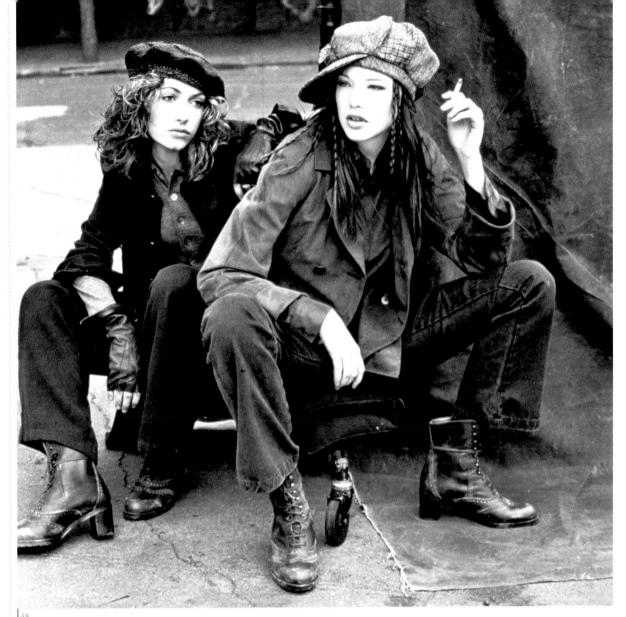

- 44-47 Martin Brading for Sportmax, F/W 1989-1990; model: Emma Sjoberg
- 48 Albert Watson for Sportmax, F/W 1993-1994; model: Kate Dillon

it is the women that conquer the vastness of the urban space with their presence and personality. In most of the photographs they are represented in pairs in perspective. Photographed from below, the models stand in a space with an interested, slightly sceptical, expression directed towards the viewer.

The 2008-09 winter collection was the last to be managed by Dusan Reljin. For this campaign Reljin uses a white cube with painted walls and prominent skirting boards. The only accessory in the studio is a red carpet that crosses the central part of the room like a catwalk. The dazzling walls give the viewer an impression of living a cinematographic experience. The model, made up like a doll and adopting artificial poses in this highly artificial environment, brings to a close, in various photographic ways, a clear transformation. The model evolves from a distanced stance with a hesitant expression to a relaxed standing pose in a black, fluttering, tulle cape with an inviting, flirtatious expression.

David Sims has been working on the campaigns of

the Sportmax collections since winter 2009. His photographs are created from smooth, white or warm grey studio backgrounds and he positions his models under perfect lighting. The poses are direct, with no aggression or insolence, and with a slightly futuristic emphasis. In the first season, Sims' images are full of emotional charge. The models show wonder and scepticism, curiosity and shyness. In winter 2010–11, Sims imbues his images with a harsher, less accessible atmosphere. The model, with diva–esque make up and backcombed hair, is positioned in front of the viewer and examines them with a fixed, yet warm, gaze.

David Sims' use of different light sources creates a lively, striking effect on the surfaces of the materials used: leather, tweed, knit and fur. In this way, his photographs once again focus on the product. Every frill has gone, the message of the photograph concentrates on the respective look and on those who wear it. In retrospect, it became evident that the photographs for publicity and catalogues presented for Max Mara and for

- 49 Albert Watson for Sportmax, F/W 1994-1995; model: Leilani Bishop
- 50 Albert Watson for Sportmax, F/W 1993-1994; model: Kate Dillon
- 51 Albert Watson for Sportmax, S/S 1996; model: Guinevere Van Seenus

Sportmax very often focus entirely on the fashion product. Unlike some of the publicity photographs of other fashion brands, which often feature overloaded settings, here there is always a balance between the contents and message of the photograph. In fact, current campaigns focus clear attention on the product.

The images of a publicity campaign are created for the current season and then rightly and normally disappear from the surface. Too often, what is trendy is put ahead of everything else with such vehemence that, due to the cyclic decline of fashion, even images are destined to disappear. Fashion photographs can only have an effect that transcends every dimension of time if the character of those photographs is infused with the relevant theme of the collection, by the great visual masters of our time. This must go beyond the limits of the commission, linked strongly to the season.

Fashion and publicity act as modern systems of symbols with several purposes: in our time, fashion once again serves to give clear distinction, to promise individuality and to allow us to exhibit ourselves. This is important on a social level, on the level that we choose. These are the cus-

tomer targets that photographs must appeal to and communicate their messages to. Images must direct the gaze of the "acquiescent" towards what fashion offers. Everything else disappears in that moment. Fashion photographs, as an essential business vehicle, act as a burning glass of creativity and production know-how. These photographs show a perfect execution of selected models in the collection on "ideal" women in "ideal" settings and, in this way, transmit messages with positive connotations.

Max Mara's entire company strategy, up to today, emphasizes the pre-eminence of the product as the objective of all creative and practical efforts. Fashion photographs achieve a focus on effective campaigns, balanced in terms of climates and dense atmospheres that prioritise technical production elements or materials. The narrative elements and the expressive humankind only play a secondary role; the explicit eroticism and the relationship between the two genders do not provide an impetus for Max Mara campaigns. The woman's individuality takes centre stage as she moves with confident sovereignty in the vast realm of fashion and develops her own style with a conscious selection of clothes and accessories.

52-54 Marc Hom for Sportmax, F/W 1998-1999; model: Audrey Marnay

5-56 Following pages Inez & Vinoodh for Sportmax, F/W 2000-2001; model: Anouck Lepere

- 57 Mikael Jansson for Sportmax, F/W 2004-2005; models (from left: Lily Donaldson, Polina Kouklina, Caroline Trentini
- 58 Mikael Jansson for Sportmax, F/W 2004-2005; model: Caroline Trentini

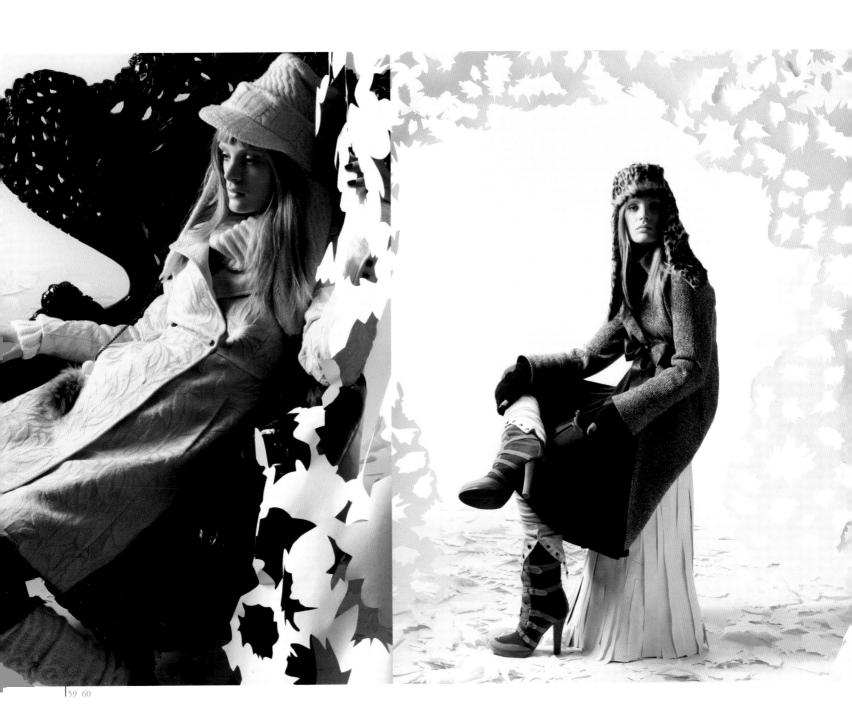

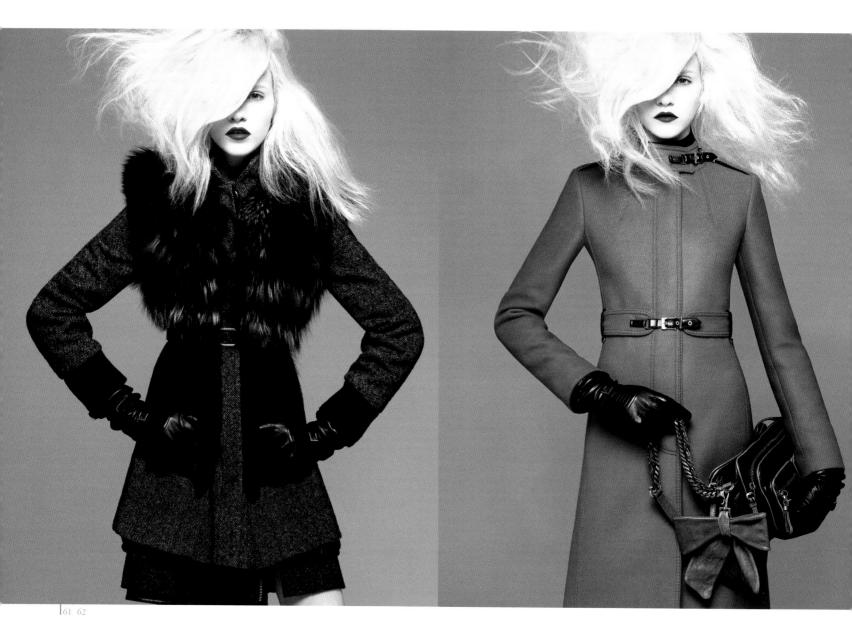

- ¹ A. Vezzani, "Marketing, moda e globalizzazione", in E. Borello (edited by), *Miti, Consumo e Moda*, Firenze 1998, p. 19 ff.
- ² Since 1955, *Max Mara* models have appeared in the fashion sections of many magazines; it is worth noting the series of articles entitled "Referendum della Moda" ("Fashion Referendum") in the magazine *Arianna*, which from 1960 on was devoted twice a year to the *Max Mara* collections. This essay does not deal with magazine articles.
- ³ In this context we are omitting biographical information, since monographs on the majority of these photographers are available.
- ⁴ T. Blanchard, Fashion & Graphics, London 2004, p. 7.
- ⁵ For further analysis of this topic: A. Semprini, *La marca. Dal prodotto al mercato, dal mercato alla società*, Milano 1996; U. Brandes, "Designing Gender: Das Drama der Geschlechter in Logo-Gestaltungen", in G. Zurstiege, S. J. Schmidt (edited by), *Werbung, Mode und Design*, Wiesbaden, 2001, pp. 197-211; Blanchard, *op.cit*.
- ⁶ Concerning the origin of the first part of the name, "Max", there are two different stories: according to the first, Max was the nickname given to Achille Maramotti by his boyhood friends; the second has it that the name was inspired by a certain Max, an elegant rather dandyish aristocrat from Reggio Emilia. "Mara" is an abbreviation of Maramotti.

- ⁷ On this topic: N. White, Reconstructing Italian Fashion. America and the Development of the Italian Fashion Industry, Oxford-New York 2000.
- ⁸ U. Brandes, op. cit. p. 200.
- ⁹ Various examples in T. Blanchard, op. cit.
- ¹⁰ In this context we have chosen not to further analyse runway shows. On this subject in general, see A. Sazzo (edited by), *Showtime*, *le défilé de mode*, Paris 2006.
- " E. Borello, "Marketing e semiologia della moda", in E. Borello, *op. cit.*, p. 30.
- ¹² D. Edkins, "Imagemakers", in Ingried Brugger (edited by), *Modefotografie* von 1900 bis heute, exhibition catalogue, Kunstforum Länderbank, Wien 1992, pp. 29–32, here p. 29.
- ¹³ The one exception is a brochure with about thirty unsigned photos of the Pop collection, presented for the first time in 1965, which are not examined here.
- ¹⁴ Quoted in T. Matteoni (edited by), "Il gruppo Max Mara i tanti gioielli di una grande famiglia", *Fashion*, no. 769, 17 April 1986, p. 80 ff.
- 15 D. Edkins, op. cit., p. 29.
- Avedon had already taken photographs for the S/S 1998 collection, using Stella Tennant.

- 61-62 David Sims for Sportmax, F/W 2010-2011; model Ginta Lapina
 - 63 David Sims for Sportmax, F/W 2011-2012; model Juju Ivanyuk

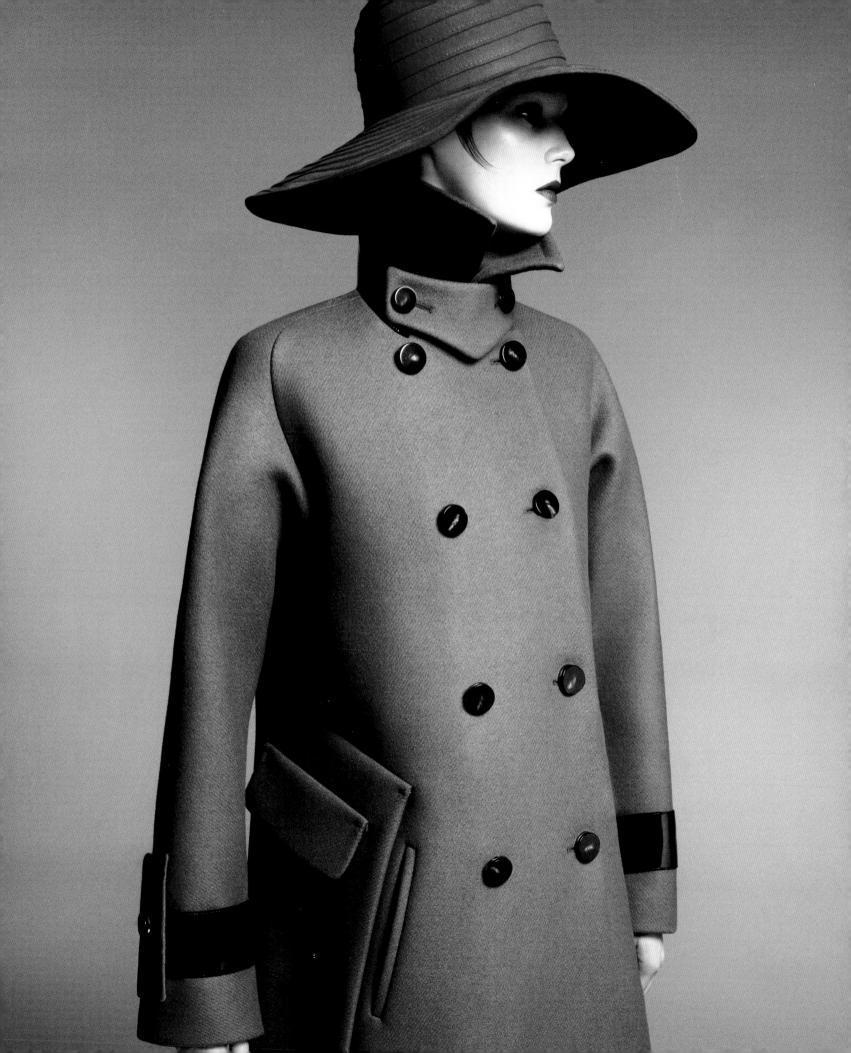

Variations on Coat

Mariuccia Casadio

The history of Max Mara is marked, among other things, by significant dialogues and exchanges with contemporary art. Particularly from the early Nineties onwards, various communication projects have been designed to support and promote emerging talents, or have come into being through the company's interaction with wellknown figures on the international creative scene. The coat, and more specifically the celebrated 101801 model, a timeless synthesis of the tailoring and research that has made Max Mara a worldwide success, has become the leitmotiv, the chosen subject of a varied repertoire of aesthetic elaborations. Represented, interpreted and reinvented in different ways, the coat has become the voice of artistic experimentation, periods and trends. Unique protagonist of a series of extraordinary events, installations and exhibitions conceived in different years and places, in particular circumstances or on special occasions, the

Max Mara coat first inspired a group exhibition presented in Milan in 1993, where it was the focus of a wealth of imagery and the subject of research, reflection and multimedial elaboration. The show was entitled "Art & Fashion: divagazioni su un cappotto" ("Art and Fashion: Variations on a Coat"), featured works by eighteen young Italian artists and was held at the Galleria Massimo De Carlo in Via Bocconi. The artworks consisted in ad-hoc conceptual and visual statements inspired by the same double-breasted cashmere-wool camel model with kimono sleeves and wide lapels: a coat created in 1981, which over the years has become a cult item, a must-have and muchcoveted status symbol. The artists who took part in the exhibition were the cream of a new Italian generation: Mario Airò, Maurizio Arcangeli, Stefano Arienti, Vincenzo Cabiati, Maurizio Canavacciuolo, Antonio Catelani, Umberto Cavenago, Maurizio Colantuoni, Mario Dellavedova, Daniela

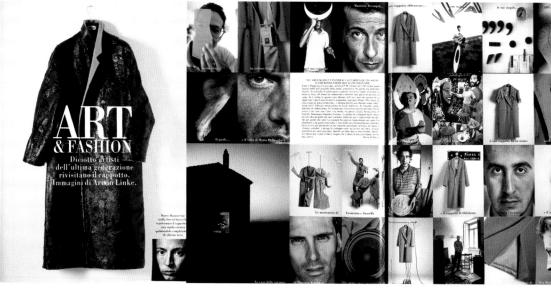

1 2

De Lorenzo, Formento and Sossella, Sergio Fermariello, Eva Marisaldi, Amedeo Martegani, Marco Mazzucconi, Aldo Spoldi, Grazia Toderi and Thorsten Kirschhoff. This exhibition highlighted, once again, the foresight and sensibility of a fashion brand that appears to have research and innovation in its genes. The functional precision tailoring of this famous coat was analysed, deconstructed and transformed, providing stimuli and conceptual, formal and material inspiration for a series of wide-ranging creative variations. In the elaborations of the eighteen artists, the coat's character, function, texture and even colour changed, but withoutlosing its identity; on the contrary, it took on even more fascinating qualities. Covered with silicon, as stiff as a board and as black as tar, it acquired surprising contemporary plastic qualities in the work by Marco Mazzucconi. While Amedeo Martegani's idea a sponge lining transforme it into an allpurpose garment, a multifunctional item that could be worn in the street, but also after stepping out of the shower. Sergio Fermariello reproduced his unmistakable recurrent pictorial graphics on the lining, while Daniela De Lorenzo and Umberto Cavenago chose, instead, to radically alter the coat's formal look and specific function. The former, in fact, transformed the soft coat into a twisted, involuted shape, a contorted cocoon closed in on itself that expressed shyness and introversion, while the latter used the inimitable camel-colour cashmere for the saddle and windscreen of an old Vespa. Maurizio Colantuoni, on the other hand, reproduced the coat to create a ghostly fashion parade, in which the models were very pale ancient marble statues. Aldo Spoldi renamed it "The Oklahoma Coat" as if it had been taken from a short story that has never been written, and decontextualised by a playful plot. In the hands of Formento and Sossella,

101801 became an extraordinary marionette, while Eva Marisaldi conceived it as the bearer of a minimalist message, as the support for secret arcane words that she embroidered on the edge of the lining. Sun-tanned, scattered with commas and question marks, transformed by military decorations or fitted with an inside pocket for carrying a book by Gogol, 101801 by Max Mara became the vehicle for personal feelings and poetic quotations, an expression of generational tastes and epoch-making moods in the works of artists like Maurizio Arcangeli, Mario Airò, Antonio Catelani and Vincenzo Cabiati.

The group exhibition "Art & Fashion: divagazioni su un cappotto" therefore constituted an illuminating antecedent. A successful experience that clearly could not remain a one-off experience, since it paved the way for further projects.

In 1997, Max Mara received an invitation from the Escola Superior de Disseny Elisava in Barcelona. Five years previously, the institute had launched an educational project envisaging direct interaction between students and businesses. The encounter with Max Mara and an analysis of communication's multidimensional role and, consequently, of the function of the image, which has always had the power to enhance product appeal and to strengthen the logic of consumption, resulted in the conception of a new creative installation project.

Starting from the strategic importance of retail outlets and consumer contexts, the aim of "Ephemeral Montages" was to conceive and reveal different ways of expressing the product, and other means of interpreting, presenting and bringing it to the public.

Once again, the 101801 coat provided the reference model, the product-symbol to be analysed, manipulated, altered and developed in new, unexpected and unforeseen

1-2 Article taken from *Donna*, October 1993; photos by Armin Linke and

designer coat to swap

- Volker Eichelmann e Ruth MacLennan, *Style Substance*, "The Max Mara Coat project", 1999
- 4 Carlos Martinez, Vela y Abstracción, 1997
- 5 Thais Caballero, Salvauñas, 1997

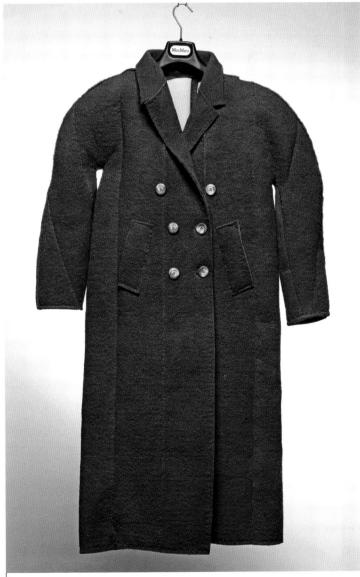

- 6 Martine Barrat, *Untitled*, 1994, invitation to the exhibition
- 7 Miwa Yanagi, Paradise Trespasser II, 1998
- 8 Miwa Yanagi, Paradise Trespasser I, 1998

ways. This produced many visualisations and creative elaborations of the Max Mara product, which were brought together in an exhibition by Jordi Cano and Núria Parés. Among the twelve works selected, 100% Natural by Natalia Gonzáles analysed and visualised the bond between two cultures, in this case Spanish and Italian, starting from a common product and one most typical of the Mediterranean area: olive oil, whose distinctive colour and rich consistency suggested to the artist a visual shortcircuit with the coat, the representation of the substantial affinity between the two markets. Entitled Vela y abstracción (Vigil and Abstraction), the work by Carlos Martínez consisted in two antithetical pieces, two ways of expanding and penetrating the identity of an iconic product, of going beyond the limits of the known. Stuffed into a polythene bag and frozen, the 101801 model actually increased in volume, underwent changes and became stiff. It deeply changed, incorporating new contextual elements and materials. Instead, the coat featured in the second piece underwent a radical cut-out: all the fabric was removed, stripped off and reduced to a skeleton made of seams. Instead of invading the space, it absorbed it, became part of it, losing its substance and definition to become a sort of drawing, a floating trace of colour, a structural evocation of the product. On the other hand, Roger Albero's project Deo Gratias sparked reflection on the predominance and all-pervasiveness of certain messages, on the power and legacies of information and the way it has influenced people in different periods and cultures. It is no accident that in this work religion and fashion are placed on the same level, and their iconographies overlapped and made to interact. Salvauñas (Nail Protector) by Thais Caballero accentuated instead the dissociations of the modern woman, torn between the refined and the practical, fashion imagery and everyday life, glossy fantasies and domestic chores. Faithfully reproduced in green and yellow sponge - double-sided like the familiar Spontex dishwashing sponge – the Max Mara coat has become a Pop icon. For her project Estrés (Stress), Núria Terricabras created a pictorial set to represent the other dimension of woman: a woman who leaves her

mark – the imprint of a Max Mara coat – while she moves through life, between solicitations and impositions.

The conception and representation of unexpected points of view on products and clothes, the search for transverse links between things, the examination of codes and values, and the conditioning and oppression experienced within our culture, are common to diverse imagery, from Buon Giorno, Buona Notte (Good Morning, Good Night) by Gerard Sanmartí to Insinuación (Insinuation) by Clara Pungi, from Ai, ai, ai by Maria Ribas to Opresión (Oppression) by Clara Lamarca. These works spotlight the infinite possibilities and potential of a direct, effective dialogue between education and industry.

Thus it was no coincidence that, already in 1999, a new exhibition project arose in London from Max Mara's collaboration with Goldsmiths College. This time four students, Kevin Grey, Sarah Raine, and Volker Eichelmann together with Ruth MacLennan, produced three fascinating aesthetic elaborations on the theme of the coat, based on different questions and viewpoints on our times. The first image, created by Kevin Grey, was his answer to the question: "What would happen if IRA militants wore Max Mara when they carried out their punitive missions?". He made the familiar 101801 model a victim of the context in which it is set. Worn by armed, masked men while

they perform violent actions, it takes on a different and more objectionable identity in Kevin Grey's imagery. The elegance and functional aspect of the fashion garment, but also its luxurious, warm texture, interact with something else, something unknown and disturbing. Placed in an inherently schizophrenic situation, the "otherness" of the coat is accentuated: it is a familiar shape that is nevertheless extraneous to the mood of the context. For Dressing, on the other hand, Sarah Raine created a photographic sequence pivoting

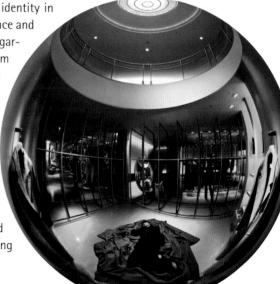

on the relationship between family life and high life. inspired by children playing at dressing up. Their way of often using things wrongly, of freely interpreting shapes and production is the starting point for the realisation of a compelling concatenation of images. The sequence of poses centres on the figure of a little girl and her interaction with a Max Mara coat, thus raising questions about the body's cultural identity, and the way it is transformed by make-up and dressing up. The Concept of Bartering, a project by Volker Eichelmann and Ruth MacLennan came from another challenge: "What would you offer in exchange for a Max Mara coat?". Published in the form of an advert in various English magazines, the question soon elicited different responses. Objects and ideas were offered in exchange, and various proposals submitted. The creative duo chose one in the form of a theatre play. Someone actually sent in a specially written story pivoting on the concept of bartering, on interpersonal relationships and communication, on a coat making its entrance on stage... Five hundred copies of the script were printed but never distributed, and it was the only work to be presented at the London exhibition held by Goldsmiths College.

Besides the exhibitions and artworks created through the company's interaction with educational structures, the opening of new flagship stores and showrooms has also provided Max Mara with further opportunities to interrelate with art. For the opening of the flagship store in Madison Avenue, New York, in 1994, a project was commissioned from the French artist Martine Barrat, internationally renowned for her work with the Japanese designer Yohji Yamamoto and for her photographic and video projects on the South Bronx and the world of boxing. Yet again the 101801 model, the Max Mara coat par excellence, was the subject of the images created. Worn by various children, the fashion garment became a toy, a protective blanket and a fun hiding place. Barrat's images were used as trademark iconography for this major inaugural event, mounted on billboards and transformed into posters and silk-screen printed vinyls on Manhattan buses, they occupied the city.

In 1998, two young Japanese artists were asked to interpret and transform the identity of the 101801 coat for the opening of another large boutique in the Aoyama district of Tokyo. The result was two giant photographic images elaborated on the computer by Miwa Yanagi, and a video by the art collective Dumb Type remarkably intense and original. Framed by the very pale minimalist space of the new boutique, laying on two levels and covering an area of 370 square metres, the huge photos featured a vertical rectangle and circle like a porthole, creating labyrinthine, sci-fi perspectives that pierced the

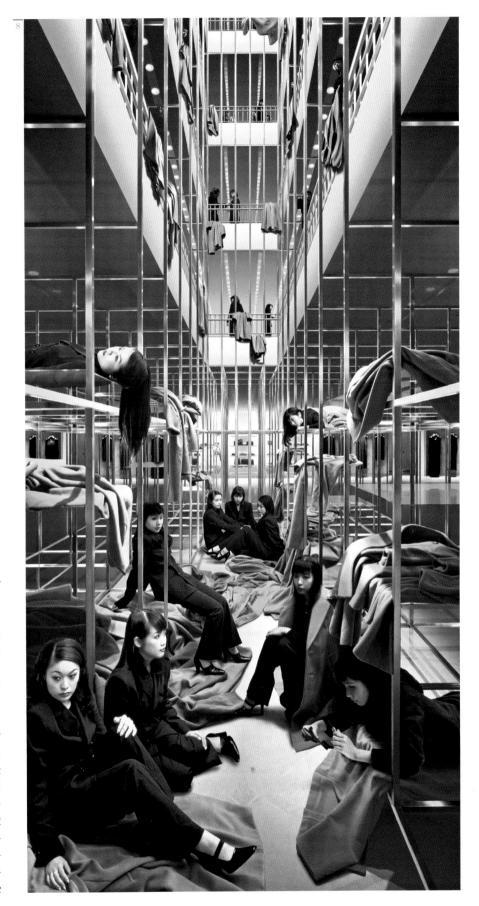

For the opening of a global store incorporating the Scandinavian headquarters and showroom in Copenhagen, a project involving the students of the Royal Danish Academy of Fine Arts was conceived. Their projects freely interpreted and represented the coat, and were installed and presented in the new wide Max Mara space overlooking the Østergade in the heart of the city. These works were the very life of the extraordinary opening: curled, folded, enveloped, dissected, evoked, reconstructed in fabric or redesigned on paper, the coat acquired innovative contemporary values.

To celebrate the company's fiftieth anniversary that

9-10 William Wegman, "Weimaraner" dog clothed in 101801 coat, 2001 (two elements of the tryptic)

1-14 François Berthoud, *Untitled*, 2001 (four elements of a series of nine prints)

same year, three images were commissioned from the New York artist William Wegman, and a series of works from the fashion illustrator François Berthoud. The former put the famous coat on one of his dogs, the recurrent and unmistakeable subjects of his surreal, playful photographic and video output for over thirty years. The latter paid tribute to the Pop nature of the Max Mara coat by superimposing different parts of its paper pattern on a variety of female types. In the work's grid-like structure, the fragments of the 101801 model were transformed into abstract brushstrokes which, as in a Warhol picture, interacted with the serigraphs of the faces: expressions of beauty "at any age" that seem to have come straight out of Francesco Scavullo's imagery, which endow the coat an up-to-the-minute feel that goes beyond fashion and shape, making it timeless.

A System of Objects The Max Mara Company Archive

Federica Fornaciari

"Words and objects are what they are but they are also many other things." Octavio Paz

An understanding of the productive processes that go into making an object such as a garment is essential for conceiving an archive, a dynamic container of documentation at the service of a company.

The fashion world appears to be characterised by the ephemeral; this is certainly true regarding production, due both to manufacturing speed and duration in the economic system. The fashion product also embodies that complex system of skills developed through the productive process, thus becoming the expression of a dense and permanent structure.

The aim of the archive is to catalogue, preserve, select, research, evaluate and pass on the history of Max

Mara and the people who founded the company. An archive acts as a repository for events and intangible atmospheres.

It was according to this concept that the Biblioteca Archivio d'Impresa Max Mara (BAI Max Mara) – Max Mara Library and Company Archive – project was launched in 2003. The BAI came into being while the new premises were being designed, and was set up by re-examining the entire documental heritage accumulated over more than sixty years of productive history. Library as research in the present; Company Archive as research in tradition; Max Mara as research applied to the future.

The library has been operative since 2005, and holds over four thousand volumes specialising in fashion and the visual arts, more than three hundreds different magazines currently in print and over fourty thousand rare historical magazines dating from the beginning of the

Twentieth century to the present. The library serves the Company's creative arm, featuring a tool for constant research aimed at developing new products.

The Company Archive holds more than two hundred thousand items, fashion garments and accessories, as well as sketches, photographs, fabrics, minutes, advertising material, furnishings and multimedia objects, that have been collected since the establishement of Max Mara in 1951 till today.

Archive and company are two words that evoke history, living experience and innovation at the same time: the bedrock of entrepreneurship. Preservation and production are closely interrelated processes, synthesised in the garment. An idea that is either abstract or inspired by cultural phenomena is transformed into a graphic sign, a sketch, and becomes the garment that will be worn. These various stages represent many creative processes stemming from craft traditions and applied at an industrial level.

But what is the precise function of an archive in a fashion company? Gathering evidences of the productive process over time has revealed just how much the documental heritage has contributed to the consolidation of the label. Such a collection benefits from the experience gained, directly or indirectly, in the production field through people whose key roles bear witness to the company's activities. One such person is the fashion coordi-

nator Laura Lusuardi, who began collaborating with Achille Maramotti as early as 1965¹ and who was responsible in 1969 for the first Sportmax collection, as well as collecting the first documental core for the archive.

The setting up of the archive not only reflects a cultural approach to business, but also the belief that innovation is the synthesis of an ongoing dialogue between research and tradition. Forges of production, workshops for building the future: the main reason for creating an archive is to pass on traditional crafts, which build up the cultural heritage of this company. It is a heritage consisting of objects and visual and oral memories: the core of company development.

The Max Mara Company Archive consists of archival fund from the "current archives" and the "deposit archives" of the various company departments: General Management, Communication Office, Style Offices, Production Office, Fabrics Office, Administrative Office and the Legal Office. These archives are combined in the new "historical archive" that constitutes the company's heritage.

"The current archive, the deposit archive and the historical archive represent three stages, which are not always separate, in the setting up of a single archive: the first stage focuses on the practical goals of the company that produces the documents and must preserve the previous ones in order to carry out an efficient and responsible action; in the second stage, these goals tend

Garments from the Max Mara
 Vintage Garments and Accessories
 Collection

to become secondary; while for the latter, the cultural goal of research predominates."³

The grouping of these collections determines the thematic sections and the related technical terms applied to the complex body of documents of which it is composed. The word document means the "testimony in any form (a text, a work, an object, a monument etc.), which pertaining to a given environment, period or culture, is an expression of it and in some way represents it, thus enabling us to know it; attestation, expression".⁴

The main heritage of the Company Archive is composed of over twenty thousand items from the Style Office collection, which consists of historical apparel and accessories, from the Sixties to the present. These documents were gathered from over forty years experience in working in the creative area by Laura Lusuardi, a conservationist way ahead of her times.

It is not easy to locate material from the first three decades due to preservation difficulties. Over the past years, Max Mara has succeeded in bringing together the pieces dating to those periods, due to donations from personal wardrobes, such as those of Laura Lusuardi herself, Giovanna Simonazzi⁵ and others, and also thanks to extensive in-depth research carried out by the archive through new and experimental channels. The winners of the Max Mara competitions held by the magazine *Arianna*⁶ in the Sixties were traced, and this research has enabled the company to locate various garments from that period, one of which appears in this volume and is on display in the exhibition.

This main core is flanked by the collection of the fabrics collection. Begun by Achille Maramotti and preserved and expanded by Laura Lusuardi in over forty years of working for the creative department, it consists of more than three hundreds boxes catalogued according to fabric typologies and supplier. This collection testifies to the development of fashion through the history of fabrics and weaving. Fine materials such as cashmere, camel hair and linen are themselves the subject of stylistic research, the results of are inherently made explicit in all Max Mara creations.

The collection also holds fabrics and sample books, together with a "fabric book". Some of these date back to the first half of the Sixties, and contain examples of sample fabrics used in the collections of that period. These are accompanied by the technical sketch of the model and the range of fabric colours that had to be presented by the sales representatives to the clients who purchased garments from the collection. In other books, the small paper pads used to record the orders for models and the various sizes, are conserved. The collection contains the only "fabric book" present in the archive. Dating back

to 1965, it is divided according to sample and supplier. This is important documentation: the fabrics are classified by collection, and the names of the suppliers certify the excellence and top quality of these materials, describing the specific accuracy of the choice of Max Mara fabrics year after year.⁸

The sketch collection in the Style Office fund consists of more than six hundreds files divided according to collection and year, containing over fifteen thousand sketches from the Sixties onwards, including those by designers who have worked with Max Mara through the years, such as Luciano Soprani, Lison Bonfils, Emmanuelle Khanh, Jacques Delahaye, Karl Lagerfeld, Anne Marie Beretta, Guy Paulin and Jean Charles de Castelbajac, to name but a few.

The Communication Office collection consists of all the material produced by the communication - advertising sector from the early Sixties to the present, including an original copy of every magazine in which a Max Mara advertising campaign appeared. This collection also contains all the books of press cuttings, divided according to year, collection, season and country of origin: from folders or publicity catalogues containing all the images of the advertising campaigns for the various labels, used to present the product to sales representatives or clients, to window point of sale material in the form of micro posters on stiff card that reproduced the advertising campaigns, initially utilised as a form of publicity and distributed to sales representatives and clients, and destined for various types of stores, to posters of varying sizes, ranging from the mid Sixties onwards. Of particular importance are certain posters from 1965 and the series created with photographs by Sarah Moon for the campaigns launched in the early Seventies.

This collection also contains two sub-collections, one consisting of photographic material, the other of audiovisual material. The former comprises all the negatives, slides, prints and original photographic material from the advertising campaigns, amounting to over fourty thousand items; the latter contains all the audiovisual material related to fashion shows, presentations of sample collections, special events, the first television commercials of the Sixties, television broadcasts on the fashion sector, and interviews, making a total of over five hundreds documents. The entire audiovisual collection is already being digitised, so that it may be preserved and passed on indefinitely.

In addition to these collections, there is the one created by Laura Lusuardi, bearing her name, which contains various of the above-mentioned types of material, catalogued chronologically and historically according to a method of her own devising. This collection is extreme-

Max Mara "sample books" from the Fifties

ly valuable due to its uniqueness, coming from both the particular archival methodology adopted and the wealth of materials conserved, to the extent that the core exhibits in the show have been drawn from it.

The Laura Lusuardi collection constitutes the main nucleus of the archive and provides the basis for documenting and attributing the items conserved therein; it today holds more than five thousand documents, including photographs, sketches, posters, magazines and texts.

It also contains important documentation on the Scuola Maramotti, mostly consisting in sketches made by students, magazines, images, information on courses, student assessments, issues and publications constitute the core of the fund recently deposited in the archive.

The partial reorganization of the Company Archive documentation results in a dual function. The first is to gather, preserve, and spread the company's historical heritage both internally and externally. Its second equally important function is what we might call a "research archive", whose main purpose is to back up the stylistic research that the company's creative personnel carried out by consulting the library.

The library contributes to the purpose of the research archive by making an on-line catalogue of a major collection available, that of vintage garments and acces-

sories, consisting of over fourty thousand six hundred items. The materials are different nature and vary from "precious" garments from the end of the nineteenth and the beginning of the Twentieth century, to "contemporary" apparel, models that have made fashion history, and even clothes and accessories of – sometimes unknown – commercial labels.

Of particular value are the three collections in the Vintage Garments and Accessories Collection, a legacy of over one thousand pieces. The first collection (evening dresses) consists of landmark models created by Italian tailors; the second (military dress), contains uniforms used during the two world wars; it is also known as "Militaria", recently enlarged by a notable acquisition of Italian uniforms. The third collection, the Vintage Coats Collection, held by the library, is mainly devoted to coats and constitutes a real museum of haute-couture collection from the Fifties to the Sixties. It contains an outfit, dating back to 1954, from Coco Chanel's personal wardrobe, consisting in a lamb's skin coat edged in red and blue with a white tweed lining, a skirt, a blouse, a bag, a necklace and a ribbon for her hair. There are also coats by Cristóbal Balenciaga and by Pierre Cardin and André Courrèges from the Sixties and by Christian Dior from the Fifties, as well as a coat - one of the rare examples - by Madame Grès from the same period.

The history of Max Mara told through such items clearly conveys the transformation of sartorial creativity into business creativity, while keeping the distinctive features and quality of a tailor-made product in a mass-produced product. Transforming a product into a fashion item until it becomes something timeless, beyond fashion, is a remarkable paradox that has generated a winning label.

The standardisation process was accompanied by a painstaking search for creative personnel, with the aim of injecting new blood into a complex conceptual system, supported also by the Scuola di Taglio e Cucito Maramotti (Maramotti School of Dressmaking), created to encourage gifted students and to create "home-grown" talent. This was the kind of technical and vocational school that did so much for Italy during the economic boom.

The marriage between business innovation and creative investment has resulted in a conception of creativity that is unique to Max Mara: "The abstract concept of creativity can be linked to the selection, from thoughts and things, of those which lead to innovation, change or improvement. Creativity can be formatively defined as behaviour which includes such activities as origination, organisation, composition and planning. Any definition we may try will not be fully satisfying because,

in order to make creativity distinguishable from mere arbitrariness, there must be a sort of legislation. We are perfectly aware, in the world of fashion, for instance, odd does not mean fashionable"."

The selection and training of creative personnel, the gathering and choosing of fabrics, automated cutting and sewing, and the distribution and collection of garments are factors of joint creativity that were conceived and introduced by Achille Maramotti in 1951.

"Creating fashion is not art, only a cultured craft, and successful designers are people who have acquired a broad knowledge of the subject and of productive processes, developing their creativity on the basis of this."

1

A garment leaves different traces over time, at each of the stages that have led to its creation. Its subsequent conservation documents these and the garment is reproduced through them, reintroduced into the pro-

ductive cycle, assimilated, refined and re-elaborated in a wide range of variations in tune with the timeless, classic quality of Max Mara creations. It is possible to reconstruct a space-time mosaic – the places of creation, production and distribution – a physical one – the material qualities and their ageing – or a relational one – whoever conceived and whoever chose to express themselves through the garment – and this mosaic is composed through the archival process, meant as researching tradition.

The meanings synthetically narrated in the fashion item are best expressed by a particular range of fashion production: outerwear, a term referring jackets, parkas, raincoats and coats.

Outerwear is the ideal metaphor of the creative process that is basted to the business's living memory: the archive or company memory.

The Max Mara fabrics suppliers book of 1965

- 4 Copies of *Arianna* from the Seventies
- 5° Sketches made in the Seventies by pupils of the Maramotti dressmaking school
- 6 Coco Chanel, suit from the stylist's personal wardrobe, 1954, Max Mara Vintage Coats Collection

It completes an outfit, creates the wearer's "public image" and immediately evokes its creator. It is a continuous present of distinctive, variable characteristics and, at the same time, the historic present of processes handed down from the craftsmen's workshops to mass production. Since it adds the finishing touch to an outfit, outerwear forms the boundary between the public and private sphere, both revealing and hiding, in a subtle equilibrium, the personality of whoever has chosen it.

As a historical memory, it provides essential reference data: year of production, season, collection, theme, fabric, sketches, designer and sales dates. It also indirectly represents customer satisfaction, that is to say the degree of label identification, through the "public sales data" indicator.

The company memory is not generic; on the contrary, it selects salient features to reconstruct the *thesaurum*, or storehouse, of no longer available collections. This kind of selectivity allows a cyclical re-elaboration of productive outputs, both by introducing innovative elements

where style is concerned and by developing research. In this context, outerwear, and more particularly the coat, the Max Mara icon that has entered the collective imagination and is recognised the world over, becomes the pivot of the company's entire productive history.

The idea of organising an exhibition retracing the story of the coat through the company's history arose when the archive materials were being reorganised in 2004.

The results of this seven-years research are crowned by the exhibition and corroborated by the catalogue that, in its turn, is added to the documents that have made the exhibition possible.

"COATS! 60°" celebrates an entrepreneurial history and the reasons for substantial investment in research, towards modernity as to tradition and future.

An investment that strengthens the complex function of the archive, as a process whose various aspects – archiving, researching, re-creating, recording, producing – all interact with the broader creative-productive process of the company.

M. Pellegrino et al., Donne nella moda. Protagoniste reggiane del fashion system, Reggio Emilia 2000, p. 106. In the interview Laura Lusuardi recalls her debut: "I was very young and I was fortunate in that I was assigned to people who taught me a lot. They put me with Antonia Montanini, who was responsible for the models, where the prototypes were made [...] I was lucky that Antonia took me under her wings at the beginning. I learned, I was able to watch and see; but I really was the factotum, the coffee girl. Then I gradually worked my way up to the study office and I had the great fortune of learning from Dr Maramotti, because he was the one who decided on the product."

² P. Carucci, *Le fonti archivistiche: ordinamento e conservazione*, Roma, 2003, p. 21. The current archive consists of the procedures underway in each office, the deposit archive of procedures no longer in use, and the historical archive of those procedures that are no longer used and must be preserved through the years. The company archive represents the evolution of this concept.

³ *Ibid.*, p. 22.

4 Ibid., p. 25.

⁵ Giovanna Simonazzi joined Max Mara in 1957 and has been Head of Administration until 1992.

⁶ In the magazine *Arianna*, published by Mondadori between April 1953 and March 1973, "XI Referendum della moda" (11 Fashion Referendums) were held from 1960 to 1969, combined with monographic articles devoted to Max Mara, in which various fashion garments could be won. The collection of these magazines has been placed in the archive to document one of the company's first forms of advertising.

⁷ This collection is subdivided according to country of origin – Italian, English and Irish fabrics – and type – prints, blouse, techno, embroidered.

⁸ The suppliers of fabrics mentioned in this volume include Lanifici Figli di Pietro Bertotto, Tessiture di Lana in Borgosesia, Lanerie Paola – Mosso S. Maria, Lanificio Pecci in Prato, Lanificio Fratelli Piacenza, Lanificio Alfredo Pria – Biella.

⁹ Achille Maramotti's mother "... Giulia Maramotti Fontanesi, ... was head of a professional cutting school for dressmakers in 1923 and later published indispensable manuals for teaching this profession. At home, his grandmother and great grandmother had been experts with a 'needle and thread', and his great grandmother Marina Rinaldi a dressmaker in Reggio Emilia in 1857...", in *Max Mara. Tradizione, esperienza e creatività nella moda*, Max Mara, Reggio Emilia 1981, pp. 9–10.

L. Maramotti, "Connecting Creativity", in N. White et al., *The Fashion Business, Theory, Practice, Image.* Oxford 2000, p. 99.

M. Pellegrino, op. cit., see note 1, p. 154. Interview with Ludovica Maramotti.

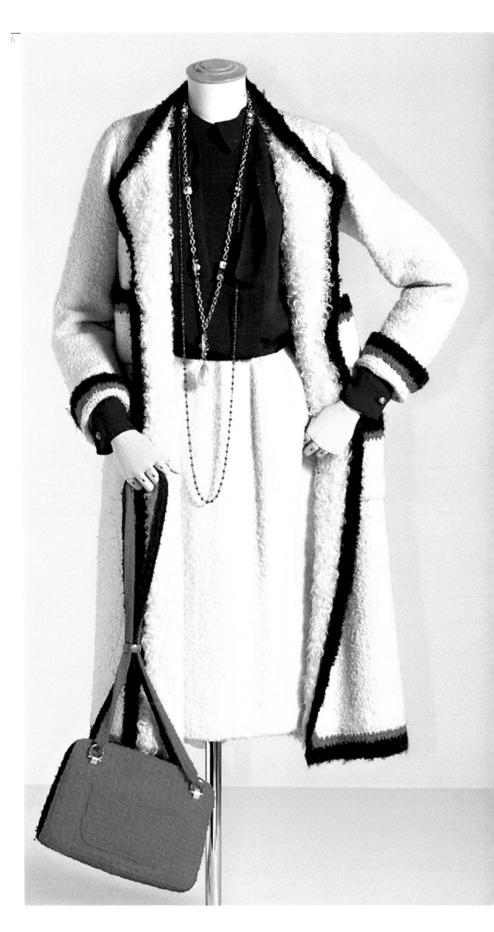

Garments from the Max Mara and Sportmax collections

All the coats, jackets and suits are from the Archivio d'Impresa Max Mara (Max Mara Company Archive), with the exception of garments provided by private collectors. For the technical information, it was deemed preferable not to indicate the sizes or repeat the label lists. The names and numbers of the models are given, where available. The catalogue texts are by Enrica Morini (E.M.) and Margherita Rosina (M.R.).

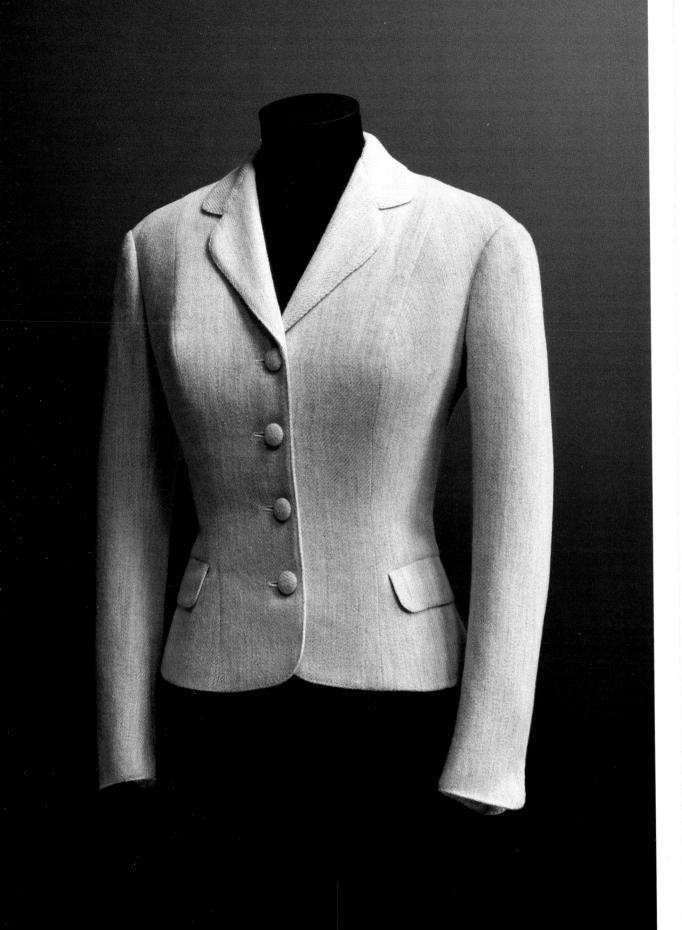

Max Mara Jacket c. 1957

Materials: white and beige *mélange* Shetland twill; white taffeta lining, fabric covered buttons

This single-breasted jacket with revers, definitely part of a suit for Spring season, is composed of small sections that make it figure-hugging in keeping with the New Look. A series of details, such as the hand-sewn buttonholes, covered buttons, the Vilene or stiffening lining, and stitching reveal that the garment was mainly handmade.

The suit itself was manufactured for the Abitex shop in Turin, as can be seen from the label.

E.M.

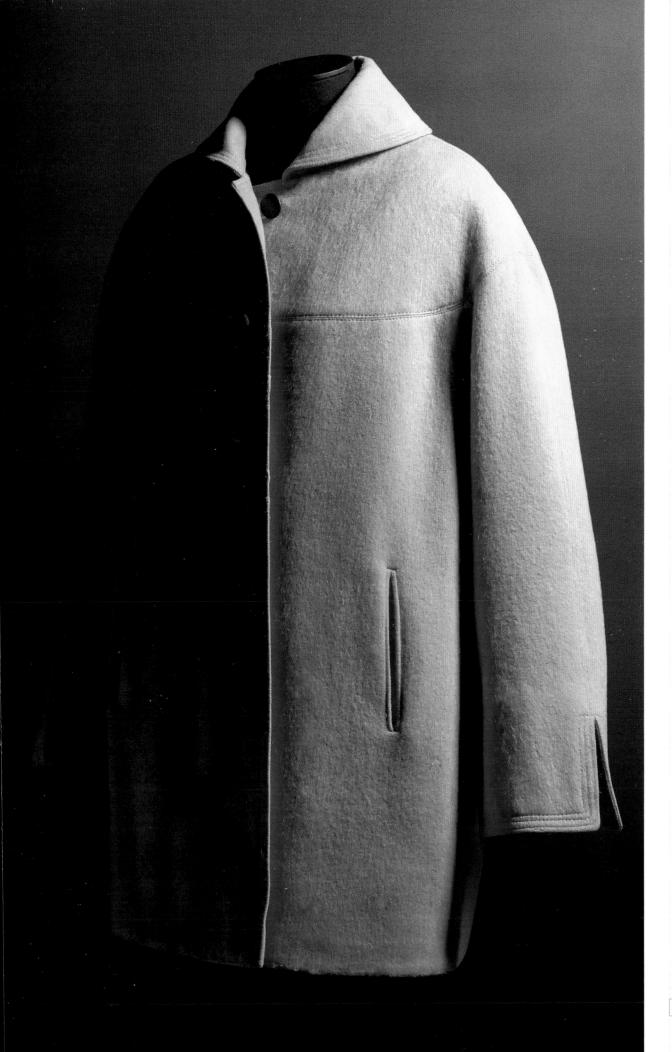

Max Mara Short coat S/S1957

Materials: beige camel cloth, beige taffeta lining, beige satin lining, round buttons covered with brown chamois

chamois Label: drawn and manufactured by Max Mara

The three-quarter-length short coat, with a four-button breast fastening, is tailored in three cloths. The coat is characterised by a large rounded yoke that creates low shoulders. The raglan sleeves turn out at the wrist. The round collar is detachable ("collar band") with two belt loops. All seams are underlined with stitching. The short coat very likely had a detachable cloth or fur collar since two lines of buttons remain on the inside, at the sides of the fastening. It must have also had a hood, as evidenced by two small buttons sewn onto the detachable part of the collar at the nape of the neck.

All of these elements characterise the short coat as a sporty coat, in line with the tastes of the second half of the 50s.

Origin: Manfredini family, from the wardrobe of Elisabetta Salvarani Manfredini Reference: photography, Max Mara S/S 1957 short coat, Archivio d'Impresa Max Mara E.M.

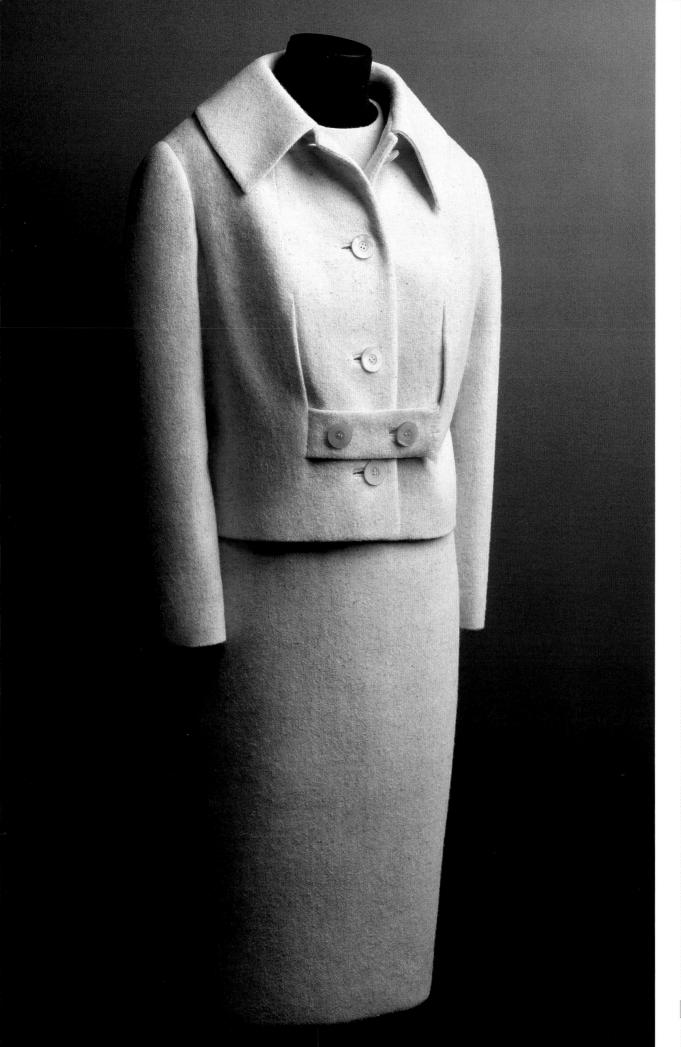

Max Mara Dress and Jacket Outfit c. 1958

Materials: white and hazelnut Shetland *chiné* twill; white taffeta lining, white resin buttons

Suit composed of a straight jacket, fitted in the front with darts and cuts, and a one-piece sheath dress with ring collar and long sleeves. The straight-cut dress has uncut waist darts that join the fabric and lining: a solution more typical of industrial production than the hand-tailoring of the time. The decorative faux belt motif, inspired by Balenciaga, was presented by Max Mara in autumn 1958 and spring 1959. This model was made exclusively for Al Duca d'Aosta shop in Venice, as shown on the label. E.M.

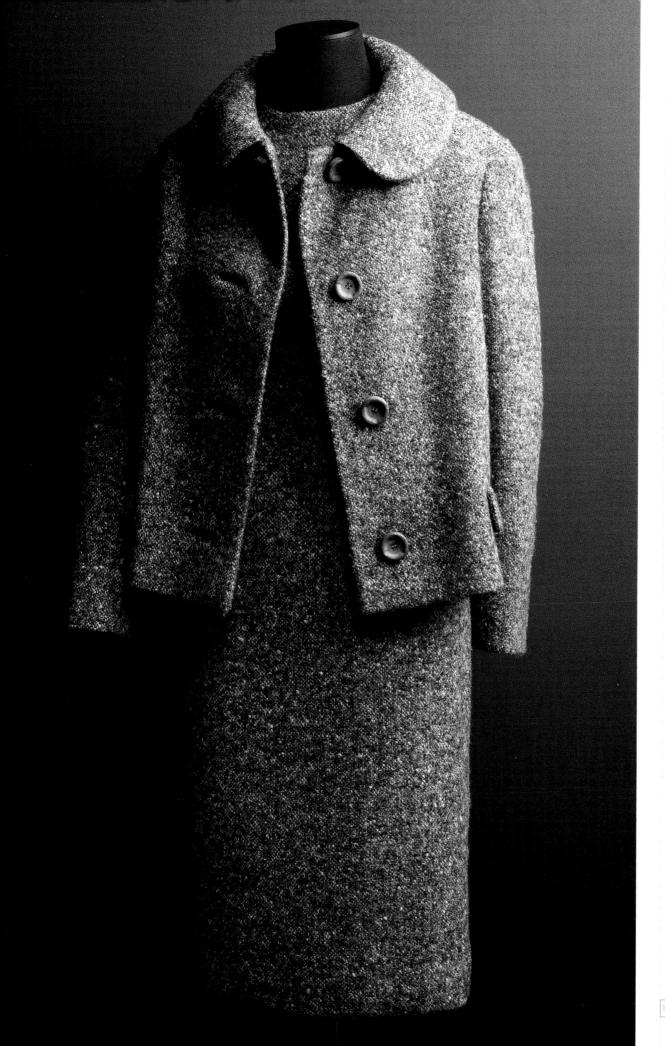

Max Mara Dress and Jacket "Dana" Outfit c. 1958

Materials: *mélange* knickerbocker in white and shades of brown; hazelnut taffeta lining, brown resin buttons

Two-piece outfit composed of a straight jacket with a round collar and big buttons, inspired by the trend-setting fashion in Paris in the second half of the Fifties, and a one-piece dress with ring collar and long sleeves. The straight-cut dress has uncut darts at the waist that join the fabric and lining, a solution that was not adopted by contemporary hand-tailoring but definitely used in industrial production.

The model was sold exclusively to Al Duca d'Aosta shop in Venice, as is evident from the label.

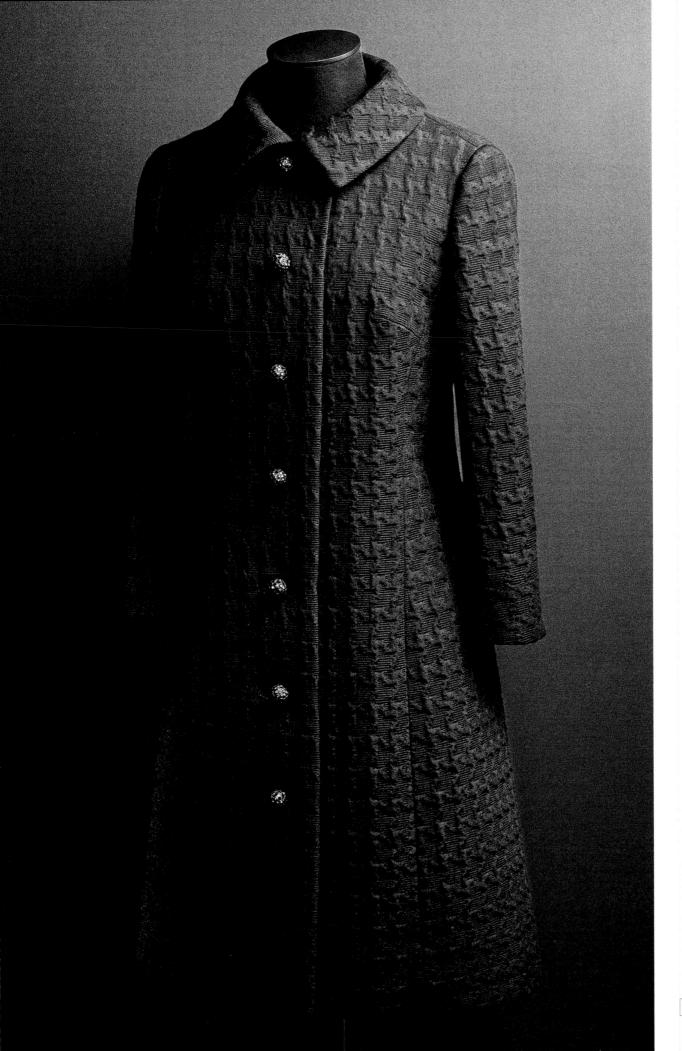

Max Mara Manteau F/W 1965-1966

Materials: houndstooth black wool matelasse (by Lanificio Ferrarin); black taffeta lining, spherical buttons covered with black jet

The elegant manteau on the lines of a redingote, in worked fabric and fastened with jewelled buttons, was very fashionable in the second half of the Sixties. Max Mara presented it in different colours and fabrics at a number of collections, varying the collar and fastenings in both winter and spring versions.

Provenance: donated by Isabella Ludovica Ghini to the Archivio d'Impresa Max Mara, formerly in Natalia Saldina's wardrobe Reference: "Fabric Book", 1965, Archivio d'Impresa Max Mara

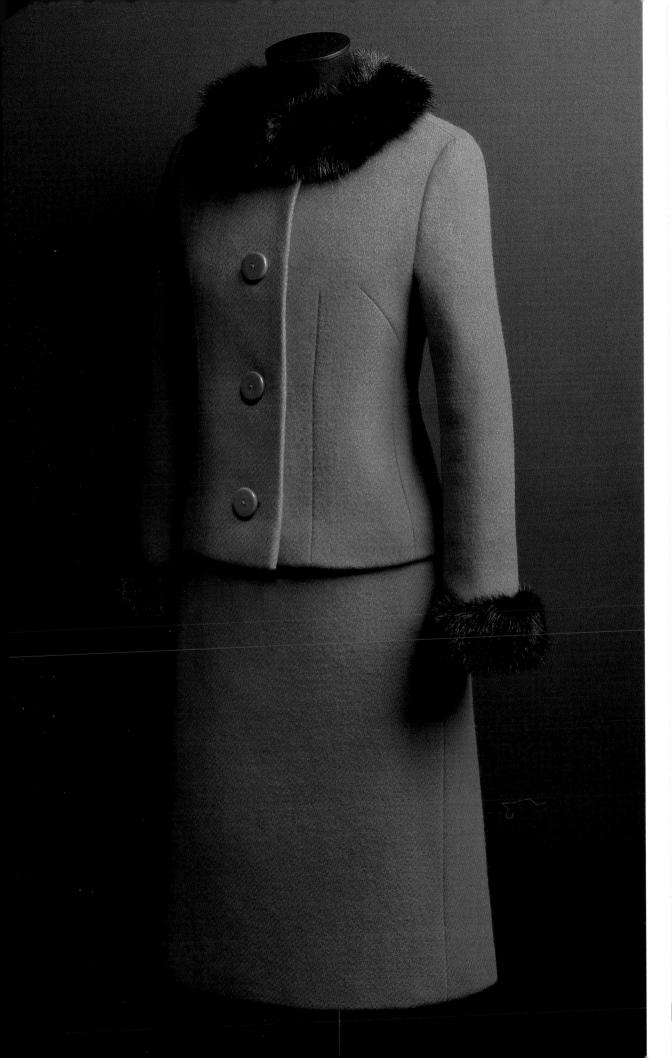

Max Mara "Fabian" Suit c. 1963

Materials: red Shetland twill; red shot taffeta lining, red resin buttons, mink

Sack-line suit composed of a flared skirt and short, single-breasted jacket with ring collar. This model, characterised by ornamental details such as the large buttons and fur trim on the cuffs and round collar, was inspired by contemporary haute-couture creations by Givenchy and Cardin, but also the style set by Jacqueline Kennedy.

Provenance: donated by Giovanna Simonazzi to the Archivio d'Impresa Max Mara E.M.

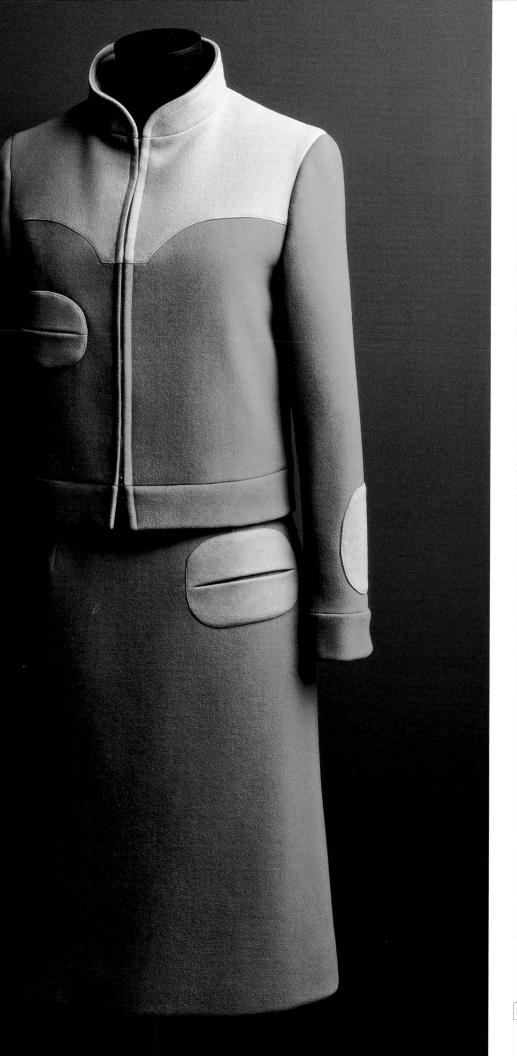

Max Mara Pop collection Suit 256107 "Saton" F/W 1967-1968

Sketch by Colette Demaye Materials: grass and apple green wool cloth; green taffeta lining

Various models in the Pop Fall and Winter 1967–1968 collection had inserts and appliqués in contrasting colours. The sharp tones and unusual combinations were typical of pop fashions, especially the psychedelic style. The trimming on the jacket and the zip fasteners, inspired by male military uniforms, were a novelty in younger fashions.

Reference: original sketch, Archivio d'Impresa Max Mara E.M.

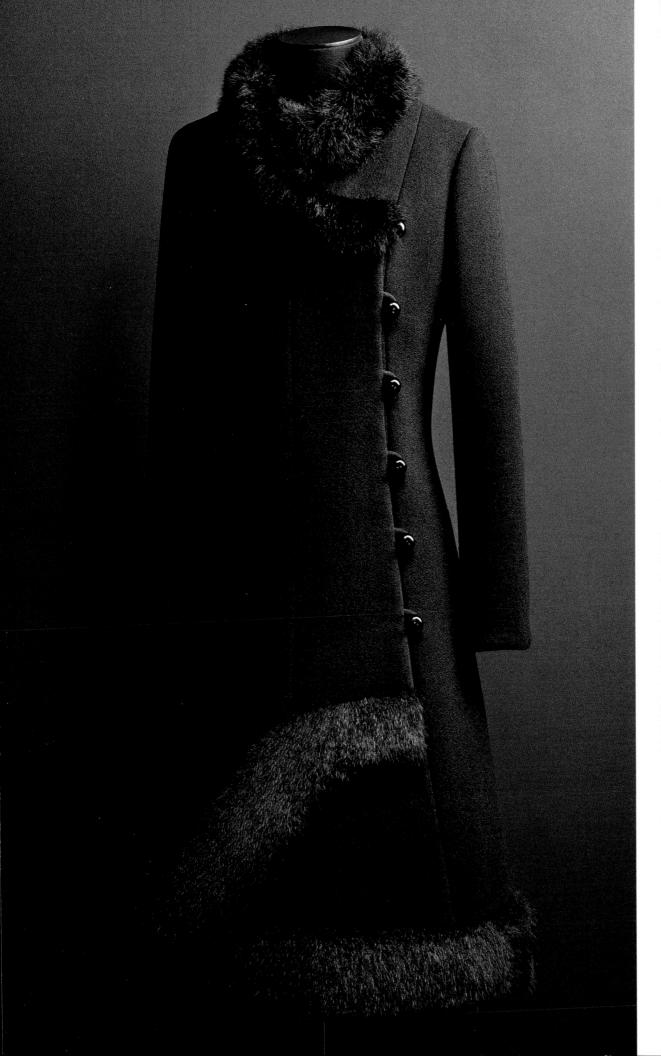

Max Mara Pop collection F/W 1968-1969 Coat 216148

Sketch by Colette Demaye Materials: black wool *crēpe*, black taffeta lining, black opossum, black dome-shaped buttons

This elegant redingote with side button fastening, fur-trimmed neck and shaped hem, was one of the prizes in a Max Mara competition for readers run in conjunction with *Arianna* twice a year from 1960 to 1969.

Forty-nine of these models, accompanied by a patent leather Piccini handbag, were given as prizes in the F/W 1968-1969 season.

Provenance: Rosalia Piaia, winner of the 10th Max Mara "Referendum della moda" in *Arianna magazine*. Reference: original sketch, Archivio d'Impresa Max Mara Bibliography: *Arianna*, October 1968; *Amica*, 29 October 1968 E.M.

There are days on which it would be great to be a Max Mara overcoat.

Stéphane Bonvin, 2001

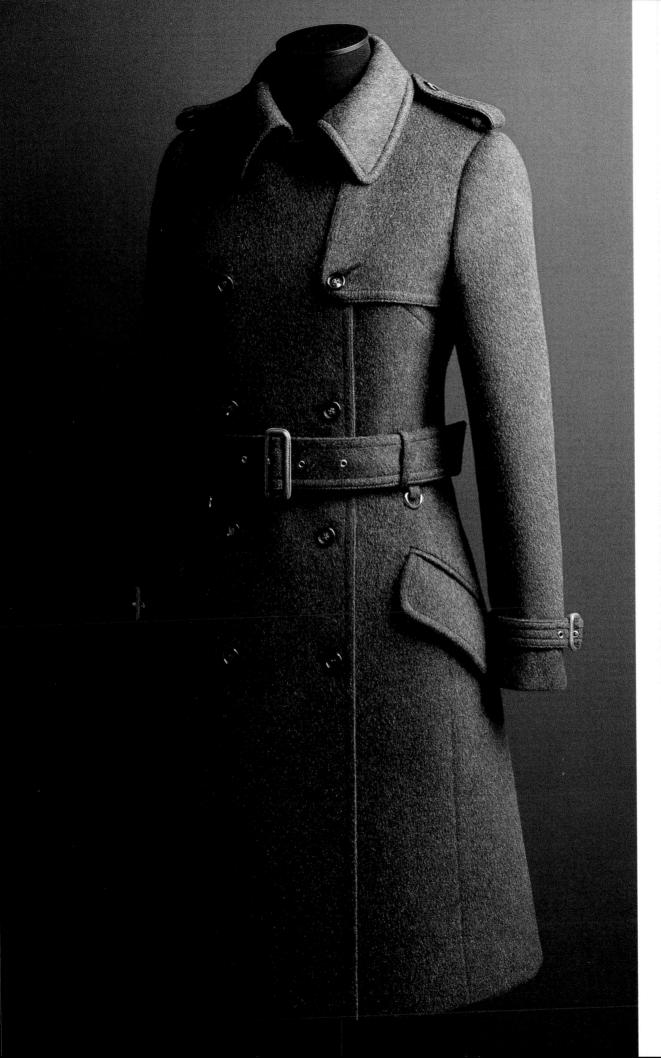

Sportmax Coat 216049 F/W 1969-1970

Sketch by Laura Lusuardi Materials: green loden, green taffeta lining, leather buckles

This short coat was presented in the first Sportmax collection, which offered a range of mix–and– match coordinates (coats, jackets, skirts, trousers, sweaters, blouses).

Conceived on the lines of a trench coat, it features all the most military details, such as the epaulettes, wrist straps, buttoned cape, inverted pleat and buttoned vent at the back, and even the rings on the belt that during World War I – when the trench coat was introduced – were used to attach hand grenades!

Provenance: donated by Laura Lusuardi to the Archivio d'Impresa Max Mara Reference: original sketch, Archivio d'Impresa Max Mara Bibliography: *Amica*, 29 October 1969; *Grazia*, October 1969, pp. 86–87 E.M.

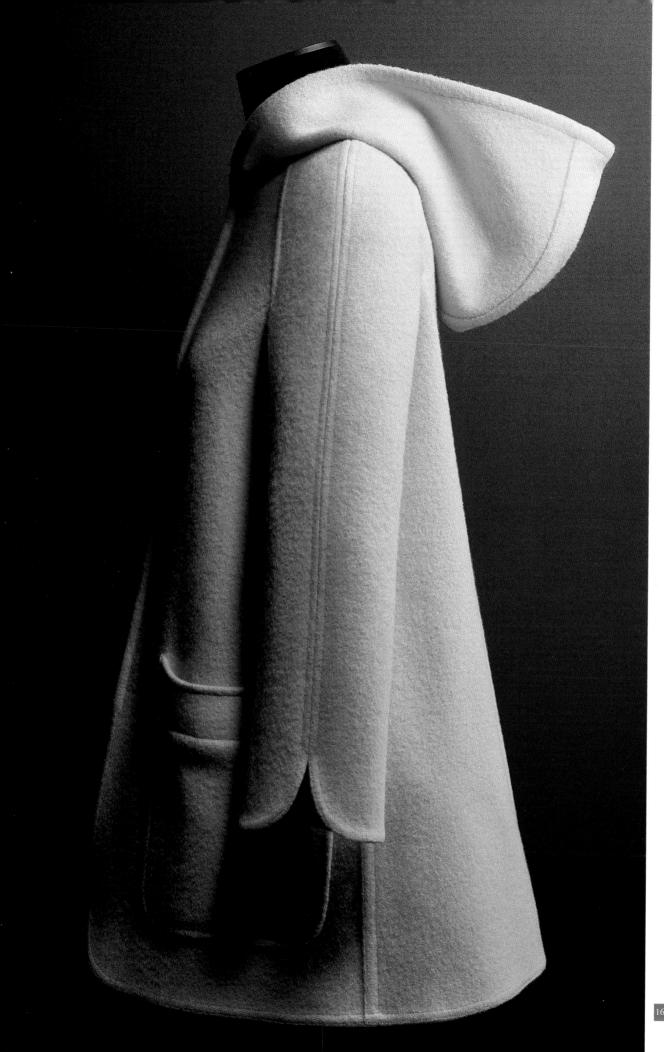

Max Mara "York" Long Jacket F/W 1971-1972

Sketch by Karl Lagerfeld Materials: teased yellow wool cloth

Trapeze jacket with hood and raglan sleeves, characterised by rounded hems accentuated by stitching. The jacket is completely lined and the stitching – done with special machines for double-face fabric – is accentuated in the manner of a French seam. This collection was characterised by models in bright-coloured fabrics that are rather unusual for the cold

Reference: original sketch, Archivio d'Impresa Max Mara Bibliography: *Arianna*, October 1971; Pia Soli, *Il genio antipatico*, Mondadori, Milan 1984, p. 343; G. Butazzi, A. Mottola Molfino, Italian Fashion: From Anti-Fashion to Stylism, Electa, Milan 1987, p. 41 E.M.

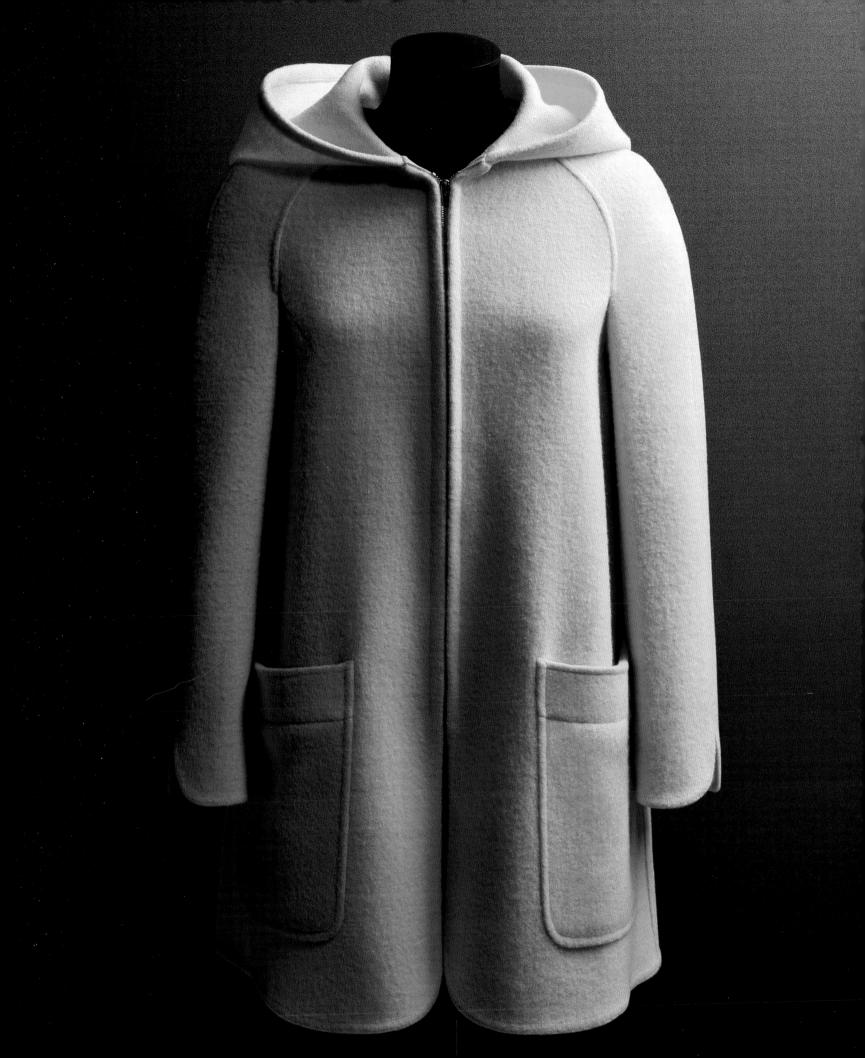

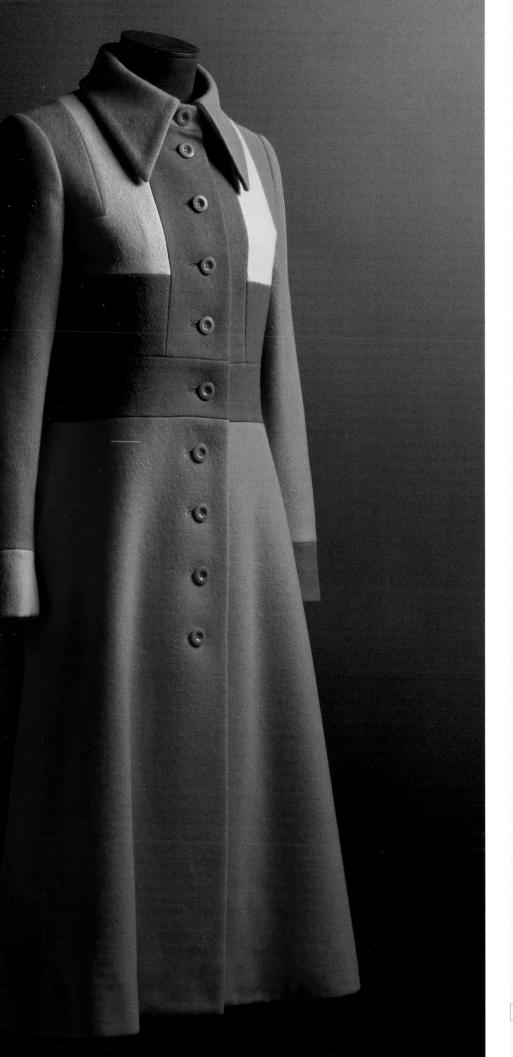

Sportmax Coat F/W 1971-72

Sketch designed by Laura Lusuardi Materials: red wool cloth, yellow wool cloth, green wool cloth, electric blue wool cloth, red taffeta lining, red round buttons

The coat, with a ten-button breast fastening, is clinched at the waist. The bodice has a close fitting line and features a false waistcoat achieved by inlaying geometric cloths of different colours. Green is used for the belt and fly front, blue for the central band, yellow for the top part. The detachable shirt collar ("collar band") is made from red cloth, as are the inset sleeves, finished off with two contrasting cuffs – one yellow and one blue. The skirt is made from four cloths and is flared.

The model is typical of the young pop fashion that characterised the end of the 60s and the start of the 70s.

Reference: original sketch, Archivio d'Impresa Max Mara

Bibliography: *Gioia*, 29 October 1971 E.M.

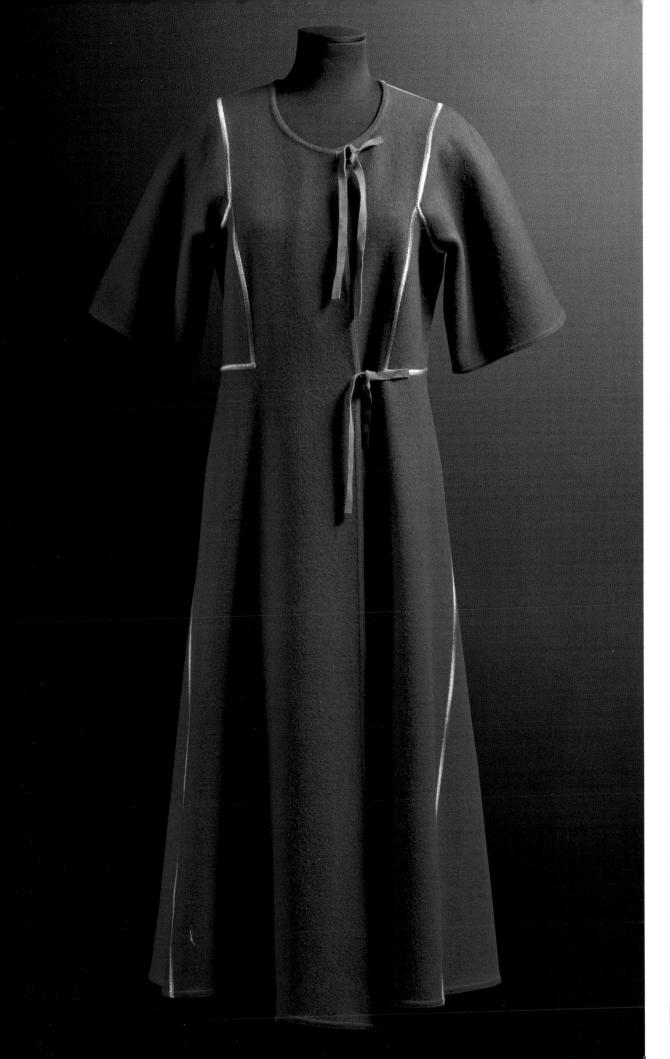

Sportmax Coat F/W 1971-72 Sketch designed by Nanni Strada Materials: blue-violet orbace wool, purple leather, blue and yellow shaded cotton thread

Double-breasted coat without lapels, fastened with two leather ties tied at the neck and waist. The unique style of this model lies in the idea of tailoring the garment with flat, geometrical cloths. The front of the coat is made with two symmetrical cloths cut diagonally from the shoulder to the waist where they broaden to form a triangle that slip into the rear part. The back of the coat is made from a central overturned trapezium panel. A triangular panel and a quadrangular panel are sewn onto the sides of this panel (on the skirt). Two small quadrangular pieces of cloth are inserted on the sides of the chest, under the armpits. The sleeves are fitted at an angle and are wide and to the elbow. All seams joining the cloth as well as the inner trim on the front and sleeve hem are "welded" (two-needle stitching with lower or upper cover) created with machines tweaked by Rimoldi. The system, derived from knitwear tailoring, was studied with Nanni Strada. The use of shaded cotton thread transforms the seams into decorative element and highlights the structure of the garment. The model is the fruit of research into ethnic clothing that Nanni Strada was conducting in those years in a text by Max Tilke, published in Berlin in 1923; Orientalische Kostüme in Schnitt und Farbe.

Origin: Archivio Nanni Strada Reference: original sketch, Archivio Nanni Strada Bibliography: "Il design nella moda. Da nuove tecniche industriali nasce un diverso modo di vestire", Vogue Italia, November 1971; Tommaso Trini, "Abitare l'abito", Domus, May 1972 E.M.

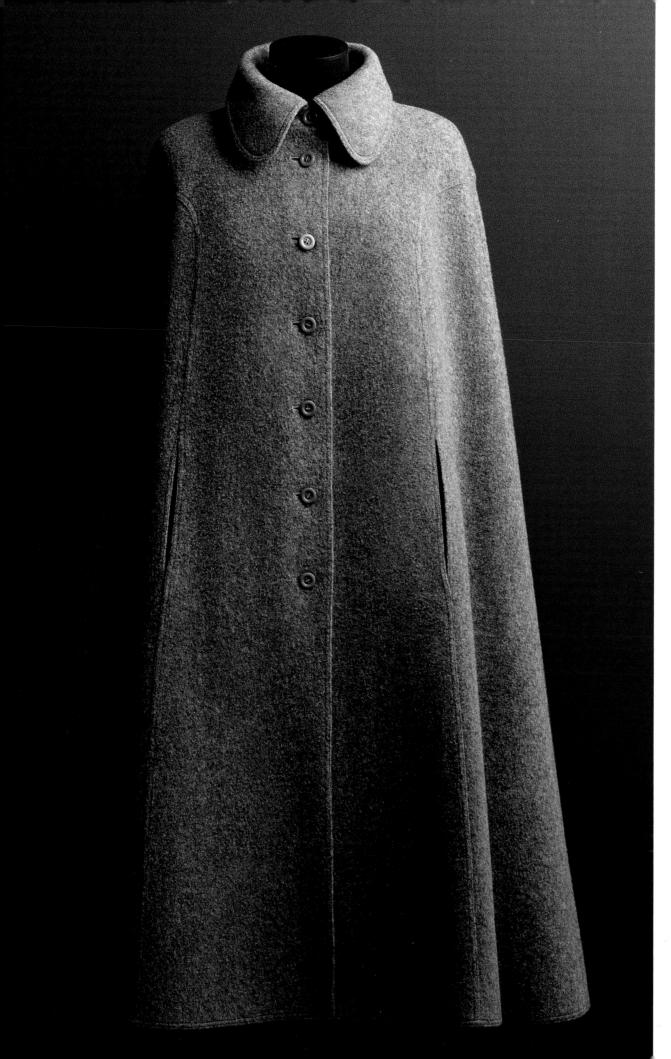

Max Mara Manteau F/W 1971-1972

Sketch by Karl Lagerfeld Materials: grey teased wool *chiné*

Manteau cut on the bias with princess front constructed in such a way that the two central sections model the shoulders. The back, with a shaped, pointed cape, is composed of two sections that extend to form the sides.

The garment is completely unlined and the accentuated stitching was done with special machines for double-face fabric.

Provenance: Fernanda Urizzi Reference: original sketch, Archivio d'Impresa Max Mara E.M.

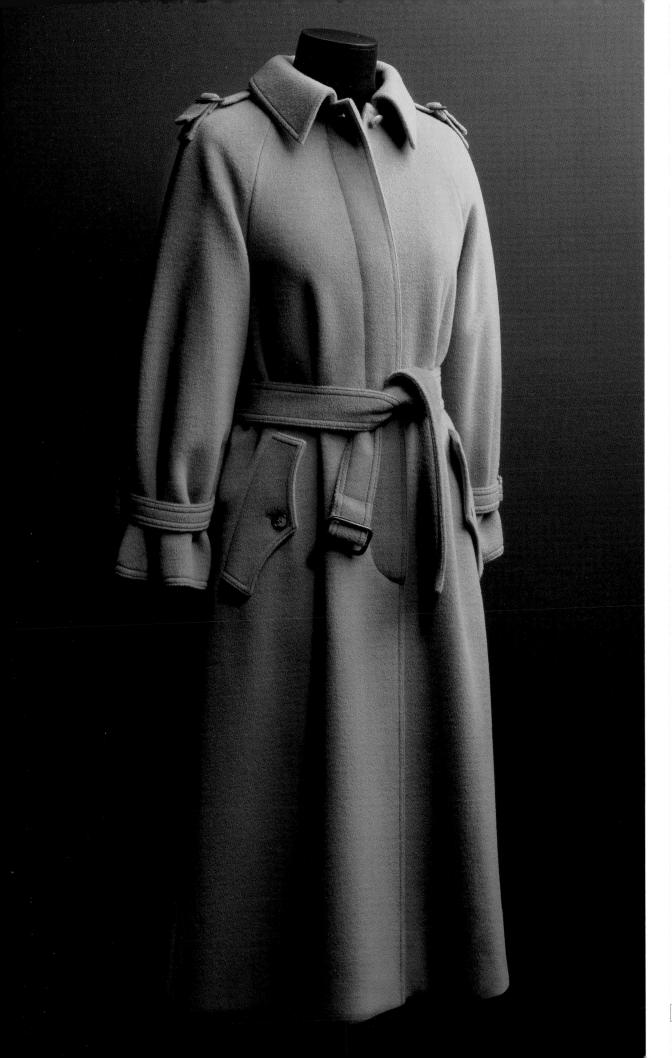

Max Mara Coat 017206 F/W 1976-1977

Sketch by Luciano Soprani Materials: wool and cashmere "beaver" (by Lanificio Piacenza); brown taffeta lining, brown leather buckles

This camel coat was chosen as the advertising icon of the F/W 1976-1977 collection. Made from a cashmere blend fabric, it was a reworking of the ample classic trench coat with *epaulettes*, wrist straps, pocket flaps, inverted pleat with buttoned vent at the back, buckle belt and concealed fastening.

References: original sketch and advertising poster for the Max Mara F/W 1976-1977 collection (photos by Sarah Moon), Archivio d'Impresa Max Mara E.M.

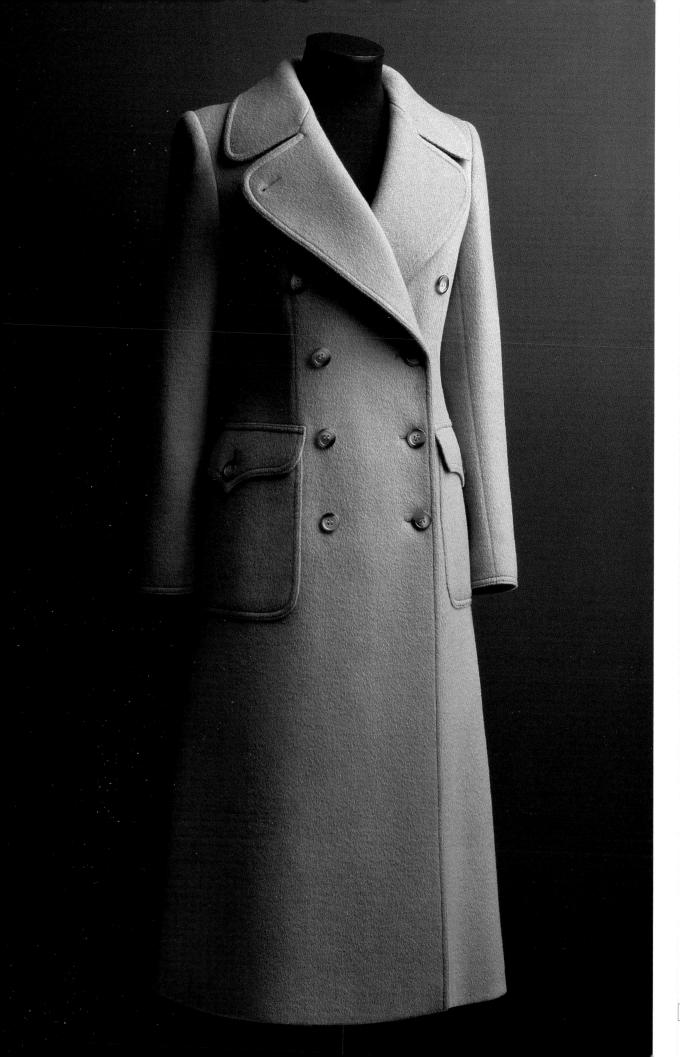

Max Mara "Delfi" Coat 016146 F/W 1976-1977

Sketch by Luciano Soprani Materials: camelhair drap; beige taffeta lining

Pure camelhair, double-breasted coat with wide revers, appliqué pockets and a three-piece half-belt at the back that secures an inverted pleat with a central vent, and two side pleats. This model, a female version of the male overcoat, is the classic example of the Max Mara coat in soft camelhair.

Provenance: donated by Roberta Vezzani to the Archivio d'Impresa Max Mara Reference: original sketch, Archivio d'Impresa Max Mara

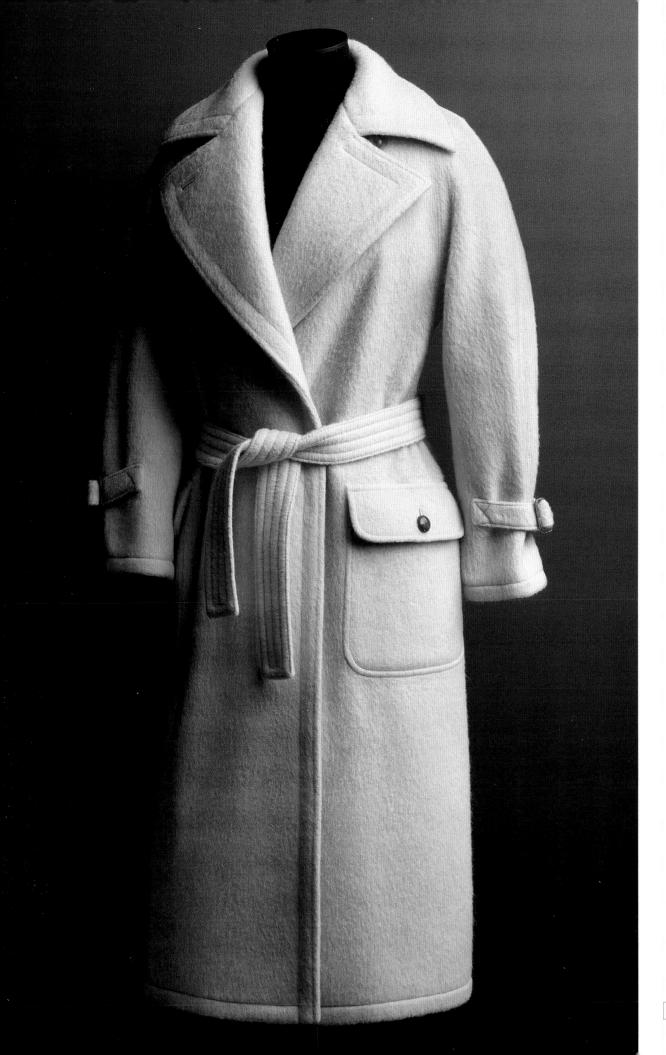

Max Mara "Lidia" Coat 017147 F/W 1977-1978

Sketch by Laura Lusuardi Materials: white wool cloth; brown plaited leather buttons, leather buckles

Coat with wide lapel collar, appliqué pockets, raglan sleeves and inverted pleat with vent at the back. Completely unlined, this model combines features inspired by the trench coat and the wraparound style so popular in the Seventies, such as the open front and tie belt.

Reference: original sketch, Archivio d'Impresa Max Mara E.M. It was one of those splendid items of clothing that understand the entire history of the life of a woman: her sentiments, affections, passions, dreams and moments of madness. An article that you wear till the very end and never give away to anyone.

Gustave Flaubert, 1845

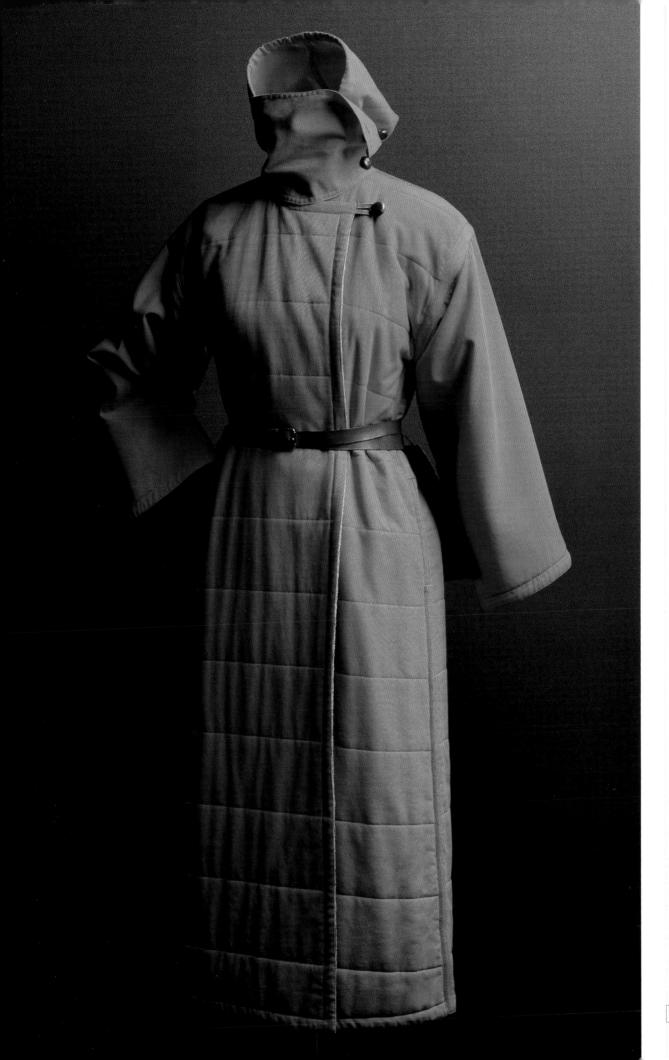

Sportmax Coat 217356 F/W 1976-1977

Sketch by Jean Charles de Castelbajac Materials: red cotton fabric, teased brown speckled wool cloth, red cotton trimming; brown plaited leather buttons, double belt in brown leather with two pockets and loops

This long straight coat is "double face", with cotton cloth on one side and wool on the other. The two fabrics are joined by parallel rows of stitching on the front and back. The shoulder, side and armhole seams are covered with matching trimming. Castelbajac drew his inspiration from technical wear and this is particularly evident in the hood with adjustable coulisse fastening and the high collar with three-button side closure.

References: original sketch and poster, advertising campaign, runway photos of the F/W 1976–1977 collection (photos by Sarah Moon), Archivio d'Impresa Max Mara Bibliography: *Amica*, 2 September 1976 F M

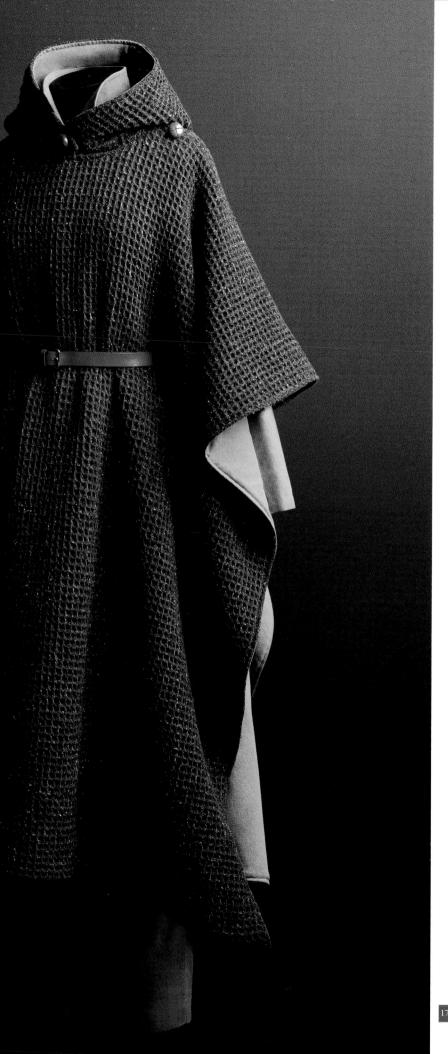

Sportmax Poncho and Jumpsuit Outfit F/W 1976-1977

Sketch by Jean Charles de Castelbajac

Poncho 216016 Materials: Honeycomb wool piqué with brown speckled tweed effect (produced by Palandri), green cotton cloth, brown plaited leather buttons, brown leather double belt

Jumpsuit 387166 Material: green cotton cloth

This outfit, presented at the Sportmax F/W 1976-1977 runway show, is inspired by technical wear. In fact, it combines straight overalls with a shirt collar and closure, coulisse fastening at the waist and appliqué pockets, with a large hooded poncho reminiscent of the waterproof capes worn by seamen and soldiers. Rectangular in shape, the poncho has four holes for the belt and two loops so that it can be rolled up on the shoulders. The materials, honeycomb piqué wool and heavy cotton cloth, are most unusual in female ready-to-wear.

References: original sketch and runway photos of the F/W 1976-1977 collection, Archivio d'Impresa Max Mara E.M.

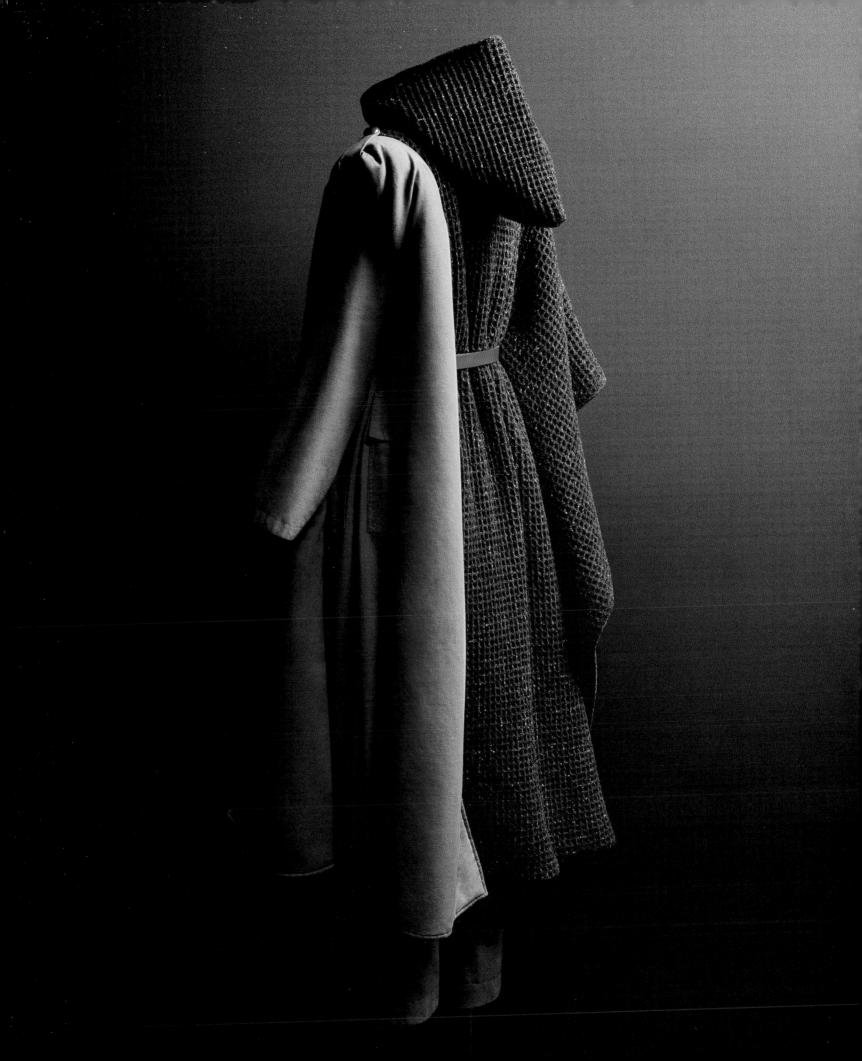

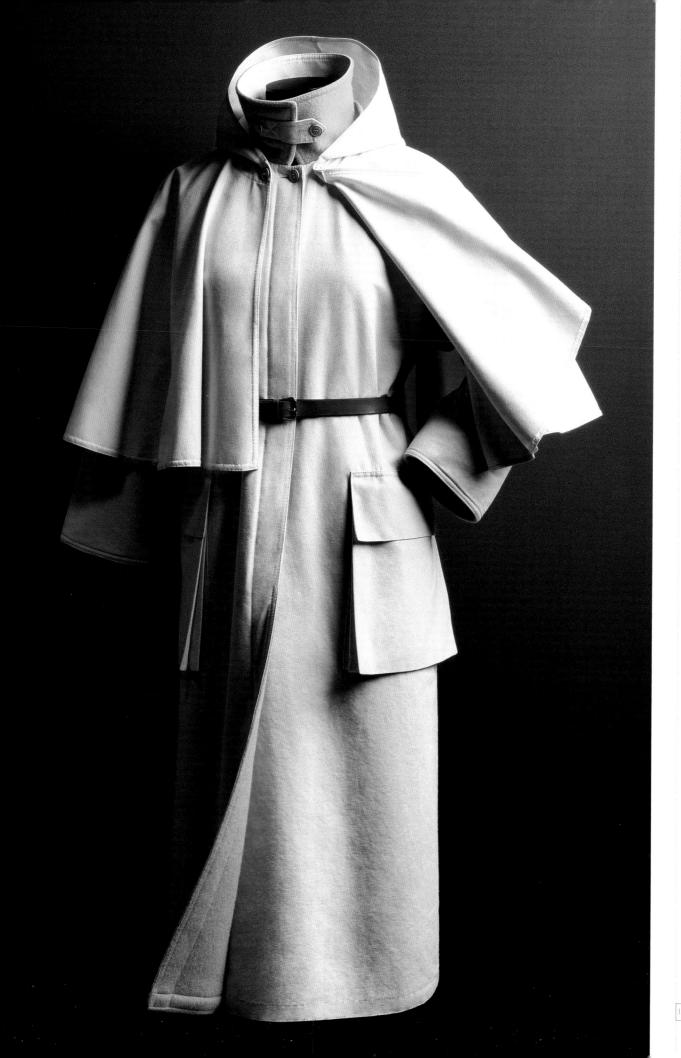

Sportmax Coat 216247 F/W 1977-1978

Sketch by Jean Charles de Castelbajac Materials: raw cotton cloth, teased yellow wool flannel, double leather belt

This straight coat in raw cotton cloth lined with yellow flannel, is reminiscent of the traditional dust coat and typifies the research on technical wear. It has kimono sleeves, a concealed closure, raincoat collar and appliqué bellows pockets. A hood and long circular cape are buttoned to the collar lined with yellow wool, which has a loop fastening.

References: original sketch and runway photos of the F/W 1977-1978 collection, Archivio d'Impresa Max Mara F M

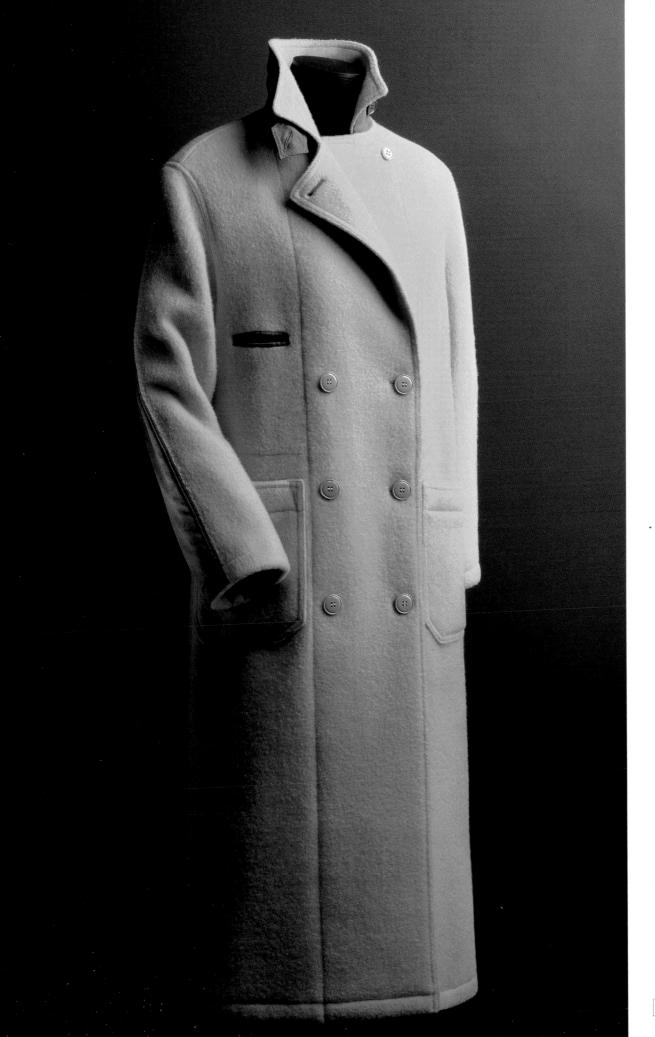

Sportmax Coat 217237 F/W 1977-1978

Sketch by Jean Charles de Castelbajac Materials: teased yellow wool flannel, dark green cotton cloth, red and yellow thread, yellow resin buttons

Straight double-breasted coat with back vent, characterised by bright colours and unusual fabrics. Inspired by the dust coat and military wear, it incorporates a series of functional details taken from these, such as the loop on the back of the collar for fastening the lapels, the sleeve patches, and the small loop pocket, all highlighted by the use of green cloth.

Reference: original sketch, Archivio d'Impresa Max Mara F.M.

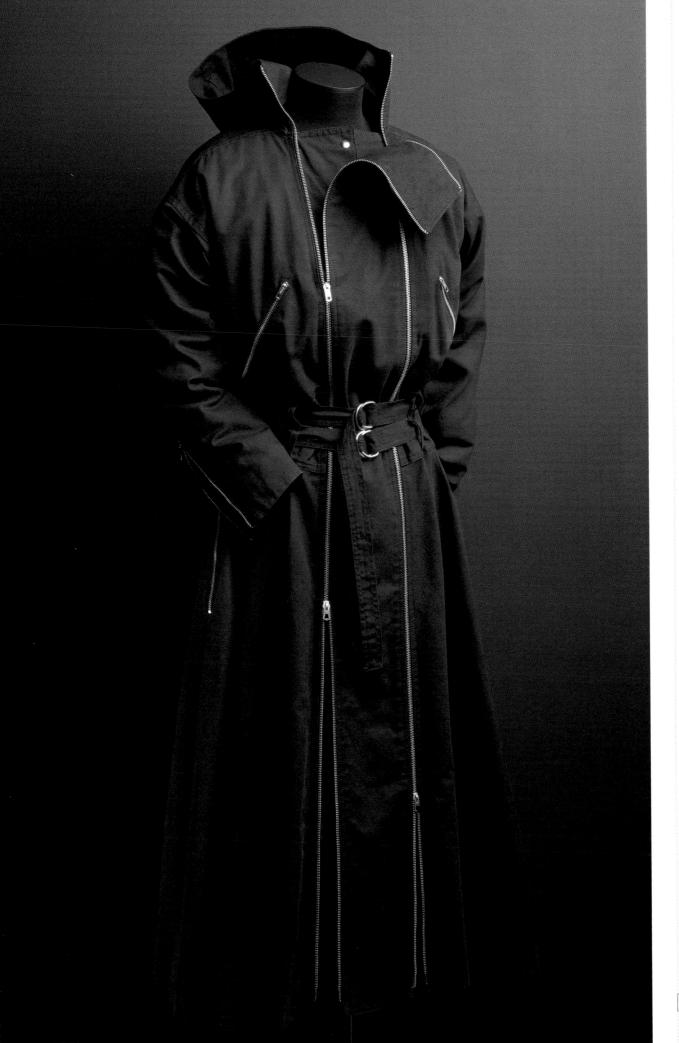

Sportmax Coat 216067 F/W 1977-1978

Sketch by Jean Charles de Castelbajac Materials: black padded cotton cloth with lozenge quilting

Several of the details of this long cotton cloth coat are borrowed from sports and technical wear, such as the bodice padding, the corset belt with straps and the zips on the pockets, cuffs and panel covering the fastening at the front.

References: original sketch and runway photos of the F/W 1977-1978 collection, Archivio d'Impresa Max Mara E.M.

Max Mara is the symbol of a utopian dream, of high quality clothing for everyone.

Quirino Conti

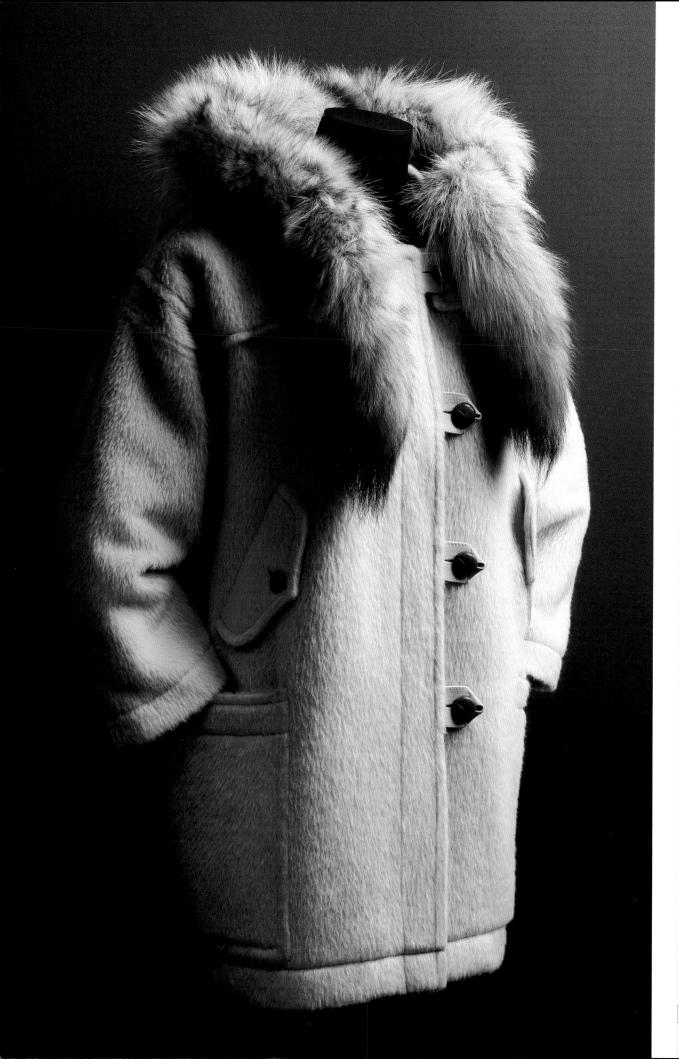

Sportmax "Palù" Jacket 247017 F/W 1977-1978

Sketch by Laura Lusuardi Materials: white long-hair alpaca and wool (by Lanificio Cangioli), coyote tails, brown plaited leather buttons, white leather loops

This amply proportioned jacket modelled on the duffle coat has an *appliqué* cape and large pockets with loop fastenings. Traditionally, wool cloth is used for such a garment, but here it has been substituted with an alpaca fabric that makes it softer and more plush. The sporty look of the cape is accentuated by the coyote tail border on the hood.

Provenance: donated by Laura Lusuardi to the Archivio d'Impresa Max Mara Reference: original sketch, Archivio d'Impresa Max Mara E.M.

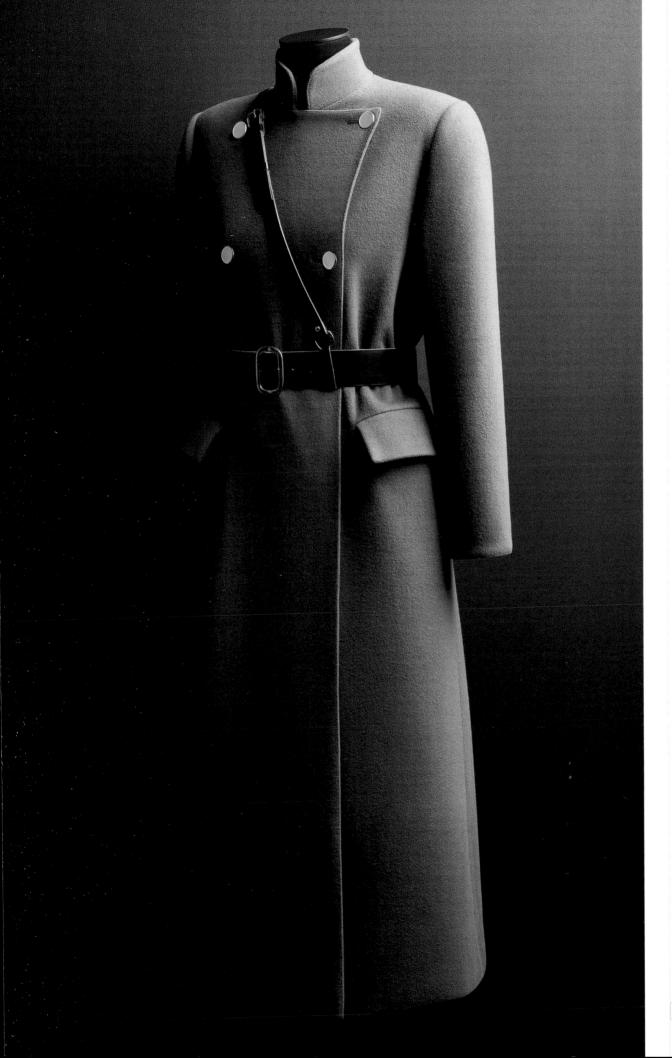

.....

Coat F/W 1978-1979

Sketch by Odile Lançon Materials: marron glace wool (cocoa), rust cotton cloth lining, round gilt metal buttons, black unfinished shoulder belt with burnished metal buckles

The F/W 1978-1979 collection was characterised by a military style. In particular, this long light-brown straight coat was inspired by historical army officers' uniforms, not only as regards the style but also details such as the mandarin collar, the button fastening and the shoulder belt held in place by a central buttoned loop at the back.

References: window display and advertising campaign for the F/W 1978-1979 collection, Archivio d'Impresa Max Mara E.M.

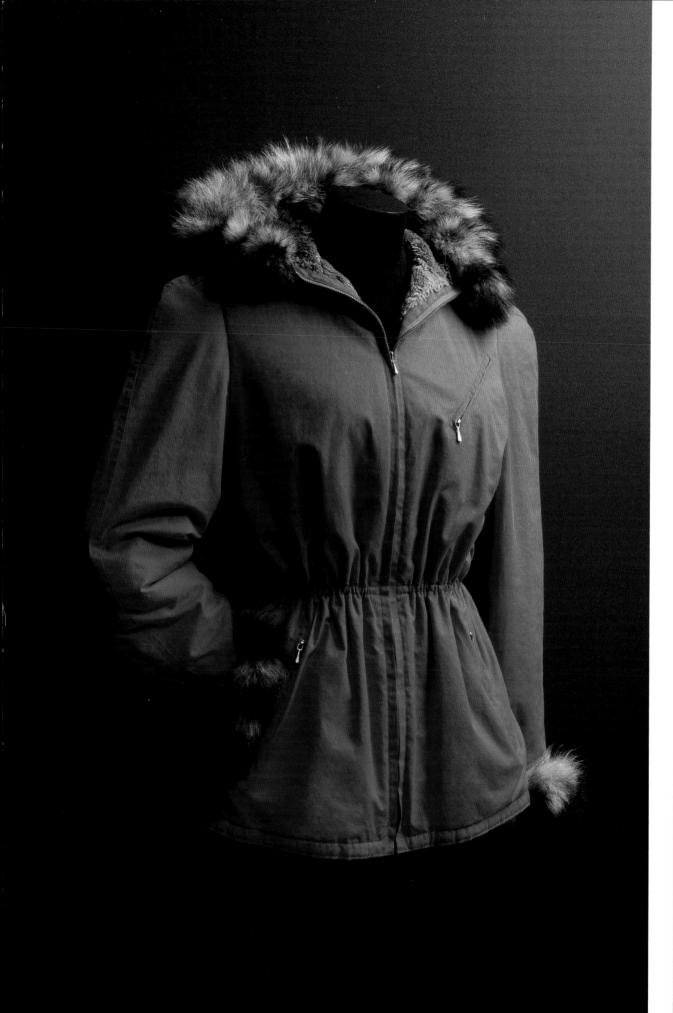

Sportmax Jacket 2046089 F/W 1979-1980

Sketch by Odile Lançon Materials: red cotton poplin, beige-grey faux fur, marmot tails

This red poplin jacket lined with faux fur has a zip and coulisse fastening at the waist; the cuffs and hood are edged with real marmot. The model is inspired by the ski jackets worn by the elegant crowd who patronised Cortina in the Thirties.

With this refined revival Sportmax made casual fashion its own, though it had already introduced sporty models with technical features into its urban wear.

Reference: original sketch, Archivio d'Impresa Max Mara E.M. An overcoat is the first refuge. Anne Marie Beretta, 2006

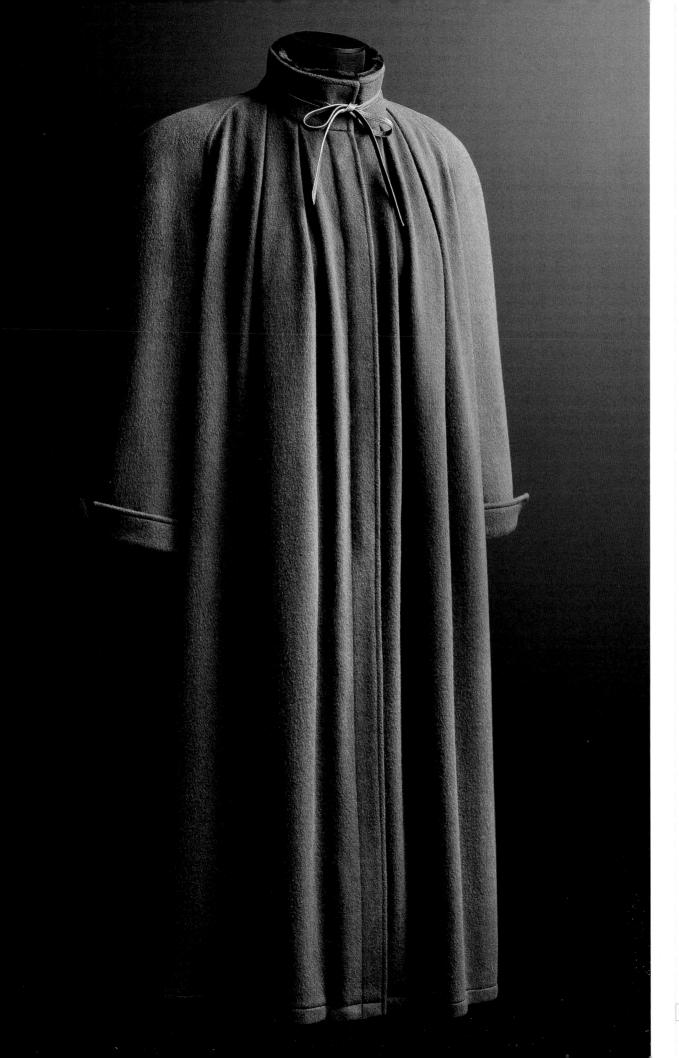

Max Mara Coat 1019168 F/W 1978-1979

Sketch by Anne Marie Beretta Materials: brown wool cloth, brown taffeta lining, brown leather, brown synthetic fur

This wide coat, with raglan sleeves and stuffed *epaulettes*, has groups of pleats around the neck, both on the front and the back. The feminine look of this model is enhanced by the high collar, padded with fur and fastened by a thin leather lace to tie in a knot.

Reference: original sketch, Archivio d'Impresa Max Mara E.M.

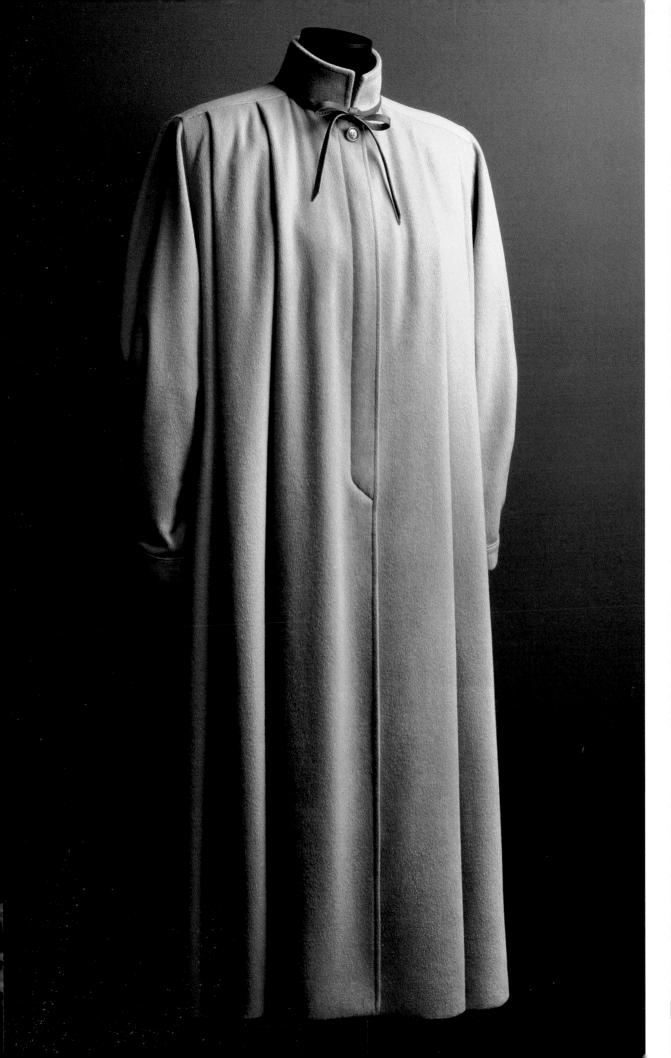

Max Mara Coat 1019028 F/W 1978-1979

Sketch by Anne Marie Beretta Materials: camelhair cloth, brown leather

The coat is designed on rectangular lines to accentuate the well-padded shoulders and the pleats which, falling from the small cape, create fullness both in the front and the back. The concept for this model is new with respect to the classic camel coats based on the man's overcoat, and the only ornament is the narrow leather tie thong on the high collar. The shape and style, which accentuate the upper part of the body, anticipated a trend typical of the Eighties.

Reference: original sketch, Archivio d'Impresa Max Mara

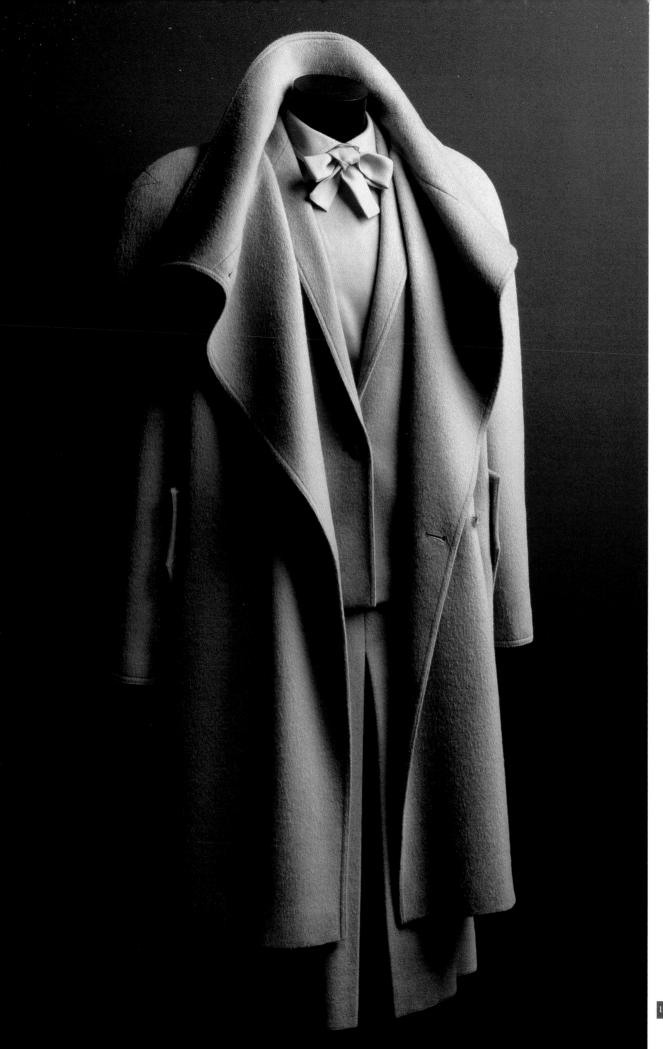

Max Mara Coat, Suit and Blouse Outfit "Nuccia" 1266019 F/W 1979-1980

Sketches by Anne Marie Beretta

Coat

Materials: pure camelhair drap; hazelnut taffeta lining

Culotte suit

Materials: pure camelhair drap; hazelnut taffeta lining

Blouse

Materials: pale pink wool and silk twill

The outfit consists of a camel coat, a suit, and a pink blouse. The double-breasted, egg-shaped coat has raglan sleeves and a band collar with handkerchief opening. The inverted pleat in the back is secured both at the top and just

above the hemline.
The straight, single-breasted jacket has narrow revers, set-in sleeves and an inverted pleat similar to that of the coat. The culottes, with stitching on the waistband and a side closure, have inverted pleats that disguise the divided skirt. The shape of the coat and jacket is created mainly by the padded shoulders. There are triangular stitching details on the pockets of the jacket and culottes,

of the Jacket and culottes, the shoulders of the coat, and the back inverted pleat in the two outerwear garments.

The masculine blouse is fastened by a single button on the left shoulder and has a small rose-coloured bow-tie at the neck.

Reference: original sketches, Archivio d'Impresa Max Mara F M

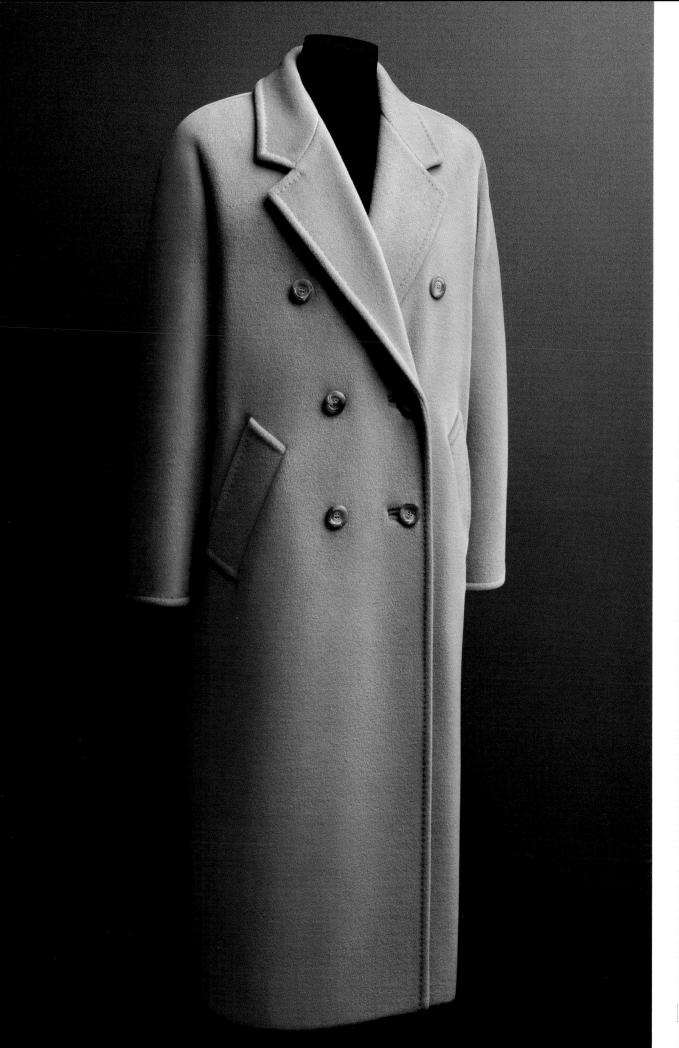

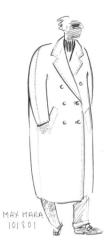

Max Mara Coat 101801 F/W 1981-1982

Sketch by Anne Marie Beretta Materials: wool and camel-colour cashmere "beaver"; viscose lining with Max Mara logo, horn buttons

Double-breasted coat with six buttons, kimono sleeves and underarm gusset, finished with pick stitching. Slightly egg-shaped, with softly padded shoulders, model 101801 was designed in 1981. The coat here reproduced was produced in 1983 according to the original model of 1981, infact ever since, coat 101801 has been presented in sample collections as the coat-symbol of Max Mara's production, due to its balanced proportions and refined understatement.

Reference: original sketch, Archivio d'Impresa Max Mara M R

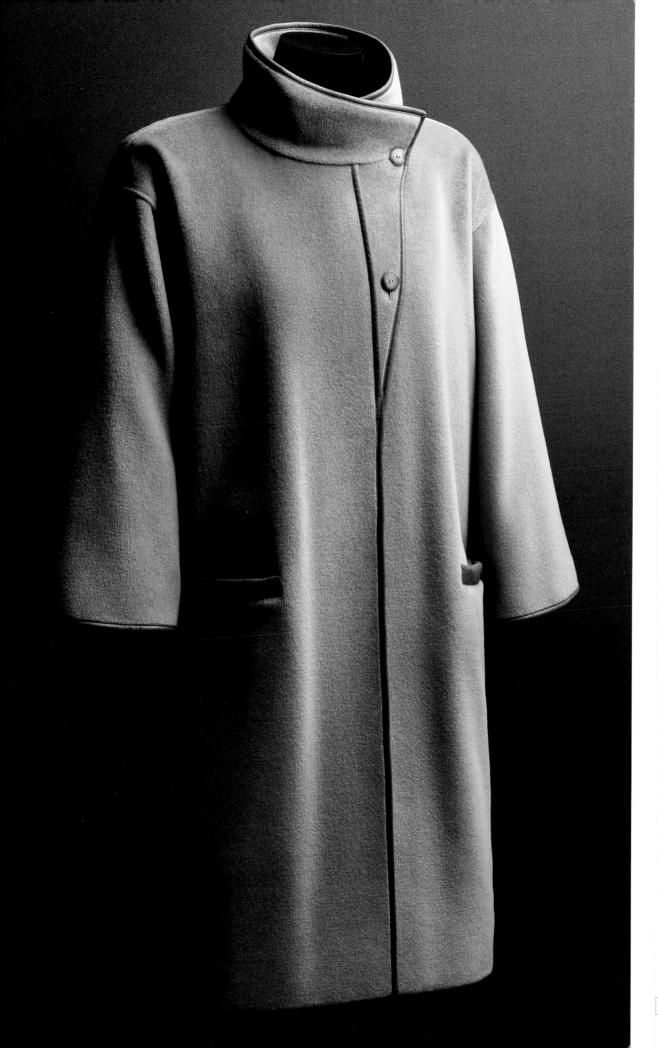

Max Mara Jacket 1047022 F/W 1982-1983

Sketch by Anne Marie Beretta Materials: wool and cashmere "beaver" (by Lanificio Piacenza); jacquard twill lining with Max Mara logo, leather.

An essential model with full, low, straight-cut sleeves, characterised by the asymmetrical closure on a triangular insert edged with leather. The large ring collar edged, like the pockets, with leather, can be left open.

Reference: original sketch, Archivio d'Impresa Max Mara Bibliography: *Vogue Italia*, 15 September 1982 M.R.

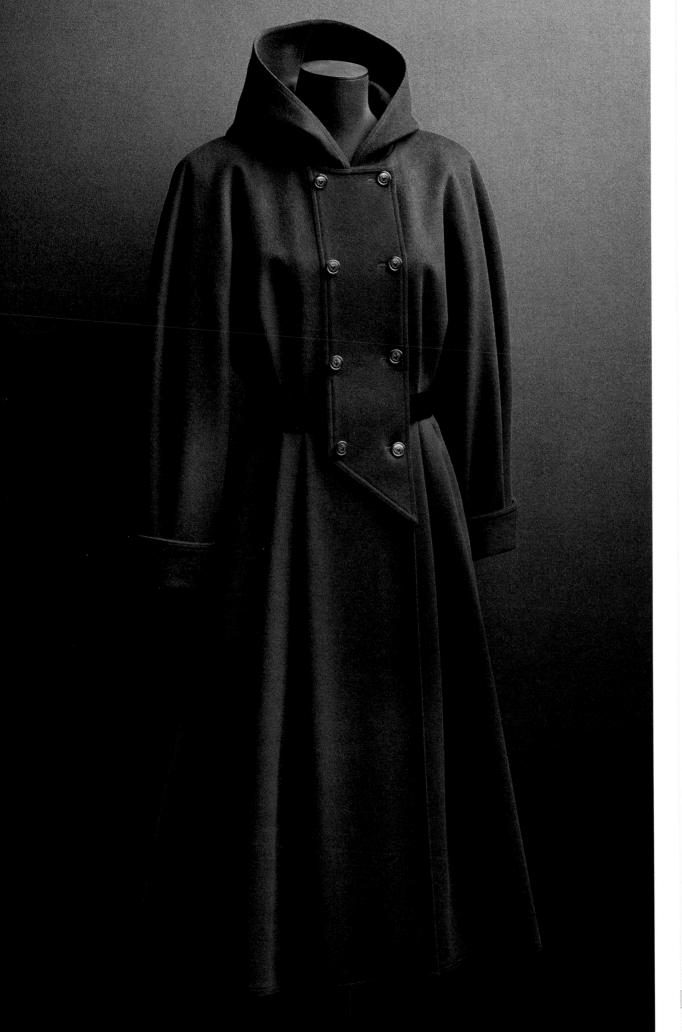

Max Mara Coat 1018602 "Genova" F/W 1982-1983

Sketch by Anne Marie Beretta Materials: dark blue wool cloth; blue taffeta lining, buttons with logo, blue leather belt with gilt rectangular metal buckle

This double-breasted, sporty coat is constructed very elaborately. Seamed at the waist, it has kimono sleeves with cuffs, a hood and belt with a flat metal buckle, probably inspired by military fastenings. The front of the skirt has fitted pleats while the back has two inverted pleats that become fuller at the hemline. There are two deep vents on either side. The buttons are printed with the monogram M framed by laurel branches.

References: original sketch and advertising folder for the F/W 1982-1983 collection (photos by Mike Yavel), Archivio d'Impresa Max Mara Bibliography: *Donna*, October 1982 E.M.

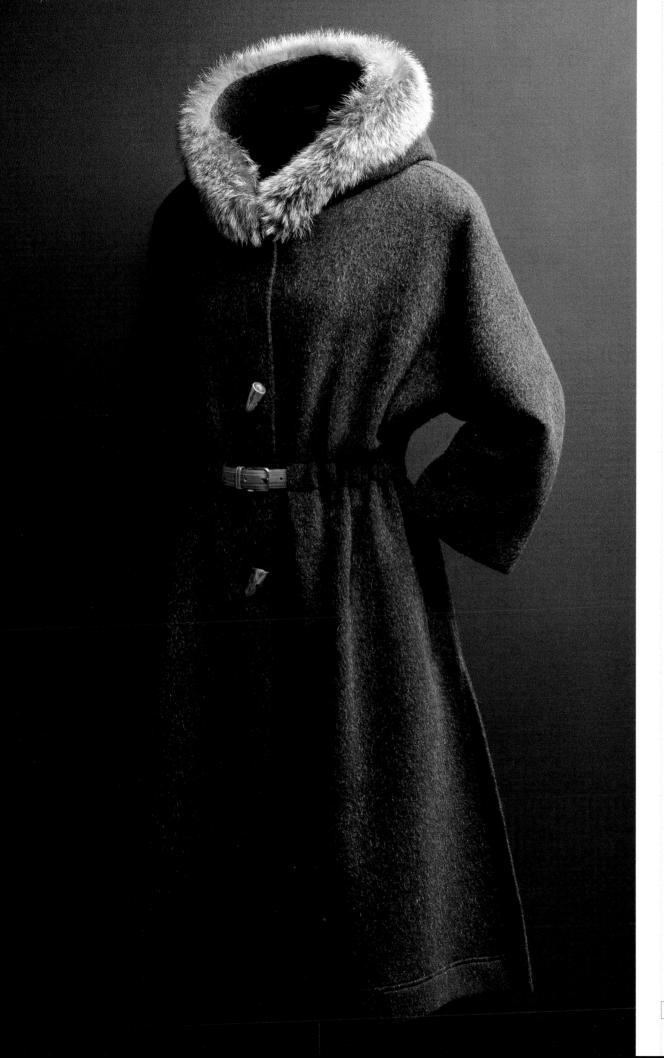

Max Mara Coat 1018512 "Garden" F/W 1982-1983

Sketch by Anne Marie Beretta Materials: green loden, horn buttons, fox fur

Straight-cut coat with hood and kimono sleeves, characterised by a coulisse at the waist, from which the cognac coloured belt emerges. The choice of fabric, the fox border on the hood and the use of horn buttons attached to the garment by a leather thong, are all typical of the Tyrolean style.

References: original sketch and advertising folder for the F/W 1982–1983 collection (photos by Mike Yavel), Archivio d'Impresa Max Mara Bibliography: Vogue Italia, dossier, July 1982, Grazia, 17 October 1982 M.R.

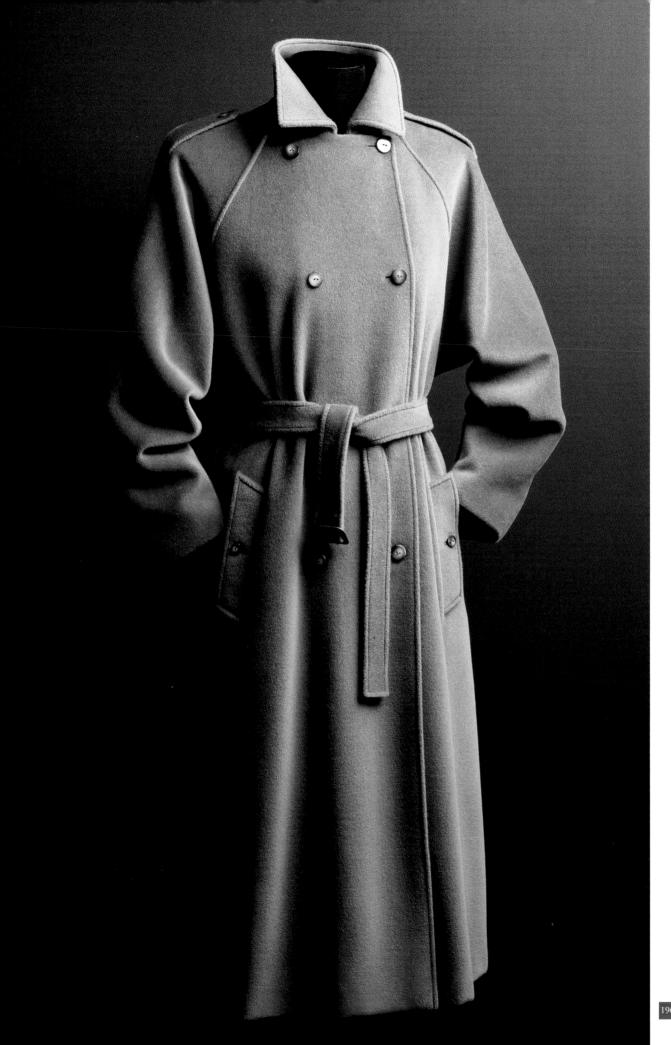

Max Mara Coat 1018532 F/W 1982-1983

Sketch by Laura Lusuardi Materials: camel colour wool and cashmere "beaver" by (Lanificio Piacenza); hazelnut satin lining

Classic double-breasted camel coat with epaulettes, buttoned wrist straps, vent and buckle belt. It has raglan sleeves in front and kimono behind that form a double back. Inspired by the male trench coat, it is made luxurious by the cashmere blend fabric. The length of the model and width of the shoulders are typical of the early Eighties' style.

Reference: original sketch, Archivio d'Impresa Max Mara Bibliography: *Marie-Claire* second edition, no. 6, 1982

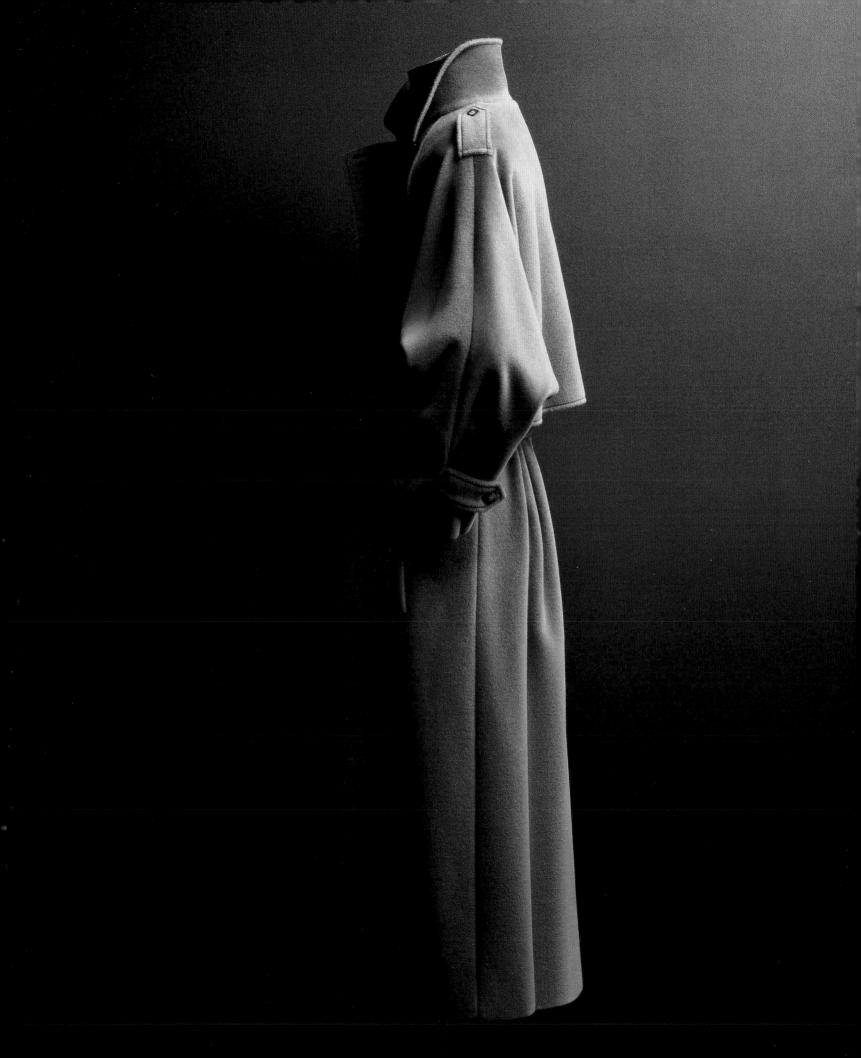

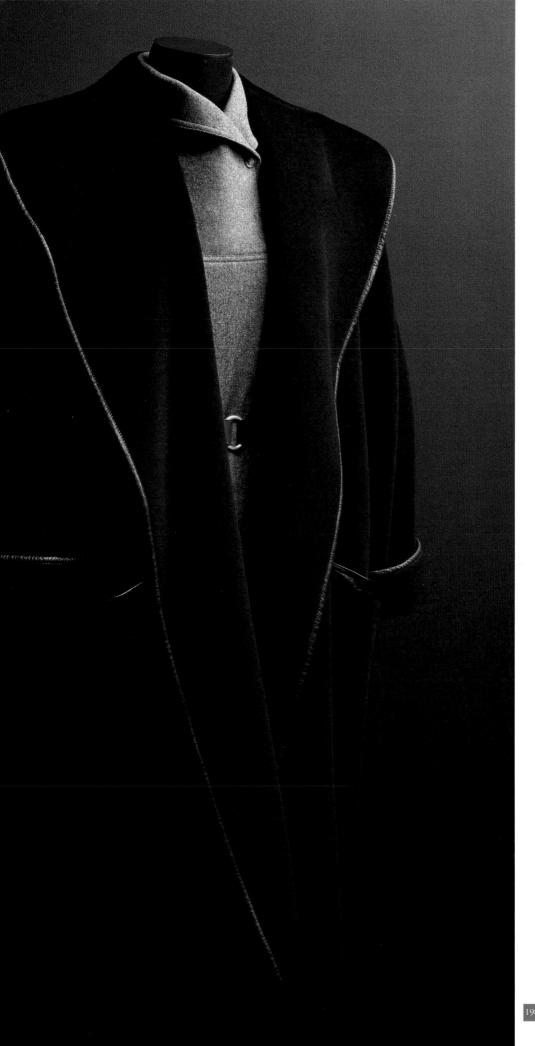

Max Mara Coat and Dress Outfit F/W 1983-1984

Sketches by Anne Marie Beretta

"Malta" Coat 1018043 Materials: dark blue cashmere and wool "beaver" (by Lanificio Piacenza); jacquard diagonal lining with Max Mara logo, dark blue

One-piece "Sidney" Dress 1166553 Materials: grey wool flannel, dark grey leather belt

Short, egg-shaped open coat trimmed with leather. The style and many of the details, like the kimono sleeves and striking shawl collar, are reminiscent of the evening coats worn at the beginning of the twentieth century. It was presented on the runway with the rigorous ample straight dress with bib top, shawl collar and batwing sleeves, clinched at the waist with a dark grey plaited leather belt.

References: original sketches, advertising folder for the F/W 1983-1984 collection (photos by Mike Yavel) and sales poster on the theme "Style and Tradition" with photos and fabrics, Archivio d'Impresa Max Mara Bibliography: Vague Italia Bibliography: Vogue Italia, July-August 1983, runway reportage, July-August 1983

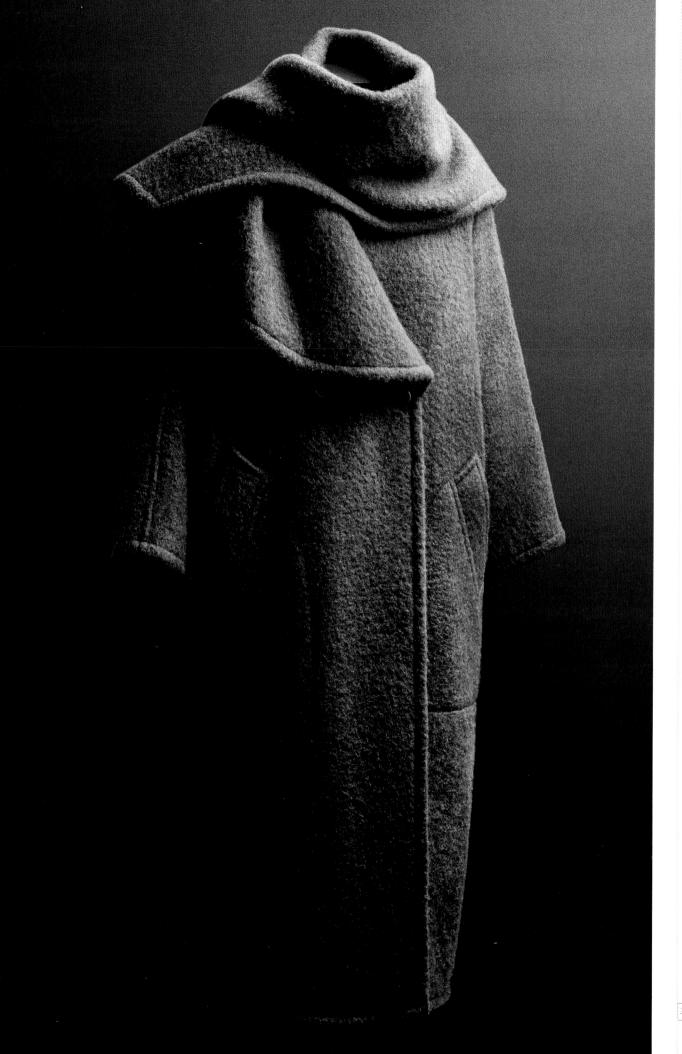

Max Mara "Santos" Coat 1017564 F/W 1984-1985

Sketch by Anne Marie Beretta Materials: dark brown (forest green) teased mohair cloth

Straight, unlined, double-breasted coat with two buttons and kimono sleeves, characterised by an ample asymmetric cape collar that becomes a pointed shawl at the back. The contrast between the straight lines of the coat and the rounded shape of the collar and shoulders are signature elements of this model.

References: original sketch and sales poster on the theme "Heaths and Moors" with fabric references, Archivio d'Impresa Max Mara M.R.

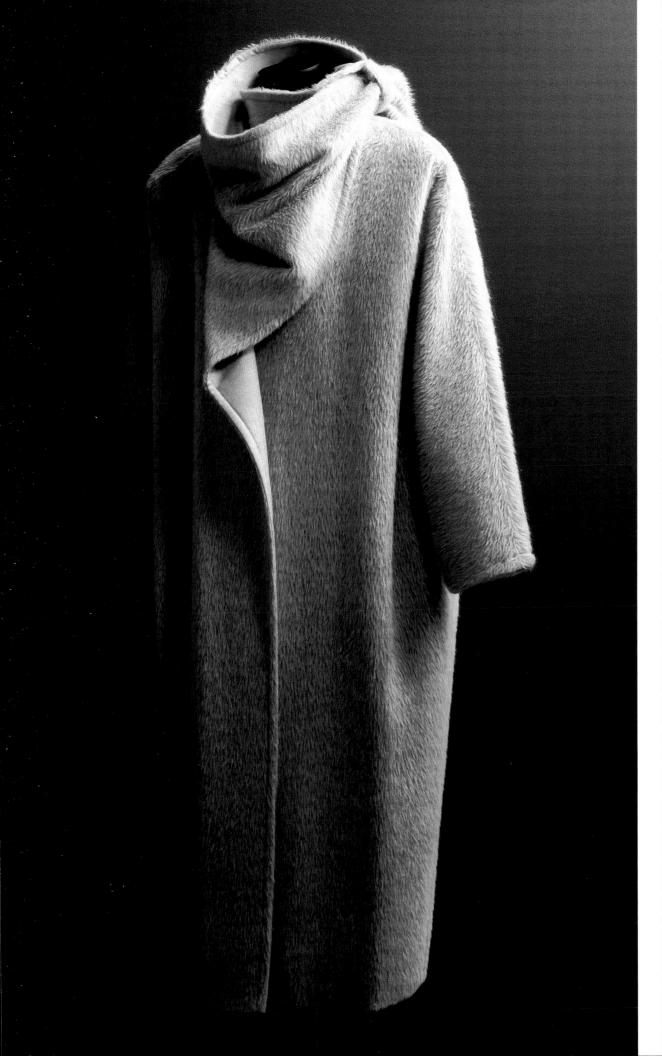

Max Mara "Sondalo" Coat 1018264 F/W 1984-1985

Sketch by Anne Marie Beretta Materials: long hair alpaca and wool (by Lanificio Agnona); jacquard twill lining with Max Mara logo

Long coat with padded shoulders and kimono sleeves. The accent is on an ample double scarf collar in soft *mélange* wool that can be tucked into a fabric eyelet at the side. To be noticed the contrast between the geometric shapes of the coat and the soft asymmetric scarf, echoed by that of the sober lining and velvety exterior.

References: original sketch and sales poster on the theme "Snow and Mist" with fabric references, Archivio d'Impresa Max Mara M.R.

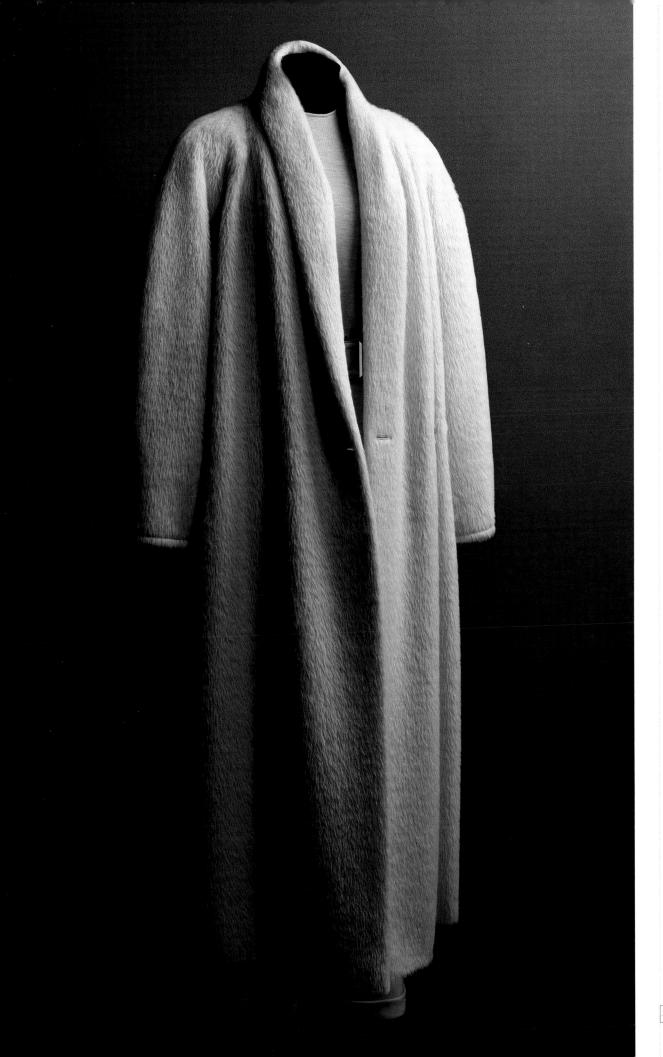

Max Mara "Cariso" Coat 1018157 F/W 1987-1988

Sketch by Anne Marie Beretta Materials: long hair alpaca and wool twill (by Lanificio Agnona); viscose jacquard twill lining with Max Mara logo

Double-breasted coat with two buttons and draped shawl collar. This model with the soft lines of a wraparound coat with draped collar departs completely from the traditional male overcoat. It could therefore be worn over any garment, especially the masculine trouser suits typical of the period.

Its wide padded shoulders and raglan sleeves are characteristic of the Eighties, and it was one of the most successful creations of the season.

Reference: original sketch, Archivio d'Impresa Max Mara M.R.

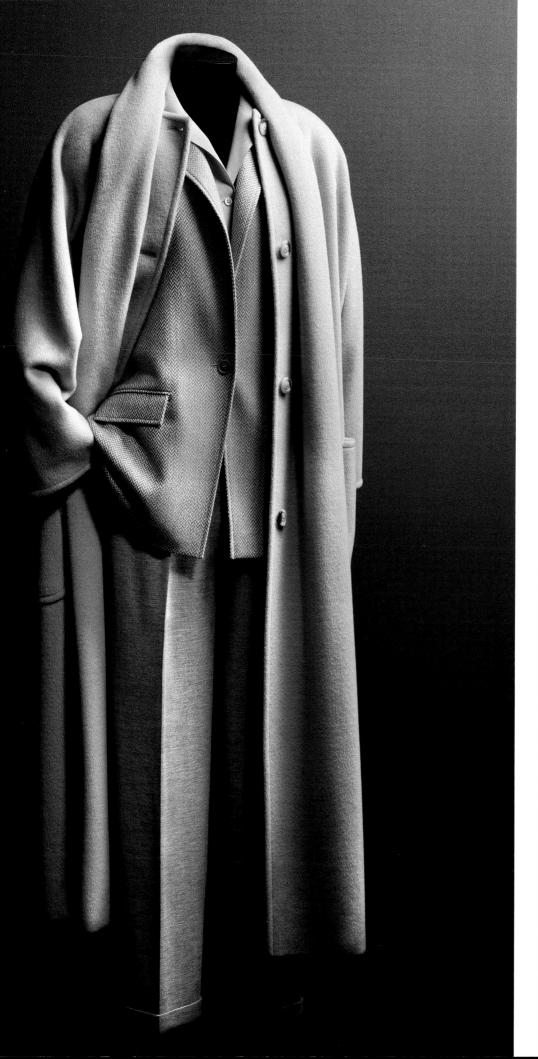

Max Mara Coat, Trouser Suit and Blouse Outfit F/W 1987-1988

Sketch by Anne Marie Beretta

"Celso" Coat 1018047 Materials: wool and cashmere "beaver" (by Lanificio Piacenza); viscose jacquard twill lining with Max Mara logo

"Pola" Jacket 1046237 Materials: white and beige herringbone wool twill (by Lanificio Ferrarin)

"Decano" Trousers 1136617 Materials: *mélange* wool jersey

"Flavia" Blouse 1116687 Materials: silk *crêpe*

Straight coat with padded shoulders, raglan sleeves at the back, and kimono at the front. The stole collar forms two deep box pleats that fall to the hem and there are two large appliqué pockets on either side. The matching trouser suit in the same sandy tones consists of masculine jersey trousers with waist tucks and turn-ups, and a single-breasted straight jacket with a short central vent at the back, in a fine woollen fabric with a herringbone pattern. The classic silk blouse has a shirt collar and appliqué breast pockets. The masculinity of the suit is deliberately offset by the coat's charmingly feminine draped collar.

References: original sketch and advertising folder for the F/W 1987-1988 collection (photos by Paolo Roversi), Archivio d'Impresa Max Mara Bibliography: *Gioia*, 2 November 1987 M.R.

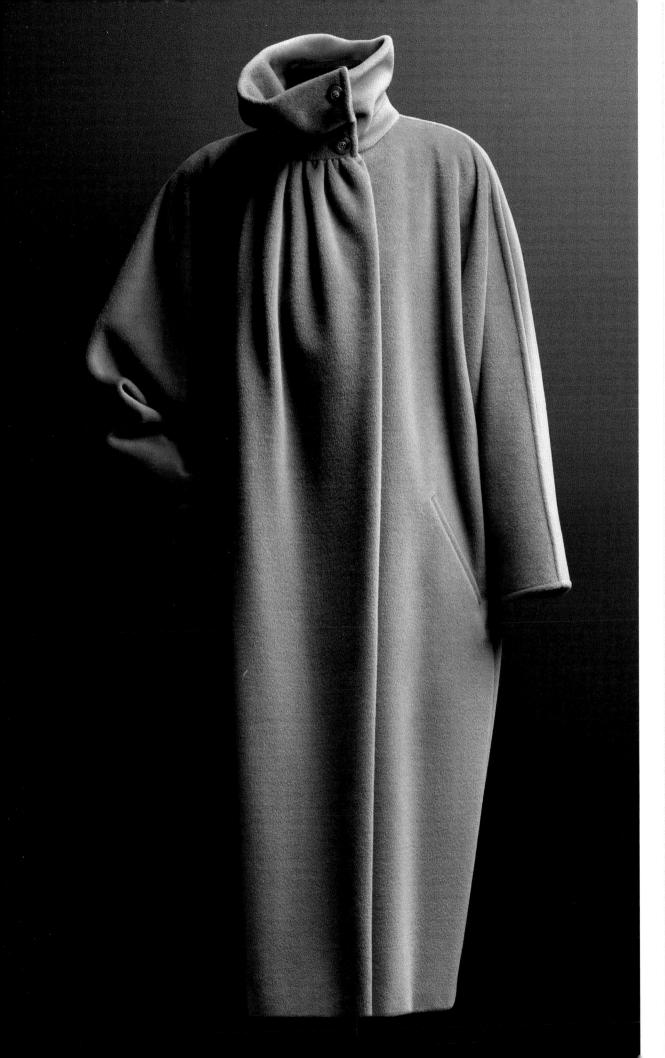

Max Mara "Cimone" Coat 1018257 F/W 1987-1988

Sketch by Anne Marie Beretta Materials: wool and cashmere "beaver" (by Lanificio Piacenza); viscose jacquard twill lining with Max Mara logo

One of the best-selling garments in winter 1987, this coat is characterised by a funnel collar on which there is a band fastened by two buttons, with gathering below in the front. Straight-cut, with kimono sleeves and padded shoulders, it is single-breasted with an overlap closure.

References: original sketch and advertising folder for the F/W 1987-1988 collection (photos by Paolo Roversi), Archivio d'Impresa Max Mara Bibliography: *Gioia*, no. 44, 2 November 1987

One's coat is a true companion. It should be reassuring. It is worn when travelling and has to put up with all kinds of bad weather, but its charisma helps to turn both routine and unusual events into something special.

Anne Marie Beretta, 2006

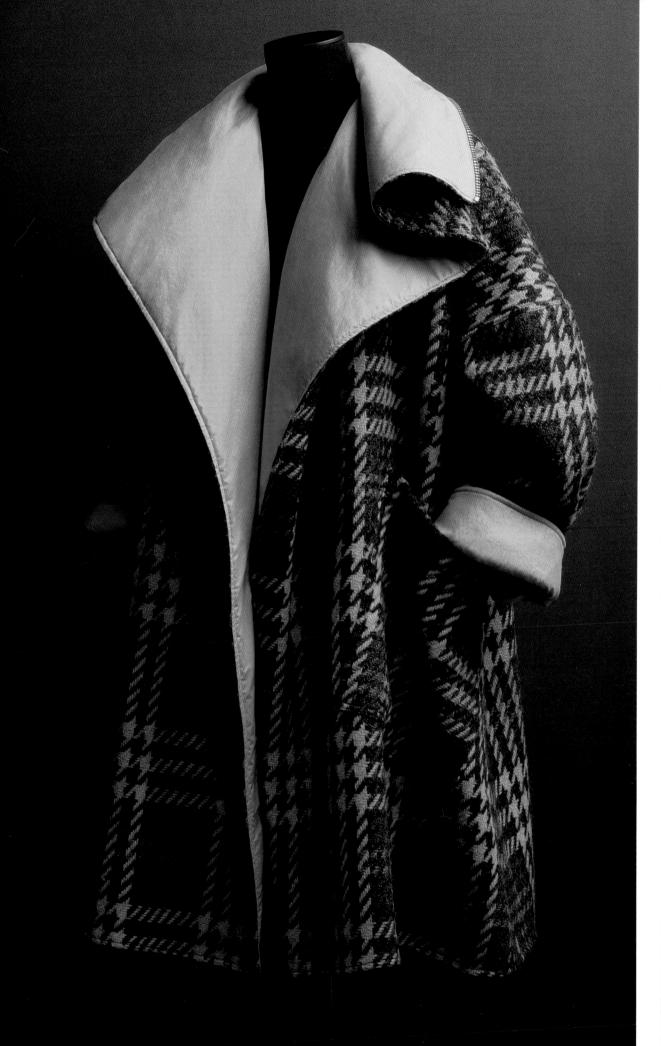

Sportmax Coat 2018333 F/W 1983-1984

Sketch by Guy Paulin Materials: large Prince of Wales check wool; bright orange cotton cloth lining

This full trapeze-line open coat with drop shoulders and square armhole has a soft hood with a zip on the top, which can be transformed into a large shawl collar. The inside, lined with bright orange cloth, is constructed in such a way as to create a draped effect in the sleeves.

The coat's personality mainly derives from the colours and the wool fabric with a large Prince of Wales check more often found in haute-couture than prêt-à-porter models.

Reference: runway's original sketch.

Reference: runway's original sketch, Archivio d'Impresa Max Mara E.M.

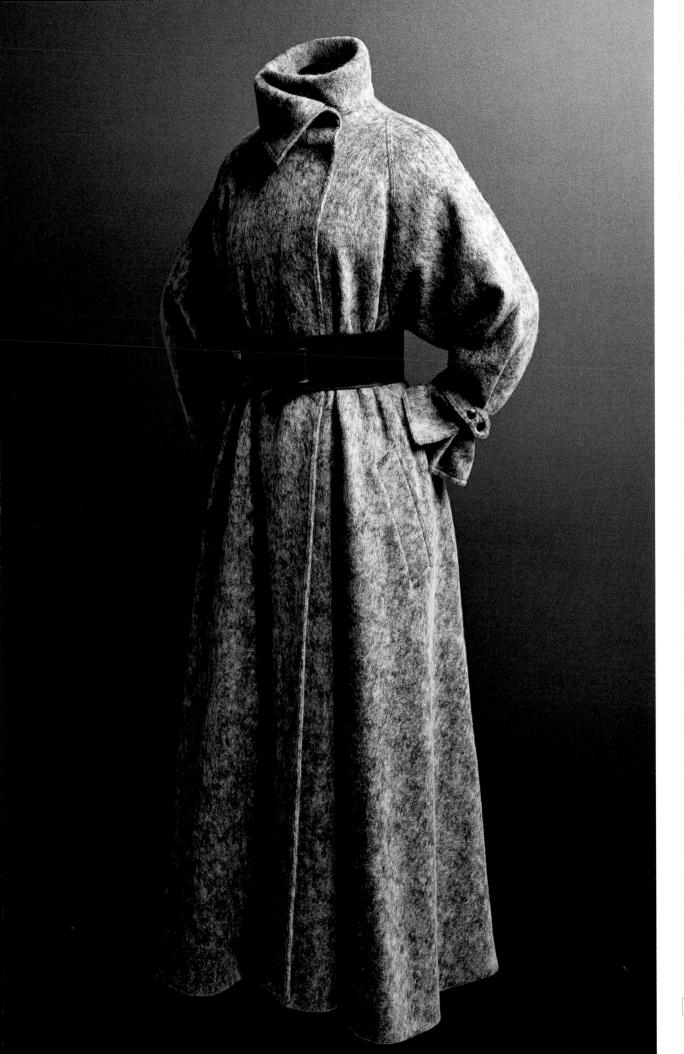

Sportmax "Azzorre" Coat 2018223 F/W 1983-1984

Sketch by Guy Paulin Materials: *mélange* felt (white and grey teased *mélange* wool cloth); viscose and acetate tartan lining, black leather

The trapeze line of this coat is accentuated by the central back pleat that opens up into a deep vent from the waist down. It has raglan shoulders and batwing sleeves with wrist straps. It fastens with press studs attached to triangles of black leather on the reverse side, has a high lapel collar and black leather belt with overlap press closure. The rough texture of the *mélange* felt is offset by the shiny tartan lining in white, black and brown tones.

Reference: original sketch, Archivio d'Impresa Max Mara Bibliography: *Vogue Italia*, July-August 1983 M.R.

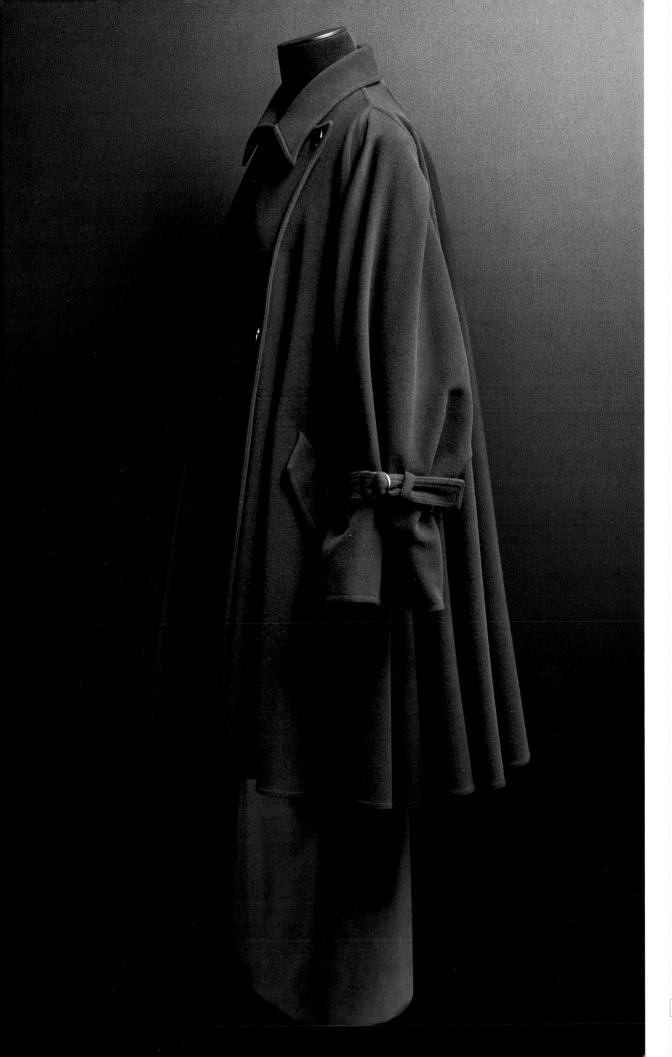

Sportmax "Cottage" Jacket 2046763 F/W 1983-1984

Sketch by Guy Paulin

Materials: dark blue wool velour, lozenge-shaped burnished metal buttons

This long double-breasted sporty jacket reinterprets the early Eighties' look, with some unusual twists. The raglan sleeves have two pleats instead of padding, and the fullness of the jacket is created by the almost circular pattern. The wide leather belt clinching the waist creates a silhouette reminiscent of the Fifties.

Reference: original sketch, Archivio d'Impresa Max Mara Bibliography: *Donna*, July-August 1983; *Vogue Italia*, July-August 1983 E.M.

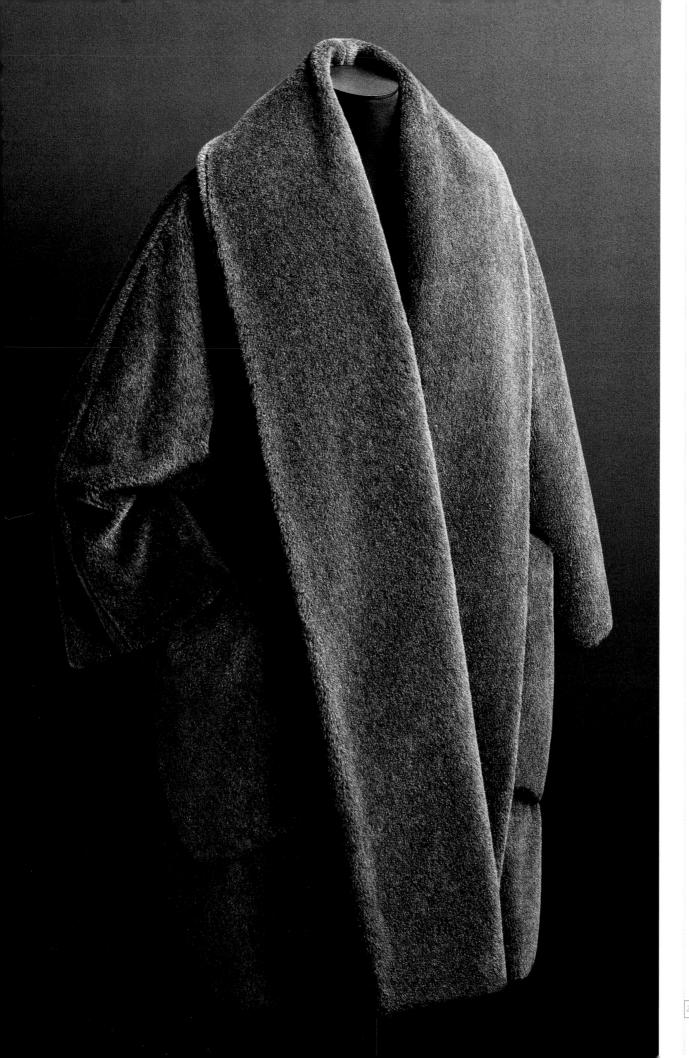

Sportmax "Atene" Coat 2018043 F/W 1983-1984

Sketch by Guy Paulin Materials: brown alpaca "koala"; cotton and modal paisley print lining, lozenge-shaped burnished metal buttons.

Coat with a flowing line, kimono sleeves and large *appliqué* patch pockets. The shawl collar reaches the hem, creating a wide asymmetric border in the front, and is fastened by two metal buttons with leather-trimmed button holes. The alpaca yarn has been woven to look like real fur, creating a pleasing contrast with the smooth, shiny paisley print lining.

Reference: original sketch, Archivio d'Impresa Max Mara M.R.

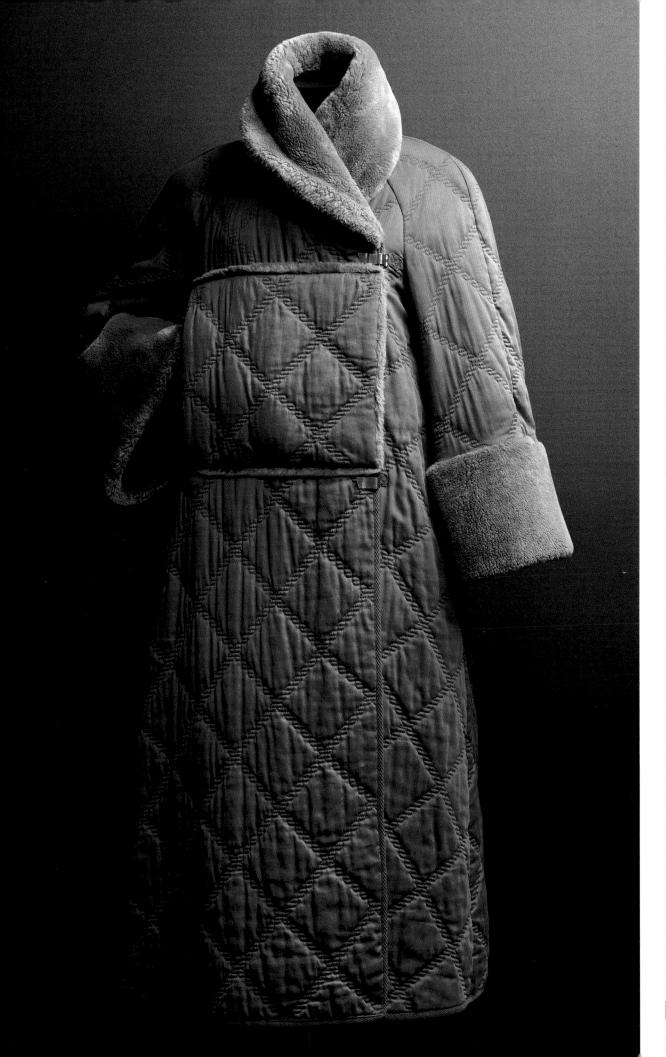

Sportmax "Anita" Coat 2018593 F/W 1983-1984

Sketch by Guy Paulin Materials: padded double-face fabric with lozenge quilting: powder blue cotton sateen on the outside and ice grey artificial silk sateen on the inside; grey faux fur (on jersey base), powder blue trimming, metal hooks

Flared coat with unpadded raglan shoulders, fastening on the left side with two metal hooks. The enveloping shawl collar and edging on the full sleeves are faux fur.

The choice of quilted cotton for a winter garment, and also the large pocket-muff in the front, conjures up a feeling of ancient Mongolia, accentuated by the choice of grey and powder blue.

Reference: original sketch, Archivio d'Impresa Max Mara Bibliography: Vogue Italia dossier July-August1983 M.R.

Women used closed coats tighter at the chest, men pulled the collar up.

Heinrich Mohr, 1931

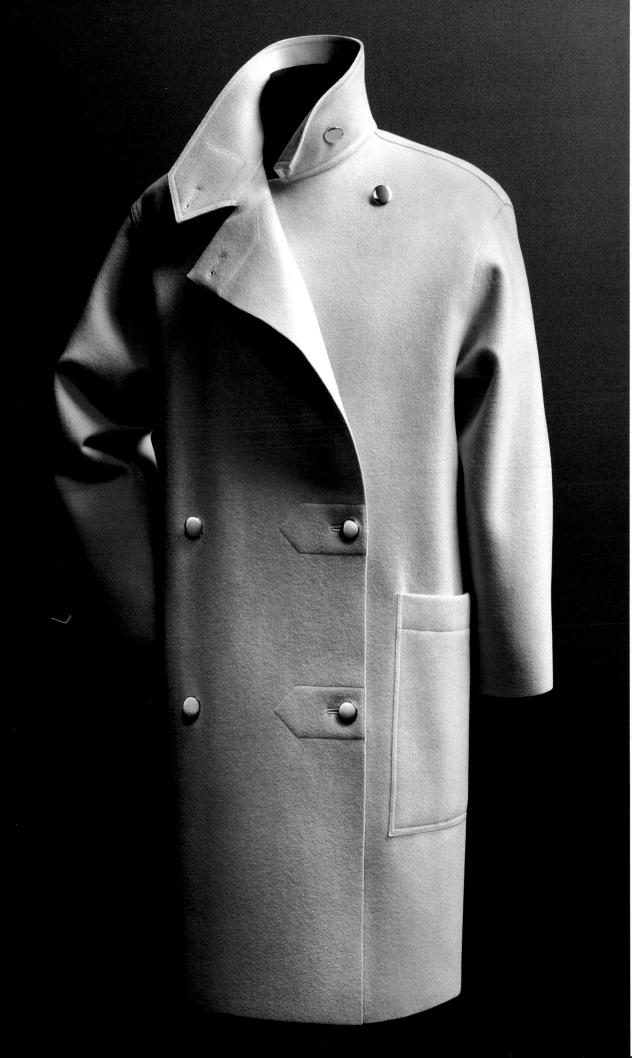

Sportmax "Avon" Coat 2017513 F/W 1983-1984

Sketch by Guy Paulin Materials: white wool cloth, gilt metal lozenge-shaped buttons

An elegant short coat with a Twenties silhouette created by the straight-cut and slightly narrower bottom. It has an unusual lapel collar that becomes a fetching rising collar when fastened.

A precursor of future trends, the model is almost completely unfinished except for the collar and pockets.

This coat was featured in one of the photographs of the advertising campaign for the Sportmax collection.

References: original sketch and advertising folder for the F/W 1983-1984 collection (photos by Peter Lindbergh), Archivio d'Impresa Max Mara Bibliography: *Donna*, July-August 1983 E.M.

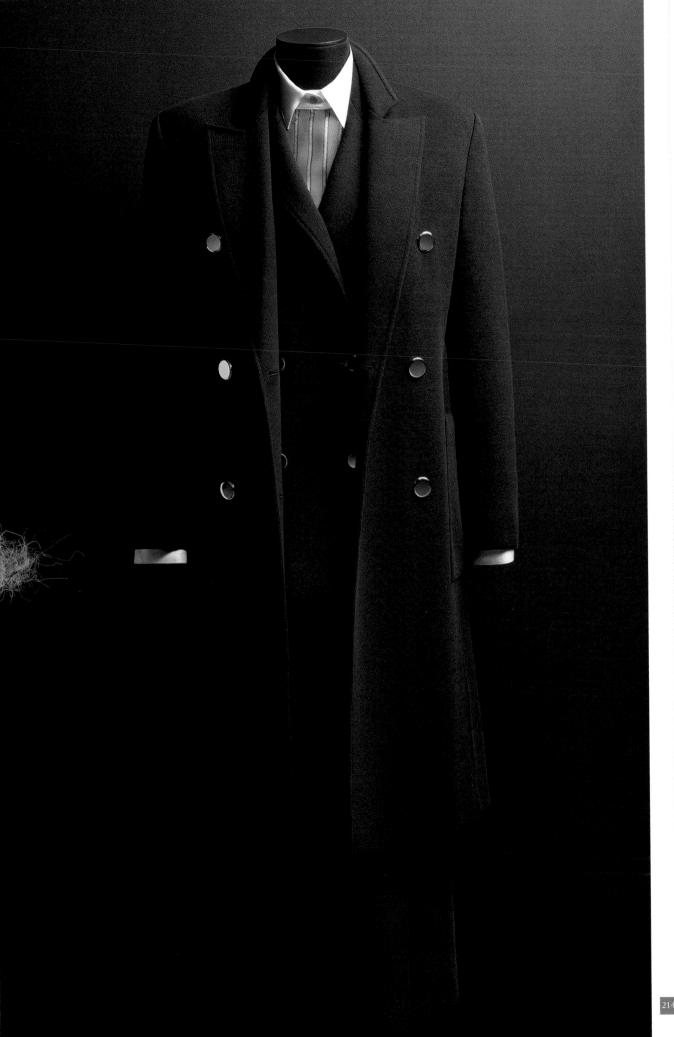

Sportmax Coat, Suit and Blouse Outfit F/W 1984-1985

Sketches by Guy Paulin

"Vacanze" Coat 2016014 Materials: dark blue jersey (by Dondi Jersey); shot bordeaux padded twill lining with herringbone quilting, gold metal lozenge-shaped buttons.

"Saba" Suit 2056014 Materials: dark blue jersey (by Dondi Jersey); gold metal lozenge-shaped buttons.

Blouse 2116564 Materials: silk diagonal

Slender double-breasted, six-button coat with lapel collar. The back is cut on the lines of a man's jacket, with a central section and side vents. It is combined with a suit in two versions, with trousers or a calf-length skirt with two inverted side pleats falling from the knee.

The double-breasted jacket follows the line of the coat.

The matching double-breasted blouse, in regimental stripe silk, is brightened by the white collar and cuffs: an outfit in the timeless French style.

References: original sketches, Archivio d'Impresa Max Mara M.R.

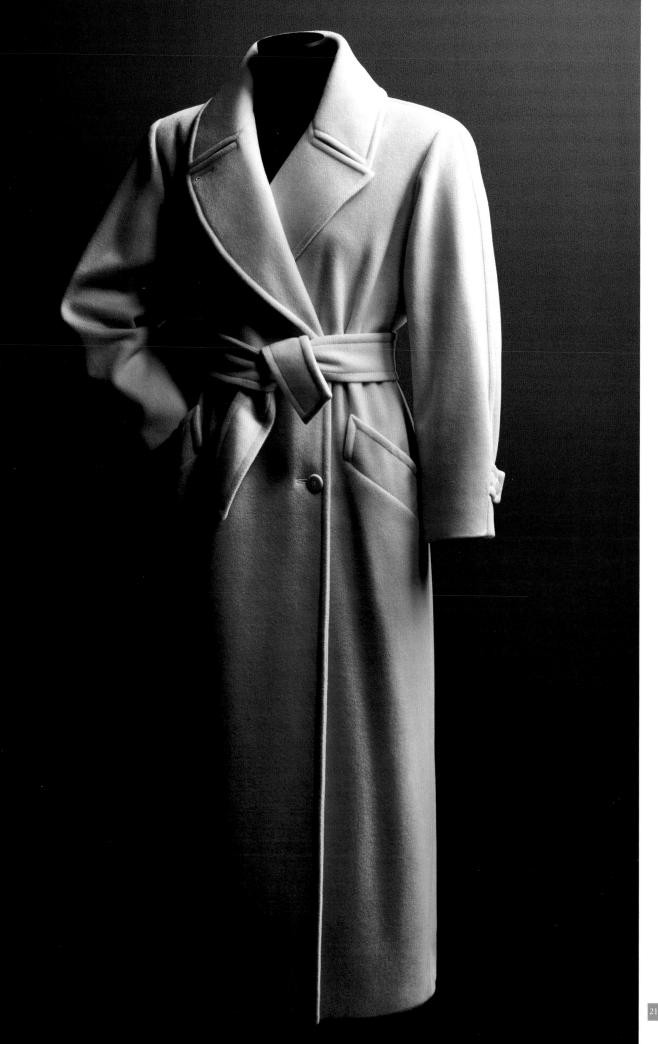

"Variety" Coat 2017144 F/W 1984-1985

Sketch by Guy Paulin Materials: white wool "velour"; viscose twill lining

Long double-breasted coat with four buttons, kimono sleeves at the back and straight-cut armholes in front, and accentuated padded shoulders. Movement is created at the back by two loose side pleats and a central inverted pleat with vent, secured by a half belt at the waist. The three-piece belt at the waist. The three-piece belt, composed of a central section buttoned to the two side sections that tie in the front, gives the back of the coat a military look that is made more feminine by the soft frontal shapes.

Reference: original sketch, Archivio d'Impresa Max Mara Bibliography: *Italia design fashion*, May 1984 M.R.

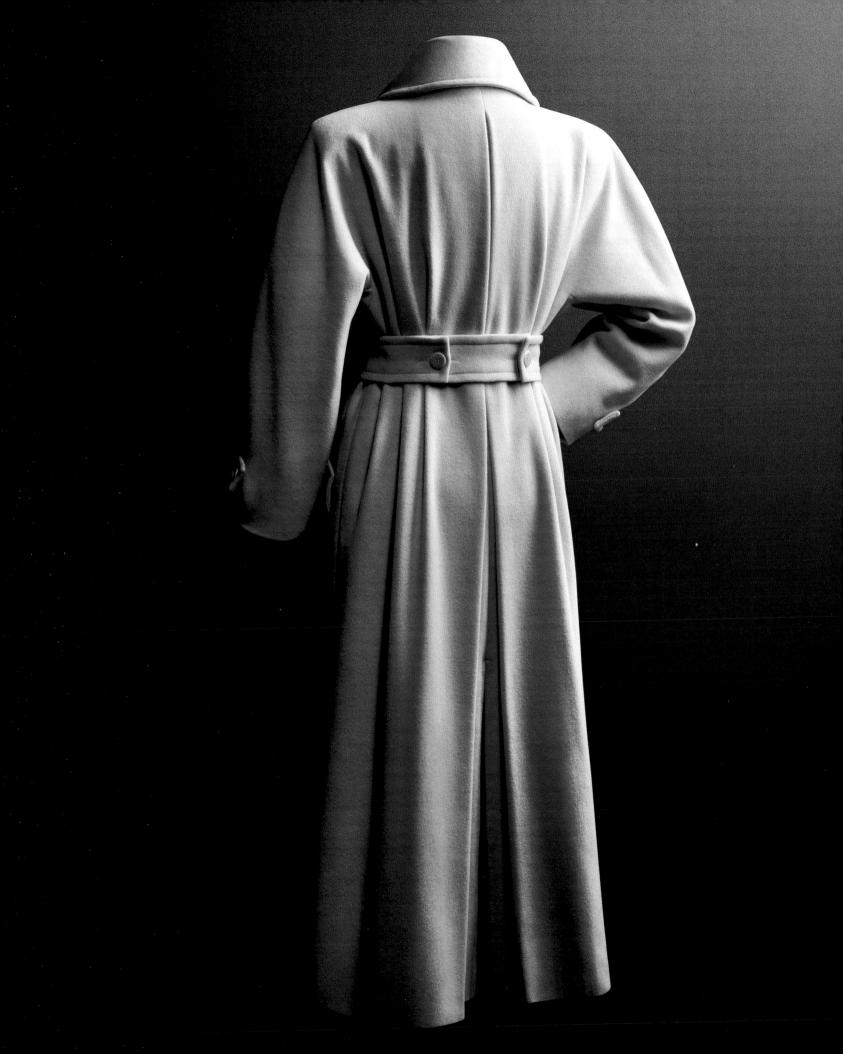

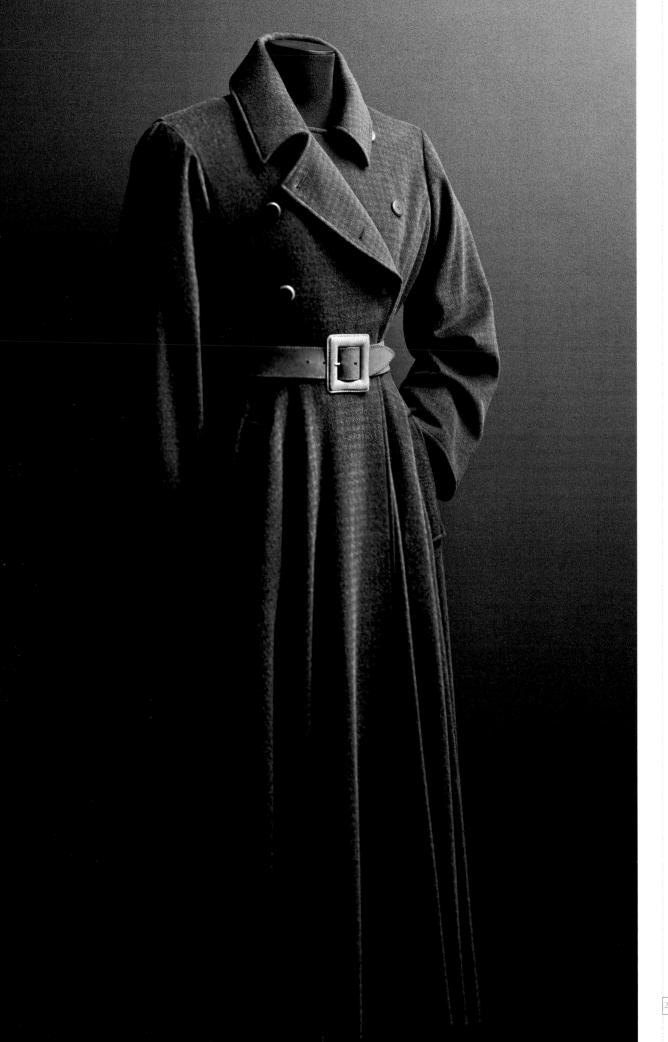

Sportmax "Valdez" Coat 2016754 F/W 1984-1985

Sketch by Guy Paulin Materials: brown and green check teased wool and angora twill, brown viscose satin lining, suede, wooden buttons

Double-breasted, four-button redingote seamed at the waist, with kimono sleeves at the back and straight-cut armhole in front. The circular skirt with a central inverted pleat at the back, wide belt with buckle, padded shoulders and ample revers, give the coat a distinct military look.

Reference: original sketch, Archivio d'Impresa Max Mara M.R.

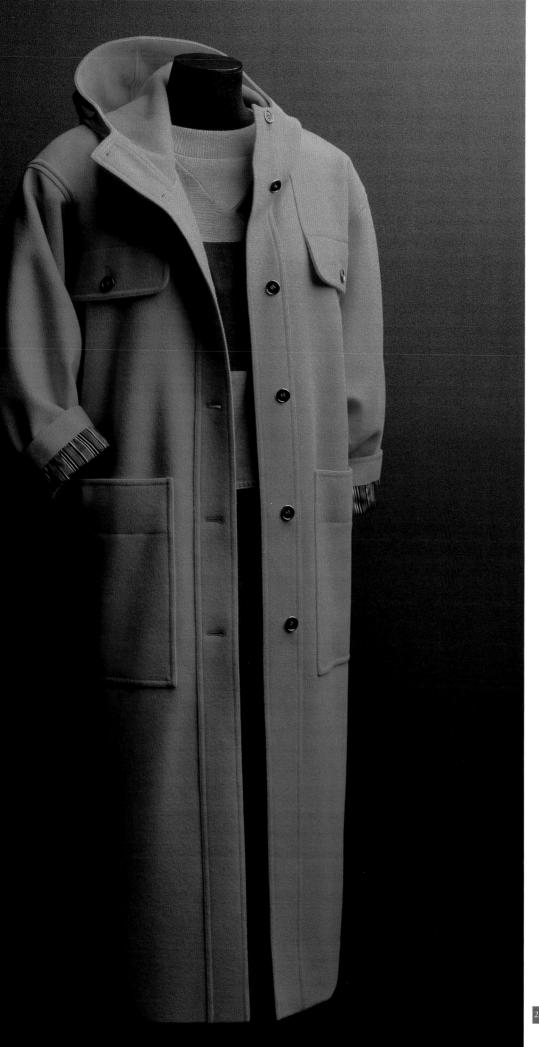

Sportmax Coat and Blouse F/W 1985-1986

Sketches by Sophie George

"Vieste" Coat 20171850 Materials: red woollen cloth; red, black and white striped viscose twill lining, burnished metal buttons

"Orvieto" Blouse 21167450 Materials: red and black tartan wool jacquard twill, red cotton

Straight hooded coat with padded shoulders and low set-in sleeves. The front is embellished with two large applique patch pockets and two faux breast pockets. Movement is created at the back by the cape fastened with three buttons.

buttons.
The striped silk lining picks up the colours of the matching tartan blouse, which is square cut with a straight armhole and batwing sleeves. The neckline and cuffs are edged with ribbed jersey.

References: original sketches, Archivio d'Impresa Max Mara M.R.

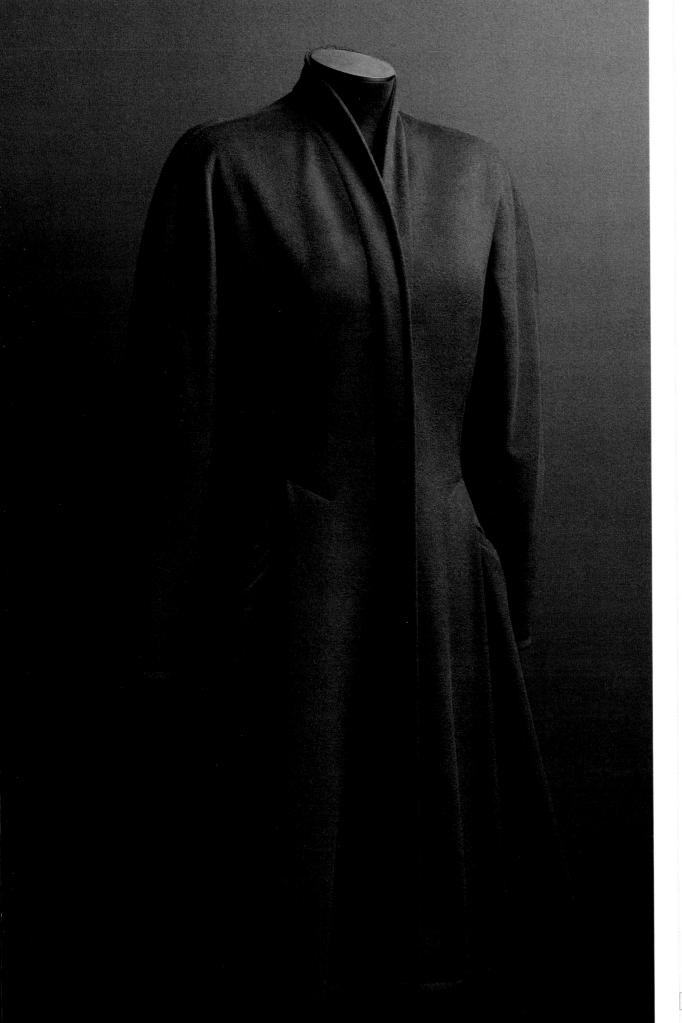

Sportmax "Chieti" Redingote 2016157 F/W 1987-1988

Sketch by Eric Bremner Materials: dark blue cloth; copper blue lining with typical jacquard neckwear pattern

This redingote with a fitted line created by the play of skillful cutting and inverted pleating that give the skirt fullness, was inspired by Forties' fashion. The kimono sleeves are rounded and padded, the rising shawl collar cut to extend flush with the front, and the fastening hidden. The essential lines of this model are typical of the transition from Eighties' fashion to the simpler style of the Nineties.

style of the Nineties. Reference: original sketch, Archivio d'Impresa Max Mara

M.R.

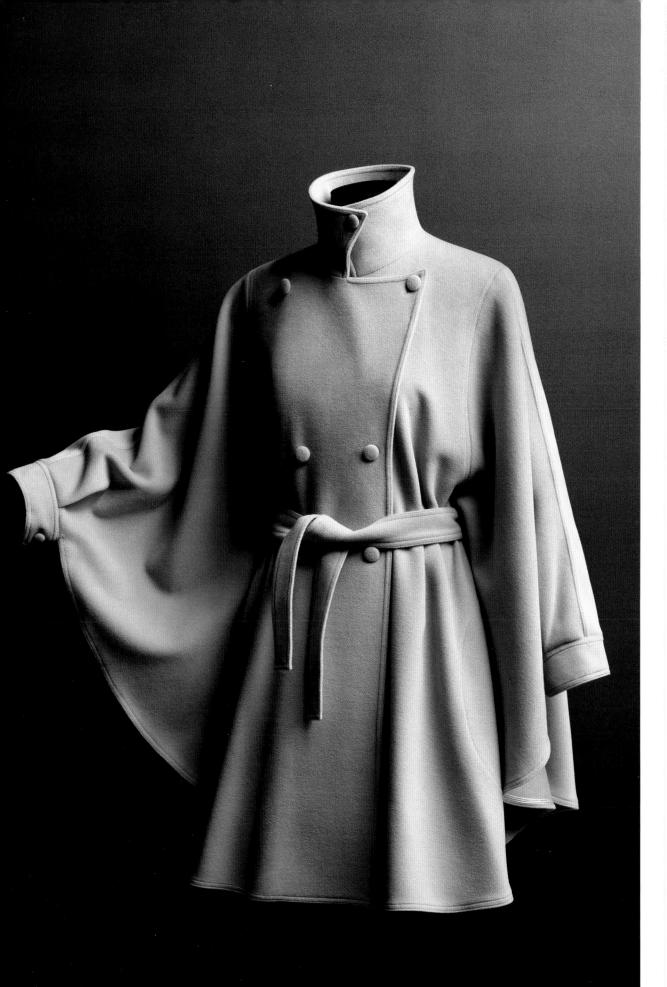

Sportmax Long jacket 2017198 F/W 1988-1989

Sketch by Eric Bremner Materials: wool and cashmere velour twill, fabric covered buttons

Unlined, circular, double-breasted, six-button jacket-cum-cape. It has a wide lapel collar with fastening and two waist-high slits in the side seams, through which a tie belt can be threaded and secured at the front, leaving the back free. The laced cuffs make this model more of a jacket than a cape.

Reference: original sketch, Archivio d'Impresa Max Mara M.R.

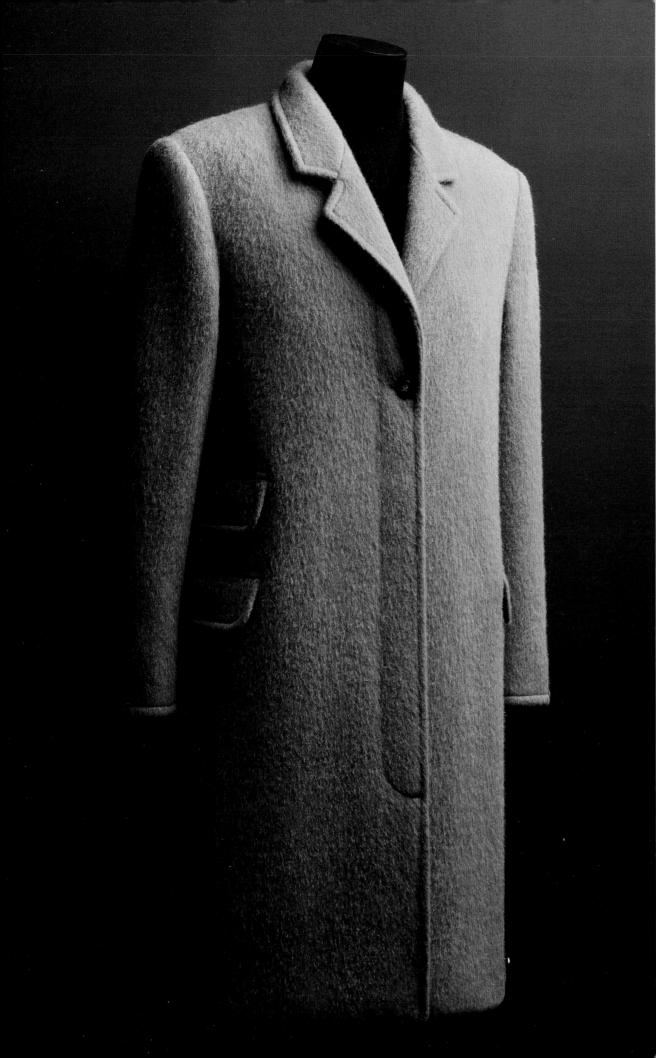

Sportmax "Clipper" Coat 2016168 F/W 1988-1989

Sketch by Eric Bremner Materials: lilac mohair, black jacquard twill lining with violet polka dots, jacquard trim with white, red and green palmettes on a black ground

Straight single-breasted coat with lapel collar, hidden closure and horizontal pockets and breast pocket with appliqué flaps. The classic style of the model is offset by the choice of fabric and colour – lilac mohair – and the unusual lining of solid-colour and polka-dot fabrics brought together by the colourful Tyrolean-style trimming.

References: original sketch and advertising folder for the F/W 1988–1989 collection (photos by Martin Brading), Archivio d'Impresa Max Mara M.R.

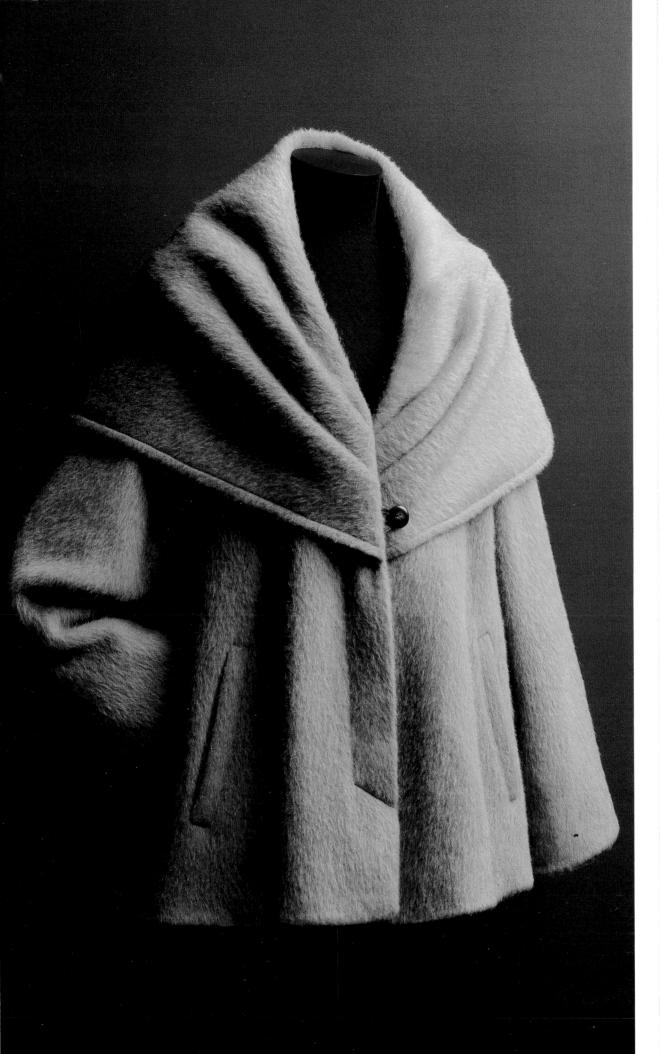

Sportmax "Pinicio" Jacket 2046258 F/W 1988-1989

Sketch by Eric Bremner Materials: green mohair, green twill and black jacquard twill; lining with green polka dots

A single-breasted trapeze jacket – reminiscent of the Fifties – with set-in sleeves, which hinges on the draped cape collar.
The lining, like that of the "Clipper" coat, is partly solid colour and partly black with green polka-dots, and the narrow green braiding ties them together.

References: original sketch and advertising folder for the F/W 1988–1989 collection (photos by Martin Brading), Archivio d'Impresa Max Mara M.R.

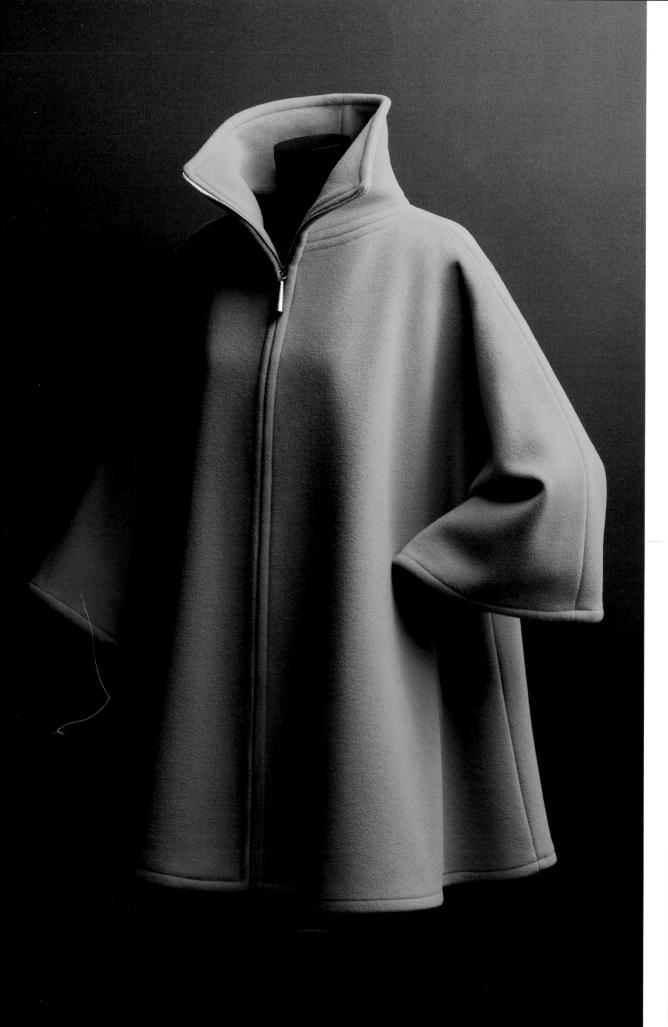

Sportmax Jacket 2086511 "Order" F/W 1991-1992

Sketch by Eric Bremner Materials: turquoise wool and polyamide cloth (by Lanificio Cangioli)

Unlined trapeze jacket with full kimono sleeves and funnel collar. An original feature, typical of that season's collection, is the zip fastening extending to the top of the collar. Equally original is the choice of bright colours, unusual for winter apparel, that characterised the Sportmax outerwear collection that year.

References: original sketch and advertising folder for the F/W 1991-1992 collection (photos by Robert Erdmann), Archivio d'Impresa Max Mara M.R.

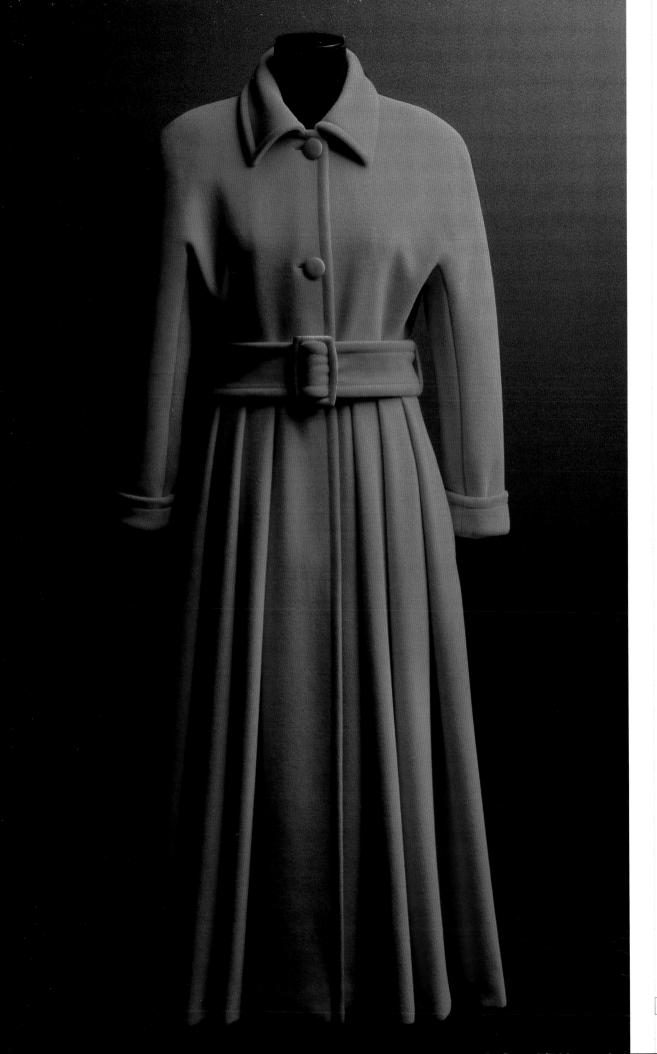

Sportmax Coat 20170520 F/W 1992-1993

Sketch by Eric Bremner Materials: red wool and cashmere cloth; red jacquard viscose lining with roses and polka dots, red lozenge-shaped buttons

Single-breasted redingote seamed at the waist, with shirt collar and kimono sleeves. The skirt, with a single back vent, is given fullness by the inverted waist pleat at the back, and the symmetrical pleats in the front. The wide fabric belt has a matching suede buckle.

Reference: runway's original sketch, Archivio d'Impresa Max Mara M.R.

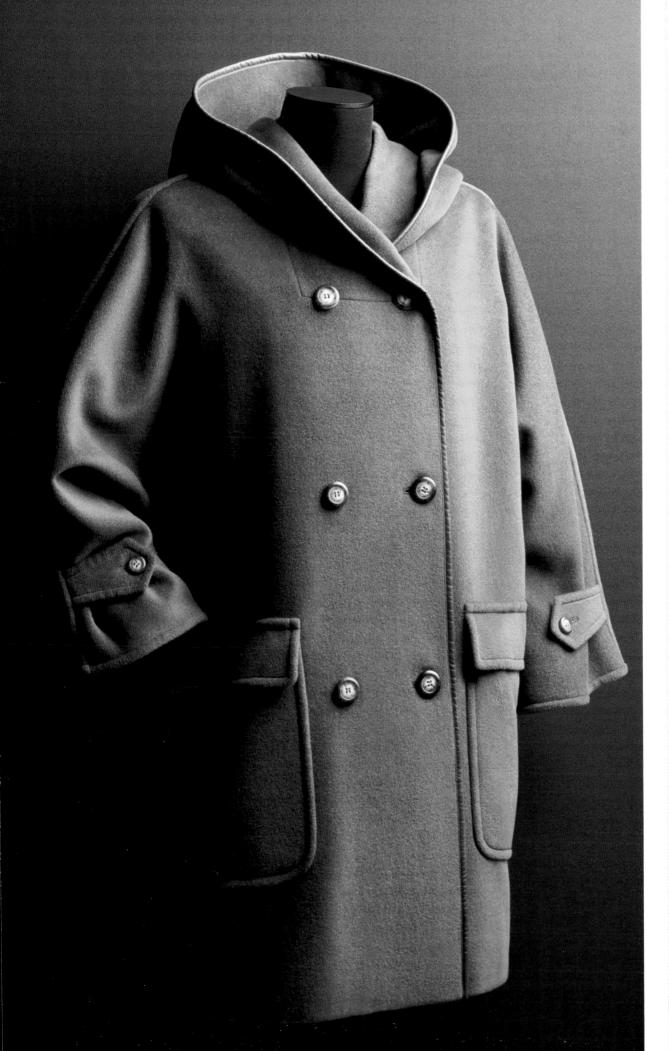

Max Mara "Bondeno" Duffle Coat 1086041 F/W 1991-1992

Sketch by Anne Marie Beretta Materials: kaki-colour wool and cashmere "beaver" (by Lanificio di Tollegno); viscose rayon taffeta lining, horn buttons, brown leather

Ample, straight-cut, double-breasted duffle coat with six buttons and kimono sleeves. Two buttons and kimono sleeves. Iwo patch pockets enliven the front. The double hood and front are edged with leather. The well-defined lines of this basic garment are typical of Max Mara's style, and it sums up the company's philosophy: focus on functional quality and careful choice of materials.

References: original sketch and advertising folder for the F/W 1991–1992 collection (photos by Arthur Elgort), Archivio d'Impresa Max Mara M.R.

materials.

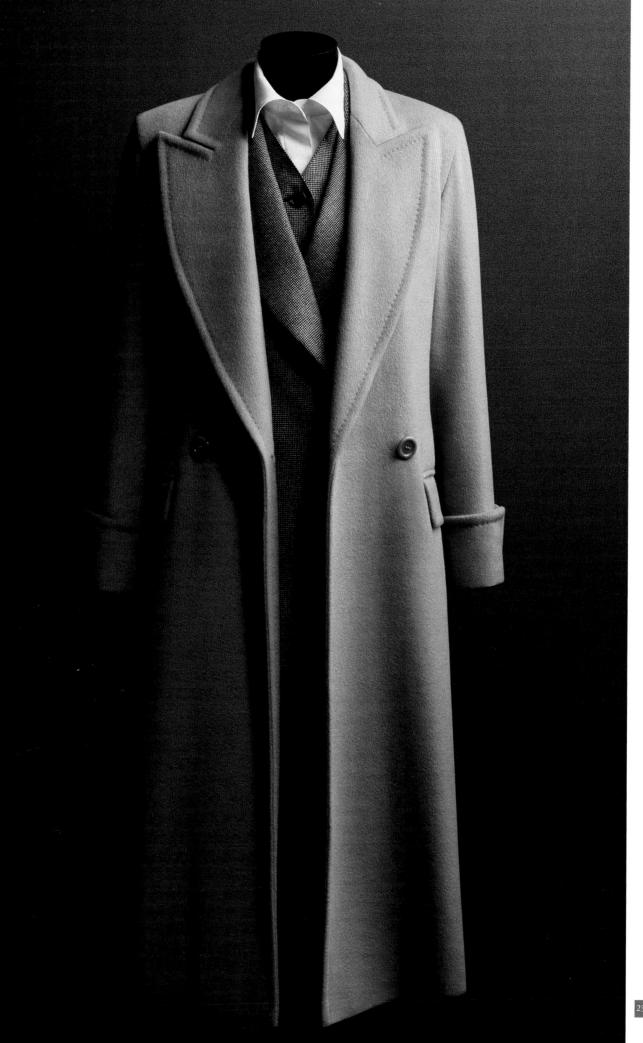

Max Mara Coat and Trouser Suit with Waistcoat F/W 1993-1994

Sketches by Anne Marie Beretta

Coat 10180234 Materials: camel-colour wool and cashmere "beaver"; viscose jacquard diagonal lining with Max Mara logo "Atollo" Trouser Suit with Waistcoat

12960434 Materials: black & white houndstooth wool and cashmere twill; rayon taffeta lining

Double-breasted, two-button coat with peaked lapel collar, arrow-shape set-in sleeves, slightly padded shoulders, and split rounded cuffs. An inverted pleat at the waist, and vent in the skirt, create movement at the back. The waist-high half-belt consists of two overlapping sections fastened with two buttons. The trouser suit has a masculine look created by the double-breasted jacket with six buttons and peaked lapels, the trousers with tucks and a hip pocket, and the single-breasted waistcoat with faux pockets.

References: original sketches and advertising folder for the F/W 1993–1994 collection (photos by Arthur Elgort), Archivio d'Impresa Max Mara M R

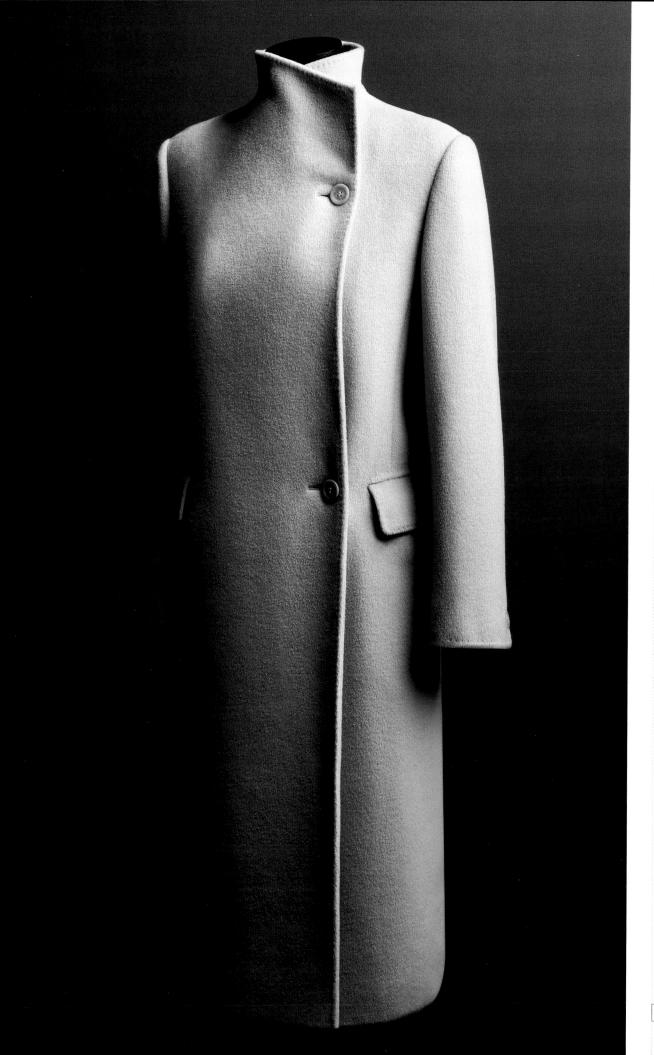

Max Mara "Giorgio" Coat 10160683 F/W 1998-1999

Sketch by lan Griffiths Materials: cement-grey wool and cashmere "beaver" (by Lanificio di Tollegno); viscose jacquard twill lining with Max Mara logo

Straight coat with set-in sleeves and softly padded straight-cut shoulders, fastened asymmetrically with two buttons. It has a central back vent and horizontal pockets with a flap. The ingenious collar, flush with the front, becomes rising when closed and shawl-style if left open. Borders are accentuated with pick stitching, and the pureness of line and absence of any superfluous details create a minimalist Max Mara style.

References: original sketch and advertising folder for the F/W 1998-1999 collection (photos by Richard Avedon), Archivio d'Impresa Max Mara M.R.

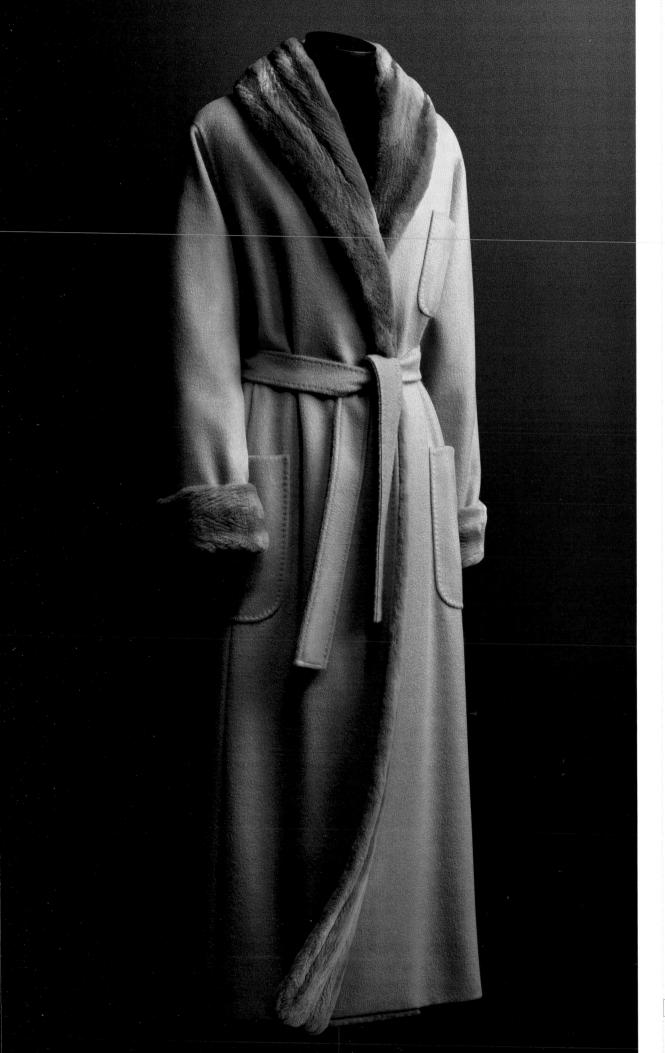

Max Mara "Jedda" Coat 10170103 F/W 2000-2001

Sketch by Anne Marie Beretta Materials: pure camelhair "sable" drap (by Lanificio Colombo); viscose jacquard twill lining with Max Mara logo, honey-coloured sateen mink

Wraparound coat with unpadded, straight-cut shoulders and set-in sleeves, appliqué patch pockets, breast pocket and tie belt. The back has a central inverted pleat with vent. The classic camel coat is made luxurious by the shawl collar that extends all the way down the front on both sides and the honey-coloured sateen mink cuffs.

References: original sketch and advertising folder for the F/W 2000-2001 collection (photos by Steven Meisel), Archivio d'Impresa Max Mara M.R.

An elegant woman is a true woman, one who is consistent in the manner in which she speaks, thinks, walks and in what she wears.

Luigi Maramotti

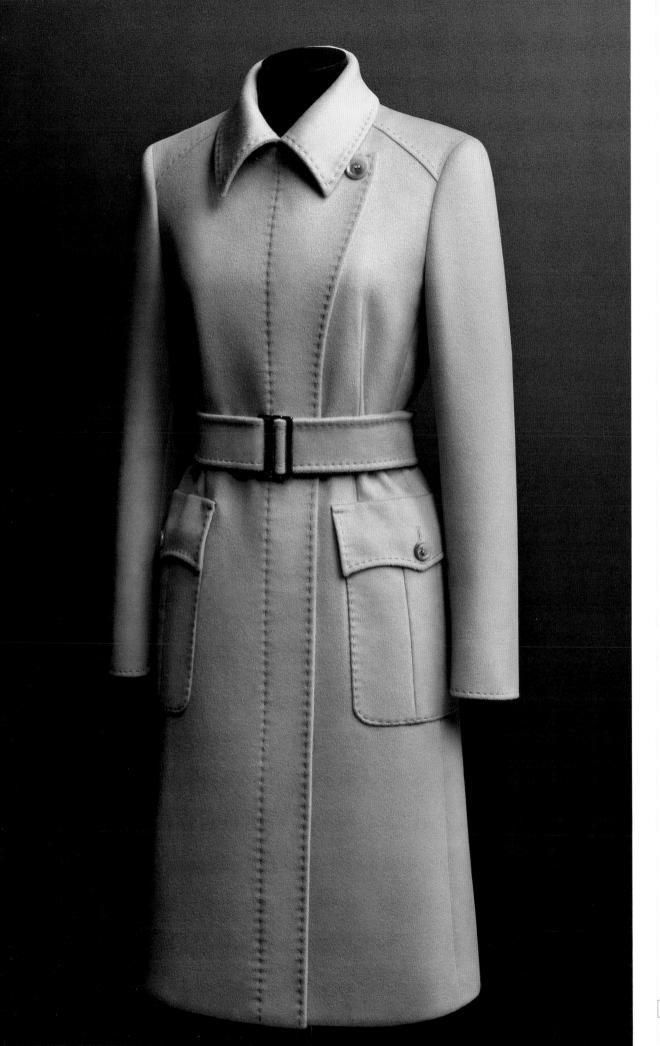

Sportmax "Giusy" Coat 20160113 F/W 2001-2002

Garment by Eric Bremner Materials: Wool and cashmere drap (by Lanificio Colombo); viscose twill lining

This straight coat has a single-button fastening on the side and concealed zip, straight-cut shoulders with cape and set-in sleeves with zipped cuffs. There are patch pockets, in three sections, with a shaped button flap and a belt with a metal buckle. The saddle stitching used to accentuate the shape of the model is a typical feature.

Reference: technical sketch, Archivio d'Impresa Max Mara M.R.

Sportmax Coat "Bligny" F/W 2003-2004

Sportmax stylists team Materials: double cashmere (by Lanificio Colombo), fox fur

This coat, seamed at the waist, has concealed asymmetric fastening, straight-cut shoulders and set-in sleeves with leather wrist strap fastened with a burnished metal buckle. The high ring collar has a similar leather trim.

The front is rendered luminous

The front is rendered luminous by a wide fox border intersected by three narrow belts, stitched to either side, that buckle in the front.

References: original sketch and advertising folder for the F/W 2003-2004 collection (photos by Phil Poynter), Archivio d'Impresa Max Mara M.R.

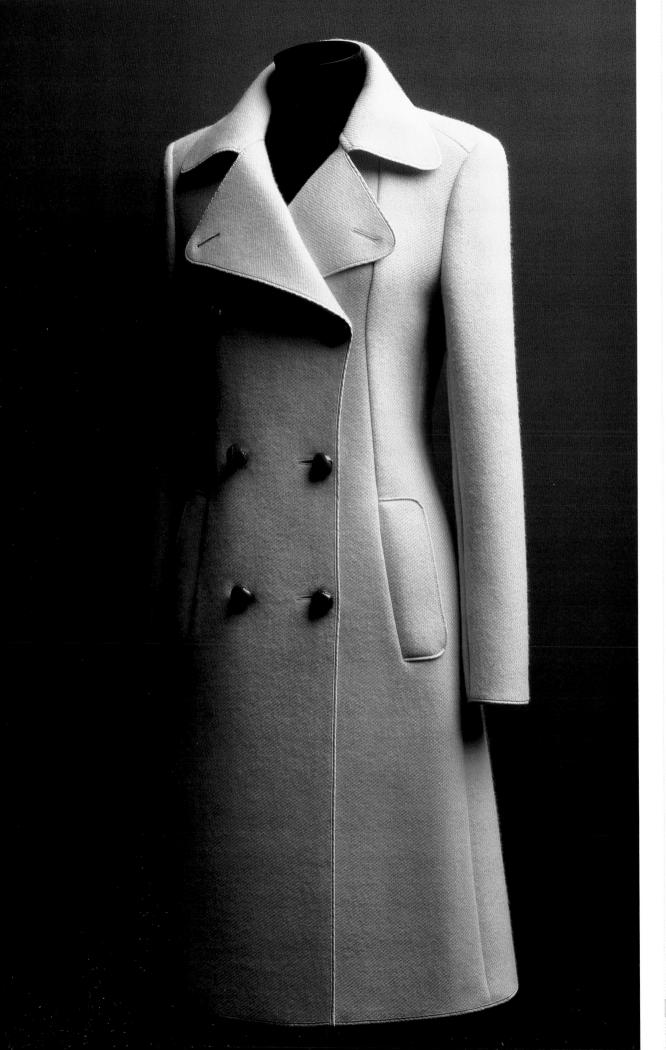

Sportmax "Matera" Coat 20165143 F/W 2004-2005

Sportmax stylists team
Materials: yellow wool and angora
twill (by Lanificio Ricceri); yellow
cotton lining, brown plaited leather
buttons

Double-breasted lined coat with wide lapels, shaped at the back by a waist-high half-belt, beneath which there is an inverted pleat with vent secured by buttons. It is completely edged with yellow cloth.

The angora in the fabric, which has the look of a rustic Shetland, makes it as soft as silk to the touch.

References: original sketch and advertising folder for the F/W 2004-2005 collection (photos by Mikael Jansson), Archivio d'Impresa Max Mara M R

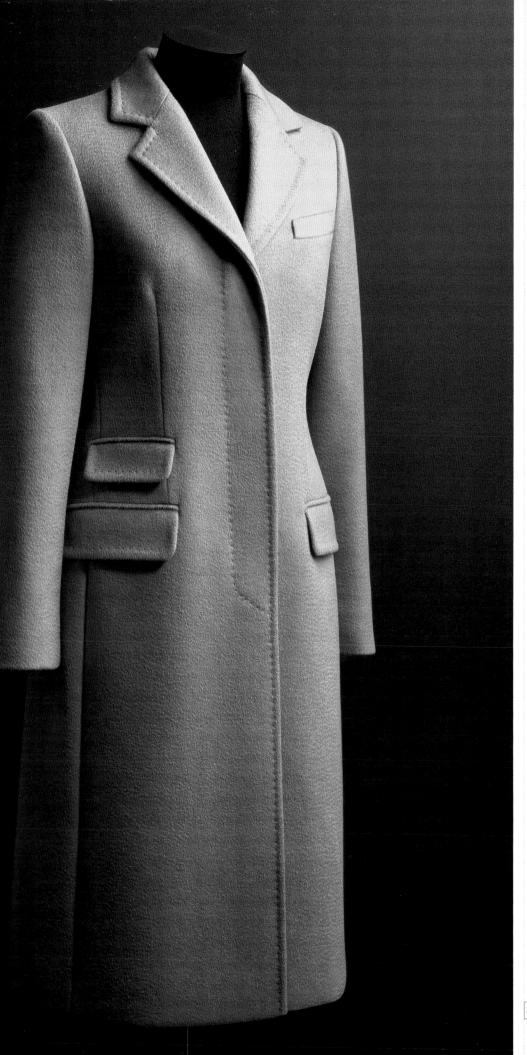

Max Mara "Morena" Coat 10172753 F/W 2005/2006

Sketch by lan Griffiths Materials: pure camelhair "sable" drap (by Lanificio Colombo); viscose twill lining

Single-breasted masculine-style coat with *revers*, hidden fastening, three slash pockets with flap and breast pocket. For this camel model, the designer drew his inspiration from the male coat.

Reference: original sketch, Archivio d'Impresa Max Mara M.R.

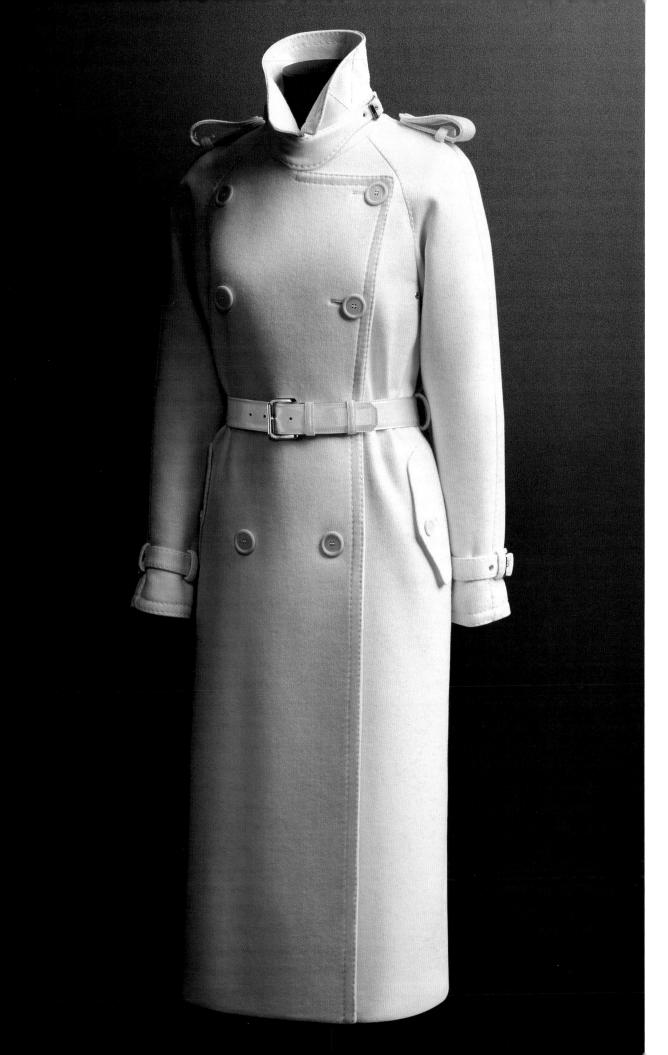

Max M Coat 10 F/W 20

Max Materia double viscose leather

Double-buttons at the war The bac movem fastene It has a a trencito the weyelets and cuff are refrand while lapels. This converse women flag duat the 1

Referer the F/W (photos Archivia M.R.

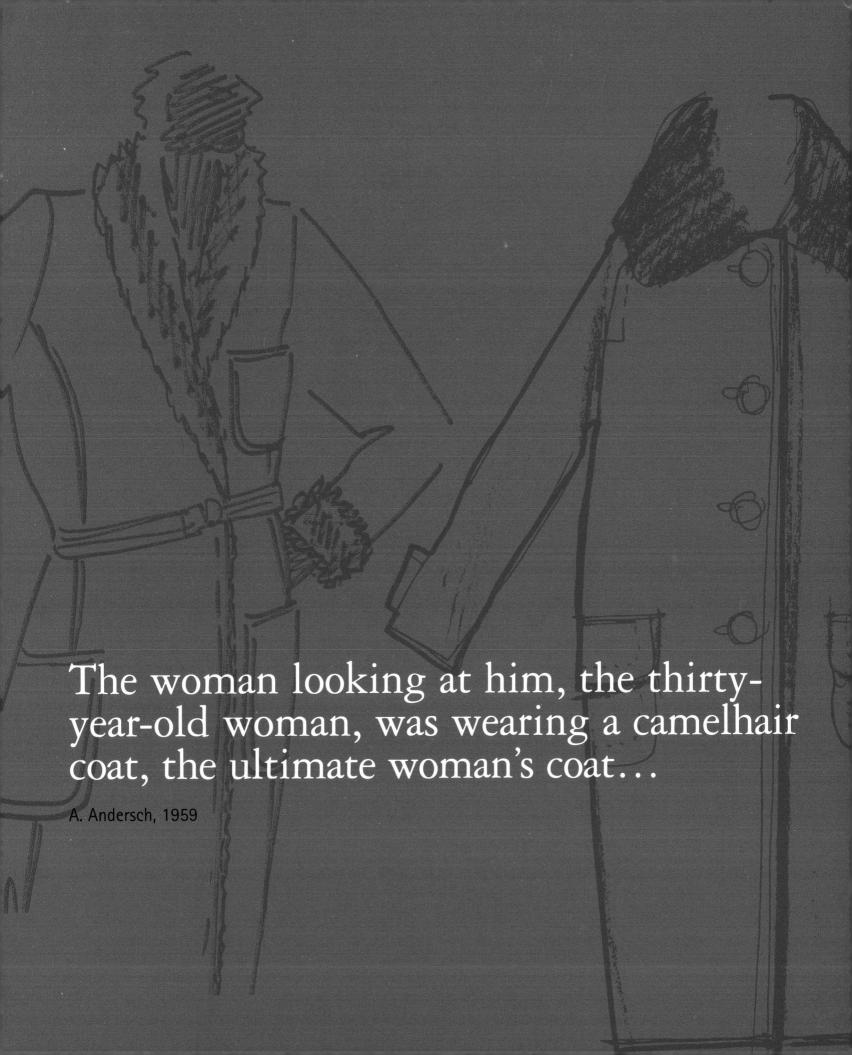

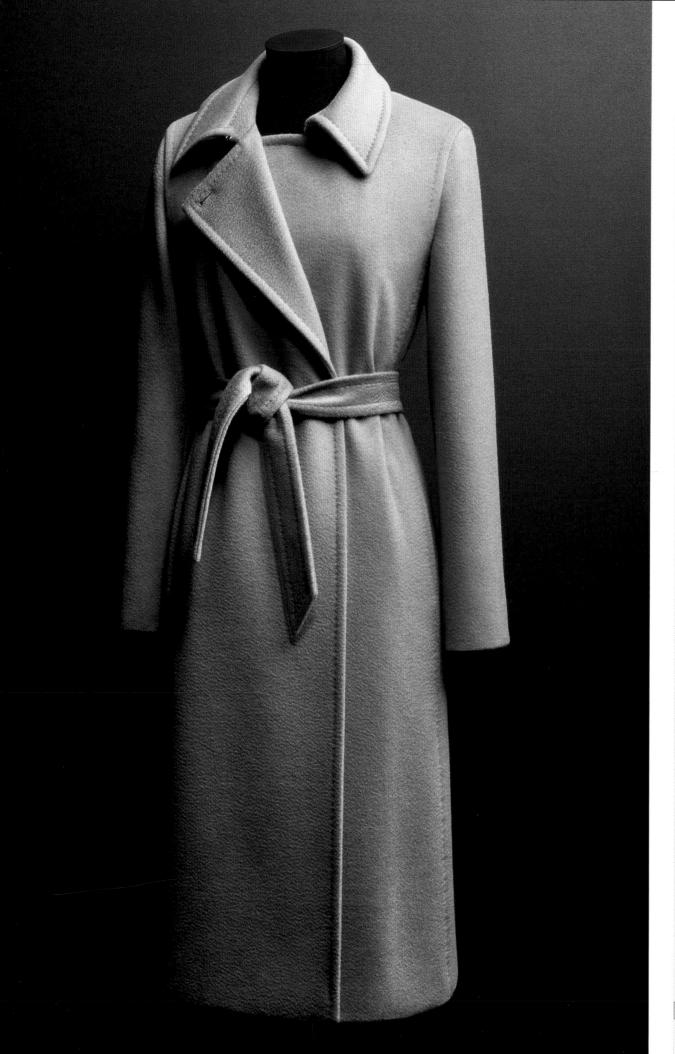

Max Mara "Modane" Coat 10162263 F/W 2006-2007

Sketch by Anne Marie Beretta Materials: pure camelhair "sable" drap (by Lanificio Colombo); viscose jacquard twill lining with Max Mara logo

Straight coat with overlap front and asymmetrical one-button fastening, slightly padded straight-cut shoulders and set-in sleeves. It has a trench collar with a hook fastener, and tie belt.

The camel coat is a Max Mara evergreen, numerous variations of which have been presented since production first began. This one is a reinterpretation of the trench coat, softened by the tie belt.

Reference: original sketch, Archivio d'Impresa Max Mara M.R.

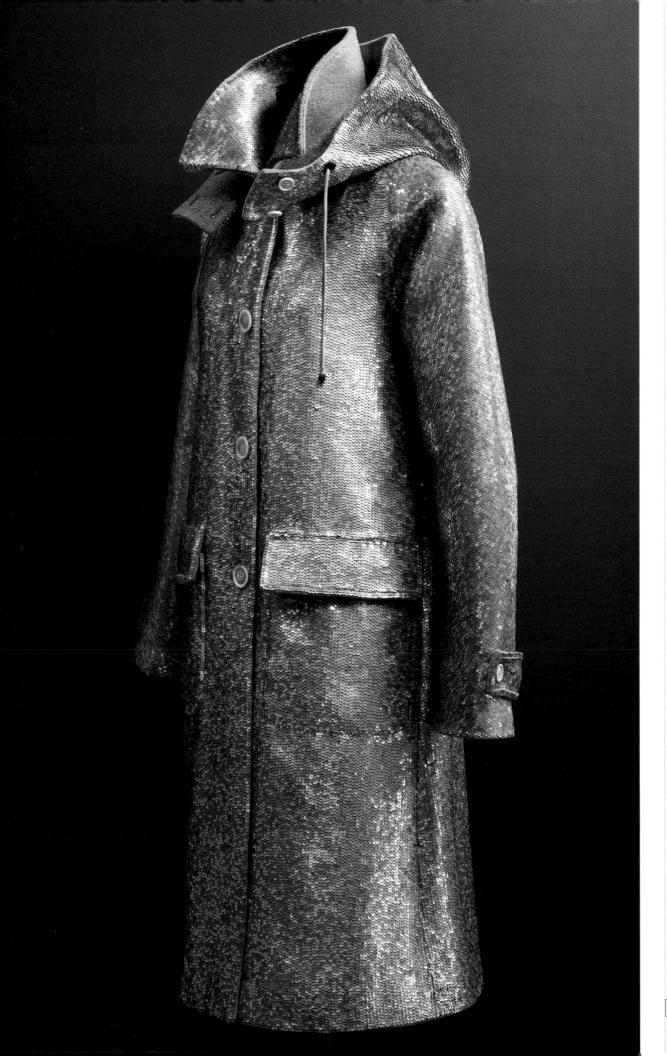

Max Mara Coat 10160166 "Musette" F/W 2006-2007

Sketch by lan Griffiths
Materials: grey *mélange* wool twill
with *appliqué* embroidery using
golden sequins and bronze *mélange*(embroidery on unfinished
garment), bone buttons

This classic sporting coat with a detachable hood and large pockets is given a radically different look through the use of unusual materials; the grey *mélange* flannel, visible only on the reverse side, has been completely embroidered with row upon row of golden sequins.

References: original sketch and backstage photo (photo by Cannonieri & Fortis), Archivio d'Impresa Max Mara M.R.

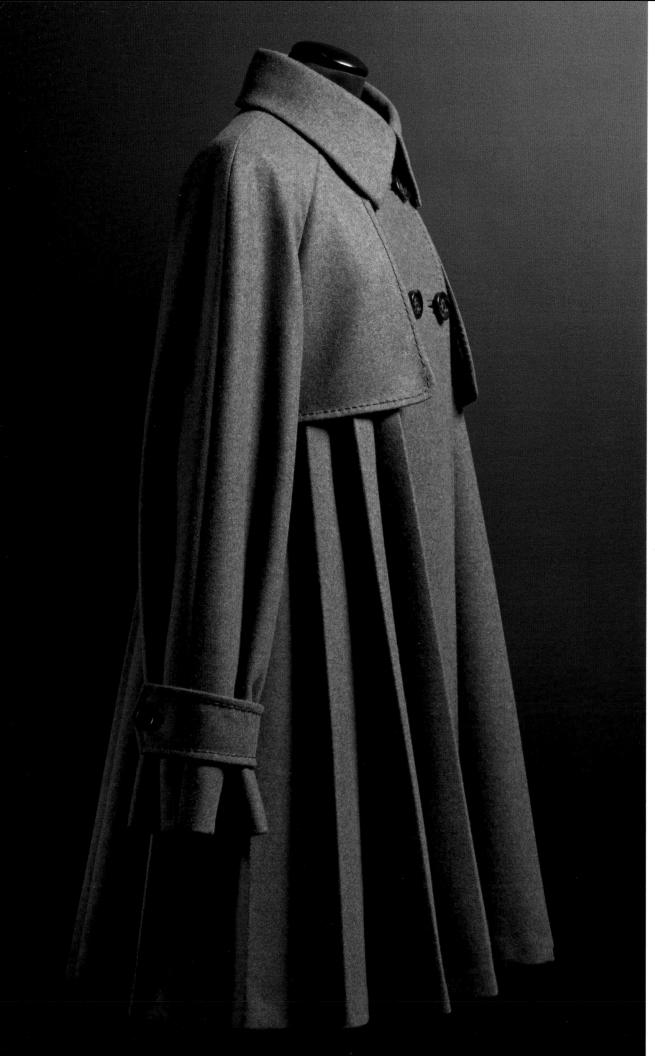

Sportmax "Lepanto" coat F/W 2008-09

Sportmax stylistic design sketch Materials: grey wool cloth, grey and blue felt, brown chamois strip, grey calico, black mechanical lace, strip of grey organza with a purple border, round buttons of two different sizes, rhinestones with silver metal bezel. Lining in: iridescent grey acetate saglia, diagonal black polyamide fabric, crèpe georgette in grey rayon, black satin, black flannel, black adhesive fabric (vlieseline).

Short, double-breasted coat fastened with four buttons, wide line. Cut to a high waist on the sides of the lapel with a full skirt modelled in 17 cloths doubled with vlieseline and folded.
The bodice is close fitting with two

cloth fronts and a grey cloth back. The coat is covered with a cape, which is decorated with the application of a paste in the middle of the rear hem. The raglan sleeves are held tight at the wrist by a strap. The pointed, detachable ("collar band") is fastened at the front with two small buttons and is doubled in blue and grey felt, edged with a small strip of brown chamois.

The entire coat is finished with a detachable lining in iridescent twill on the front and shoulders and georgette on the back. The garment is completed with a small strip of lace on the hem. The seams are underlined with dot stitching.

Inspired by the classic trench coat, the model is tailored using a single fabric for the exterior but several different textiles for the hidden parts using a method that harks back to the rules of old tailoring.

Reference: original sketch, Archivio d'Impresa Max Mara E.M.

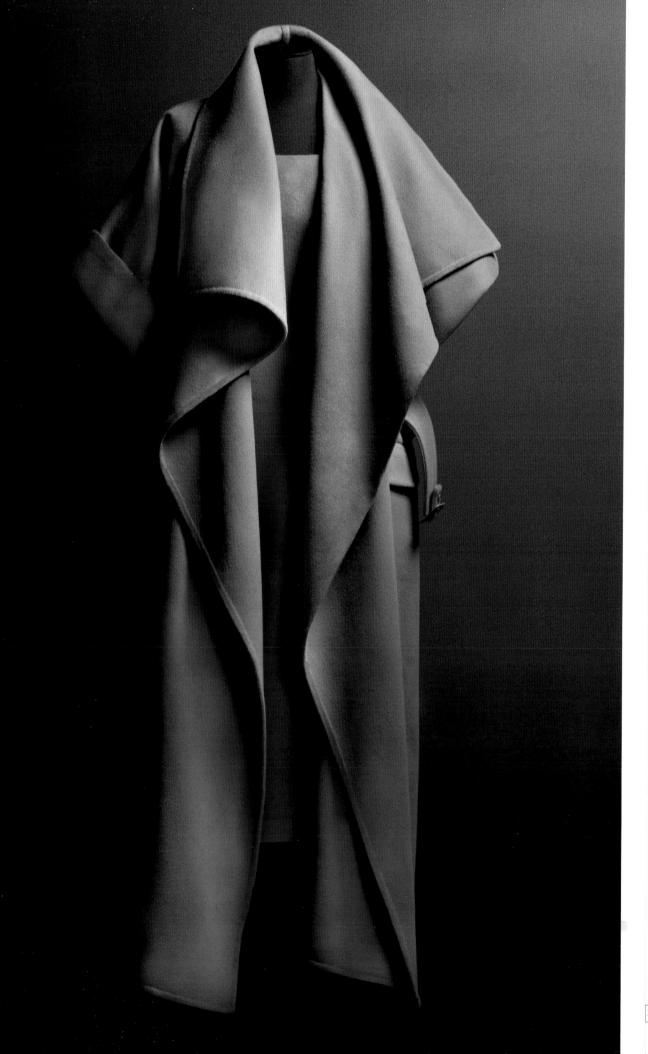

Max Mara Suit comprising a dress and "Disco" coat 10161596 F/W 2009-10

Sketch designed by lan Griffiths Materials: wool cloth and cognac cashmere, cognac taffeta lining, acetate and iridescent rayon green satin, stiffeners, strip of cognac satin.

The suit comprises a dress and coat in the same fabric.

The fourreau is close fitting with a straight neckline and full front, modelled with pinces at the breast and sides while the back is clinched at the waist. The suit is supported by a reinforcing corset sewn to the inside. The unlined coat is cut in four rectangular pieces of cloth with a kimono line that is perfectly geometrical. The back of the coat is made from two cloths that also make up the rear part of the kimono sleeves. The front comprises two identical rectangular pieces of cloth. These are wide, in keeping with the rest of the coat and perfectly overlap each other. These pieces form the front side of the sleeves and the large quadrangular collar. The two parts of the collar are sewn in the middle of the back and fitted on a detachable collar ("collar band") at the nape of the neck. The large sleeves are rolled up to the elbow. The seams are English-style or "double hand stitched". The coat is held tight at the waist by a band belt with a leather-covered buckle. The suit combines two different types of approach to tailoring and clothing design: on one hand typically western, modelled on the body with pinces and corsets, and on the other hand extra-European, cut according to flat geometric shapes that rest on the shoulders and enshroud the body.

Reference: original sketch; photo campaign F/W 2009-2010 (photo by M. Sorrenti), Archivio d'Impresa Max Mara E.M.

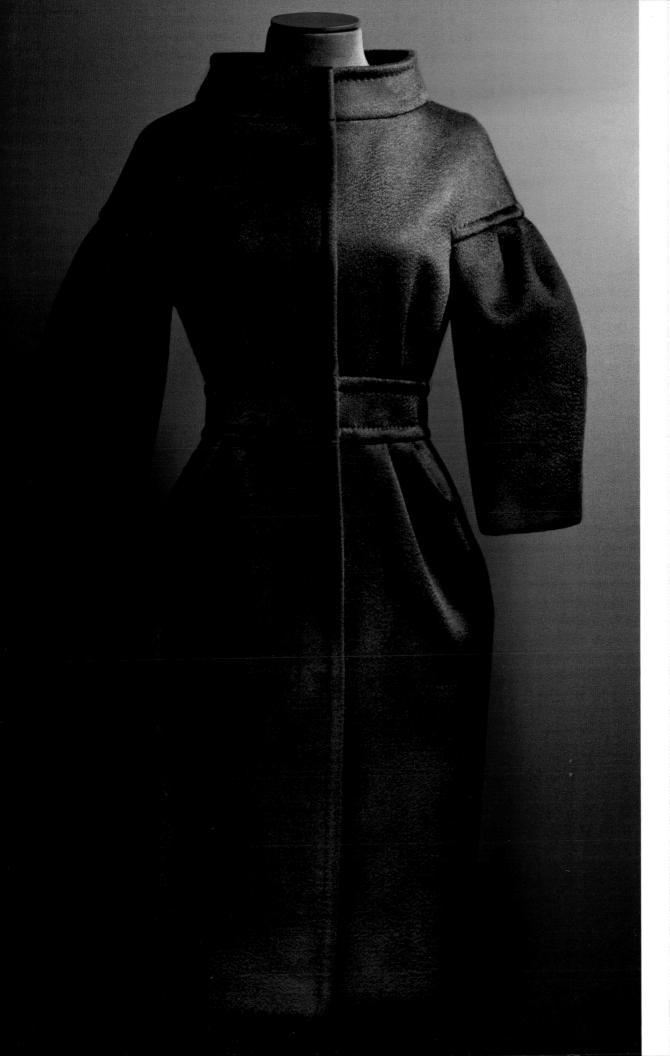

Max Mara Atelier "Destino" Coat 30160495 F/W 2009-10

Materials: black cashmere double cloth, black fluid satin silk and cupro (rayon), snaps covered with black satin.

Single-breasted coat, clinched at the waist, fastened with six large snaps covered with black satin. The "tulip coat" model is shaped with four folds that unfasten on the front and back, held by a belt inserted at the waist. The bodice has a pieced together crater collar and low shoulders. The three-quarter-length sleeves are folded at the top to create a rounded line.

The skirt is made from four cloths and features a "tulip" line and rear slit.

The external seams are underlined with stitching. The lining is attached with white thread

attached with white thread stitching.
The line of the model is inspired by early 60s Parisian haute couture and also harks back to tailoring trends such as armhole sleeves, stitching and fitting hand crafted buttons buttons.

Reference: original sketch, Archivio d'Impresa Max Mara

*			

Back matters

Bibliography

Monographs and Essays

- M. V. Alfonsi, *Leaders in Fashion. I grandi personaggi della moda*, Cappelli, Bologna 1983
- I. Griffiths, "The invisible Man", in Nicola White and lan Griffiths (eds.), The fashion business: theory, practice, image, Berg, Oxford 2000, pp. 69-90
- L. Lusardi, a cura di, *Max Mara*, dattiloscritto non pubblicato,
- L. Maramotti, "Connecting Creativity", in N. White and I. Griffiths (eds.), *The fashion* business: theory, practice, image, Berg, Oxford 2000, pp. 91–102
- Max Mara tradizione, esperienza, creatività nella moda, Max Mara, Reggio Emilia 1981
- E. Merlo, *Moda italiana. Storia* di un'industria dall'Ottocento a oggi, Marsilio, Venezia
- E. Pagani, R. Pavoni, "Clothing Manufacturers in the Sixties: between Crisis and innovation", in G. Butazzi and A. Mottola Molfino, Italian Fashion: From Anti-Fashion to Stylism, vol. 2, Electa, Milano 1987
- M. Pellegrino, D. Spaggiari and R. Spagni, *Donne nella moda*. *Protagoniste reggiane del fashion system*, Diabasis, Reggio Emilia 2002
- P. Soli, *Creatività e tecnologia* della moda italiana 1951-1983, Mondadori, Milano 1984
- E. Strada, Max Mara: la storia e lo stile negli anni '50 e '60, degree thesis, IULM University, Milan, academic year 2004-2005
- N. White, "Italy: Fashion, Style and National Identity 1945-1965", in N. White and I. Griffiths (eds.), *The fashion business: theory, practice, image*, Berg, Oxford 2000, pp. 183-203
- N. White, "Max Mara and the origins of italian ready-to-wear", in *Modern Italy, Journal of the Association for the study of modern Italy*, vol. 1, n. 2, Routledge, Oxford 1996
- N. White, Reconstructing Italian Fashion. America and the Development of the Italian Fashion Industry, Berg, Oxford

Selected Articles

- "Moda e produzione. Risponde Achille Maramotti", in *Giornale Tessile*, 13 May 1971
- M. dell'Aquila. "Tu compri un vestito, però non sai...", in *Arianna*, October 1971, pp. 88-91
- "Il design di moda da nuove tecniche industriali nasce un diverso modo di vestire", in *Vogue Italia*, November 1971
- T. Trini, "Abitare l'abito", in *Domus*, May 1972
- G. Brolatti, *La Moda val bene una Laurea in Legge*, in *Analisi*", October 1983, pp. 16-18
- M. Mezzanotte, "Laura Lusuardi, la donna ombra di Max Mara", in Informatore Tessile del Mezzogiorno, April 1984, pp. 58-59 M. Clerici, "Cavaliere della moda", in Amica, 11 September 1984
- E. Magrì, "Faccio il cattivo per essere alla moda", in *L'Europeo*, 15 September 1984, pp. 20-21
- M. Oriani, "La Guerra dei 30 Anni del Cavalier Achille", in *IF*, October 1984, pp. 36-37
- L. Pericoli, "Non conosce crisi l'impero del prêt-à-porter", in *Il Giornale*, 6 October 1984
- C. Verdelli, "L. Lusuardi. Una caparbia ragazza nel grande mondo della moda", in *Donna Più*, December 1984, pp. 122-126
- "Max Mara, un grande 'sistema"' per fare moda", in *Vogue Italia Speciale*, October 1985, pp. 544-
- T. Matteoni, "I grandi Gioielli di una grande famiglia", in *Fashion*, 17 April 1986, pp. 80-81
- Gruppo Max Mara. Quando l'azienda entra nella scuola, "Fashion", 23 April 1986.
- A. Maramotti, "Prêt à porter sfondare all'estero" in *Civiltà del Lavoro*, August–September 1986, pp. 21-22
- A. Maramotti, "Lo sviluppo del sistema distributivo nel settore dell'abbigliamento", in Civiltà del Lavoro, September-October 1988, pp. 18-21
- L. Armstrong, "The Max factor", in *Vogue*, English edition, October 1988, p. 262
- H. Raccah, "Un integrazione flessibile", in *Gap Italia*, June 1989, pp. 52-53
- R. Zincone, "Max Mara, principe del 'prêt-à-porter", in *Il Sole 24 Ore*, 22 August 1989
- "Le P.D.G. de Max Mara parle de l'Europe", in *Journal du Textile*, January 1990, pp. 3-5
- "Le interviste parallele/Achille Maramotti. Una evoluzione totale", in *Fashion*, 8 January 1990
- J. Piganeau, "Max Mara ne cesse de faire des gammes", in *Journal du Textile*, 2 September 1991, pp. 98-100

- P. Reed, "Feels Famiglia", in Fashion, The Sunday Times Magazine, Autumn 1991, pp. 11-16
- N. Favalli, "La Moda, quarant'anni vissuti con stile", in *Amica*, 21 October 1991, pp. 37-42
- C. Le Brun, "Du coté de chez Max Mara", in *L'Express Weekend*, 19 June 1992, pp. 24-26
- S. Gay Forden, "Max Mara, Italian Apparel Giant, Targets U. S. for Growth", in *Women's Wear Daily*, 26 October 1992
- R. Tredre, "Not-at-all-mad Max", in *The Independent*, 5 November 1992, p. 25
- S. Mower, "Maximum impact", in *Harper's & Queen*, March 1993, pp. 121-124
- V. Windels, "De Max van Maramotti", in *DS Magazine*, 21 May 1993, pp. 22-24 R. Sannelli, Come l'anima, la moda vive i dubbi della transizione, in "Allure", June 1993, p. 76
- G. Lecompte-Boinet, "Max Mara préfère les petits pas", in *Journal du Textile*, 18 October 1993
- M. Marozzi, "Com'è difficile essere semplici", in *Amica*, 1 November 1993, pp. 110-112
- "The Story of Max Mara", in *Marie Claire*, English edition, April 1994, p. 154
- A. Weber, "Max Mara, eine italienische Familie", in *Elle*, May 1994, pp. 162-164
- D. M. Pogoda, "Max Mara Takes Madison", in *Women's Wear Daily*, 1 September 1994, pp. 8-9
- B. Nagel, "Wer erfand eigentlich die Pret-à-Porter Mode?", in Welt am Sonntag, 30 October
- B. Polan," Maximum Effect", in *You,* the mail on Sunday, 30 October 1994, pp. 46-47
- E. Paillié, "Max Mara, de mères en fils", in *Depêche Mode*, November 1994, pp. 34-35
- "Innovazione, ricerca e qualità, le nuove esigenze del mercato", in *IWS Economy*, issue of *IWS Wool News*, January 1995, p. 4
- P. Chiesa, "Classico, ma con personalità", in *Il Resto del Carlino*, 20 March 1995
- "The Max appeal", in *Elle*, English edition, May 1995, pp. 33–34
- J. Fairley, "Coats & Max", in Woman's Journal, September 1996, pp. 80-84
- G. Bertolini, "Nell'impero Maramotti è arrivato il momento della seconda generazione", in *EconErre*, March 1997, pp. 16-18
- K. Fruehe, "Frauen wissen, was sie wollen. Max Mara weiss, was Frauen kleidet", in *Frankfurter Allgemeine Zeitung Magazin*, 11 April 1997, pp. 53-57

- K. Wheeler, "When vogue means danger", in "How to Spend It", issue of the *Financial Times*, 2 August 1997, p. 11
- R. La Ferla, "To the Max", in *Elle*, USA Edition, September 1997, pp. 356-364
- G. South, "Designed to stay with the family", in *Sunday business*, 9 August 1998, p. 23
- A. Coppet, "Un manteau qui fait le tour du monde", in *Marie Claire*, October 1998, pp. 250-255
- "The Birth of a Max Mara Coat", in *Marie Claire*, English edition, October 1998, pp. 282-287
- A. Smith, "Mad Max", in *The* Guardian Style, 13 August 1999, pp. 10-11
- P. Pollo, "Lunga vita alla regina e al paletot. Lussi d'esportazione, Max Mara in mostra a Londra", in Sette, weekly issue of *Corriere della Sera*, 26 August 1999, pp. 93-94
- Max Mara in west Broadway, "Milano Finanza Fashion", 3 November 1999.
- S. Frankel, "The Max Factor", in *The Sunday Review*, 29 December 1999, pp. 29–30
- D. Allen, "Max Mara, min risk", in Yes Please Italy, March 2000, pp. 10-14
- *Il nostro referendum*, "Fashion", 24 March 2000
- A.-M. Quilleriet, "La saga Max Mara", in *Le Monde*, 30 September 2000, p. 30
- Max Mara, l'export cresce, "La Gazzetta di Reggio", 29 November 2000.
- U. Sauer, "Stiller Riese aus Emilia", in *Wirtschaftswoche*, 12 December 2000, pp. 94-96
- D. Bagnoli and P. P. Polte, "Die Liebe zum Unterstatement", in *TextilWirtschaft*, 15 February 2001, pp. 74-76
- A. Urbauer, "Mad on Max", in *Spruce*, Autumn/Winter 2001, pp. 107–110, 198, 204
- Chiara Modini, Elisabetta Campana, Franchising: a ciascuno il suo in "Fashion", 16 November 2001, p. 19.
- Giusi Ferré, *L'immagine, che imbarazzo*, "Il Corriere della Sera", 10 December 2001.
- Giusi Ferré, *Maramotti (Max Mara)*: "Ritorna la famiglia", "Il Corriere della Sera", 10 December 2001
- Paola Bottelli, *Max Mara, il 2002* é partito con slancio, "Il Sole 24 ore", 3 March 2002.
- B. Epinay, Max Mara, l'éternelle leçon d'élégance, in "Les Echos Série limitée", 6 December 2002, pp. 13-14
- I. Griese, "Cashmere und Parmesan", in *Die Welt*, 22 February 2003

M. R. Stiglich, "Fare Storia a sé", in *Pellicce Moda*, March 2003, pp. 75-79

Paola Bottelli, *Max Mara + 4% i ricavi 2002*, "Il Sole 24 ore", 2 March 2003.

D. Horvath, "Wer ist eigentlich Max Mara?", in *Stern*, 23 October 2003, pp. 172-176

Paola Bulbarelli, *D&G*, *Ovvero quando il futuro è un revival*, "Il Giornale", 26 February 2004.

L. Eliez, "Le 101 801 de Max Mara", in *Stiletto*, Autumn 2004

Giampietro Baudo, *Mancano* progettisti Max Mara se li forma, "Milano Finanza Fashion", 7 September 2004. E. Vorobieva and L. Missir de Lusignan, "Max Attaque", in *Elle Belgique*, October 2004, pp. 127–129

Cristina Mello-Grand, *Max Mara. Conosciamo il nostro mestiere*, "Modaonline.it", 25 October 2004.

S. Ricotta Voza, "La creatività? È far tutto a 'puntino'", in Specchio, weekly issue of La Stampa, 15 October 2005, pp. 52-55

S. Allerstorfer, "Max Mara, mehr als eine Marke", in *Bolero*, April 2006, pp. 130-135

Giulia Landini, *La sposa di Max Mara*, "Cherie Sposa", July-August 2007, p. 116-121. Laura Asnaghi, Dolce&Gabbana, Versace: chiffon e seta, "La Repubblica", 22 February 2008

Francesca Lucat, *Max Mara riscopre le spalle*, "Imore", 26 February 2008.

Max Mara la carta della ricerca, "La Repubblica", 23 February 2009.

Face to Face. Laura Lusuardi – Max Mara, "Showdetails", Spring 2010.

Maria Silvia Sacchi, *Moda Sorpresa, la Cina salva il made in Italy,* "Il Corriere della Sera", 19 July

Index of Names

Numbers in italic are referred to illustrations

Abital, p. 28
Airò, Mario, pp. 141, 142
Albero, Roger, p. 144
Albini, Walter, p. 35
Allende, Isabel, p. 71
Ann, Lilli, pp. 20, 25
Apem, p. 33
Arcangeli, Maurizio, pp. 141, 142
Arienti, Stefano, p. 141
Armani, Giorgio, pp. 47, 52, 62
Avedon, Richard, pp. 106, 118, 120, 232
Avoncelli, p. 46

Bacall, Lauren, p. 89 Bailly, Christiane, p. 37 Baldo, Luigi, p. 40 Balenciaga, Cristóbal, pp. 25, 28, 29, 83, 84, 89, 152, 160 Ballarini, p. 28 Ballo, Billy, p. 37 Barrat, Martine, pp. 144, 145 Barthes, Roland, pp. 93, 94, 99, 102 Battles, Nolanie, pp. 30, 34, 39, 102 Bellati, Manfredi, pp. 105, 108 Beretta, Anne Marie, pp. 50-52, 54, 61, 88, 89, 151, 188-190, 192-195, 198, 200, 201, 203, 205, 229, 230, 233, 242 Berthoud, François, p. 146, 146 Bialetti, Alfonso, p. 88 Bishop, Leilani, p. 130 Black, Cilla, p. 35 Bonanni, Sergio, p. 40 Bonfils, Lison, pp. 33, 151 Borello, Enrico, p. 108 Brading, Martin, pp. 106, 120, 129, 224, 225 Bremner, Eric, pp. 55, 61, 222-227, 235 Breuer, Marcel, p. 88 Brooks Brothers, p. 23 Bruni, Carla, pp. 115, 117, 118 Buosi, p. 28 Burberry, p. 34

Caballero, Thais, pp. 143, 144 Cabiati, Vincenzo, pp. 141, 142 Cacharel, Jean, p. 37 Cadette, p. 46 Caesar, p. 28 Canavacciuolo, Maurizio, p. 141 Cannonieri & Fortis, p. 243 Cannonieri et Fortis, p. 243 Cano, Jordi, p. 144 Cantoni, Gino, p. 20 Carboni, Erberto, p. 107 Cardin, Pierre, pp. 152, 163 Cassano, Chiara, p. 73 Cassini, Oleg, pp. 30, 33 Castaldi, Alfa, p. 111 Castelbajac, Jean Charles de, pp. 48-50, 58, 106, 108, 111, 151, 177, 178, 180-182 Catelani, Antonio, pp. 141, 142 Caumont, Jean-Baptiste, p. 35 Cavenago, Umberto, pp. 141, 142 Chancellor, Cecilia, p. 113 Chanel, Coco, pp. 29, 30, 30, 36, 87, Chatto, Marco, p. 142 Chéruit, p. 84 Chiesa, Piero, p. 40 Chloé, p. 46 Ciampelli, Agostino, p. 72 Ciarlini, Amos, p. 20 Clark, Petula, p. 35 Clemente, Alba, p. 90 Close, Glenn, p. 91 Colantuoni, Maurizio, pp. 141, 142 Coltellacci, Giulio, p. 37 Cori-Biki, p. 40 Courrèges, André, pp. 34, 152 Crotti, Marisa, pp. 19, 20

De Lorenzo, Daniela, p. 142 Delahaye, Jacques, pp. 37, 151 Dellavedova, Mario, p. 141 Demaye, Colette, pp. 37, 42, 164, 165 DeWavrin, Leah, p. 137 Di Centa, Manuela, p. 71 Diaghilev, Sergej, p. 52 Dietrich, Marlene, p. 89 Dillon, Kate, pp. 129, 130 Dior, Christian, pp. 25, 83, 84, 88, 152 Donaldson, Lily, p. 136 Dondi, p. 214 Dorothée Bis, p. 46 Duca di Bard, p. 40

Edkins, Diana, p. 113 Eichelmann, Volker, pp. 143, 144 El-Moutawakel, Nawal, p. 71 Elgort, Arthur, pp. 106, 113, 114, 115, 229, 230 Erdmann, Robert, pp. 69, 106, 226 Erichsen, Freja Beha, p. 126 Evan, Charles, p. 23 Evangelista, Linda, pp. 118, 123 Evan-Picone, p. 23, 38

Farago, Max, pp. 75, 75, 76 Fermariello, Sergio, p. 142 Ferrè, Gianfranco, p. 52 Ferrè, Giusi, p. 69 Feurer, Hans, p. 105 Fias-Lo Presti Turba, p. 18 Fiorucci, p. 46 Fontana, Graziella, pp. 37, 38, 38, 40 Fontanesi Maramotti, Giulia, pp. 17-19, 106 Fontanesi, Giuseppe, p. 18 Forest, p. 28 Formento e Sossella, p. 142

George, Sophie, pp. 55, 220 Ghini, Isabella Ludovica, p. 162 Giorgini, Giovanni Battista, p. 21 Givenchy, Hubert de, pp. 25, 26, 28, 30, 163 Gonzáles, Natalia, p. 144 Gordon Lazareff, Hélène, p. 33 Grassi, Duccio Maria, p. 72 Grey, Kevin, p. 144 Griffe, Jacques, p. 88 Griffits, lan, pp. 61, 232, 239, 243, 245 Grignaschi, Renato, p. 60 Gruppo Finanziario Tessile, pp. 28,

Gucci, pp. 62, 87 Guidotti, Giorgio, pp. 64, 66, 69, 113 Hechter, Daniel, p. 37 Heim, Jacques, p. 37 Hepburn, Audrey, p. 30

Hepburn, Katharine, p. 89 Hermès, p. 36 Hernandez, Lazaro (Proenza Schouler), p. 61 Hettemarks, p. 45 Hom, Marc, pp. 106, 133

lliagirl, p. 40 Inez & Vinoodh, pp. 106, 133 Iotti, Gianni, pp. 29, 30 Ivanyuk, Juju, p. 138

Jakobson, Roman, p. 95 Jansson, Mikael, pp. 126, 136, 237 Jenny, p. 84 Juvenilia, p. 28

Karan, Donna, p. 59 Kelly, p. 87 Kennedy, Jacqueline, pp. 26, 30, 33, 33, 163 Khanh, Emmanuelle, pp. 37, 41, 151 Kirschhoff, Thorsten, p. 142 Klein, Calvin, p. 59 Kouklina, Polina, p. 136 Krizia, pp. 37, 52 Kummernuss, Ines, p. 37

Lagerfeld, Karl, pp. 37, 40, 42, 46, 151, 168, 170, 172 Lamarca, Clara, p. 144 Lamsweerde, Inez van (Inez & Vinoodh), p. 106 Lançon, Odile, pp. 51, 52, 54, 185, 186 Lanificio Agnona, pp. 201, 203 Lanificio Cangioli, pp. 184, 226 Lanificio Colombo, pp. 233, 235, 236, 239, 242
Lanificio di Tollegno, pp. 229, 232
Lanificio Faudella, pp. 30, 33
Lanificio Ferrarin, pp. 162, 204
Lanificio Piacenza, pp. 193, 196, 198, 204, 205
Lanificio Ricceri, pp. 237, 240
Lapina, Ginta, p. 138
Lavatelli, Carlo, p. 40
Le Bon, Jasmine, p. 113
Lelong, Lucien, p. 88
Lepere, Anouck, p. 133
Lindbergh, Peter, pp. 106, 113, 113, 114, 213
Linke, Armin, p. 142
Lombard, Carole, p. 89
Lombardini, Adelmo, p. 20
Loren, Sophia, p. 71
Lovit, Roxanne, p. 111
Lubiam, p. 28
Lucchini, Flavio, pp. 41, 50
Lunardi, Giovanni, p. 35
Lusuardi, Laura, pp. 39, 40, 45, 46, 71, 72, 76, 150, 151, 152, 167, 175, 184, 196, 204

Maathai, Wangari, p. 71 MacLennan, Ruth, pp. 143, 144 Madame Grès, p. 152 Maeda, Tokuko, p. 55 Mafbo, p. 40 Magistretti, Vico, p. 89 Magli, Bruno, pp. 35, 37 Malgoli, Bruno, pp. 35, 37 Malagoli, Grazia, p. 55 Malta, Silvano, p. 29 Mam, Somaly, p. 71 Manifattura Lane Marzotto, p. 28 Mapplethorpe, Robert, p. 113 Maramotti, Achille, pp. 17-20, 23, 25-30, 33, 35-42, 46-51, 56, 58, 61, 72, 76, 77, 105-107, 111, 113, 150-153 Maramotti, Luigi pp. 55, 59, 62, 65, 71, 72 Marisaldi, Eva, p. 142 Marnay, Audrey, p. 133 Martegani, Amedeo, p. 142 Martinez, Carlos, pp. 143, 144 Marzotto, p. 32 Matadin, Vinodh (Inez & Vinoodh) p. 106 Matteoni, Titti, 46 Mazzucconi, Marco, p. 142 McAslan, John, p. 66 McCardell, Claire, pp. 83, 89 McCollough, Jack (Proenza Schouler), p. 61 McDean, Craig, pp. 73, 106, 118, Meteral, Clarg, pp. 73, 106, 116, 125, 240 Meisel, Steven, pp. 71, 106, 113, 118, 123, 233 Mert &t Marcus, p. 120 Merveilleuse, p. 18 Metzner, Sheila, p. 113 Mihalik, Eniko, p. 126 Miss Rosier, p. 40 Missoni, p. 37 Monaci Gallenga, Maria, pp. 79, 84 Mondino, Jean Baptiste, p. 113 Montanini, Antonia, p. 19 Moon, Sarah, pp. 105, 111, 113, 151, 173 177 Murphy, Carolyn, pp. 118, 123 Mutola, Maria, p. 71

Palandri, p. 178
Paraphernalia p. 46
Parés, Núria, p. 144
Paulin, Guy, pp. 46, 55, 64, 66, 151, 207-211, 213, 214, 216, 218
Pergreffi, Iacopo, 43
Perretta, Marco, pp. 94, 101
Piaia, Rosalia, p. 165
Piccini, p. 165
Piccini, p. 165
Piccone, Joseph, p. 23
Pirelli Confezioni, p. 28
Poiret, Paul, pp. 88, 88
Poli, Ubaldo, p. 20
Poly, Natasha, p. 125
Poynter, Phil, p. 236
Prada, p. 62
Premet, p. 84
Proenza Schouler, p. 61

Promostyl, p. 50 Pungi, Clara, p. 144

Raine, Sarah, pp. 144, 145 Reljin, Dusan, pp. 75, 106, 126, 129, 137 Ribas, Maria, p. 144 Rizer, Maggie, pp. 118, 120 Rosier, pp. 28, 32, 45 Rosier, Michèle, p. 37 Rossellini, Isabella, p. 91 Rossi, Alberto, p. 20 Roversi, Paolo, pp. 106, 111, 113, 205 Ruggeri, Cinzia, p. 40

Saint Laurent, Yves pp. 25, 47

Saldina, Natalia, p. 162
Salvarani Manfredini, Elisabetta, p. 159
Sanmarti, Gerard, p. 144
Scavullo, Francesco, p. 146
Sarandon, Susan, p. 71
Sealup, pp. 28, 40
Sebastian, p. 64
Seidner, David, p. 113
Shaw, Sandy, p. 35
Sidi, p. 40
Simonazzi, Giovanna, pp. 151, 163
Sims, David, p. 129, 138
Sjoberg, Emma, pp. 120, 129
Soprani, Luciano, pp. 46, 151, 173, 174
Sorrenti, Mario, pp. 76, 118, 126, 245
Soukupova, Hana, p. 125
Spoldi, Aldo, p. 142
Strada, Elena, p. 22
Strada, Nanni, pp. 40, 41, 46, 48, 49, 171

Tennant, Stella, p. 118
Terricabras, Núria, p. 144
Tescosa, p. 28
Thea Boutique, p. 40
Toderi, Grazia, p. 142
Trentini, Caroline, p. 136
Trini, Tommaso, p. 42
Turlington, Christy, pp. 115, 118
Type, Dumb, p. 145

Unimac (Ruggeri), p. 45 Unwerth, Ellen von, p. 113 Urizzi, Fernanda, p. 172

Vadukul, Max, pp. 106, 113-115, 117, 118 Vallhonrat, Javier, p. 113 Valstar, p. 28 Van der Veen, Steevie, pp. 111, 113, 114, 114, 115 Van Seenus, Guinevere, p. 130 Versace, Gianni, p. 59 Vezzani, Roberta, p. 174 Vita, Max, p. 40 Vreeland, Diana, p. 52

Walker, Perter, p. 66 Warhol, Andy, p. 146 Watson, Albert, pp. 106, 120, 129, 130 Weber, Bruce, p. 113 Wegman, William, pp. 146, 146 Weill, Alain, p. 19 White, Nicola, pp. 19, 20, 25 Winkler, Liisa, pp. 118, 123

Yamamoto, Yohji, p. 144 Yanagi, Miwa, pp. 144, 145 Yavel, Mike, pp. 67, 106, 194, 195,

Zimmerman, Raquel, p. 125 Zoran, p. 59

Photographic Credits

During the realisation of this book the Publisher has taken utmost care regarding copyrights for images reproduced herein. Should there any omission, the Publisher is available to rectify the error.

Jörg Anders, Gemäldegalerie, Staatliche Museen zu Berlin p. 83 Archivio d'Impresa Max Mara – pp. 30, 38, 40 (right), 41 (right), 42, 45, 47 (below), 48 (below), 59, 65, 66 (left), 68 (right above and below), 89 (left), 101, 106, 107, 150, 152, 153, 154, 155 and all reproductions of sketches p. 164 to p. 247 © The Richard Avedon Foundation pp. 120, 121 Martine Barrat – p. 144 (above) Giò Belli – pp. 44, 50, 51, 52 (left), Martin Brading – p. 128 Manfredi Bellati – pp. 48 (above), 109 Dhyan Bodha d'Erasmo – pp. 85 (second and fourth image from left), (second and fourth image from left) 89 (right), 158, 160–169, 172–243 Alfa Castaldi – p. 41 (left) Bettmann/Corbis – p. 33 Marco Chatto – p. 142 Matteo Consolini – p. 155 Manlio Conte – p. 52 (right) Roland Di Centa – p. 46 Arthur Elgort – pp. 114, 115 Robert Erdman – pp. 69 Max Farago – p. 74 Stanislao Farri, Fototeca Biblioteca Panizzi, Reggio Emilia – pp. 94, 95 Panizzi, Reggio Emilia - pp. 94, 95 Hans Feurer – p. 58 Foto Castellani, pp. 39, 40 (left) Foto Castellani, pp. 39, 40 (left) Foto Lux, Venezia – p. 19 Giovanni Gastel – p. 63 Renato Grignaschi – p. 60 Marc Hom – pp. 132, 133 Hulton Archive – p. 35 Inez & Vinoodh – pp. 134, 135 Interphoto Press Agency, Milano – pp. 22, 23 Mikael Jansson – p. 136 Dietmar Katz, Kunstbibliothek, Staatliche Museen zu Berlin – pp. 82, 84 Tony Kent – p. 42 (second and fourth image from left) Bill King – p. 64 (left) Peter Lindbergh – pp. 68 (above and below the left), 112, 113 Armin Linke – p. 142 Saturia Linke, Kunstgewerbemuseum, Staatliche Kunstgewerbemuseum, Staatliche Museen zu Berlin – p. 85 (first and third image from left) Renato Losi – p. 15 Roxanne Lowit – p. 90 Giovanni Lunardi – p. 37 Steven Meisel – pp. 70, 122, 123 Tommaso Mangiola – pp. 96-100, 102, 103 102, 103
Craig McDean – pp. 71, 73, 124, 125
Dusan Reljin – pp. 75, 137
Paolo Roversi – pp. 62, 110
Mario Santana – pp. 43, 53
Francesco Scavullo – p. 66 (left)
David Sims – pp. 138-139
Mario Sorrenti – pp. 76, 126-127
Studio Vaiani, Fototeca Biblioteca
Panizzi, Reggio Emilia – p. 18
Max Vadukul – pp. 116-119
Carlo Vannini – pp. 159, 170, 171, 244, 245, 247 Albert Watson - pp. 129, 130, 131 William Wegman – p. 146 Miwa Yanagi – pp. 144 (below), 145 Mike Yavel – p. 67

Thanks to the following models:

Leilani Bishop Carla Bruni Cecilia Chancellor Alba Clemente Inès de la Fressange Leah DeWavrin Kate Dillon Lily Donaldson Freja Beha Erichsen Linda Evangelista Juju Ivanyuk Hanna Hojman Polina Kouklina Ines Kummernuss Ginta Lapina Jasmine Le Bon Anouck Lepere Audrey Marnay Ali Michael Eniko Mihalik Susan Moncur Carolyn Murphy Nadege Snejana Onopka Hye Park Natasha Poly Maggie Rizer Hilary Rhoda Guinevere Van Seenus Emma Sjoberg Hana Soukupova Caroline Trentini Christy Turlington Steevie van der Veen Liisa Winkler Raquel Zimmerman

"Azzorre" Coat 2018223 F/W 1983-1984, sketch by Guy Paulin

Richard Avedon for Max Mara F/W 1998-1999 collection model: Maggie Rizer © The Richard Avedon Foundation

Catalogue edited by Adelheid Rasche

with the collaboration of Laura Lusuardi

Scientific Coordination Federica Fornaciari Laura Lusuardi

Organisation Diego Camparini Giorgio Guidotti

Studio Migliore+Servetto Architetti Associati, Milan Ico Migliore Mara Servetto with the collaboration of llenia de Stefano

Editorial Coordination Giovanna Rocchi

Editing

Michele Abate, Martine Buysschaert & Francesca Malerba with the assistance of Nicola Hawkins, Timothy Stroud

Paola Pellegatta, Paola Oldani

Iconographical Research Paola Lamanna

Translations Scriptum, Rome

Assessments

Studio Ligabue, Reggio Emilia

All rights reserved under international copyright conventions. No part of this book may be reproduced or utilized in any form or by any means, electronic or mechanical, including photocopying, recording, or any information storage and retrieval system, without permission in writing from the publisher.

© 2006, 2011 Max Mara srl, Reggio Emilia For this edition © 2006, 2011 Skira editore, Milan

Texts: © 2006, 2011 Marco Belpoliti, © 2006, 2011 Mariuccia Casadio © 2006, 2011 Federica Fornaciari, © 2006, 2011 Colin McDowell © 2006, 2011 Enrica Morini, © 2006, 2011 Adelheid Rasche © 2006, 2011 Margherita Rosina, © 2006, 2011 Christine Waidenschlager

ISBN 978-88-572-0889-3

Distributed in USA, Canada, Central & South America by Rizzoli International Publications, Inc., 300 Park Avenue South, New York, NY

Distributed elsewhere in the world by Thames and Hudson Ltd., 181A High Holborn, London WC1V 7QX, United Kingdom.

First published in Italy in 2011 by Skira Editore S.p.A., via Torino 61, 20123 Milano, Italy

Printed in Italy

www.skira.net

ACKNOWLEDGEMENTS

Thanks are due to all those who have helped to produce this catalogue and the exhibition, in particular Giuseppe Bacci Sara Bassi Mara Bellicchi

Anne Marie Beretta Eric Bremner Elisa Calzolari Massimiliano Camellini

Lucy Charlotte Capstick Vito Daga

Giulia De Lisi Elisabetta Farioli Emanuela Ferretti Laura Gasparini Anna Maria Giarrusso Isabella Ludovica Ghini Giuseppe Gonzaga Ian Griffiths Elvi Lugli Giovanni Lunardi Grazia Malagoli Rosanna Menozzi

Rosalia Piaia Loretta Piccinini Maurizio Sarati Gabriella Schiatti Giovanna Simonazzi

Nanni Strada Fernanda Urizzi Roberta Vezzani Lidoska Virgulti

We also thank all the people over the years have contributed to the development of Max Mara, in particular Marisa Crotti Amos Ciarlini Antonia Montanini

Finally, we are grateful to the Maramotti family

Coats! Max Mara, 60 Years of Italian Fashion State Historical Museum Red Square, Moscow 12 October 2011 - 10 January 2012

An exhibition by

Exhibition curated by Adelheid Rasche

in collaboration with Laura Lusuardi

Scientific Coordination Federica Fornaciari Giorgio Guidotti

Organisation Diego Camparini

Design Studio Migliore+Servetto Architetti Associati, Milan Ico Migliore Mara Servetto

with
Alice Azario
Michela Colasuonno
Yu Fung Ling
and
Chiara Berselli, Daniele Pellizzoni, Elena Prokina, Alicja Gackowska
(Moscow Edition)
Yang Guo, Stefano Avesani (Beijing Edition)
Aya Matsukaze, Kyotaka Iwami (Tokyo Edition)
Ilenia de Stefano, Alessandro Poli, Cristina Tomada, Giacomo Lietti,
Matteo Mocchi (Berlin Edition)

Exhibition layout and construction lighting: Tecnolegno Allestimenti s.r.l. mannequins: Veroni, Reggio Emilia multimedia: ELETECH Sistemi Video clothing restoration: R.T. Restauro Tessile, Albinea paper restoration: Chiara Ferretti, Reggio Emilia

Insurance Axa Art

Transports Arteria

Lenders
Archivio d'Impresa Max Mara
Archivio Nanni Strada
Famiglia Manfredini
Rosalia Piaia
Kunstbibliothek Staatliche Museen zu Berlin
Marco e Fernanda Urizzi
State Historical Museum, Moscow

L _a			
			4
	*		